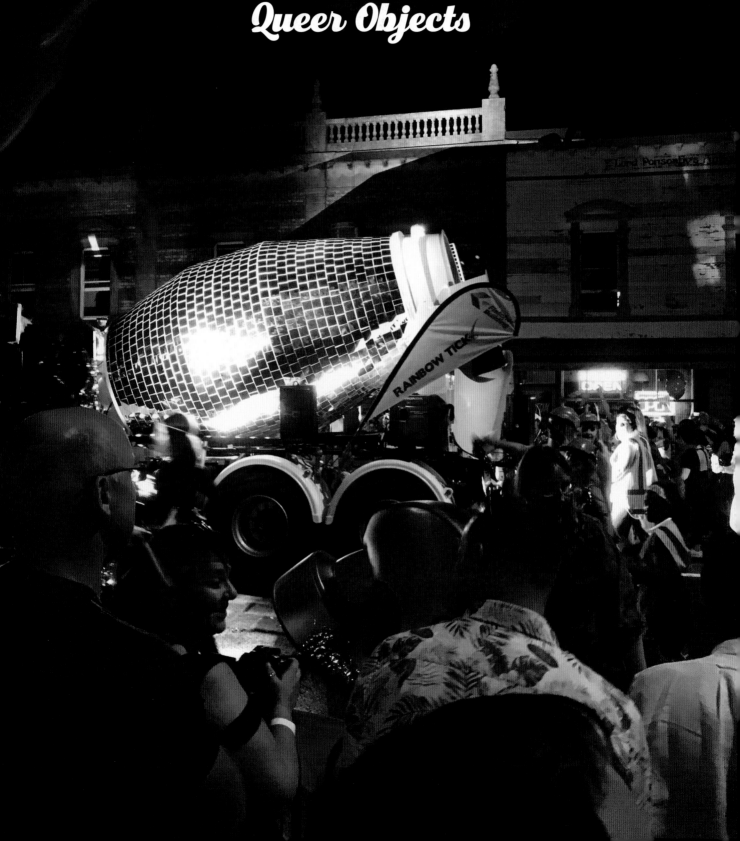

Queer Objects

Published by Manchester University Press
Altrincham Street, Manchester M1 7JA
In association with
Otago University Press, Dunedin, New Zealand

British Library Cataloguing-in-Publication Data
A Catalogue record for this book is available from the British Library

ISBN: 978-15261-3576-6 paperback

Editor: Anna Rogers
Index: Diane Lowther
Design/layout: Katy Yiakmis

Printed in Hong Kong through Asia Pacific Offset

MIX
Paper from
responsible sources
FSC
www.fsc.org FSC® C136333

Queer Objects

EDITED BY CHRIS BRICKELL & JUDITH COLLARD

MANCHESTER
1824

Manchester University Press

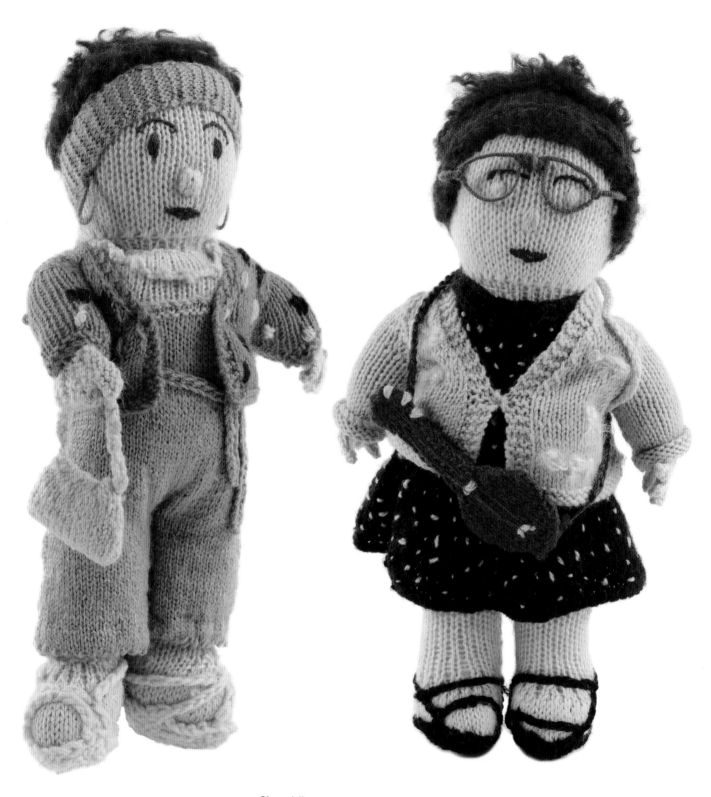

These dolls represent Jools and Lynda Topp ('The Topp Twins'), well-known New Zealand entertainers and lesbian icons.

Contents

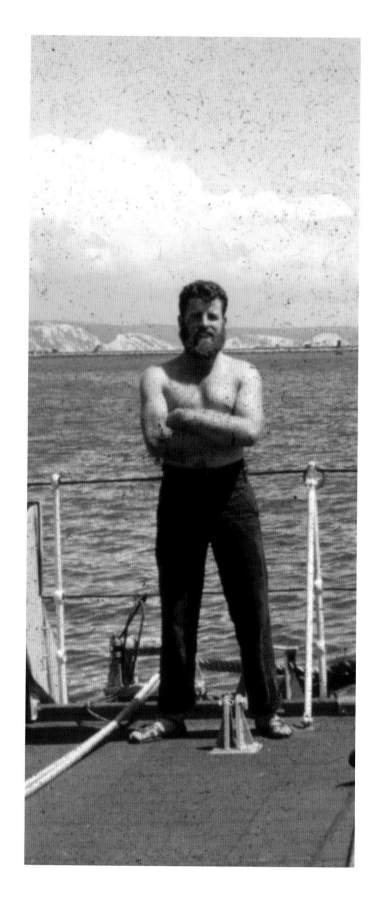

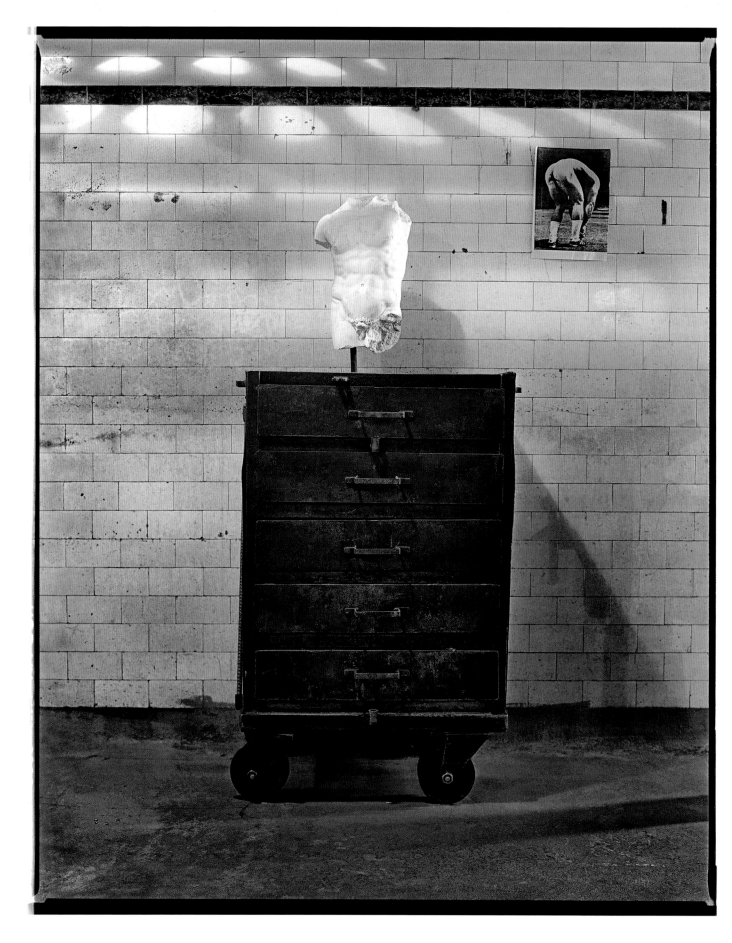

1. The Queerness of Objects

CHRIS BRICKELL & JUDITH COLLARD

Queer lives include a range of objects: the things with which we fill our houses, the gifts we share with our friends, the commodities we consume, the things we wear and the technologies we use to communicate with one another. But what makes an object queer? The chapters in *Queer Objects* consider this question in relation to lesbian, gay, bisexual and transgender communities as they are broadly conceived across time, space and culture.

 This collection takes its place at the intersection of two main bodies of writing. The first concerns itself with queer histories. This vast and ever-expanding field spans the centuries from the ancient world to the recent past and explores settings from towns and cities to whole countries and regions. It examines the shape of experience, relationships and activism among those who live outside prevailing norms of gender and sexuality.[1] The second thread considers the significance of things: mundane, everyday items as well as spectacular or famous ones. Art historian and museum curator Neil MacGregor famously suggested we might come to understand the history of the world by examining 100 objects.[2] Writings on queerness have occasionally intersected with this investigation into material culture. In 2013 Richard Parkinson, a contributor to *Queer Objects*, wrote *A Little Gay History*, a book based on the collections in the British Museum. Parkinson draws upon objects — sculptures, paintings, drawings — as examples of same-sex or ambiguous desire, illustrations of the complexity of human sexuality and changing social attitudes.[3] We move beyond Parkinson's original project to ask how objects — some of them very ephemeral items that may easily have been destroyed — have shaped and been shaped by gay, lesbian, bisexual and transgender lives around the world.

 Writers in the broad field of object studies and material culture make many useful observations. They note that geographical context is important, that the meanings of things and the significance they hold for people are

Marcus Bunyan, 'Two Torsos', 1991. Gelatin silver print.

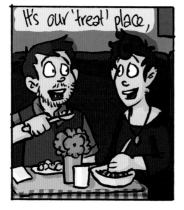

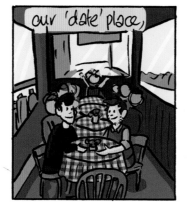

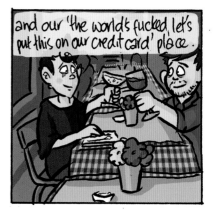

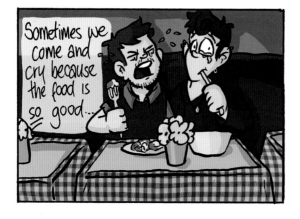

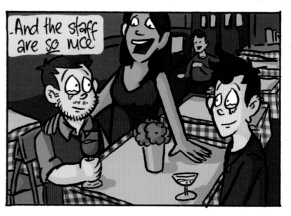

Thank you for being so lovely - Happy 7th Birthday!

embedded in specific places. We might celebrate each anniversary of a relationship at the same table in a restaurant, for instance, and keenly feel its loss when the place closes down and the tables are replaced with shelves of books or rows of clothes. Some objects travel between locations. Magazines, for instance, are published in one place and then spread through the postal system. A periodical like *Transvestia*, a pioneering transgender title from 1960, originated in California and went on to reach a much wider community, its meaning changing in the hands of each geographically diverse reader.

A succession of owners embellishes an object's 'social biography' as it moves through time and space, and new owners' lives become part of its story.[4] These new owners may also bestow objects with new value[5] – the old idea that 'one person's trash is another's treasure'. A couple may spot a chair, vase or tea-set cast aside by someone else and incorporate it into their own domestic lives. Objects can also be reimagined, reinterpreted, pulled apart and reassembled. What does a pumpkin mean, for instance, when it is stylised as a sculpture covered in dots? What if we imagine the dots as holes that, in turn, evoke the existential instability of social assumptions about sexuality? What about the condom, when it becomes a communion wafer in the rituals of the Sisters of Perpetual Indulgence, an international order of queer nuns?

The camera – whether a stand-alone device or as part of a phone – is the ultimate travelling object. We pick it up, stuff it in a pocket or cart it around in a bag. But it is also a means of recording other objects in their everyday settings: activist ephemera, snaps of friends on holiday and photos of public places appropriated for erotic encounters. Cameras create a visual record of the kinds of sex toys, erotic postcards and suggestive paintings that feature in *Queer Objects*. The camera also records cultures and the ways people feel about them: the happiness of a couple exchanging rings, cutting their cake and dancing at an unofficial gay wedding during the 1950s; the sailors sitting together on a sofa, awkwardly self-conscious, as they pose for the photographer.

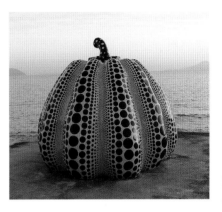

One of Yaoi Kusama's pumpkin sculptures.

The camera is an object in its own right, and it also records other objects.

Opposite: A restaurant's setting, staff and food – all of which combine to create an atmosphere – can become an integral part of a relationship. Comic strip by Sam Orchard.

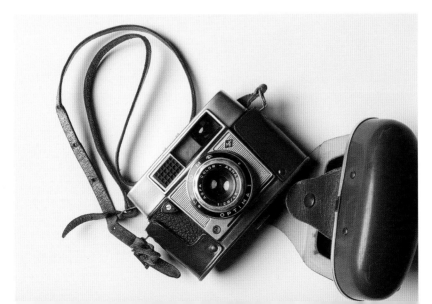

These examples demonstrate that the broad interests of object studies, including insights about the malleability of things, are also the specific concerns of queer history and culture. We inscribe books with dedications to our friends and lovers, for instance, and sometimes we modify and wear clothes in ways that challenge taken-for-granted ideas. Dress codes can reinforce differences of gender, class, age and status, but we can also mess with clothes by adding symbols of pride or defiance.[6] There is a long history of queer clothing, whether seen from the vantage point of its designers – many of whom have been gay – or its wearers.[7] During the early years of the twentieth century, some American men put on red ties in order to signal their interest in other men.[8] When we decorate a waistcoat or a leather jacket with queer signs, that item becomes a powerful signal of its wearer's community affiliations and we express both difference and belonging.[9] But this is not always straightforward. The monocle of the 1920s, for instance, signified class, bohemianism and sometimes lesbianism, but in any moment one of these meanings could mask the others. Was a monocle wearer merely signalling her social status, or was she telling others she was a particular kind of woman?

Objects – and not just the monocle – can be messy and contentious in their meanings.[10] What does a pair of Speedos, an item of swimwear, tell us about gay cultures in particular? What about the Action Man toy (or is it a doll)? And why is there such confusion? As Parkinson writes, 'Some objects are directly and unambiguously informative about desire and gender identity, while others speak to us more indirectly.'[11] There is little doubt about the significance of the protest button or placard, but the implications of other items are murkier. We might be tempted to read between the lines or against the grain, and it helps if we have a place to start. We know Australian women Freda du Faur and Muriel Cadogan were lovers at the

A Māori carved box or papa hou, now in the British Museum, shows figures entwined in sexual poses.

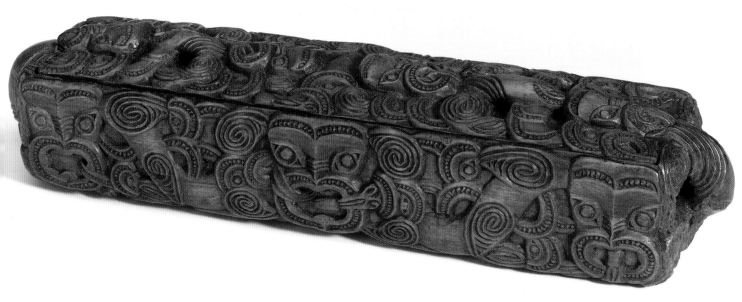

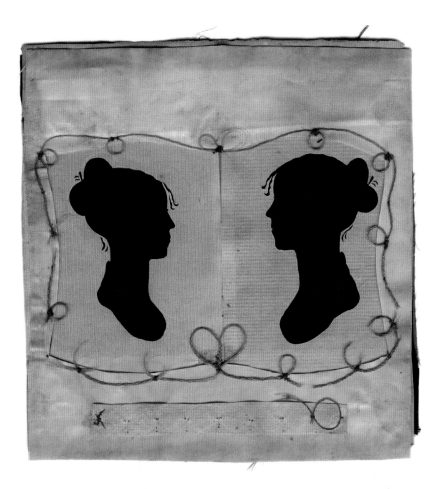

Charity Bryant and Sylvia Drake lived, worked and were eventually buried together in Weybridge, Vermont, during the early decades of the nineteenth century. This pair of silhouettes is framed in their braided hair. Note the plaited heart at the bottom.

start of the twentieth century, and this fact helps us to interpret Freda's ambiguously written mountaineering memoir as, in part, a documentary of an intense relationship. But other examples are harder to pin down. When we look at the floor plans of a house occupied by a pair of Australian women who lived contentedly together for several decades in the mid-nineteenth century, or silhouettes drawn by another pair from the American state of Vermont, how might we make sense of their households?[12] How can we even try to answer that question if these women did not define themselves in terms of their sexuality?

What do we make of the centuries-old Māori papa hou, or carved box, that shows male figures engaged in sexual activity? Who carved the box, and what were they trying to convey? And what about a set of ancient Egyptian tomb paintings of two men? Its subjects stand closely and look at one another intently, and sometimes they embrace, but does this suggest they were a couple? We can speculate in the context of the available historical evidence but, in the end, we will not always agree on the stories that objects tell. Objects may even come to mean fundamentally different things to their many viewers or users; they speak to us in different ways. Susan

Stabile reminds us that people 'invest symbolic power in objects', and that there is a reasonably long history of seeing things – and the conditions in which they came into being – as personally sustaining or politically useful.[13] The texts, pottery and drinking vessels that reveal the homoeroticism of ancient Greece and Rome, for instance, have long inspired those who sought reference points for their own feelings. So, too, have Sappho's poems, which tell of desires between women. The sexual character of the classical world is not directly analogous to Western societies over the last 300 years – the former imposed rigid limits of age and social status in terms of who did what with whom – but traces of older social patterns live on in collective imaginings. A pair of early-twentieth-century collectors purchased a Roman silver drinking cup that inspired their own written defence of love between men; a late nineteenth-century postcard with classical themes was passed down the generations and is now a treasured possession of a twenty-first-century gay couple.

Les Mots à la Bouche bookshop, Paris, 1983.

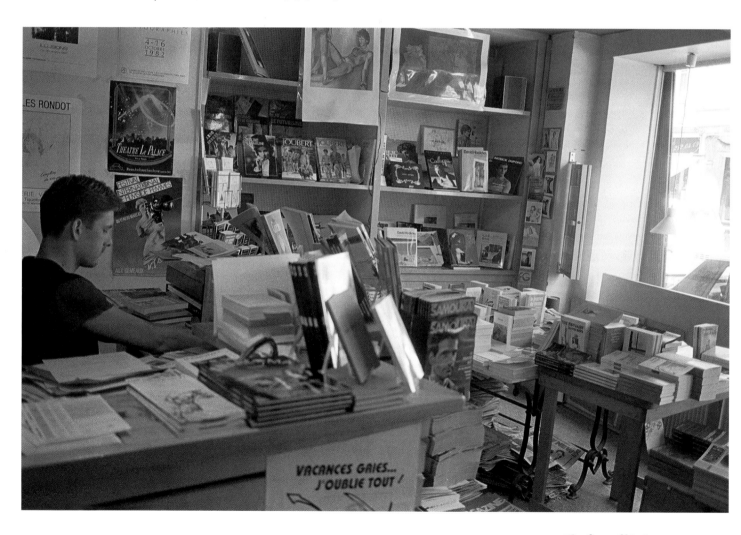

These ambiguities bring us to 'queer' itself. Why use that word to describe the objects in this collection? The term 'queer' is not universally liked: its history recalls name-calling of an often-derogatory sort. Since the late 1980s, though, 'queer' has been used as an umbrella term for the communities also denoted by more recent acronyms: LGBTIQA and its multiple variants. Queer is a useful, if somewhat controversial, shorthand for lesbian, gay, bisexual, transgender, intersex and asexual identities, but it is more complex than that. Queer also refers to non-normative expressions of sexuality and gender that transgress prevailing expectations of what is 'natural' or respectable. 'Queer theory', the philosophy that accompanies these ideas, first appeared in academia during the early 1990s. Queer theorists questioned the idea that normative and non-normative sexualities stand astride a clear-cut binary, and they challenged presumed relationships between desire, power, social norms and sexual categories.[14] Many sought to destabilise 'institutionally sanctioned hierarchies'.[15] Some even rejected the notion of identity itself, arguing that eroticism, intimacy and selfhood are constantly in flux.[16] This impulse, along with queer theory's focus on shifting social contexts and meanings, is useful for a project such as ours. The idea of 'queer' exposes the instability of the status quo and challenges the power of heterosexuality as well as the marginal status of homosexuality. It helps us to unpick what we thought we knew, and to subject almost any object to a rigorous — and sometimes surprising — set of reinterpretations.

Whether something can be said to be 'queer' is only sometimes inherent in the object itself. Liberationist tracts speak loudly of their ideological commitments, but the telephone, tram ticket, record player and powder puff are everyday objects that become queer when placed into particular scenarios and frames of meaning. Since the 1920s, telephones have functioned as nodes in complex social networks, including those involving queer men and women.[17] The portable record players of the 1960s helped foster lesbian culture when women took them to house parties and got everyone dancing. The passage of time renders other objects somewhat more curious to modern eyes, including some of the items associated with the repressive power of medicine and the state. During the 1920s and 1930s, in jurisdictions where male homosexual activity was illegal, police collected powder puffs from men and presented them in court as evidence.[18] The man with the powder puff was surely effeminate, they reasoned, and guilty of 'indecency'. In another example of social regulation, a modified Largactil pill bottle was the basis of an improvised plethysmograph: a device used in the attempted 'treatment' of same-sex desires.[19] Such objects could be two-sided: some, including the plethysmograph, were enlisted in attempts to suppress such erotic impulses, while others — including the powder puff, before it fell into the wrong hands — helped people to forge queer

cultures. Other items reveal the continuing impact of state regulation: in Thailand, for instance, the identity cards carried by every citizen do not fully acknowledge gender transitions. This causes a range of practical difficulties for transgender card holders and denies them full personhood.

Many scholars have explored the complex connections between art and queerness, and the visual arts can broaden conversations around gender when they are carefully interpreted.[20] Saint Eugenia disguised herself as a man and became a monk in order to preserve her virginity, and representations of her from the mediaeval period demonstrate that gendered embodiment was highly nuanced in Europe at the time. New Zealander Lois White's exuberant 1933 painting, *Persephone Returns to Demeter*, is seemingly unambiguous in its presentation of female erotic love, but it also reminds us that classical mythology has been used to grant possibly risqué material an aura of respectability. White, a single woman, was, however, a highly ambiguous figure who presents an almost asexual persona to the viewer. What do her paintings 'really' signify — and what does it mean when we speculate?

Queer objects in our homes also engender a wide range of feelings and emotions. They may evoke in their owners a sense of curiosity, familiarity, reassurance, safety or pride.[21] Furnishing an apartment and curating multiple objects in a room, including artwork, signals culture and sophistication, reveals a queer aesthetic and serves a social function.[22] The things we arrange within our homes express various aspects of our identity: not only our sexuality, but also our various tastes, hobbies and memories.[23] When we invite friends to our stylishly decorated apartment, we eat, drink and relax in the atmosphere we have created with objects. As John Potvin suggests in his work on male domestic spaces in early twentieth-century Britain, the dimensions, arrangement and décor of a room shape the homosocial interactions that take place there.[24] Once again, though, the ambiguities are never far from the surface: personal spaces become social, and sometimes political. People write, plan and organise there. Many apartments of the 1970s and 1980s were the home of lesbian and gay publishing initiatives, including the Polish magazine *Ephebos* as well as *Transvestia*. These publications offered a way to express anger, determination and pride.

How do modern readers put themselves in the frame when confronted with things from the past? We might imagine ourselves using old objects. When we open a mid-twentieth-century make-up box we may wonder what the thick oily pastel would feel like on our own skin and then imagine our way into a world of theatrical glamour and exotic personae. Other kinds of objects, though, engender feelings of distress or distaste.[25] How do we feel when we read the story of the certificate authorising the expulsion of a woman from the military for being lesbian? Or the book that portrayed

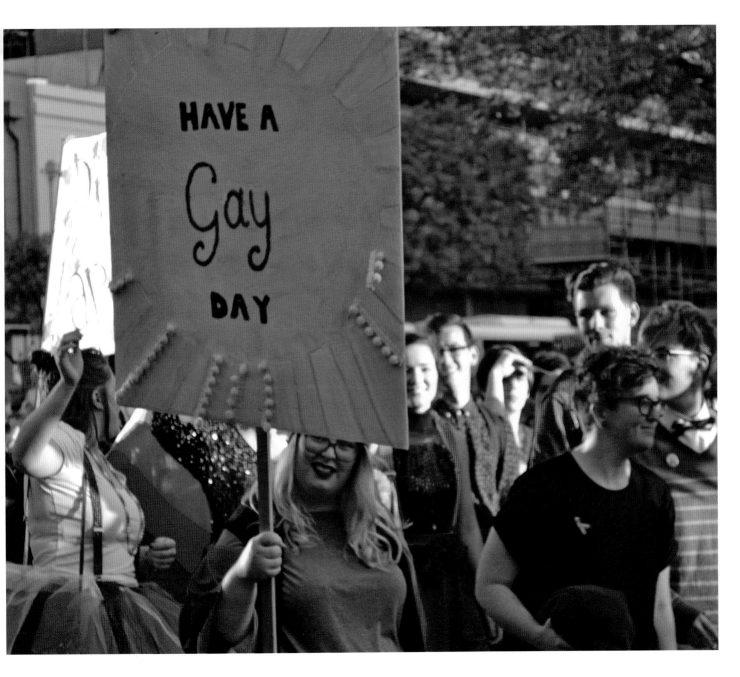

Pride in Adelaide, 2015.

a sexually abused slave finding her own voice and exercising resistance through violent sadism? These examples raise the question of how much distance writers and readers can place between the queer past and their own present.

Objects rarely exist in isolation; instead they are elements of wider networks of time, space and sociability. Queer bookshops offer a good example of assemblages, 'wholes whose properties emerge from the interactions between parts'.[26] Bookshops include many individual volumes, shelves, tables and the associated miscellanea of small-scale commerce, but

they also belong to wide national and international networks of readers, publishers, ideas, libraries and collections.[27]

The pride parade, another example of an assemblage of objects, is also entangled in far-reaching webs. The 2015 Adelaide Pride Parade featured a homemade sign that read 'Have a Gay Day', which jostled with rainbow tutus, cloaks, ties, umbrellas, other banners and the parade participants who made creative use of these items. The 'Gay Day' sign took its meaning from nearby things, and drew upon material cultures of queer protest that have spanned multiple countries since the 1960s.

Networks also involve the intricate connections between people and objects. We have already mentioned the relationships between queer people and institutions like the state and medicine, and connections between lovers and between friends, but what about relationships between people and their pets? What does a photograph say about the familial bonds between lesbians or gay men and their dogs or cats, for instance? The links between people and technology often have a queer twist too. One object has shaped the intimate worlds of those living in the twenty-first century in especially powerful ways: the smartphone, with its dating apps and geolocation features, is a high-stakes example, and our experiences on social media remind us of the possibilities afforded by networks and the perils of social surveillance. Desire, identity, society and technology are intricately interconnected, and this is no less true of the queer world than anywhere else.[28]

Tensions between the past and the present become clear when we look at how objects memorialise those who have gone before us. Gravestones are the most obvious examples, and their inscriptions hint at the feelings for the people buried below. There are sometimes queer puzzles to be solved: what was the relationship between the dead and those mentioned on their grave, and how did it take shape? Our contributors examine other examples too. What does it mean for one man to give to another a locket containing his photograph? In a case like this, old intensities of feeling may still be palpable even after many years. Many of the items explored in this book are mundane and humble, and in many ways their queerness rests in their role as mnemonic devices. These gain resonance because of what they represent to the writers, and they project past and present memories into the future.[29] In other words, they can be imagined as vehicles for memory rather than as objects with an intrinsic material presence.[30] We do not always know whom a particular object memorialises: the set of wedding photos that feature in this book are of an anonymous couple, and the survival of the images was by no means assured. The study of material culture and its multi-layered meanings continues to provoke us into further explorations of emotions and ideas, and sometimes we go far beyond the expectations of the original participants and owners. These tangible memories continue to provide even

the humblest of objects with value, and with complex insights into the experiences of queer people across the centuries.

Queer Objects takes on the 'task of tracing associations'.[31] The contributors in this volume carefully examine the associations between objects and history, between objects, and between objects and their owners. Many authors focus on individual objects, some of them expertly designed and some homemade, while other writers adopt a broader approach and look at the assemblages that come into being when objects interact with people and contexts, sometimes across vast spans of time. Our oldest item dates from the twenty-fifth century BC; the newest is an example of twenty-first-century technology. Fourteen countries feature in this collection. A little over a third of the chapters deal with New Zealand and Australian objects; the remainder examine items with connections to Thailand, Japan, the United States, Britain, France, Spain, Germany, the Czech Republic, Italy, Poland, Greece and Egypt. The international significance of objects, though, is not limited to any single country. Ancient artefacts, books and beliefs have moved across borders, and queer inhabitants of South Pacific and Asian nations, for instance, have drawn upon imagery and ideas emanating from the ancient world and nineteenth-century Europe as well as the goods and media produced during the globalised twenty-first century.[32] The networks of objects take shape in complex ways.

By exploring this wide range of things and places, arranged a little like a cabinet of curiosities in a sequence of rough themes – identity, growing up, literature, sex, art, domesticity, memorialisation, regulation, adornment, activism and leisure – *Queer Objects* reveals both the diversity of social classifications and human experiences and the continuities in the world of love, sex, friendship and intimacy.[33]

Is this button a queer object? Perhaps it depends on who is wearing it?

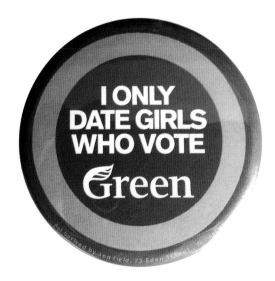

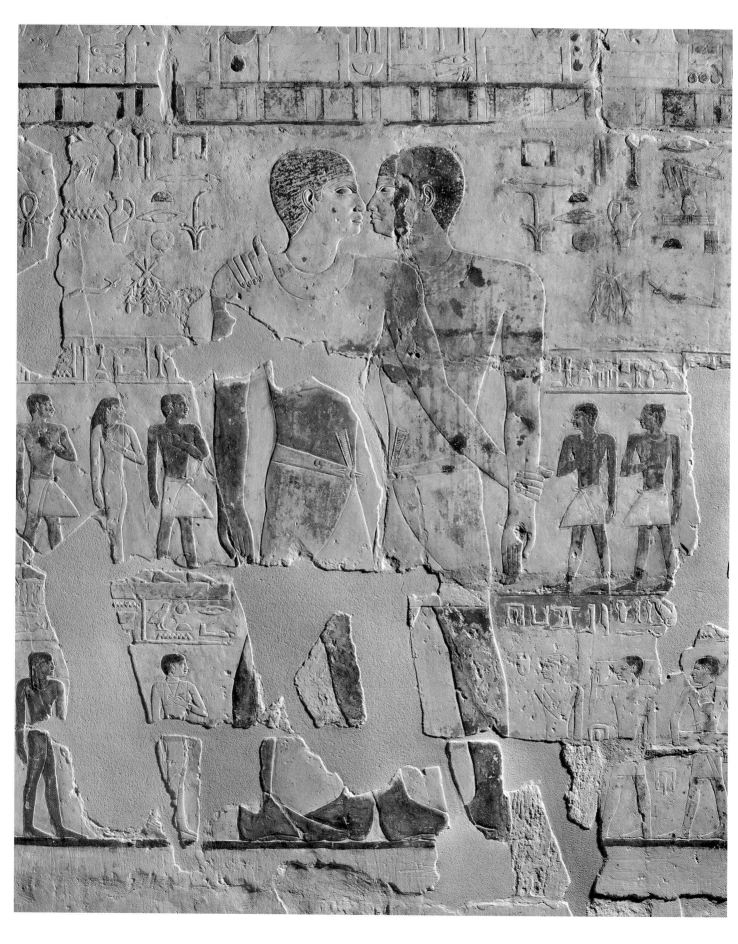

2. The First Gay Kiss?

RICHARD BRUCE PARKINSON

Around 2450 BC, at the end of the reign of King Neuserre, two ancient Egyptian courtiers named Niankhkhnum and Khnumhotep built a tomb for themselves in the royal cemetery at Saqqara.[1] Both men held the ceremonial title 'royal manicurist', which signalled a prestigious closeness to the king, and both had strikingly similar career paths, although it seems likely that Khnumhotep died first.[2] Their monument included a tomb-chapel decorated with standard scenes of the two office-holders in all their elite status. These depictions conformed to the normal conventions of gender and high rank and the men were shown with their wives and children. They also kissed, embraced and sat with each other, often in the type of scene where a tomb-owner was usually shown with his wife. Decades later the whole monument was buried when the causeway of King Unas's pyramid was built over it. Although the men's graves were robbed in antiquity, the tomb survived remarkably intact. Rediscovered in 1964, it has become a case study in the uncertainties of interpretation for queer history.[3]

To modern eyes, the embracing men look very much like a same-sex couple. Available evidence suggests that ancient Egyptian society was highly heteronormative, and that there was social and cultural pressure on individuals to marry and have children. This does not, of course, preclude same-sex desires or relationships. Egyptian literary texts provide clear examples of these, including *The Tale of Neferkare and Sasenet*, which deals with the clandestine sexual relationship between a king and his unmarried general.[4] Sexual relationships between mature men were clearly possible, at least in fiction, although they were apparently regarded as scandalous aberrations. In this cultural context a state monument depicting a same-sex couple would be exceptional and other readings of the unusual scenes are possible. Although Egyptian tomb scenes can appear immediate and lively, they display their owners' elite social identities in ways that do not necessarily match the modern idea of a family as two romantically attached individuals. They do not necessarily show, in Philip Larkin's words, that 'all that survives of us is love'.

The tomb owners embrace surrounded by their children, in Room 6.

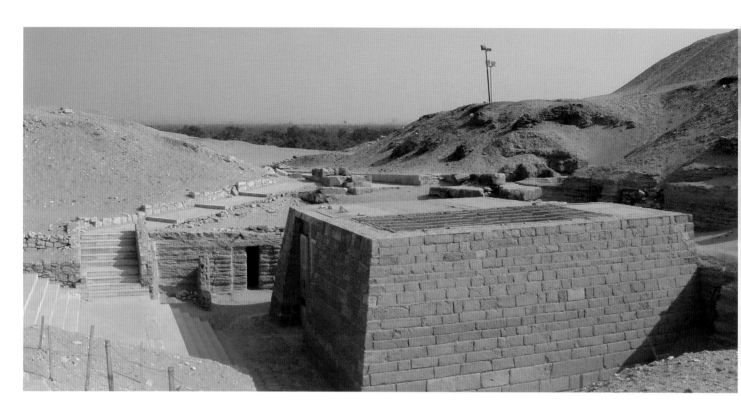

The tomb-chapel of Niankhkhnum and Khnumhotep in the desert cemetery at Saqqara.

The pairing of the two men in the iconography suggests they could have been twins, perhaps identical twins.[5] The men's parentage is not recorded, but their names are strikingly similar. Both evoke the creator god who shaped children's bodies – they mean 'Life-belongs-to-Khnum' and 'Khnum-is-content' – and since names were given at birth, a close genetic relationship is suggested. Although it is conceivable that the men were unrelated individuals who adopted new matching names when they became a same-sex couple, there is no evidence from pharaonic Egypt of such a practice. One banquet scene in the chapel includes a reference to the song of 'the two divine brothers', which may evoke the sibling gods Horus and Seth as mythical prototypes for the genetic relationship between Niankhkhnum and Khnumhotep. Nevertheless, this allusion is not without its queer possibilities: in mythology the disorderly god Seth attempted to have sex with Horus. In some versions of the myth, Seth attempted to humiliate Horus, but in one version he chatted him up with the line, 'What a lovely backside you have!'[6]

A reading of Niankhkhnum and Khnumhotep as twins is nevertheless accepted by most Egyptologists, including me. A few scholars have argued that the pair's iconography is so similar to the imagery used for a tomb-owner and his wife that it marks them out as a same-sex conjugal couple, even though their mutual style of embrace more resembles scenes of kings and gods kissing.[7] Still, embraces and kisses are not exclusively signs of sexual desire: such gestures can have many meanings. The dividing lines

between homosociality and homosexuality in any culture are unstable and complex and can be hard to determine for both insiders and outsiders. As an Egyptian once discreetly asked my husband and me, 'Brothers or friends?' The passage of time adds to these difficulties.

Ancient examples of same-sex desire are important for modern sexual self-awareness and social identity, especially in cultures where 'homosexuality' is considered to be a modern American or European 'disease'.[8] Treasured as a 'positive image' of gay history, Niankhkhnum and Khnumhotep feature extensively in online resources, modern artworks and campaigns for equality as the first recorded male–male couple in human history.[9] Ancient Egyptian textual evidence, including the examples I mentioned earlier, show that same-sex desire existed, but the historical relevance of these scenes to ancient same-sex desire is less certain.[10] Queer archaeologists and online commentators have often dismissed the twin hypothesis as an example of heterosexist bias, and the interpretative issue is staged as a binary dispute between heterosexist academics and radical queer interpreters of the past.[11] As a gay Egyptologist who supports the view that the men were twins, I was told at one conference that I was therefore

Perspective drawing of the tomb-chapel of Niankhkhnum and Khnumhotep by Harold Parkinson.

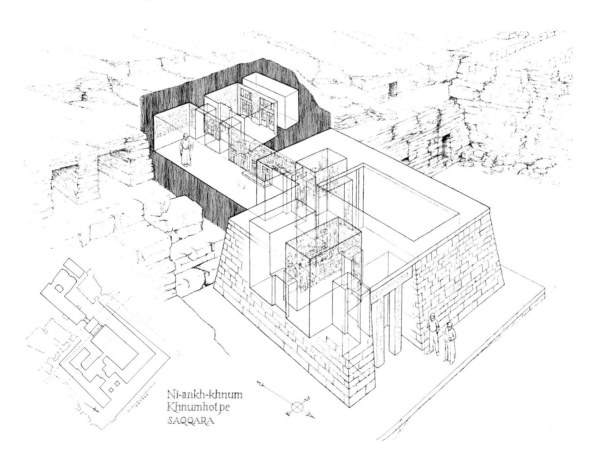

Ni-ankh-khnum
Khnumhotpe
SAQQARA

'not gay enough' for holding this opinion. This is an example of a wider dilemma faced by historians: between seeing ourselves in the past and seeing the past as differently constructed.

The interpretative problem is paralleled in a similar symmetrical pairing on the funerary monument of two architects, Hor and Suty, from around 1375 BCE. They are named after the sibling gods Horus and Seth, and in the inscription Suty says that Hor 'came forth from the womb with me the same day', suggesting that they were twins.[12] Egyptologist Greg Shubert has suggested that the monument had been erected by a same-sex couple and was later defaced by their outraged wives and families,[13] proposing that they were unrelated individuals who happened to have the same birth date. While this reading of the text is conceivable – it does not explicitly say that they came from the *same* womb – other evidence argues against his hypothesis: on another stela belonging to them, their wives have also been defaced. Which do we prioritise in assessing the shifting balance of such fragmentary evidence: reading against the grain, or reading within a documented context? Reading for similarity, or for difference? With Niankhkhnum and Khnumhotep, there is unfortunately no such additional evidence to help resolve these dilemmas.

These uncertainties and ambiguities are frustrating, but they also mirror the fact that, in any society, polymorphous human desire tends to resist strict boundaries and black and white definitions. Friendship, affection, desire and love are often parts of a fluid continuum that varies even within a single culture and resist the imposition of any binary definitions. The scenes of Niankhkhnum and Khnumhotep have held a range of meanings for viewers over time. The men are powerful symbols of ancient male intimacy, and it is easy for a modern queer viewer to read them as erotically charged. For many people, they have become queer icons, even though they were arguably not originally intended to be so. Nevertheless, given the well-documented existence of same-sex desire in ancient Egypt, it is possible that they were objects of ancient queer gazes when their tomb-chapel was still accessible; modern viewers are not necessarily the first to read same-sex erotic desire in these scenes of fraternal affection. All views are fashioned within specific political, cultural and personal contexts, and the controversy is a reminder that negotiating the relationship between our own experiences and ancient identities will always be difficult and complex: we must be self-reflexive and open to all possibilities.

Two men on a wall are shown embracing and kissing, and they have been holding hands for over 4000 years. That much is certain, and it is very probable that they were ancient twins, but the emotional reality of their lives beyond the iconography remains unknowable. As one ancient Egyptian poem noted, 'one cannot know what is in the heart'.[14]

'Khnumhotep + Niankhkhnum' by Ryan Long.

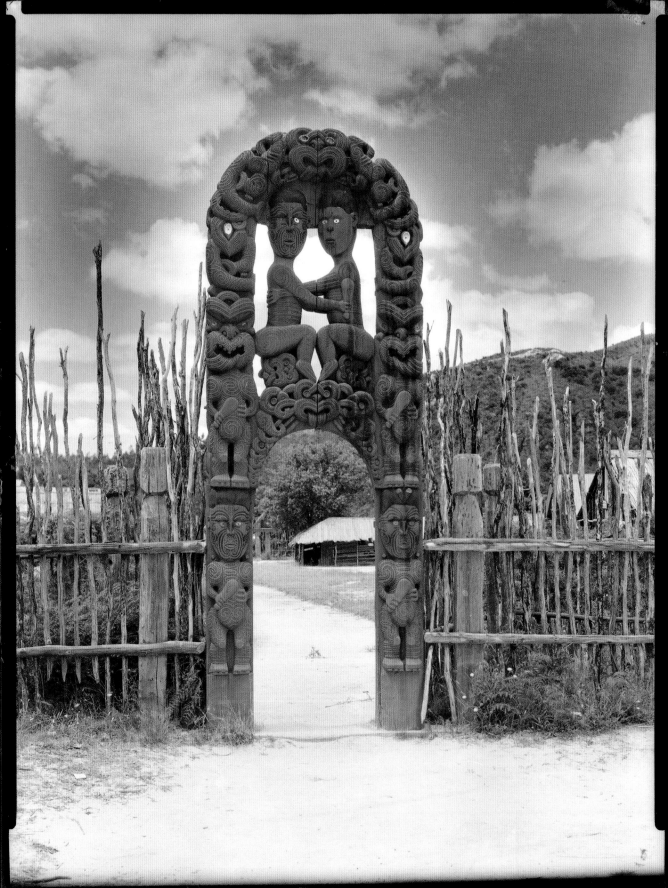

3. Tūtānekai's Flute

PAERAU WARBRICK

As a child I was taught the Māori song 'Haere ra e hine ki Mokoia'. I did not really know its meaning, but I knew it was a love song that involved Mokoia Island in the middle of Lake Rotorua in the Bay of Plenty. It was there that Te Arawa, the Māori tribal grouping to which I belong, was defeated by Ngā Puhi, an upper North Island iwi (tribe) and their allies in about 1823. And it was at Mokoia that the famous Māori love story between Tūtānekai and Hinemoa took place some 400 years ago.

The basic outline of the story is well known in New Zealand.[1] Because Hinemoa was of a higher class of kinship than Tūtānekai a union between them was socially unacceptable. Tūtānekai, who lived on Mokoia Island, played tunes on his flute for Hinemoa, who lived on the southern edge of Lake Rotorua. Unable to bear being parted from Tūtānekai, in the evenings she swam to be with him and returned to her people before sunrise. Eventually Hinemoa and Tūtānekai were betrothed, and many Māori, especially from the Bay of Plenty, are descendants of the couple. I am one of them.

The flute that Tūtānekai played to Hinemoa, of a type known as kōauau, still exists.[2] It was made at the time of Tūtānekai's birth, about AD 1600, by his father Whakaue. Twelve centimetres in length, it is carved out of bone, has three finger-holes and at each end are simple Māori patterns. The custodians of such a prized taonga, or treasured item, are the Tapsell whānau of the Bay of Plenty, also descendants of Tūtānekai and Hinemoa.

Although Tūtānekai's story usually focuses on his relationship with Hinemoa, there is more to it than that. The flute was also played by Tiki,

Opposite: The carved wooden waharoa (gateway) at the Māori settlement of Whakarewarewa in Rotorua: the two intertwined figures shown in an embrace represent Tūtānekai and Hinemoa.

Tūtānekai's flute, now on loan to the Rotorua Museum Te Whare Taonga o Te Arawa.

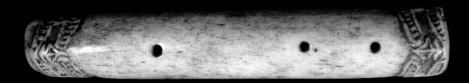

with whom Tūtānekai had a deep and loving relationship.[3] This pre-dated Tūtānekai's serenading of Hinemoa and continued in one form or another after Tūtānekai married her. A mid-nineteenth-century manuscript written by the chief Wiremu Maihi Te Rangikaheke mentions Tūtānekai and Tiki:

> Ka aroha a Tutanekai ki a Tiki, ka mea atu ki a Whakaue,
> 'Ka mate ahau i te aroha ki toku hoa, ki a Tiki.'

> Tūtānekai loved Tiki, and said to Whakaue,
> 'I am stricken with love for my friend, for Tiki.'[4]

Tūtānekai also refers to Tiki as 'taku hoa [my friend] takatāpui',[5] which *A Dictionary of the New Zealand Language*, compiled by missionary William Williams, defines as 'an intimate companion of the same sex'.[6] The word went out of use during the colonial period and made a return when, in the late twentieth century, Māori promoted the recognition of such traditional cultural terms and world-views. Now takatāpui describes an intimate and emotional relationship with a person of the same gender, and includes Māori gay, lesbian and transgendered people.[7]

Various accounts of takatāpui have existed within Māori society over the 400 years of the flute's existence, but the the role of whānau, or family, in Māori society is the starting point for understanding takatāpui relationships. We can contextualise Tūtānekai's flute by examining the role that Tūtānekai and Tiki played within whānau structures, and the ways in which Tūtānekai's descendants dealt with the question of takatāpui.

In the centuries before British colonisation, Māori society had its own values, principles and religious beliefs and these did not preclude the recognition of takatāpui.[8] Because there was no centralised government, whānau and hapū (clan) dynamics determined how takatāpui relationships functioned in practice. Different kinds of relationships were not mutually exclusive. Tūtānekai still felt deep love for Tiki when he forged his relationship with Hinemoa. Tiki even lived with Tūtānekai and Hinemoa for a time, and Tūtānekai arranged for Tiki to marry his sister Tupaharanui. These arrangements emphasise the importance of kinship in Māori society.

About 100 years after Tūtānekai, Hinemoa, Tiki and Tupaharanui had died, Tūtānekai's descendants, who had the small bone flute in their possession, witnessed the arrival of English explorer Captain James Cook, who travelled along the Bay of Plenty coast in 1769. His voyages paved the way for the arrival of Europeans in New Zealand. In the first decades of the nineteenth century British Protestant, and later Catholic, missionaries began to influence a small number of Māori communities, but at first their impact on Māori attitudes towards same-sex relations was marginal.[9]

A formal missionary post was established in Rotorua among Tūtānekai's descendants in the 1830s. The missionary Thomas Chapman lived for a time on Mokoia Island, the very place where Tūtānekai and Tiki played the flute to each other.

After 1840, when New Zealand was declared a British colony, the churches became increasingly influential among Māori. British law penalised some types of male homosexual activity, but its effect on Māori and their whānau was minimal. Most Māori lived in rural areas where legal administration was barely effective and takatāpui relationships were not actively policed. But as the numbers of British immigrants increased, the dominance of church teachings intensified and the formal state education system imbued young people with British customs and values. (The 1877 Education Act, which established free, secular and compulsory education, also allowed Māori to attend school with their parents' agreement.)

By the end of the nineteenth century, Tūtānekai's flute bore silent witness to a Māori society increasingly influenced by British prohibitions against same-sex relations. There was no formal place for takatāpui in a New Zealand society now overwhelmingly dominated by Pākehā settlers. At least one such person came to know Tūtānekai's flute: Danish mariner, whaler and trader Phillip Tapsell married a descendant of Tūtānekai, and his own descendants looked after it before depositing it in the Rotorua Museum.[10]

Increased interaction between Māori and Pākehā during the Land Wars, and after the end of World War I, brought takatāpui into contact with British legal systems. As more Māori lived in the growing towns and settlements, newspapers reported a few court cases of town-dwelling takatāpui who challenged Pākehā gender norms. In Wellington in 1928, for instance, when George Grace, a nineteen-year-old Māori from the East Coast, was prosecuted for stealing and wearing dresses, the newspapers described him as effeminate in nature.[11] There was still a rural/urban divide, however, and takatāpui were accepted among their whanau in the countryside.[12] In the 1930s my own great-aunt and uncle Te Kunu Sarah Moko and Hirikanawa Moko, both descended from Tūtānekai, lived as takatāpui. This branch of my whānau lived in the rural eastern Bay of Plenty, an area occupied by their Ngāti Awa iwi before Europeans arrived in New Zealand, and there was limited contact with the orthodox Christian churches.

Social patterns changed after World War II when large numbers of rural Māori moved into towns and cities for work and other opportunities. Although many takatāpui did not experience extreme discrimination among their whānau in traditional areas, they were sometimes confronted by prejudice in the Pākehā-dominated cities. There were strict gender roles for boys and girls in the education system, for instance, and the game of rugby, which relied on a strict model of masculinity, left no role for takatāpui.[13] At the same

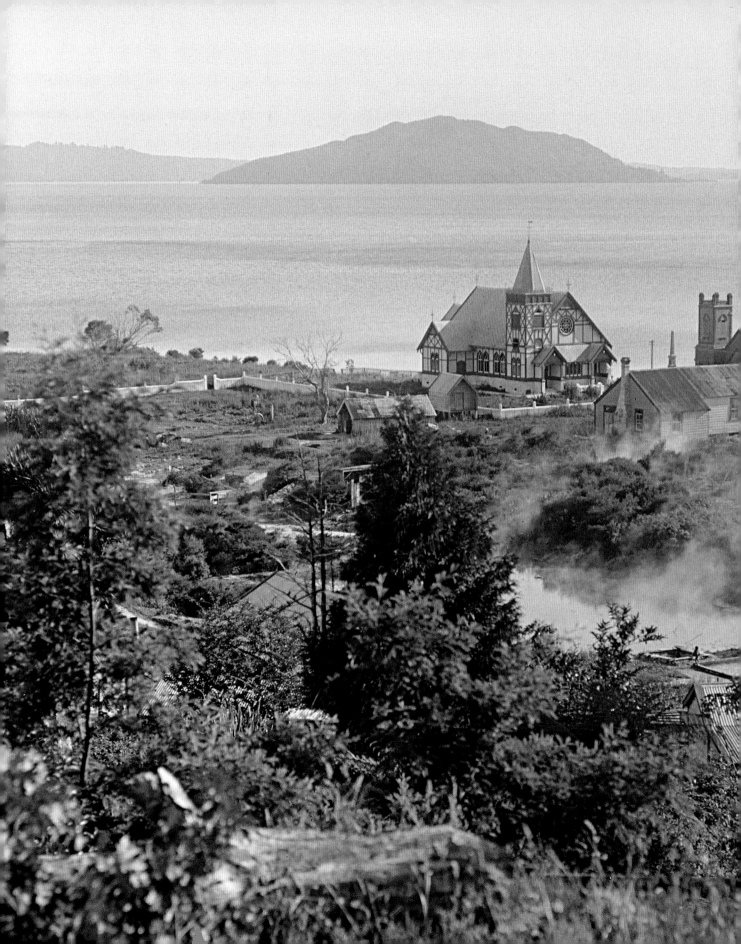

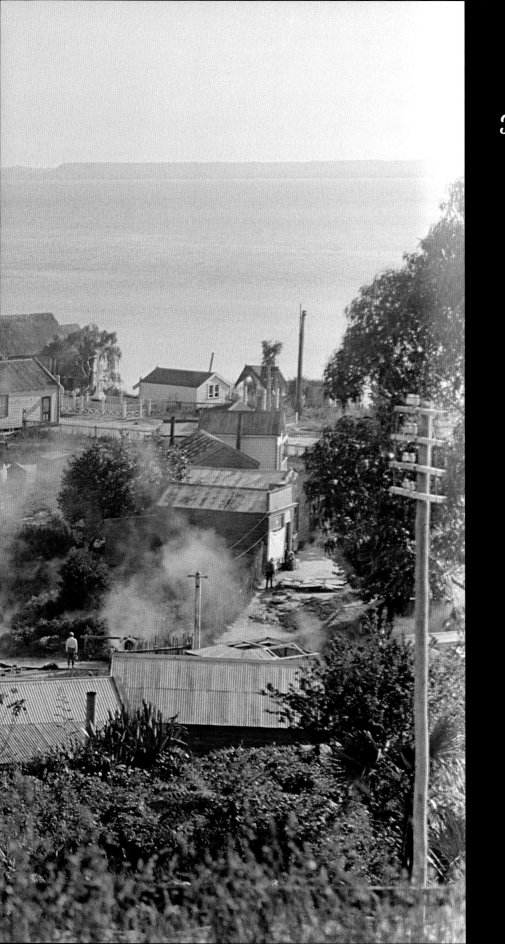

Tūtānekai = Hinemoa
Te Whatumairangi
Te Ariarirangi
Tunohopu
Te Kurainoiao
Hinerangi
Hineriu
Mahi
Te Rangikawehea
Hatua
Rangitukehu
Maata
Te Mokohaerewa
Paranihia
Paretoroa
Paerau Warbrick

Mokoia Island, Lake Rotorua, and the Māori settlement of Ōhinemutu. Ōhinemutu was Hinemoa's home, and Tūtānekai lived on Mokoia Island. St Faith's Anglican Church can be seen near the shoreline.

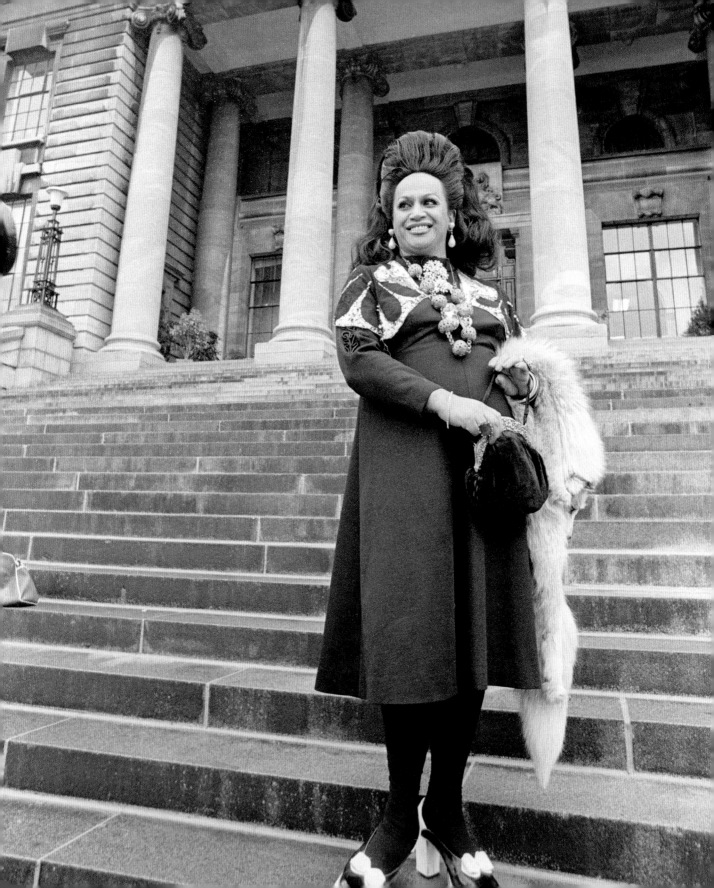

time, though, the more dynamic urban culture brought new opportunities for takatāpui to interact with gay and lesbian Pākehā.

In the late 1980s, when I was the student representative on my high school board of trustees, I proposed that the drag queen Carmen Rupe, a descendant of Tūtānekai, should be invited as guest speaker to our annual student prize-giving. Many of us teenagers who lived in rural New Zealand in the 1980s had seen Carmen on television and understood how she challenged stereotypical gender roles. She taught us that men did not need to be stoic figures and that they could wear dresses and make-up. The discussion of my idea, however, was promptly shut down by the other board members.

It was during my high school years that profound questions were being asked about the place of Māori people and culture in New Zealand.[14] Some scholars and commentators asserted that takatāpui relationships had always been part of Māori society. Ngahuia Te Awekotuku, another of Tūtānekai's descendants, retold the story of Tūtānekai and Tiki for a new era. After reading the account of Tūtānekai's intimate relationship with Tiki in the Te Rangikaheke manuscripts, she concluded that Tūtānekai was less impressed by Hinemoa than the romantic Victorian narrative had suggested. She also imagined that Hinemoa was herself takatāpui, 'a woman conscious of the many erotic possibilities offered in her world; a woman who chose a man who preferred his own sex – just as she preferred hers'.[15]

Things continued to change in the new millennium. The Civil Union Act of 2004, and the legalising of same-sex marriage in 2013, allowed state recognition of the loving partnerships of takatāpui. Te Ururoa Flavell, a member of parliament who represented the Māori Party, supported the Marriage (Definition of Marriage) Amendment Act. In his speech to New Zealand's House of Representatives he read out Tūtānekai's words: 'I am stricken with love for my friend Tiki.'[16] Māori media celebrity Tamati Coffey entered into a same-sex civil union with his partner and went on to win the Māori seat of Waiariki from Flavell in the 2017 general election. Not only is Coffey, like Flavell, one of Tūtānekai's descendants, but the electorate of Waiariki covers Mokoia Island.

Tūtānekai's flute, its associated genealogies, and the lives of takatāpui, have all been entwined across history. The flute has witnessed the changing shape of Māori society from the time of its creation some 200 years before the beginning of European settlement in New Zealand through to the present day. Following a period of dominance by conservative British cultural values, takatāpui are once again accepted in Māori society. Each whānau, however, will always have its own story to tell about the place of its takatāpui members.

Tamati Coffey was elected to the New Zealand House of Representatives in the 2017 general election.

∽

Opposite: Trevor Rupe, widely known as Carmen, on the steps of the New Zealand parliament in 1975.

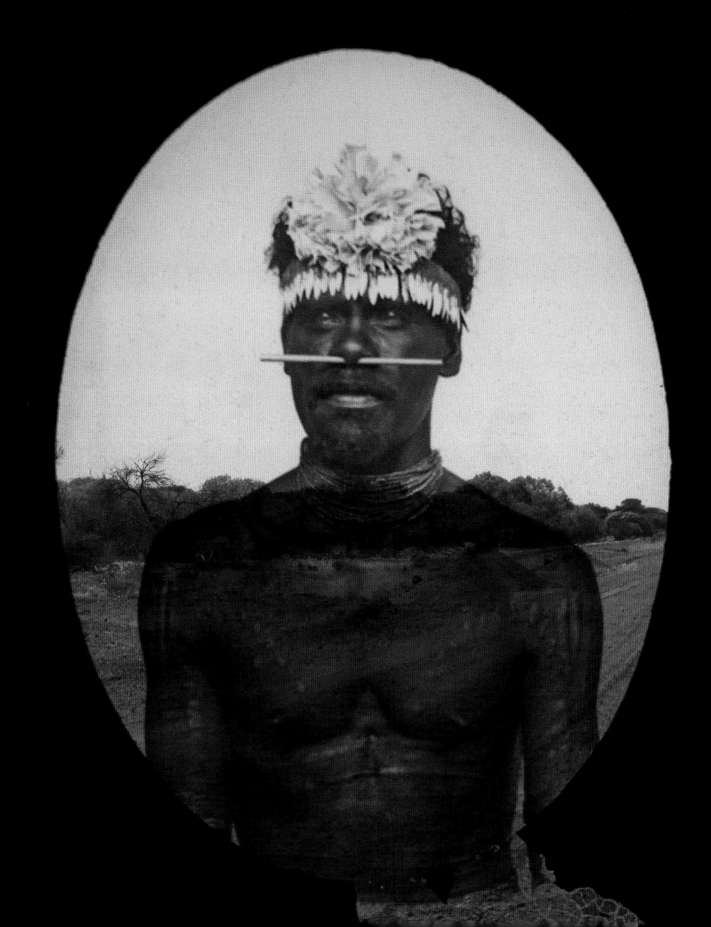

4. Faces of Queer-Aboriginality in Australia

DINO HODGE

> The lived realities of colonisation have constructed a silencing force that mutes Queer-Aboriginality. It is as if history has constructed Aboriginality as being so pure and so savage, so purely savage, that if tainted by the complexity of sexuality and gender, mixed ethnographies, mixed geographies and mixed appearances, the whole look would be ruined.
>
> TROY-ANTHONY BAYLIS

Sometimes a new way of knowing is accompanied by a eureka moment. For me it has taken decades and the encouragement and support of many good friends, including my mate Gary Lee. We met in 1983, shortly after I moved to Darwin, the capital city of Australia's Northern Territory. Darwin was then a male frontier world imbued with alcohol and violence. Homosexual acts between men were illegal, and people led closeted lives in fear of the police and of any public revelation about their love lives.

A distance prevailed between the lesbian and gay male communities in the Northern Territory. Lesbians generally had broader interests than the gay men: feminist responses to sexism and social justice, the Working Women's Centre, and establishing services for victims of domestic violence, assault and rape. For homosexual men, much of their political agenda was simply surviving institutionalised homophobia and social ostracism. There was a schism, too, along race lines. It would be the late 1980s before Aboriginal gay men felt comfortable attending Darwin Gay Society gatherings. Gary once explained to me, 'You'll never see many Aboriginal people at Gay Society events. You can be walking to the bar and overhear, "What's that black cunt

Aboriginal man, c. 1890, photographed by Paul Foelsche.

doing here?" It's boring but you learn to live with it and deal with it.'

Darwin is on Larrakia country, and Gary is a mixed-race Larrakia man with Chinese and Filipino heritage. It was a rare gay whitefella who would be seen in public talking with or even acknowledging a gay blackfella. Gary recalls the first time he saw me. I was sitting in the back of a car at a beach chatting with some of his countrymen. He says he knew then that we would be firm friends. This friendship influenced the creation of queer objects over the coming years, including collaborations on two books.

When I met Gary he was researching the life and work of Paul Foelsche, a German migrant to Australia. In 1869 Foelsche was tasked with establishing the Darwin Police Service. His personal interests included photography and he enjoyed an unofficial career exhibiting images of Darwin and its inhabitants in major cities around the world. A substantial part of Foelsche's efforts focused on Aboriginal people, whom he photographed either 'in the field' or at his studio. He maintained in his studio a collection of body decorations made by local people with which he adorned the 'natives', the depersonalising catch-all description for Indigenous peoples. Gary was interested in the ways photographic 'studies' of Indigenous subjects like Foelsche's eliminated personal identities and cultural authenticity. He established that although the artefacts Foelsche used were Larrakia, the photographer took a degree of artistic licence designed to make his natives appear even more exotic. Such a stylised approach would have been foreign to the Larrakia themselves. Perversely, it extinguished any recognition of diversity in Indigenous peoples' sexual and gender identity. Foelsche turned a dynamic blackfella subject into a queerly fantasised object intended to intrigue and please the Western eye. The display and sale of these images brought Foelsche international fame and reward; at the same time he created an important archive of the times. In 2014 his legacy was celebrated with an exhibition at the Northern Territory Library. Controversy erupted when a historian complained that the exhibition glossed over the slaughter of innocent Aboriginal people in the northern half of the Territory which, as police inspector, Foelsche had masterminded and orchestrated over the course of 30 years.

Such elements of Australian history were never taught when I was a schoolboy. Indeed, my conversations with Gary and his countrymen continued over several years and exposed other silences to me. From them I learnt about European colonisation, the dispossession of lands and the disappearance of languages and cultures. These men's parents and ancestors experienced life in compulsory residential compounds with identity tags and forced labour. Public segregation of races was imposed, as were curfews. Those who wished to marry had to obtain the permission of the whitefella administrators. Because it was widely believed that full-blood Indigenous

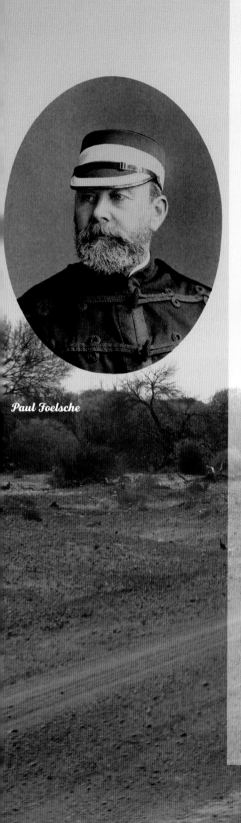

Paul Foelsche

Australians were a dying race, officials attempted to civilise and integrate mixed-blood children. They were incarcerated separately or sent for training to work on the land or as domestic servants, as part of a government policy to breed out the First Australians.

My discussions with Gary and others taught me that Queer-Aboriginality was a strong but unrecognised presence in Australia's past. I was keen to learn about this history of colonialism in the same way that I wanted to learn about all queer history. The silences in our history books allowed mainstream Australia to comfortably ignore the continuing discrimination against both Indigenous and queer and trans citizens. It is difficult to improve your circumstances when you do not exist as a legitimate historical presence and when there is only limited, if any, documentation detailing past wrongs and contextualising your legacies.

At the time I moved to Darwin there had been scant research published in Australia about the history of sexuality. I was acutely aware that life in the city was changing, as it was elsewhere. The city's first pride festival was celebrated in 1985, despite attempts by the Darwin Gay Society to prevent it for fear that public displays of homosexuality would provoke a backlash. As it turned out, homosexuality became the subject of intense public debate not because of the festival but because HIV/AIDS arrived that same year. The accompanying moral panic reinforced the need for anti-discrimination legislation. By the end of the decade Darwin's gay community had begun to lobby publicly for new laws and protections. A significant social transformation rapidly took place.

Gary and his countrymen became key interviewees for my oral history book, *Did You Meet any Malagas?*, which was released in 1993. (Malaga is a local word for man.) I was not trained as a historian and *Malagas* was a self-funded project. For Gary and other blackfella interviewees, the critical defining feature in their lives, other than sexual orientation, has been the intergenerational impact of colonisation. In order to honour this we need to accept that colonisation has involved both blackfellas and whitefellas. This means not defining colonisation as solely a blackfella problem and, importantly, situating whitefella interviewees in a historical context that reveals their experiences of colonisation as well as sexuality.

Malagas could have simply documented a singular narrative of Darwin's white male gay community. This would have traced underground life before the decriminalisation of homosexuality: gay bashing, police persecution and discrimination; gay liberation and pride festivals; and dealing with the bigoted responses to the HIV/AIDS pandemic. Such is the standardised, mostly monocultural narrative of Australian 'gay history'. In contrast, I actively recruited interviewees from differing cultural backgrounds and documented a multi-faceted history in which sexuality intersected with

colonisation and race relations. My intention was not to essentialise people as 'black' or 'white'; instead I sought to acknowledge the historical categorisations and treatments imposed upon specific racial groups.

Gary's interview in *Did You Meet Any Malagas?* begins with a discussion of Larrakia culture, its continuing traditions and the legal claim then under way over the land around Darwin. It goes on to describe experiences of racial segregation, racism, and sexual objectification within the gay community. My most difficult challenge arose when I asked whitefellas to reflect on colonisation. Those interviewees had diverse perspectives. One

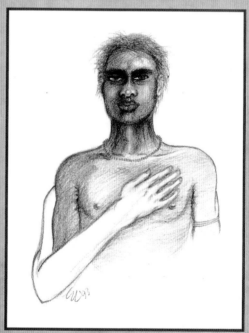

Did you meet any malagas?

A homosexual history of Australia's tropical capital

Dino Hodge

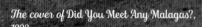

The cover of Did You Meet Any Malagas?, 1993.

was a linguist whose work addressing terminologies and cultural aspects of sacred sites was used in support of land claims; another was a lawyer working with the Northern Territory government fighting those land claims. Another whitefella interviewee, a community leader, offered his view about the absence of blackfellas at Darwin Gay Society events: 'I can only assume that what we were offering wasn't what they wanted. Perhaps with the Aboriginals certain of the hotels didn't actively discriminate but they inactively discriminated. Against the other ethnic origins, I can only assume that they had their own network and no wish to mix with the colonial masters.'

Race has an impact on desirability. Whitefellas were known to seek fleeting, anonymous intimacy with blackfellas. As one full-blood interviewee explained, 'We were "hot chocolate" and everyone looked at us like "Blacker the berry, the sweeter the juice".' Yet another whitefella interviewee was an arts administrator working in a remote community. He was in a relationship with a married blackfella. When the book was released, this interview stimulated the most comment from the mainstream whitefella gay male readership. Their titillation over black cock seemed to reinforce the historical erasure of sexual colonisation and racial objectification.

The reading of an object can diverge from the original intentions of its creator. Rather than engage with the book's core themes, many whitefella readers talked with me about blackfellas as exotic sexual objects. Only one academic reviewer publicly articulated an appreciation of the book's contributions:

> Hodge does far more than reclaim a pure gay history of the Northern Territory. His questioning of white gay men reveals the way in which class and race intersect to create a commercial sub-culture dominated by relatively affluent white men. Yet Hodge also leaves some space open for homosexual contacts across divides of class and race, though that contact is always structured through power ... This is not to construct Aboriginal sexuality as monolithic or static, or as an exotic other to the West, but rather to further contextualise dominant understandings of homosexuality and sexual identity.[1]

Gary's image for the book's cover honoured blackfella experiences. He subverted Foelsche's oeuvre by producing a self-portrait identifying his mixed-race heritage. His interracial relationship with his partner is represented by a whitefella arm reaching across Gary's chest and the hand resting lightly upon his heart. Here the whitefella presence is subordinated

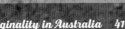

to a blackfella declaration of personhood. Foelsche sought to devise a pure savage devoid of racial and sexual complexity, but Gary's self-portrait celebrates this while also challenging historical silences.

In 1995 Gary became the first Indigenous person to work with the Northern Territory AIDS Council, nearly a decade after it was established. Through this work he mentored Crystal Johnson, a yimpininni (transwoman) from the Tiwi Islands located to the north of Darwin, whose whitefella first name was inspired by Patsy Cline's song 'Crystal Chandeliers'. In 2012, when Crystal's community voted her onto the Tiwi Islands Regional Council, she made history as Australia's first Indigenous trans politician to be elected to public office.

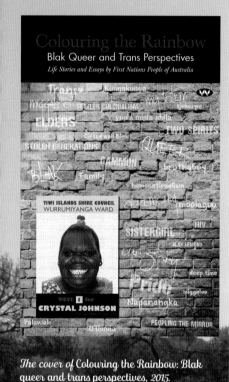

The cover of *Colouring the Rainbow: Blak queer and trans perspectives*, 2015.

In 2014 I was honoured to be invited to edit *Colouring the Rainbow: Blak queer and trans perspectives*. In the two decades since *Malagas*, educational opportunities for blackfellas had improved and an Indigenous intelligentsia versed in European academic traditions had emerged from embryonic beginnings. Contributors to the new book were drawn from across Australia and from all walks of life. *Colouring the Rainbow* examines intersectionality across sexuality, gender and race. Since the 1970s, gay liberation as a social movement has had an indirect impact on the lives of many people not specifically involved as activists, but the book reveals that contributors did not identify gay liberation as an influence in their lives. Rather, Indigenous Australians have been profoundly influenced since the 1920s by a social movement focusing on racial justice, and many contributors discuss activism from this perspective. Moreover, for some years now, First Nations Australians have been refuting their portrayal in public discussions as victims. Colouring the Rainbow is a celebration of agency and achievements across fields such as health, education, law, the arts and cultural institutions, academia and political activism.

Another stark contrast with mainstream gay history books is the abundant honour given to celebrating family, cultural and spiritual traditions, illustrating their high value for First Nations peoples. Relationships are everything and trust is their hard currency. In line with these values, Crystal in her chapter pays tribute to Gary as her mentor. The cover of *Colouring the Rainbow* acknowledges Crystal's successes in advocacy and public office by incorporating her election campaign poster. As with Gary's self-portrait for *Malagas*, Crystal's poster image subverts Foelsche's fantasy by revealing her true powers and strength. The Darwin launch of *Colouring the Rainbow* was a double celebration, since it also gave the AIDS Council an opportunity to honour Gary with life membership. He was the first Indigenous Territorian to receive this award.

My friendships with Gary and other First Nations people have resulted in transformative collaborations. Gary's research into Foelsche's work inspired

him to visually challenge the inherited notion of the pure savage by creating a new representation embodying complexity and self-determination. Our collaboration introduced both new imagery and a publication that challenged silences in sexuality and colonisation. At the time of its release, *Malagas* enjoyed a limited domestic whitefella readership; 20 years later it found a new, mainly Indigenous audience. In 2015 *Colouring the Rainbow* repudiated heterocentric colonial racism and whitefella homonormativity while celebrating the lives and achievements of queer and trans First Nations Australians. Its first print run sold out in under a week. By the time of its third reprint a year later it had established an international readership. Both books and their covers have become queer objects that transcend the forces muting Queer-Aboriginality.

Gary Lee, 2016.

WIFE WHO BECAME WRESTLING CHAMPION

A Few Years ago, Mrs. Agnes Clark of Leith (Scotland), complained that her husband was away from home too much at night. Mrs. Clark knew that his explanation that he was out with the boys was perfectly true. A wrestler of ability, he put in a lot of time at his physical culture club, but that did not help while away the dour Scottish evenings for Mrs. Clark. He invited her to come along with him. He was amazed when she accepted, because she said hard things about wrestling. That started the wrestling bug in Mrs. Clark. She took up physical develop- ment, progressed to learning wrestling holds. She decided that it was an ideal recreation for women, formed the Leith Health and Physical Culture movement for women, and soon had a big list of members. She has since wrestled in many Scottish and English centres, held championships including the 8-stone title. Men who scoffed at the idea, visited club— and came away confirmed supporters.

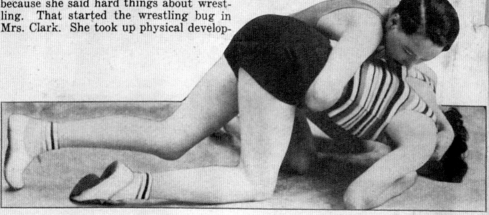

On The Mat Mrs. Clark Has A Friendly work-out with a clubmate at gymnasium. She is applying a half-nelson. After a few visits to husband's club, he initiated her into art of wrestling holds. Apt pupil, she soon was an accomplished grappler, anxious for competition.

Juveniles Juvenile Section. They receive tuition in all forms of physical culture, wrestling, from Mrs. Clark. Some mothers were at first horrified, thought it altogether too unladylike. They, however, soon became converts. Children thrive on vigorous, but harmless, contests.

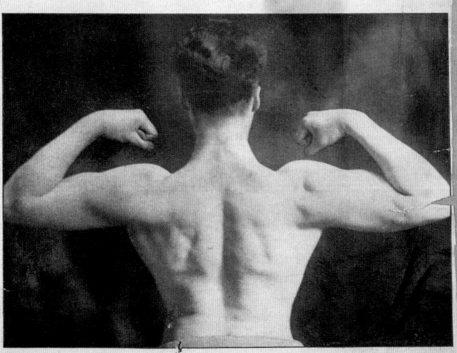

Biceps Although proud of her arm development, Mrs. Clark stresses that object of club is not to develop big, muscular women. "Girls lose nothing in feminity," she says, "and can vie with any ballroom beauty. Our aim is to make them healthy, look real women."

5. Pasting Together an Identity

HELEN PAUSACKER

With a few clicks on a computer or a mobile phone, the lesbian of the twenty-first century can search for information about others like her and find her 'tribe'. She may also search for other topics important to her but unrelated to her sexual preference, such as chess or bird-watching. All these computer searches will be lost to the future historian.

The only way that Ethel May (Monte) Punshon, born in 1882, could assemble information about her 'tribe' and her interests was by collecting snippets of information in the newspapers. And how Monte snipped. These newspaper clippings were stuck into two scrapbooks, now held in the Australian Lesbian and Gay Archives. Although Monte chopped the newspaper names and dates off most of the clippings, many of the articles can be found by searching historical newspapers online.[1] They cover a 30-year date range, from about 1923 to the mid-1950s. Some stories are pasted into both scrapbooks and a few clippings are grouped together in themes.[2]

The articles in the scrapbooks cover a wide range of topics that reflect Monte's eclectic interests. These include the Australia—Japan relationship, sailing, the arts, and women working in charity organisations. Other clippings focus on women's non-traditional occupations and female adventurers, as well as cross-dressing and women as life partners. There are a few newspaper photos of naked women in artistic poses and, surprisingly, there are also two advertisements for whisky: mementoes of good times? When taken together, the clippings reveal something about Monte's interests and her search for identity.

Many relationships between women made it to the newspapers only because something had gone seriously wrong. One 1931 article described the sad end to the relationship between a Miss Newman and a Miss Skipper. They had set up a successful banana plantation in Samsonvale

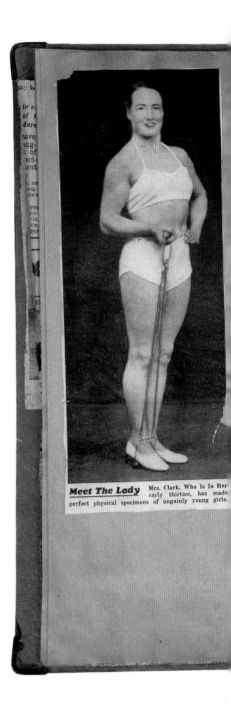

Meet The Lady Mrs. Clark, Who Is In Her early thirties, has made perfect physical specimens of ungainly young girls.

and their bananas received high prices. Unfortunately Miss Skipper suffered
a nervous breakdown and was hospitalised. Then, on her return to the farm,
she fatally shot herself while Miss Newman was buying supplies in town.
Another article, this one from 1930, describes the murder-suicide of Mrs Post
and Mrs Palmer, who were in love with each other. A third clipping, from
1949, relates how Mrs Williams had always loved women but had married on
the condition the marriage was not consummated unless she desired it. Her
husband became jealous of her, and after she started drinking heavily she
stabbed him to death.

Other, less tragic articles show unmarried women as companions. Miss
Marjorie Wreford, an author, manages a cattery with her assistant, Miss Judy
Smith, while Miss Ann McBean and Miss Fleury run a garage together.[3] An
American singer, Miss Dusolina Gianni, visits Melbourne with her pianist
and companion of four years, Miss Molly Bernstein, and comments that she
and her pianist 'understand each other on and off the platform'. We cannot

assume that these women had sexual partnerships. It is likely, though, that Monte wondered if they did.

The scrapbooks also include articles and photos of women whose female companions are unmentioned but of whom Monte would probably have been aware. There is a photo of writer Gertrude Stein, well known for her long relationship with Alice B. Toklas (see Chapter 29). A small 1929 clipping mentions the death of 80-year-old Miss Agnes Simmons, who had lived like a hermit in the hills near Ferntree Gully for about three decades and always wore riding breeches and leggings. Did Monte know that Agnes had been a swimming teacher at St Kilda, near where Monte lived, and that later, with her companion Geraldine Helena Minet, she set up a farm in Clayton on which they allowed no 'masculine member of the furred, haired or feathered tribe'?[4] Stories about women with 'female companions' reflected Monte's own life. She began her first relationship with a woman, Debbie, in about 1914, when she was 32 years old. It ended in 1926.[5]

Other stories in the scrapbooks concern women who had relationships with other women while 'passing' as men and whose 'masquerades' were discovered. There are 10 clippings from 1929 about the case of Valerie Smith. She married an Australian soldier, had two children, then lived in a de-facto relationship with a different man and finally adopted a male identity, Captain Leslie Barker, before marrying Elfrida Haward.[6] A 1939 article describes Annie Payne, who lived as Harcourt Payne for 51 years. Payne, who worked as a salesman, labourer, tram conductor and assistant town clerk, took one wife and then another. In 1939, when her gender was discovered, she was sent to a mental institution in the New South Wales town of Orange.[7] Monte found kinship with those who 'passed' as men and had relationships with other women.

Women in non-conventional occupations and leisure activities are shown with strong bodies, and many adopt masculine clothes in order to achieve their goals. One article describes the young American Portuguese bullfighter, Conchita Citrón, and a photograph of a woman wrestler shows her bare back and well-developed musculature. This was a period when women sailors and aviatrices travelled the world: Amelia Earhart, Jean Batten and Winifred Spooner all make appearances in Monte's scrapbooks. Since these also cover World War II, articles about women in the military feature prominently.

Theatrical and social cross-dressing is a strong theme. Some of the cross-dressers were homosexual but others were not. There is a photo of Marlene Dietrich, and one of the English singer Ella Shields, who played the character Burlington Bertie from Bow and visited Australia in the 1930s. There is a portrait of a woman in a suit and tie, holding a gun. In a move from the sublime to the ridiculous, there is also a newspaper photo of a line of men in tutus at the Commonwealth Bank's ball in the Melbourne Town Hall.

Jean Batten
Wonder girl of the air

Jean Batten has dark hair, lovely eyes and a priceless complexion. She has great courage, uncanny flying ability, and that mysterious and valuable thing called "personality."
Miss Batten's record-breaking flight from England to Australia is an epic. Tens of thousands of women are curious to know what Miss Batten

Monte was not herself a cross-dresser. There are photos of her in shirt and tie and with cropped hair, but also many of her in frocks. But casual drag was a part of the 'camp' world that overlapped with the theatrical world: a photo of a camp wedding shows Monte's men friends in dresses and Monte in a suit.

Monte wanted to become an actor, but her father did not consider this to be a respectable profession for a woman and persuaded her to become a teacher. She toured with children's theatre groups, however, and her father's attitude softened about 1914, when Monte began acting in theatrical fundraisers for the war effort and studied for a degree in drama.[8] She also had her own photography and art studio for a few years during the 1920s. Her enthusiasm for new technology led her to work both in the warehouse of a firm selling parts for wireless sets and as a broadcaster. Her main occupation, though, was as a teacher. Monte taught in numerous primary, secondary and tertiary schools in Melbourne, Vanuatu and Japan over many decades. She taught Japanese to Australians, and English to Japanese people living in Australia. In 1942, when World War II had reached the Pacific, Monte, aged 60, became a warden at an internment camp for Japanese civilians near Tatura in Victoria, where she ran a school for the children, assisted the women, and helped with interpreting.[9] After the war she worked with the government's Resettlement Bureau and helped to find jobs for returned soldiers. Even though her work life was exciting and varied, however, Monte stayed within the limits of what was considered acceptable for a middle-class woman.

By the age of 100, more than two decades after she pasted the last clipping into her scrapbooks, Monte was leading a quiet life with the public persona of a respectable single woman. She had a few gay male friends whom she met socially but otherwise little contact with the commercial or political gay scene. Unsurprisingly, the gay liberation movement, dominated by young people, had little impact on her. This changed in 1983 when, aged 101, Monte met her last partner, Margaret. On arriving at a lesbian bar one night, Monte commented, 'Goodness, I wouldn't have thought there were this many lesbians in the whole world, let alone in Melbourne!'[10] Margaret was open about her sexuality but Monte did not think it particularly tasteful to publicly discuss her personal life. When asked about her sexuality on a radio programme, she retorted, 'Surely that's not the most interesting thing about me!'[11] In her earlier years, though, the clippings in Monte's scrapbooks provided her with the knowledge of other women like her and role-models for living her own life.

WHEN A WOMAN POSES AS A MAN

WHY IT IS EASIER TO-DAY THAN EVER BEFORE.—WILL

WOMEN BECOME MORE MASCULINE?

Another man-woman—Catherine arrested at Los Angeles for posing [as a] girl. She has masqueraded as a [man to be] able to make more money disguise[d] explanation.

…ERIE BARKER found it a com-
…ple matter to masquerade as a
…deceive hundreds of men with
…e in contact about the truth of
…he success of her ruse, however,
…e of credit to that much-malign-
…n girl," with her shingled hair,
…easy posture and walk, and her

…the War it would have been a
… the average woman to pose as
…the fashion then, and a flat-
… envious eyes at her plumper
…various padding devices, so that
…delicately rounded as the more
… sex.

…doubt," said one Sydney doctor,
… average woman of to-day, pro-
…enough voice, to imitate a man
…erage woman of 20 years ago.
…e may be no scientific figures to
…girls of to-day are slimmer than
… the evidence of your eyes. Go
…and there you will see scores
… men's clothes would fit like a

…n is at present a mere fashion,
…s fickle as some other fashions,
…t look for any enduring physio-
…race; but if it goes on for cen-
…that not only will women have
…ering of flesh, but there may
…infinitesimal modifications in

…nain reasons for the slimness of
…rfing, climate, sport, and occu-

…any surfing beach, and you will
…rfluous flesh," he says. "Most of
…o men and women who are not
…Except in cases where fat is
…aulty action of the glands, it is
…very long a daily buffeting from
…, there is plenty of fine exercise
…f the body in surfing, but, as a
…ctual battering from the waves

"The surf was still there in 1910, but it was not the
people's sport nearly to the extent which it is to-day.
Thousands of women in those days still regarded mixed
surfing as rather an immodest procedure, and the most
that some of them did was to take off their stockings
and dabble their feet in the shallowest ripples. To-day a
majority of Sydney's girls are regular surfers.

"That climate plays its part is shown by the fact
that most fat people find that they can hold their own
in the battle against adiposity in summer, but in winter
increased flesh descends upon them. Stoutness is an un-
comfortable condition in a hot climate, and the mere
discomfort is an incentive to make a struggle against it.
Few fat white women are to be seen in South Africa, for

instance. Yet, in a cold climate, a reasonable layer of
fatty tissue under the skin makes a good buffer against
the cold. That, I think, is why the average Australian
woman is thinner than the average Englishwoman.

"It is useless to look for drastic changes in women's
bones yet—it will take centuries of battering by the surf
before the most fractional reduction in the width of
women's hips (to take one example) could occur, and it
is difficult to see how nature could propose to modify
woman's skeleton without making motherhood a still
more difficult business."

A large firm of corset manufacturers agrees with
this doctor. For the sake of its business, it has had to
tabulate a host of measurements of Australian women
and girls, and it finds that in the last 14 years the waist
measurement of the average slender girl has increased
by four or five inches. Whereas it used to be 19 inches,
it is now 23 or 24 inches, which is claimed to be the nor-
mal, healthy "waist" for a slightly built girl.

Corresponding with this, is a big reduction in the
hip line, and a somewhat smaller reduction in the size
of the chest. The result is that the girl of to-day is
very close to the Venus de Milo ideal—a little smaller
in all measurements, but with the same proportions.

The reason of it is that the old vice-like corset was
designed to give a small waist at all costs, and it forced
the flesh from the waist down on to the hips, and up to
the chest. As it was worn by growing girls, the result
was that the flesh retained its abnormal position even
when the corset was not being worn.

"This is an interesting question," said Dr. Charles
Anderson, Director of the Australian Museum. "Still, I
am afraid that I am not prepared to believe that the
girl of to-day is any smaller than she was 20 years
ago. I believe that she could be dressed up in the volu-
minous dresses of those times, and she would fill them
just as ably as did her predecessors. Conversely, I think
that the girl of 1910 could have masqueraded as a man
just as easily as the girl of 1929—or with just as much
difficulty.

"The sexes are just as far apart as
ever they were, and it is going to
take more than a passing fashion to
bring about any drastic changes. In
the past, when rounded figures were
fashionable, women adopted all
kinds of contrivances to look plump.
When wide hips were

fashion, which certainly rend[er]
[prom]inent, but which was unsigh[tly]

"To-day, the flat, boyish […
the adaptable girl is able to […
matter of tightening in the wa[ist
of course, a dress which hangs […
ders gives the required straig[ht
the modern girl is able to se[e es]
sential curves of her figure by […
her bathing costume.

"There is one way in whic[h
slimness may have a permanen[t
he continued. "If slim figures […
men as by women, and if men […
the thin girls, and the stout g[irls
it is possible that the girls wh[o are
nation of thin parents will b[e
generations. That is the onl[y
likely to have the effect of mo[re
and so truly giving them a m[ore

Another doctor, who is a […
University, said that unfortu[nately
scientific data to support th[e
to-day were actually more ma[sculine
of the pre-war period. A wide[
cal statistics would be needed […
for such a statement, and scie[nce
silent in the absence of such […

He thinks that it is at lea[st
that the changed life of the […
permanent effect upon the bo[dy
women of the future—and th[e
possibility that the sedentary […
of men in city life may do its […
sexes closer together.

Scarcely one of the so-cal[led
been invaded by women, who […
and football, swim, smoke, an[d
men. The result upon women […
shoulders with men becomes […
every day, but it takes more th[an
to make any very great chang[e in
ferences of the sexes. Just h[e does
not pass on his disability to […
changes, which occupations br[ing
not, theoretically at least, to […

But—the University lectur[er
whether theory was going to b[e
in this case, and he upheld […
marriage selection might have […

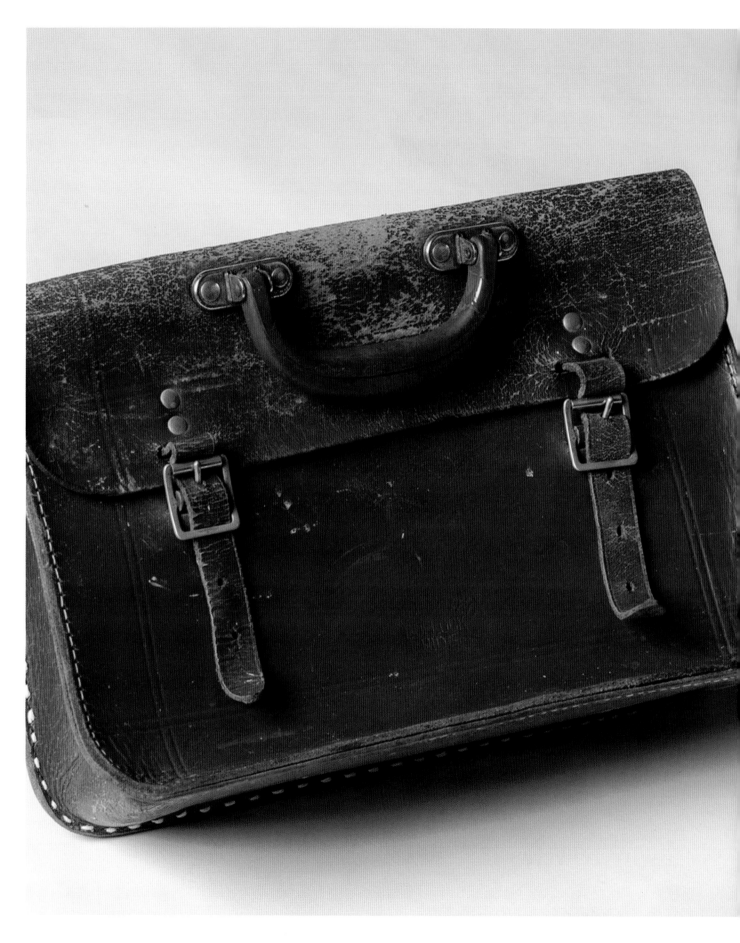

6. The Strapless Satchel

JEFFREY VAUGHAN

It was a Tuesday, 6.45am, and I was woken by the phone. It's never good news when it rings that early. It was Mum, telling me Dad had died earlier that morning. I was living in Wellington, 90 minutes' drive from the family home. I'll have a shower and drive up. Or I'll just go, so I can be with my mother, and have a shower when I get there. No, it'll be better to have a shower first and then go. This debate went on in my head for several minutes until I just shoved some clothes in a bag, hopped into my VW Beetle and hit the motorway.

Halfway there, having had a chance to wake up and think, I wondered if it might have been a dream and I was going to look a little stupid when I arrived to find Mum and Dad sitting at the breakfast table — mashed avocado on toast for her and a boiled saveloy for him. But when I turned off the main road and onto the very familiar street where I grew up, I saw the front porch light was on and I knew it was real.

The relationship I had with Dad was mixed and followed a pattern I'm sure is not unique. When I was young I thought my father knew everything. When I was a teenager I thought he knew nothing. Once I left home I began to realise he was human after all and he knew a lot about some topics but only a little about others. Things were at their lowest point when I was in my late twenties, probably when the relationship with my mother was at its best. I felt I could talk to her about most things and she was occasionally very open and honest about her life. But Dad and I had become strangers and spoke very little. My sister later told me that when she was visiting and walking through town with him, they bumped into a friend of the family who asked after me and whether I was married. My father replied that he didn't think I would get married. My brother-in-law gave me some good advice: Dad was a practical man and the way to get to know him was not by talking to him, but by doing things with him.

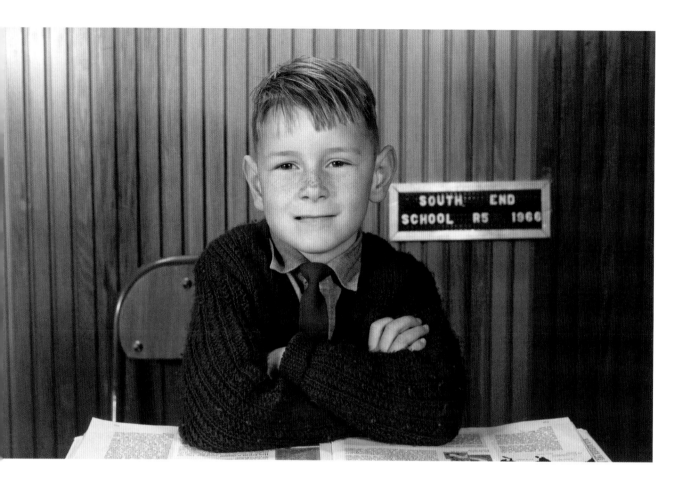

The author in 1966, during his first year at school.

I first came out to a friend in the early 1980s and then started on my family, beginning with my cousin, then working my way closer to home. Pretty much everyone, though, said that it probably wouldn't be a good idea to tell Dad. One of the things that changed that was when a close friend of mine suggested I see a channeller – a guy in town who could channel an ancient guru. So, with a healthy dose of cynicism, I fronted up with my cash to see what he would say about my life. I came away still cynical, but he had a way with words that made me feel positive about the past and confident about the future. He also said that I should get to know my father, as I didn't have long. That could have been a good guess, given I was in my early thirties and Dad was approaching an age where health would probably start to become an issue. Not long after that, he had his first heart attack.

So, I bit the 'coming out to my father' bullet. I couldn't bring myself to do it face to face, but instead chickened out and wrote a letter. It was quite subtle. I didn't directly say I was gay but that I had had relationships with both men and women, which was true, adding that if I was going to 'settle down' it would probably be with a chap. I ended the letter by saying that I didn't expect him to understand but that I would appreciate it if he

acknowledged the letter. He did, and it was probably the strangest phone call I've ever received. I think he appreciated me taking the time and the risk to tell him, and it brought us closer together.

Always a very keen gardener, he grew most of the vegetables for the family and we had two chest freezers that were always full. His motto was 'A good vegetable is a big vegetable.' I hated the broad beans and Mum's thick soup made from the large grey beans was hard to stomach. My favourite, though, was sweet corn, freshly picked, boiled and dribbling with melted butter. Because of his heart attack, Dad had to take it easy, so I would travel home for weekends and help him in the garden, digging holes, staking the tomatoes and planting way too many broad beans for my liking. My brother-in-law was right.

One of my earliest memories is the night before I started primary school. Dad called me out to the wash house, which was just a small room with a large washing machine and tub. He had bought me a satchel to take to school and he'd had a handle riveted to the top of the bag and then proceeded to cut the strap off. I didn't think much of it at the time but the following day, I noticed all the other boys with their bags over their shoulders like backpacks and me with a very unusual 'hand bag'. Maybe no one else noticed it, but I did. I felt different. The girls had bags with handles; the boys had bags with shoulder straps. It was the first time in my life that I felt like I didn't belong, that I was different. When I was 10, just starting puberty, I stole my sister's copy of *The Little Red School Book* — a small, illicitly distributed book with information about sex. I read the page on homosexuality and everything clicked into place.

But I wonder now if Dad had seen something in me those many years ago.

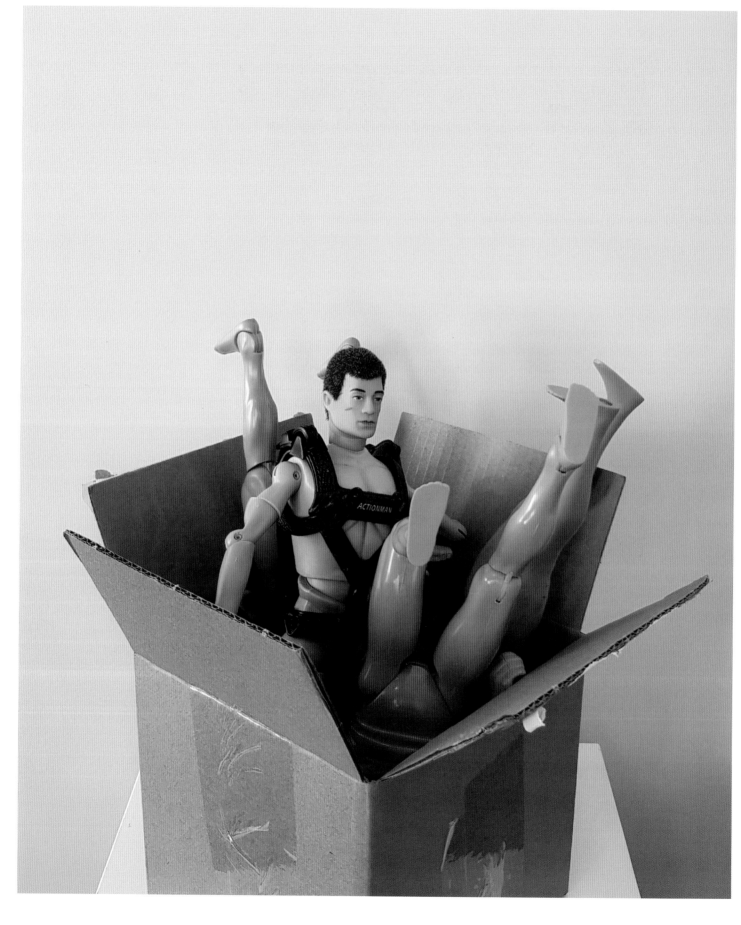

7. The Queering of Action Man

GREGORY MINISSALE

> When I was a child, I spoke as a child, I understood as a child,
> I thought as a child; but when I became a man, I put away childish
> things. CORINTHIANS, 13:11–13

When I was young there was a special place in my heart for Action Man, but almost half a century later I have put away childish things. It is impossible to say when this 'putting away' actually occurred, though: the boy doll may be gone but there is still some of this queer object in me. I learnt about the doll in social history, psychoanalysis and in art and philosophy. Each step, in its own way, represented different stages of my becoming a man.

Action Man and his US counterpart, GI Joe, have entered into the hearts and minds of millions. The doll has become a bellwether of masculinity, a perpetual model for boys to emulate in changing times. Yet consistently this masculinity is tied up with the notion of action and conquest: the boy's own power over the doll teaches the ballistics and kinaesthetics of war. GI Joe, who appeared in 1964, was modelled on Robert Mitchum in the 1945 film *The Story of GI Joe*. The toy manufacturer Hasbro marketed him as 'America's Moveable Fighting Man'. This 28-centimetre miniature Caucasian had 21 moveable parts. Two years later, in Britain, Palitoy launched a licensed copy of GI Joe under the name Action Man ('my Action Man', 'your Action Man', 'his Action Man'), and there were three variations: Action Soldier, Action Sailor and Action Pilot. They had different uniforms, but all shared the same curious scar on the cheek that was registered as a trademark.

In 1965, during the struggle for civil rights in the United States, the first black GI Joe was introduced as an acknowledgement of racial diversity. Then, in 1966, Special Forces 'Fighter Green Beret Joe' was based on the American soldiers in the Vietnam War. In 1969, with increasingly repellent revelations about this conflict and rising anti-militarism, the brand risked contamination. Hasbro responded in 1970 by changing Joe to an Adventurer who captured tigers and fought pygmies in the jungles of Africa. In 1974, at the height of the popularity of the Kung Fu films, he acquired a judo outfit

and a Kung Fu grip. Then he journeyed into a new frontier with science fiction and the Six Million Dollar Man, and into outer space with *Star Wars*. In 1994 a black version was withdrawn because of disappointing sales. In later years GI Joe and Action Man were armed, Terminator-style, and provided with more up-to-date semi-automatic assault weapons, the kind that are regularly employed in massacres at American high schools.

When I studied psychoanalysis as an undergraduate I was always disappointed by the general descriptions of childhood play, which never seemed to capture the dreamlike imaginative power that the doll exerted on my mind. Psychoanalytic theorists understood dolls like Action Man as a way for children 'to project unconscious processes and facilitate the resolution of conflicts which the child is unable to articulate'. Sometimes they told of cases in which a girl 'uses a doll in an aggressive manner, which is interpreted as a substitute for the absent penis, or where a little boy is brought to the therapist because he plays with dolls, which is interpreted as his pathological identification with the mother'.[1]

Dolls speak to the key human drives as Sigmund Freud understood them: Eros, the drive directed towards life and sex, and Thanatos, the drive to death and self-sacrifice. In psychoanalytic terms the doll acts as a temporary figure for children as they work through the discovery of Eros. The Action Man doll beloved by the gay child offers an oblique way to explore the homoerotic desire he may, or may not, want to recognise. I paraded Action Man in uniform, threw him about in numerous grenade attacks and, when both of us were exhausted, I undressed him, put him into pyjamas and subjected him to all the countless inanities of pillow talk I could embroider into

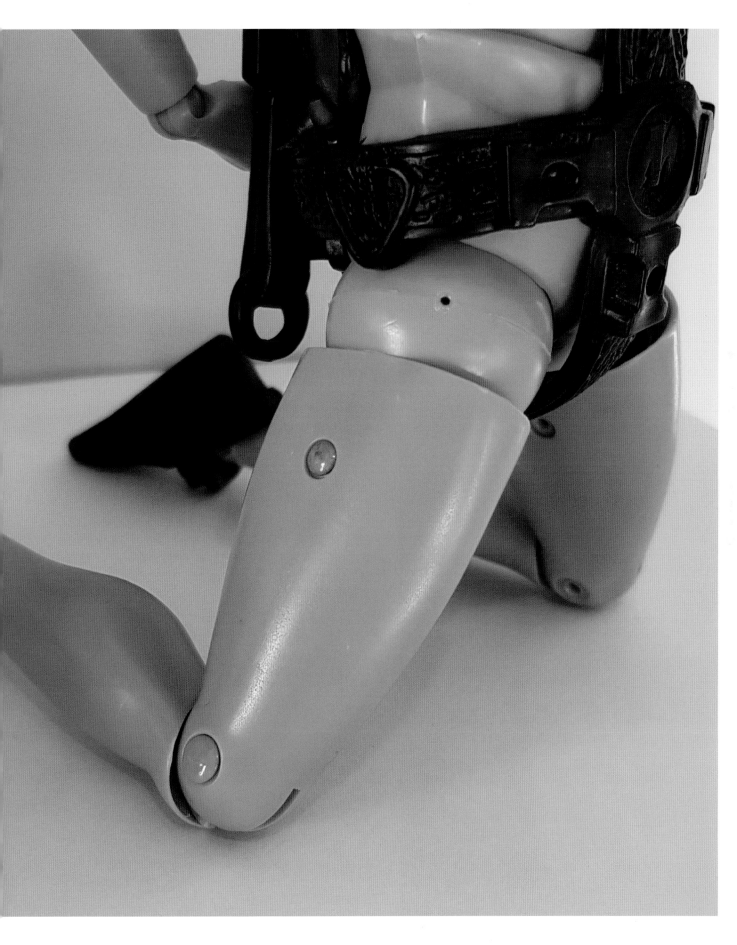

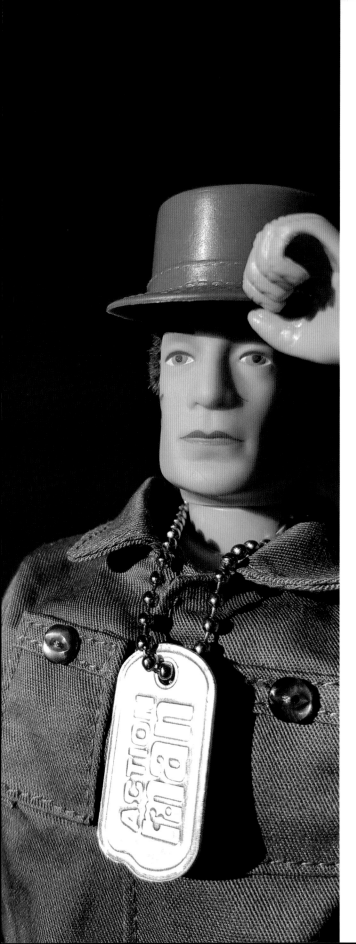

the fabric of slumber. But Action Man veers towards Thanatos when the emotional and erotic investment in him remains unfulfilled. When the doll does not respond to us in kind he turns into a kind of corpse, and ultimately his indifference to our existence reveals that the power we had over him is a sham. Poet Rainer Maria Rilke cogently describes this silence: 'At a time where everybody made an effort to give us quick and soothing answers the doll was the first who made us suffer this immense silence which later on would often breathe at us out of space whenever we stepped on the limits of our existence ... [w]e experienced for the first time ... that certain hollowness in our feeling.'[2]

At some point in my childhood Action Man became dead to me. A splitting occurred: he withdrew into being an object, plastic and mute, and I became a detached observer. My own imaginative play was rooted in a lust for life that is Eros, and at first it was blind to the lifelessness of Action Man, whose eyes spoke to me deeply and whose scar was not to be doubted. I protected him in my grasp as we went out to fight together and projected each assault on the bullies, football referees and maths teachers. But in the end these pipe dreams were depleted by Action Man's silence and obedience, and I was exhausted by imagining his inner thoughts. In psychoanalysis, and in the everyday world, the child turns away from Action Man by pulling him apart or simply forgetting to bring him indoors. He is abandoned at the bottom of the garden where the snails agglutinate and where last year's fireworks left behind black stars of ash and soot.

But it does not have to be this way, as philosophy and art show us. For Félix Guattari, 'schizoanalysis' liberates us from the burden of psychoanalysis, which explains homosexuality as an inability to grow up and recognise that sexual desire should be predicated on sexual difference.[3] From the Greek skhizein, meaning 'to split', schizoanalysis is a 'splitting of mental functions'. Splitting can be used as a way to radically rethink

such 'wholes' as masculine/feminine and normal/abnormal. Schizoanalysis resists the traditional form of psychoanalysis that tries to insert the patient into 'normal' family life. As a technique of taking apart wholes or givens, it finds good use in art and literature. Artists split apart stereotypes and conventions and rearrange the fragments in creative endeavours. This also happens with the doll insofar as it is a learning tool used for unifying an image of appropriate desire and 'normal' gender assignment.

In the twentieth-century art of Hans Bellmer we see harrowing visions of mutilated bodies, corpses and playthings. When I first saw Bellmer's decapitated and dismembered dolls, mannequins made and photographed in the 1930s, I was horrified at the suggestion of violence, particularly as a doll seemed unthinkable without its reference to childhood. Bellmer shows the deleterious psychological effects of the stigma suffered from not living up to the standard of the macho, heterosexual, blue-eyed doll, and violently pulls it apart. Contemporary art, too, has reframed my own memories of Action Man. Cindy Sherman's dolls, for example, are pornographic fragmentations that seem straight out of a catalogue of misogynist techniques of humiliation. The mental images grate and slice through any feeling of composure. If, according to psychoanalysis, homosexuality is the inability to put away childish things and recognise or embrace sexual difference, then how far away is this 'recognition' from the distortion of the woman's body into painful and threatening sex positions? I realised that Sherman's and Bellmer's dolls showed me the unbridled power we exert over the doll in our childhood. Both their dolls have much in common with psychoanalyst Wilhelm Reich's notion that the patterns of political and social repression filter down into personal and individual play and sexual gratification.

Another artistic practice expands the existential dilemmas of the childhood encounters with the doll to humanity itself: the dolls of British visual artists Jake and Dinos Chapman are propelled towards a

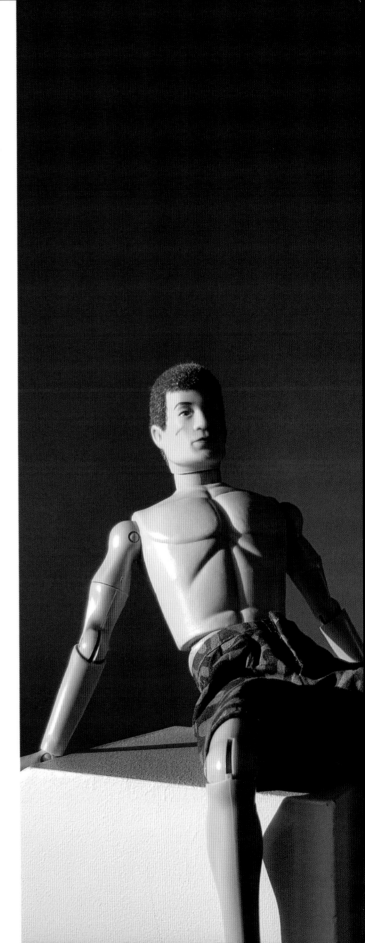

dark, post-human future. Body parts are detached and jammed together again in the wrong order, into swastikas. These works split apart gender essentialism: dicks sprout from noses and vaginas from armpits, multiple bodies are amassed and grafted onto each other to produce wild mutant orgies.

These artworks are material and practical extensions of schizoanalysis. They scramble the psychology of gender essentialism that we learn, or fail to learn, with Action Man or Barbie. There are parallel developments in popular culture. Now Action Man-style dolls have passed into the gay mainstream with bear, leather and rubber unofficial versions. Marketed as 'the world's first out and proud gay doll', Billy Doll was introduced in the United States in 1997 with numerous different outfits that decompile Action Man into a thousand deviant codes. In 2018 Money Supermarket ran a trailer depicting Action Man in desert fighter, skier, sailor and deep-sea diver uniforms as part of a Village People-style YMCA number, dancing in formation to the song 'Finally' by CeCe Peniston. What remains unsaid is that the doll did not actually have a penis; perhaps Action Man was always waiting to be imaginatively embraced as transgender. There are also numerous trans dolls on the market. It could be that, as a sign of the times, the aura of Action Man as an idol of hyper-masculine patriarchy is destined to be disseminated into a thousand permutations of desire, as described by Judith Halberstam:

> guys with pussies, dykes with dicks, queer butches, aggressive femmes, F2Ms lesbians who like men, daddy boys, gender queens, drag kings, pomo afro homos, bulldaggers, women who fuck boys, women who fuck like boys, dyke mommies, transsexual lesbians, male lesbians. As the list suggests gay/lesbian/straight simply cannot account for the range of sexual experience available.

As she adds, 'In a way I claim we are all transsexuals.'[4]

My so-called pathological inability to grow up and recognise sexual difference has now become a celebration of creative play in art, and in philosophy, the recognition of many sexes. In an individual there may be 'a thousand tiny sexes', as if sexes are continually effervescent within us and in the world.[5] I am buoyed by the idea that the queering of Action Man can become stellar: he shrugs off his heavy historical burden as Thanatos and shoots into a thousand different versions of Eros for our times. Action Man has come a long way in his journey into the hearts and minds of millions. Although his voyages into a thousand sexes will not be easy, the power of the imagination is on his side.

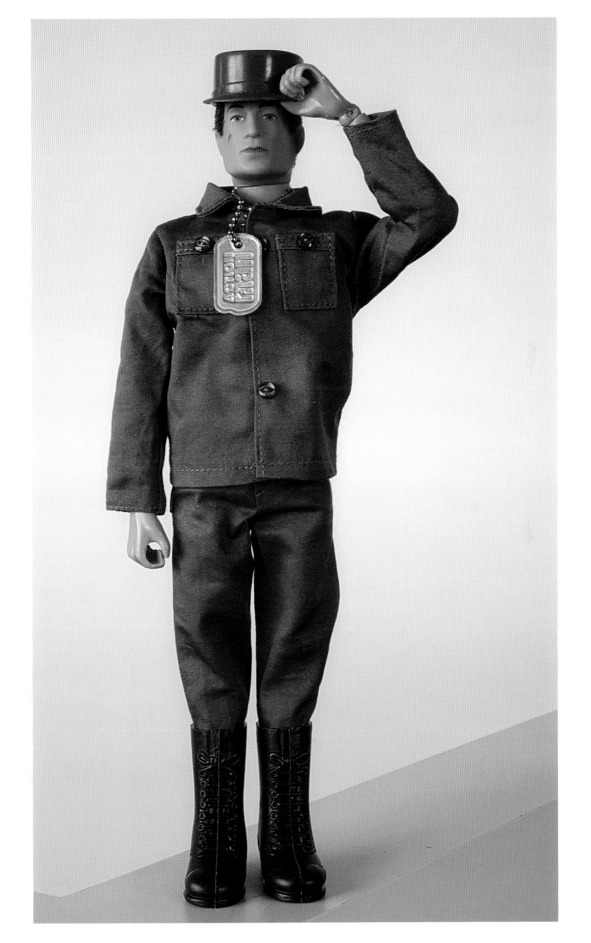

our common

ong the

and downs—

o help each

ek and we

week together.

be done, as

making, without

ery week when

But this is

n our first few

t he is the

to the CAP s

very strange

men I d

ldn't giv

in a ba

mething

wouldn't bo

ing check-in when

nute

quick synopsis of the la

, the next f

8. Reading Two Gay Histories

BEN ANDERSON-NATHE

People often say that having a gay parent must have made my own coming out experience easier than it might have been otherwise. I suppose in other circumstances that might be true. But that's not my story.

I grew up in a small, conservative town about 30 minutes' drive from Portland, Oregon. My parents were university-educated high school sweethearts who returned home to raise children in our working-class community. They taught me and my siblings to be politically progressive, to speak our mind and to take care of other people. We grew up in a liberal religious tradition that encouraged ethical conduct, sexual morality (but not necessarily abstinence) and critical inquiry. They raised me, the middle child, to be responsible above all else. We were, still are, close. We loved each other and we liked each other. We still do.

When my dad came out in 1986 after almost 18 years of marriage he moved into an apartment nine blocks from our family home. I was 11 years old. His new lover, the man who would become my step-dad, moved in with him. Although their path was not easy, my parents and my step-dad were each other's closest friends and confidants, and they remained committed for the rest of their lives. Even so, they separated after four years together, and my dad moved to the city. Although he lived only half an hour from us and was meant to visit one night a week, with every other weekend at his house, we drifted apart, both physically and emotionally. Over the next two years he went through a series of lovers, and he changed a lot. He never had any money even though he had a full-time job in finance. To make sure my sister, then still a young girl, wouldn't lose connection with him I gave him gas money so he could make his weekly visits.

I began to resent him. He abandoned the value he and my mother had placed on sexual fidelity, and I became repulsed by what I saw as his hypocrisy. In two years he dated and moved in with three different men;

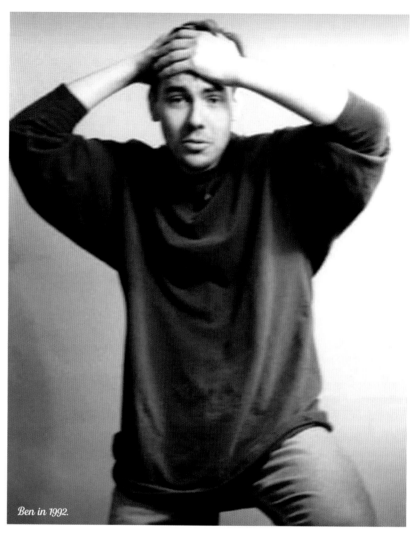
Ben in 1992.

there were more than a dozen others in between. He once told me that sex in gay life meant something different than sex in the straight world, and that I need not worry. But I did. It was 1990 and AIDS ran rampant. AZT was the only treatment on the market, and for all intents and purposes AIDS was a death sentence. I watched my father's friends fade and die. They would be at a barbecue one weekend and when I asked about them a month later I learnt they were gone. When I finally got the courage to ask, sitting in my dad's car on a cold, rainy autumn night, he told me he was HIV-positive. I was certain that night that I would lose him, and I was angry. Over the next few months I felt rage instead of compassion.

As early as the age of 12, I knew I was attracted to men. I knew this meant I was gay. But I refused to be. *He* was gay. His lovers were gay. All those dying men were gay. And they were nothing like me; they were everything

I wanted *not* to be. I came out at 16, determined to be different from him, to prove to him that 'gay' did not have to mean becoming something unrecognisable, contemptible. Although I loved my dad deeply, I came out as much in spite of him as because of him. Contrary to what most people assume, it did not draw us closer together.

When he died in 1995 my dad left me his journals. He began writing in 1990 and continued religiously for 18 months. Written in a perfect, deliberate script, the three volumes are unassuming notebooks he probably bought for $1.29. They tell not just his story; they also offer a window into a formative part of my own story and the stories of other otherwise ordinary gay men living in a moment that is now largely lost. The world of these journals is characterised by pain and confusion, punctuated with moments of joy. It narrates his search for connection amid many experiences of disconnection. His words tell of a journey I had previously seen only through my own eyes. Reading them now, reflecting on his memories and my own recollections of the young person I was, I feel rejoined to my own history. Having read these journals, I now understand my dad as a product of his time. He was flawed but he was trying. He had changed, but those qualities he and my mother instilled in us children ran strong through those changes – even if they were obscured.

As a newly out gay man in the late 1980s and early 1990s, my dad struggled to find his place in gay culture. He craved intimacy but also revelled in the sexual expression he'd long denied himself. He couldn't, however, crack the complex relationships between sex and intimacy that gay men grappled with at that time. He experienced betrayal when he sought closeness. He was ridiculed for being promiscuous when he looked for sexual fulfilment. As he wrote, 'When B and I were together, he taught me that ... sex was no more meaningful between people than a handshake ... I don't want to believe it. I want desperately not to believe it. But I have a terrible tendency to believe what I want to believe ... besides that, all the evidence I have before me tells me that B is right.'

The journals tell of serial relationships, each weeks or months long, which I once viewed only through a lens of irresponsibility and risk. They tell of the fear that he would never find the relationship he sought, but also the fear of dying alone without having tried:

> I've also been pondering how it can be that I still love so many men so strongly? Being lovers with them again wouldn't work any better than the first time, but I love them. Is that impossible? Or unusual? Are there others who feel this way? In the straight world is there any comparison?

I am beginning to wonder if it is possible for gay relationships to endure. D asked me once when we were very intimate whether I believed it was possible for two people to stay together ... I said I did. He said he did, too. Now I'm not so sure, not if the two people are gay.

By 1991 my dad's heart had been broken again, for the fifth or sixth time in just over a year. His journal tells of his friends' unsympathetic reactions. They told him to get over it, to understand that gay men's lives are not like the married life he once led. He was unsure what to believe, how to live his new life without compromising his integrity, his theology, his relationships. And his conflicts remained. He had a conversation once with my mother, in which she 'challenged me with the question of whether my current sexual behavior fits with my theology of sex; is it a theology I would want to impart to my kids?' In response, he wrote:

So, my old theologies don't work like they used to anymore. They broke down somewhere during my relationship with B. Maybe someday I can rebuild them with a man of similar beliefs, but more likely I will never meet such a man. But in the meantime, I try to be responsible somehow without knowing what that means. I know that you and others think I am being a slut ... but there is meaning in the touching. There is goodness in the melding, there is wonder in the discovery of the person, there is caring and concern and respect and sharing. There is driving away the loneliness of existence for a while.

In closing that entry he thanked my mother: 'Thanks for the question. You put me through my paces. Again.'

All my dad's searching unfolded against the backdrop of HIV and AIDS. His fear of becoming sick, of fading as so many of his friends had faded, bled into every corner of his life. It affected his intimate relationships, limiting closeness for fear of rejection and highlighting the need for care and responsibility: 'I have been safe ... I have not exposed any of them and I have not put myself in a position to be re-exposed. I am proud of that.' It affected his work, leading him to burn through vacation time simply to avoid exposure during flu season: 'Everyone at work is coming down with a cold ... I am terrified that I will catch it. My God! How do I protect myself against a common cold? If I catch it, will I survive it? Are they killing me by coming to work sick? Is this how it starts?'

He joined a group for people with HIV. Before I read the journals I never

The author's father Ron at Lake Chelan, Washington, 1993.

knew about his group, this collection of men who came to mean so much to my dad, who normalised his experiences in a way I never even knew he sought. They gave him space to express what his straight world could not understand: fear, compassion, comfort:

> I missed group. And I *miss* group. I really felt the need to talk to those guys tonight. First there was the soreness in my gums, then the infection in my eye, and now the glands in my throat, under my chin, are swollen and sore as hell ... I went back to see Dr S about this ... after all, this is what they say to watch for when AIDS starts. He was so kind, so comforting; after feeling the swelling, he held my head for quite some time and told me this is nothing.

In a perfect illustration of our distance from each another, I had also joined a group of my own, for gay and lesbian youth. Neither of us ever discussed our groups with one another, and I later learnt they both met on the same night, Thursday, just three downtown blocks from each other.

It's been 23 years since my dad died, in his home and surrounded by family. He lived less than four years after his final entry in these journals, written the day before his forty-fourth birthday. We missed each other a lot during this time. Although the details were different, we both struggled with the same monumental task: we were trying to understand ourselves, to find ways of creating and naming the selves we wanted to be. But our languages didn't match. Our worlds didn't match. I don't show up much in the journals, although I read my own experiences around the margins of every page. Once, though, he wrote of a conversation with T, a short-term lover:

> T said that Ben is in an enormous and intolerable amount of pain. Pain from being separated from me, pain at being gay but not being ready to come out yet and not knowing what to do about it, pain from just being a teenager ... Maybe because I have my life here and he has his life there, we just don't spend enough time together for me to see what is obvious to others.

He was right. He was wrong, too. We each filled in the gaps of what we missed in the other's life; sometimes our assumptions were right, but often they fell far short. But the gift of these journals helps me to reclaim something.

We reconciled before my dad's death. When he first got sick his life changed and he came back home; we had two, nearly three, very good years. I am now 43, the same age he was at his last entry. I live, love and play in the same city. My queer world is different from his gay one in many ways,

but I remember Portland's gay ghetto, with all the bars the journal brings to life. Many I went to for the first time with my dad, as a late teenager, for weekend brunches and afternoon happy hours. Later I went as he did, to be out, to be dancing: 'I went out last night and danced like I haven't danced since B and I were together. It felt great ... I was out as a single man just to have fun ... and I came dragging in at 4:15.' The ghetto has now all but disappeared, a casualty of gentrification and a symbol of queer integration (or is it assimilation?). One of the last holdouts just closed its doors this winter, after 40 years. Only two of my dad's bars are left, each in a new location and one with closure looming.

I'm often surprised at how little young queers know about our history. But should I be? How do those who have come before us share our history? We don't generally get to raise our own young. We come out, we fight to find or make a place for ourselves, and that place is situated in a kind of perpetual present day. But it is also a present situated in the context of a rich, complex and often painful past. But my story is different. I was raised by a gay parent, in a very queer family. Even still, knowing my history has been difficult. Reading myself into my dad, reading my memories of him through the echoes of his own handwriting, has allowed me to (re)discover myself and him. It has connected us, *l'dor vador*, from generation to generation. I am grateful.

Scandals, the last gay bar on Stark Street, Portland.

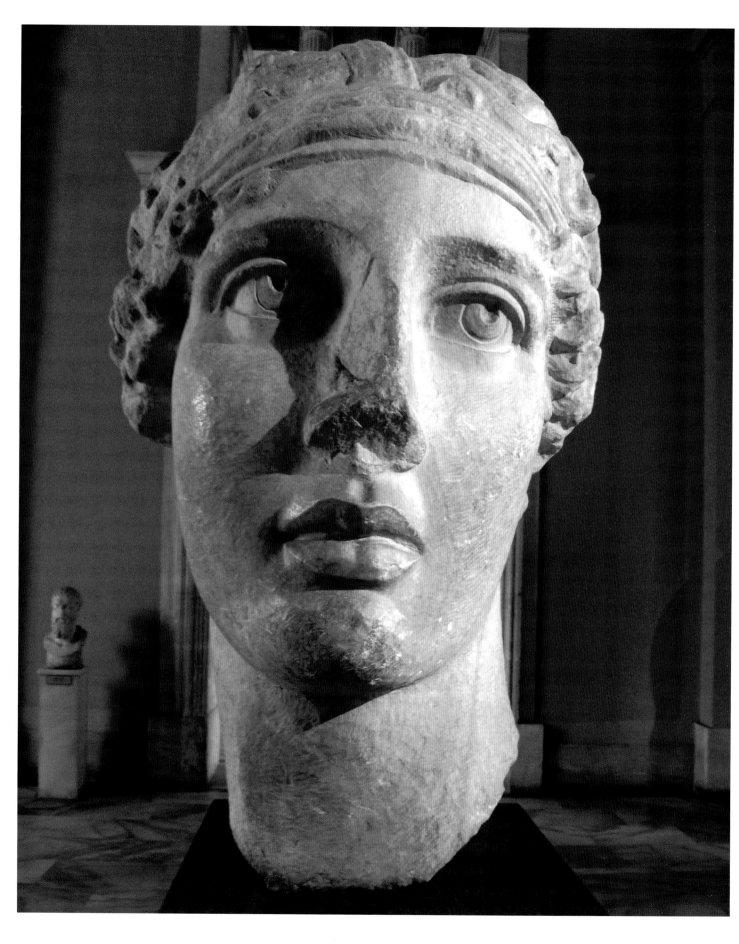

9. Fragments of Sappho

CHRIS BRICKELL

The famous Greek poet Sappho lives on in fragments: hints and rumours about her biography; the busts, vase paintings and other interpretations produced centuries after her birth; and the shreds of papyrus on which her poems are recorded. The details of Sappho's life are blurry. Born on the island of Lesbos around 600 BC, she may or may not have married a man called Kerkylas, and she may have had a daughter named Kleis. Some of what has been said about her – including the suggestion she threw herself off a cliff after the failure of her relationship with a ferryman named Phaon – has been heavily disputed by Sappho scholars.[1] Those who have taken an interest in her life, including the ancient Greeks themselves, disagree over whether she was 'hypersexual and equally interested in men and women', and they dispute that she might have been involved, both emotionally and sexually, with the young women whom she taught in the art of singing.[2]

The homoeroticism of much of Sappho's poetry is less contested. Although many of her compositions have been lost, one whole poem, 10 substantial fragments and 50 scraps have lasted to the present day.[3] These are written on sheets of papyrus, a thick paper made from the pith of the sedge *Cyperus papyrus*, and some only just survived the ravages of time, having been cut into strips and used to wrap mummies.[4] Although several of the poems tell of love between women and men, others are 'very explicit about the physical relationships of Sappho with young women'.[5] In one fragment, for instance, the female narrator tells of watching a man who sits near a woman whom she desires:

Papyrus fragment of one of Sappho's poems.

Opposite: A bust of Sappho produced during Roman times.

To me it seems that man has the fortune
of gods, whoever sits beside you
and close, who listens to you
sweetly speaking

and laughing temptingly. My heart
flutters in my breast whenever
I quickly glance at you –
I can say nothing,

my tongue is broken. A delicate fire
runs under my skin, my eyes
see nothing, my ears roar,
cold sweat

rushes down me, trembling seizes me,
I am greener than grass.
To myself I seem
needing but little to die.

Yet all must be endured, since ...[6]

Another poem included this verse:

I would rather see her lovely step
and the radiant sparkle of her face
than all the war chariots in Lydia
and soldiers battling in arms.[7]

Sappho's poems were sung to the accompaniment of a lyre and their
powerful verses appealed to men and women alike. Ovid, a Roman poet
who lived at the time of Christ's birth, wrote: 'what did Sappho of Lesbos
teach but how to love women?'[8] Some influential nineteenth-century
commentators tried to minimise the homoerotic aspects of Sappho's
poetry, but others were inspired by it.[9] Natalie Clifford Barney, an American
playwright and novelist who lived in Paris, was one such enthusiast. Barney
claimed she was a 'page of love' sent by Sappho and, looking to antiquity for
her references, she visited Lesbos in 1904. After Barney returned to France
she staged 'pagan ritual and Sapphic "theatricals" in her garden at Neuilly',
and her weekly 'salon' was a central part of Parisian lesbian life for over 50
years.[10] Renée Vivien, a sometime lover of Barney, suggested in 1901 that
'Sappho lives and reigns in our trembling bodies', and her own poetry evoked
the spirit of the ancients:

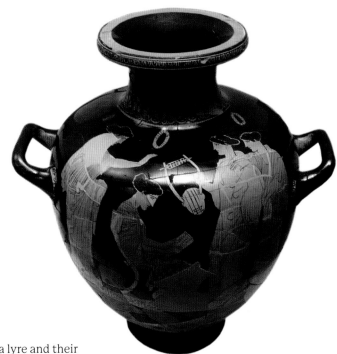

*Opposite: A sketch of Sappho by Maria
Hadfield Cosway, 1826.*

❧

*Sappho, seated, reads one of her poems to a
group, c. 440 BC.*

Our bodies are for theirs a sisterly mirror,
Our friends, with breasts white as springtime snow,
Know in what strange and suave manner
Sappho used to bend Attis to her will.[11]

Homoerotically inclined men also found inspiration in Sappho's life and work. In 1864 the English painter Simeon Solomon painted a watercolour that suggests a romantic entanglement between Sappho and Erinna, another ancient Greek poet. In 1927 the New Zealand author James Courage picked up a book 'containing fragments of Sappho' and wrote about the moment in his diary: 'I was so profoundly stirred that I spent two hours writing an excessively erotic poem addressed to an unknown youth.'[12] No doubt Courage, then in his twenties, was moved by excerpts like this: 'and on soft beds ... delicate ... you quenched your desire'.[13]

The fragments of Sappho's work have intrigued readers for centuries. They came to symbolise same-sex love — between women in particular, but not exclusively — and Sappho was incorporated into the intellectual life of lesbian liberation during the 1970s and 1980s. Sidney Abbott and Barbara Love published a landmark text titled *Sappho Was a Right-On Woman*, although they mention her only in passing.[14] Laura Doan's more recent history, *Fashioning Sapphism: The origins of a modern English lesbian culture*, discusses the concept of Sapphism, popular during the interwar years, but does not mention its namesake at all.[15] For centuries Sappho's name and legacy have been continuously fragmented into a kind of shorthand, just as pieces of her poems survive on disconnected scraps of papyrus.

Sappho and Erinna in a Garden at Mytilene, a watercolour by Simeon Solomon.

∾

Opposite: Natalie Clifford Barney, photographed around the turn of the twentieth century.

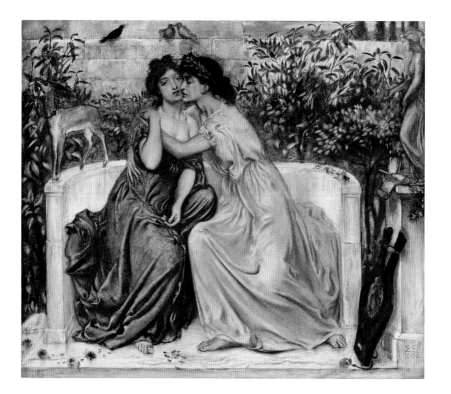

Miss Barney

10. New World Slavery's Queer Object

CARINA PASQUESI

Harriet Beecher Stowe was a dedicated abolitionist from Connecticut. She wrote *Uncle Tom's Cabin* in 1852 in an effort to convince fellow Americans, mainly northern, white, middle-class women, to join the anti-slavery movement. Stowe believed that if her readers sympathised with the plight of slaves, especially slave mothers, they would experience what she called 'right feeling' and be movitated to act. Although a mess of good intentions, *Uncle Tom's Cabin* reproduces racist stereotypes. In Stowe's hands, the novel's black characters are minstrel-like, requiring assimilation into whiteness in order to become 'civilised'. She also wants slaves to resist non-violently, 'turning the other cheek'. This mandate is most obvious in the novel's hero, the passive, pleasing and Christlike Tom, who is ultimately beaten to death.

Cassy, the sadistic Creole slave woman on the margins of *Uncle Tom's Cabin*, is no Uncle Tom. When she and Tom both end up, enslaved, on Simon Legree's plantation, she cannot understand why Tom allows Legree to beat him continually. Cassy takes a different approach: she terrorises her master while experiencing an eroticised pleasure in the process. Although her role in the book is in some ways minor, she is politically and historically important as an unruly character who needs, but refuses, Stowe's brand of discipline. As a slave, and therefore not a woman in a legal sense, Cassy is an object under the law, and she aspires to neither 'proper' femininity nor its mandate of self-sacrifice and abasement. If New World slavery classifies Cassy as an object, then her sadistic resistance makes her queer.[1] She rejects prevailing ideals of gender and ethnicity, and embraces transgression. Far from passive, she resists her situation in ways that liberal white subjects reject because it is violent. Cassy's sadism challenges the sentimental masochism, to use Marianne Noble's term, that was a dominant model of white femininity in the United States.[2]

Kara Walker's Silhouettes, a violent plantation tableau, depicts racist fantasies of blackness – sambos, pickaninnies and mammies – much like Stowe's representation of the slave figure.

Cassy embraces the monstrous, non-human status she is assigned as a slave. Her resistance cuts across the ideal of sympathetic fellow feeling that dominated the abolitionist project, but it allows her to survive. She commits infanticide and murder, and her violence ultimately brings down the plantation owned by her master Legree. Cassy escapes to Canada, where she is reunited with her long-lost children, but she refuses to fully embrace motherhood and remains distant from her offspring. At this point, though, Stowe renders her more passive, and the violence stops. There is no place up north for a resistant queer object like Cassy: former slaves must become docile.

The portrayal of Cassy poses wider questions. What were the complex intersections between pleasure and resistance in Antebellum America?

An advertising poster from the 1850s.

135,000 SETS, 270,000 VOLUMES SOLD.

UNCLE TOM'S CABIN

FOR SALE HERE.

AN EDITION FOR THE MILLION, COMPLETE IN 1 Vol., PRICE 37 1-2 CENTS.
" " IN GERMAN, IN 1 Vol., PRICE 50 CENTS.
" " IN 2 Vols., CLOTH, 6 PLATES, PRICE $1.50.
SUPERB ILLUSTRATED EDITION, IN 1 Vol., WITH 153 ENGRAVINGS,
PRICES FROM $2.50 TO $5.00.

The Greatest Book of the Age.

How might we think about desire and domination before science and the law began to solidify categories of gender and sexuality at the end of the nineteenth century? Cassy's sadism lays bare the erotics of slavery, because her resistance is predicated upon a cross-racial eroticism between herself and the white master whom she dominates. Rape, miscegenation and forced reproduction were the basis of the overriding master–slave dynamic, but Cassy finds ways to take control of her body and experience pleasure. This is a sexual revolution of a kind, carried out on Cassy's terms. Rape and forceable childbearing give way to a sadism that offers an alternative to legal reform, prevailing modes of femininity and assumptions about how to be human (or not).

As a commodity who challenges readers, and ultimately gets away from the author who imagined her in the first place, Cassy retreats from comprehension.[3] She does not ask for anything or plead with anyone: she simply acts. Cassy directs her rage outwards: she 'hates and curses'; kills one of her children, without regret, rather than have the child sold into slavery; stabs the man who sold her other children; and repeatedly emasculates Legree by stealing his money and scaring him to death. He lives in fear of her: in one recurring nightmare, Legree stands over an abyss and Cassy pushes him to his death while laughing loudly.[4] Her elaborate fantasies of killing Legree are always followed by a 'wide, long laugh' that attests to her pleasure.[5] Every time he attempts to dominate Cassy, she reminds him: 'You're afraid of me, Simon ... and you've reason to be! ... for I've got the devil in me!'[6] Cassy verbally levels the inequality of their relationship, and her recurring undermining of it allows her to experience something akin to freedom, while dissolving the hierarchy that places the white man above her. That Cassy's transgression is pleasurable to her (and maybe also to Stowe) is made clear in the novel's recurring depiction of her laughter, an ongoing metonymy of pleasure erupting in the face of oppression and the masochistic mandate of turning the other cheek.

Cassy experiences eroticised pleasure in making Legree suffer. In a cast of sentimental masochists, she is a true sadist. Her haughtiness stands in sharp opposition to the subservient piety Stowe typically foregrounds. The sentimentalism of *Uncle Tom's Cabin* positions the reader as a caring witness to unspeakable acts of injustice, but Cassy turns the tables on any association of the slave with suffering. 'There was a fierce pride and defiance in every line of her face, in every curve of the flexible lip, in every motion of the body ... scorn and pride [were] expressed by her whole demeanor ... she was erect and proud.'[7] How might the reader respond to the slave as an agent of sadistic pleasure, a woman who reduces her master to a quivering girl in her presence?

Cassy mocks Legree for not producing as much as his neighbours: 'If

A lithographic print from 1889.

your crop comes shorter into the market than any of theirs, you won't lose your bet, I suppose? Tompkins won't lord it over you, I suppose, – and you'll pay down your money like a lady, won't you? I think I see you doing it!'[8] In this inversion of the master–slave dynamic made famous by the philosopher Hegel, Cassy pictures a sissified Legree at the mercy of his (male) neighbours. Cassy's pleasure in her fantasy of Legree's abjection involves an element of spectatorship: the scene of debasement is witnessed by others. An able manipulator of belief and fantasy, Cassy terrorises her captor by exploiting his anxieties about his public persona. This scene is subversive because Cassy upends the text's masochistic logic. No longer does the slave's body appeal only to the white reader's sympathetic feelings; the reader's attention is drawn to the marketplace where Cassy symbolically castrates Legree in public.

Cassy does not aspire to subjecthood as such. Instead she comes to terms with her agency as *something else* in relation to pleasure and power. How did her situation come about? Legree's rape of Cassy when she first arrived on his plantation set in motion her ongoing revenge drama: she refused to be victimised by the cycle of rape and abuse. Queer folk who are part of BDSM subcultures are well used to the challenging questions posed by the mixed pleasure and danger inherent in Cassy's power. What does it mean to get off on a violent act or fantasy? Are those who do so simply replicating patriarchal power structures? What might it mean when the oppressed come to power by oppressing?[9] To dismiss sadistic resistance as a mere replication of patriarchal, white-supremacist power structures is to avoid grappling with the complexities of act, affect, race, gender and the power structures that shape existence. Subjecthood is not only realised within the rules of liberalism.

As a queer object, Cassy haunts her author as well as Legree. Stowe's Abolitionist support of the removal and colonisation of freed slaves was motivated by a fantasy of black agency. Cassy confirms for her creator that cross-racial conviviality cannot be achieved after the end of slavery: Stowe even suggested sending freed slaves to Liberia, an American colony in Africa. For this reason, Cassy must be pulled back into the norms of motherhood and disciplined by the love of a child. Having arrived in Canada, she is reunited with her daughter Eliza, who tries to transform Cassy into a loving mother. But the authorial lesson in sentimental sympathy falls flat, as Eva Cherniavsky writes: 'as much as Stowe seeks to reinscribe Cassy's face with the tender expression of white motherhood, and engineers that altogether implausible return of Cassy's children to her, Cassy stands out, apart, in the scenes of familial reunion that follow, a strange, unsettled figure.'[10] Cassy still does not desire proper femininity, and fails to connect with her daughter's Christian model of love.

Queer objects, like Harriet Beecher Stowe's Cassy, embody ways of being and a set of pleasures not accounted for in the official historical narrative. At the same time, their existence – in all its fantastic forms – invites us to think about identity and association in ways that depart from our liberal definition of the 'human'.

Cassy, from an 1889 edition.

TO

MY FRIEND

MURIEL CADOGAN

WHOSE LOVE AND SYMPATHY HAVE NEVER FAILED ME

I DEDICATE

THIS BOOK

11. Freda's Mountaineering Memoir

CHRIS BRICKELL

This dedication graces the second page of a book published in 1915:

TO
MY FRIEND
MURIEL CADOGAN
WHOSE LOVE AND SYMPATHY HAVE NEVER FAILED ME
I DEDICATE
THIS BOOK

The volume was *The Conquest of Mount Cook and Other Climbs*, and mountaineer Freda du Faur was its author. Muriel Cadogan, as the dedication implies, was more than a friend to Freda: the two were lovers who shared their lives until death parted them.

Muriel and Freda met about 1910 in Sydney, where they had both grown up. Born in 1882, Freda had trained as a nurse, but she hated the job and quit early on. She had an independent income, though, and did not need to work. Instead she spent her time rambling and climbing around the New South Wales landscape.[1] Muriel was a physical culture instructor – a personal trainer – at the Dupain Institute in Hunter Street. An increasing number of young women took part in the booming physical culture movement of the early 1900s, and Freda and Muriel worked together at boxing, ball punching, weightlifting and rhythmical exercises. The year they met they travelled to New Zealand, lured by the mountains. Climbing was Freda's hobby at first, but Muriel was soon bitten by the bug. 'I saw every sign of her catching the mountaineering fever badly,' wrote Freda, 'and was thereat greatly rejoiced.'[2]

The Conquest of Mount Cook functions in two ways. The book is first and foremost an account of Freda and Muriel's mountain climbing. Freda was the first woman to climb Mount Cook, New Zealand's highest mountain: 'it was

Freda's dedication to Muriel in The Conquest of Mount Cook.

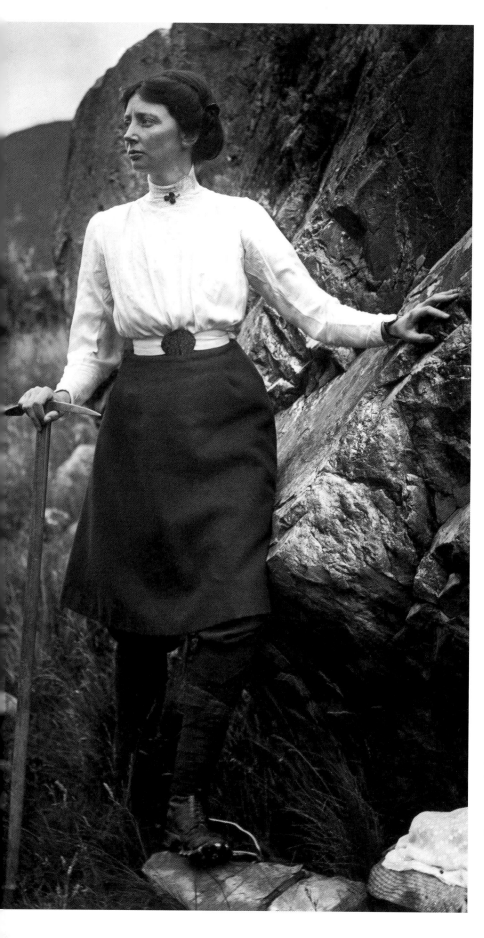

only 8.40 a.m., and we had beaten any previous record by two hours, and I a mere woman! I felt bewildered, and could not realize that the goal I had dreamed of and striven for for years was beneath my feet.'[3] Some mountaineering men admired Freda's determination and skill. 'Women climbers will always have reason to thank Miss du Faur [who] fought the battle for emancipation of her sex in matters of mountaineering,' one wrote years later.[4] Girls found inspiration in a young woman sloughing off social expectations of timidity and reticence. 'I regret having to give Miss du Faur's [book] back [to its owner], I have enjoyed it so much,' a teenage girl noted in her own diary in 1919. 'Her climbing descriptions make me feel rather envious.'[5]

The freedom of the mountains set the scene for a rejection of social convention. A series of trips from Australia to New Zealand took Freda away from the surveillance of her family and gave her room to move in both a literal and a figurative sense. When she first set eyes on Mount Cook she was spellbound: 'The great peaks towering into the sky before me touched a chord that all the wonders of my own land had never set vibrating … I left behind me

all the worries of everyday life and felt free and irresponsible as the wind that stung my cheek.'[6] The book includes several photographic plates, images of glaciers, peaks and valleys, which show the majestic, liberating qualities of New Zealand's mountainous countryside. In a typical passage, Freda describes her feelings at the end of one climb: 'Soon I stood alone on the crest of the range, and felt for the first time that wonderful thrill of happiness and triumph which repays the mountaineer in one moment for hours of toil and hardship.'[7]

But *The Conquest of Mount Cook* is more than an account of mountaineering exploits that enthused and inspired Freda's eager readers. It is also a place to express emotional intensities and the affinity of mountain climbing and same-sex desire. Written when Freda's and Muriel's relationship was young, and when few writers addressed the theme of love between women, the book contains coded references to lesbian sexuality and evokes the connections between place and identity. Some outdoor and indoor spaces constrained sexual difference, but others enabled it. What are we to make of this passage, for instance: 'An unsympathetic environment and want of opportunity may keep this love hidden even from its possessor; but alter the environment and give the opportunity and the climber will climb as naturally as the sparks fly upward.'[8] There can be no doubt this hidden love refers to mountaineering: Freda wrote about an 'inborn love of climbing' that came to fruition as a result of her passionate encounters with the landscape.[9] But it is just as likely that she is also referring to her feelings for another woman. The concept of a hidden or secret love was common at the turn of the century; the phrase 'the love that dare not speak its name' was made famous by the widely publicised 1895 'gross indecency' trial of Irish playwright Oscar Wilde.

Freda's memoir suggests she experienced her passions for the mountains and for Muriel as two sides of the same coin, and the physical environment unlocked the passions of the body. *The Conquest of Mount Cook* includes several intense descriptions of Freda's and Muriel's time together. One morning they sallied forth from the Hermitage Hotel, 'clad in oilskins, with our lunch in a rucksac': 'I dragged Muriel out at some unearthly hour to show her the first glimpses of Mount Sefton and Mount Cook. Her sympathetic understanding was all I expected it to be, and I felt infinitely the richer by a thoroughly sympathetic companion, the first in all my seasons in the mountains.'[10] The other end of the day had its own pleasures: 'The evening was so lovely that Muriel and I considered it a sin to waste it rushing down to be in time for dinner. The others being of a different opinion, we sent them off without us. Then we threw ourselves down in the soft grass at the margin of the lake and drank in all the beauty of the ever-changing night sky. Two happy hours slipped away ...'[11]

The splendour of the natural environment gave rise to a profound 'sympathy' between Freda and Muriel, to use a word that appears in the book's dedication. The drama of the setting brought them together and excited their emotions: they 'drank in the beauty' of the night sky and of each another. Back at the Hermitage, they swapped wide-open spaces for something cosier. 'Quarters were rather cramped, and we finished up our experiences by trying to sleep together in a top bunk three feet wide,' Freda wrote, before adding enigmatically: 'It was an exciting experiment but hardly restful.'[12] The confines of the bunk, much like the grass near the lake and pages of the book, became a place where Freda and Muriel's intimacy took shape. An open meadow and a cramped bed gave rise to differing kinds of entanglement, while the hotel's public spaces no doubt occasioned other – more restrained – kinds of interaction. It seems unlikely that Freda was quite as tactile with Muriel in the Hermitage's lounges and sitting rooms.

Freda and Muriel were restless souls. They left for London in 1914, moving even further away from their families, and took a bohemian cottage in Pinner. The pair socialised with the English suffragists and made new friends who described them as 'a married couple'.[13] They heard about others like them and a doctor talked to Freda about her 'inverted hedonistic persuasion', adopting a term popularised by other physicians, including Havelock Ellis.[14] In inverts, Ellis wrote, 'the sexual impulse is *organically and innately* turned toward individuals of the same sex'.[15] Freda brushed off the doctors' prognostications but Muriel was made to feel guilty about her sexuality and suffered a mental breakdown. Finding herself in a rest home, Muriel was subjected to hypnosis and the infamous 'rest cure' – a fate that met many a rebellious woman. She was plied with sedatives and kept asleep for days at a time.[16] The treatment further weakened Muriel's constitution and her mental state, and she died in 1929. A distraught Freda struggled to carry on without her partner and gassed herself to death six years later. *The Conquest of Mount Cook*, with its coded record of an intense relationship, stands as testimony to these women's lives together during happier times.

The Hermitage, Mount Cook, in its splendid setting.

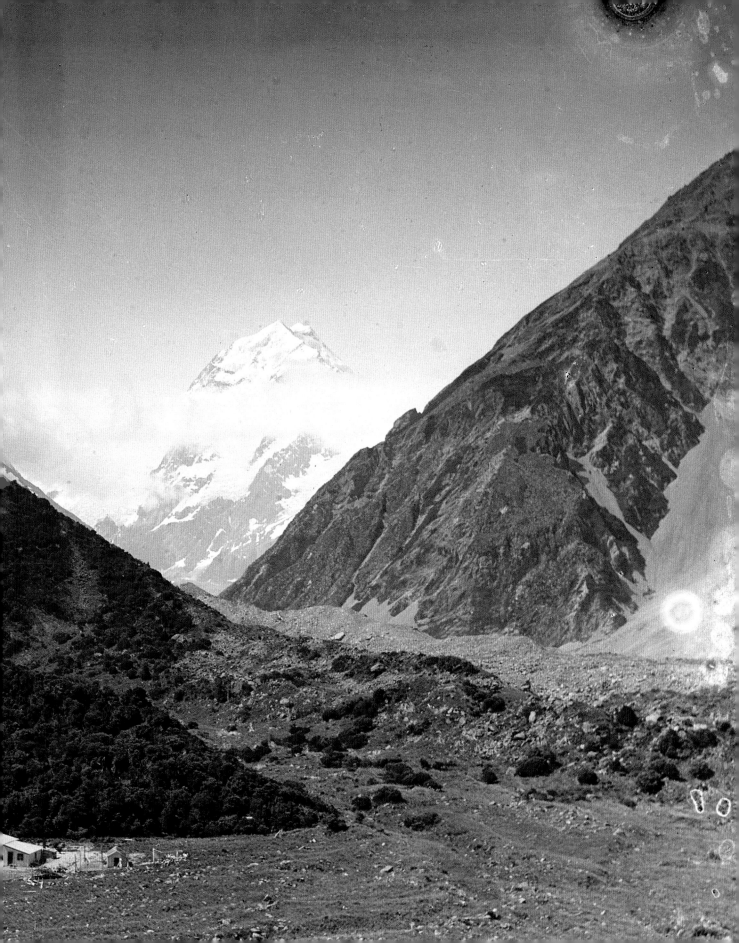

i Jatti,
Settignano

a. 1 Aug.

Dearest Douglas
I have just packed up
the book and your key
and in a few moments
time, I hope they will
be on their way to you
I hope that you will
get them safely.
The little boy at your
house thought I was
a burglar and I made
him come up into your
flat to see that I only
took the book. He looked
rather charming.

12. Teddy's Illustrated Letter

RACHEL HOPE CLEVES

Illustrations of naked dancing boys painted in tones of ochre and blue crowd the margins of an August 1924 letter from South African artist Edward 'Teddy' Wolfe to the Scottish writer Norman Douglas.[1] The paintings and the words they frame are artefacts of a ribald pederastic subculture that attracted many foreign artists and writers to the Italian city of Florence during the early twentieth century. Florence, however, had a historic association with intergenerational sex between men and boys long before then. Historian Michael Rocke has used court records to calculate that between 1459 and 1502 at least half the youths in Florence were implicated in a charge of sodomy before they reached the age of 30. Despite the notorious friar Savonarola's brutal efforts to rid the city of pederasts during the late fifteenth century, this subculture survived into recent times.[2]

Florence's reputation for sexual toleration attracted many privileged queer male visitors from Britain and Germany during the nineteenth and early twentieth centuries. In 1889 the passage of Italy's Zanardelli Code decriminalised sex between males throughout the nation. This legal tolerance stood in sharp contrast to the prosecution of same-sex encounters between males in Britain under the 1885 Labouchere Amendment, and in Germany under Paragraph 175 of the German Penal Code. A number of highly publicised attacks on wealthy queer men at the turn of the twentieth century, including the 1895 Oscar Wilde trials, inspired a small migration to Italy, and in particular to Florence, which already had sizeable Anglo-American and German colonies. This queer exodus included a significant number of men who were sexually drawn to boys and male youths.[3]

The Italian antiquarian book dealer and publisher Giuseppe 'Pino' Orioli wrote about Florence's pederastic expatriate subculture in his 1938 memoir, *Adventures of a Bookseller*. Orioli described an early twentieth-century 'group of about ten men, most of them Germans, and all of them queer'

Opposite and overleaf: Teddy Wolfe's letter of August 1924.

I am still working on
my horrid fat old
nudewoman. But
I think I'll go away
somewhere after the
7th of August. I would
love nothing better than
to come and spend a few
weeks with you but
alas I have so little
money that I cannot
go anywhere

except near
Florence or Venice
most likely it will be Volterra
anyway I'll let you know
what does eventually happen
to me.

who sat around café tables 'saying charming things about Donatello or Dante or Michelangelo or Bruno or Benevenuto. If you took a table near enough to overhear what they were saying, you soon realized that they were not comparing the merits of those famous Italians of bygone days, but those of the best-looking modern youngsters about town who bore the same names.'[4] Orioli was himself attracted to males in their late teens and early twenties, but he did not object to men whose tastes ran younger. In fact, during the 1920s and 1930s his closest friend in the city was Norman Douglas, who preferred boys aged between 12 and 14.

Douglas was born in in 1868 in Austria, where his wealthy Scottish family had moved to open a textile mill in the Alps. He went to public schools in England before completing his secondary education in the German city of Karlsruhe. Douglas first visited Italy in 1888, and at the turn of the century he moved to Posillipo on the northern tip of the Bay of Naples. Later the loss of his family's wealth forced him to move to London where he took a job as subeditor of the *English Review*. In 1916 he was arrested at the South Kensington tube station and charged with making an indecent assault on a 16-year-old whom he had picked up a week earlier at the nearby Natural History Museum. In January 1917 Douglas jumped bail and fled to Italy. In 1921, after several years of peripatetic travel through France and Italy, he settled in Florence. During the next 16 years, before he fled arrest for molesting a young girl, he frequently had young male lovers living with him, ostensibly as cooks. But the writer made no secret of his sexual practices.[5]

By the early 1920s Douglas had become a literary celebrity renowned for *South Wind*, his hedonistic novel set on a fictional island modelled on Capri. He also wrote several highly admired travel books set in Italy and Austria, inspired by his journeys in the company of a series of young boyfriends. Douglas held court in Florence's caffés and trattorias where he mixed with the city's giddy society of queer residents and visitors. He had a ribald sense of humour and joked freely about his sexual affairs with the city's male youths. When the writer Joe Ackerley lunched with Douglas at a Florentine caffé, the latter pointed out one of the young waiters: 'hasn't got a hair on his body, Joe. It slips into him like a knife in butter. When are you coming out here to join us?'[6]

Edward Wolfe met Douglas in Florence in the spring of 1924 and joined him for a series of pleasurable dinners in the company of queer male friends, including Orioli and C.K. Scott-Moncrieff, Marcel Proust's first English translator. In June 1924 Douglas invited his friend Muriel Draper to dine with him and Wolfe, whom he described as a 'fin-de-siecle artist and rather pleasant'.[7] By linking Wolfe to the world of Oscar Wilde, Aubrey Beardsley and other luminaries of 1890s British Decadence, Douglas was signifying his queerness. Wolfe was born in 1897 in the South African city of Johannesburg. His mother was an actress from Northumbria and his father a gambler from Lithuania. Wolfe worked as

an actor while he was a boy. At the age of 16 he began a sexual relationship with his music teacher, Barclay Donne, and a few years later the pair moved together to London. Wolfe studied art at the Slade School in 1917 and was swiftly adopted into the Bloomsbury Group. He painted lampshades for the Omega Workshop, had a sexual affair with Duncan Grant and became a close friend of Nina Hamnett. His aesthetic sensibility was influenced by French artists Henri Gaudier-Brzeska and Henri Matisse, as well as the Italian painter and sculptor Amedeo Modigliani. Wolfe moved to Paris in 1922 and then to Florence the following year.[8]

Many of Wolfe's paintings had a homoerotic quality. During a return trip to South Africa in 1920, Wolfe painted the naked bodies of black workers at

Edward Wolfe's painting of Pat Nelson (right) hangs in the Queer British Art exhibition at the Tate Britain in 2017. The image on the left is PC Harry Daley, painted by Wolfe's sometime lover, Duncan Grant.

the Village Deep gold mine, although the choice of subject caused a negative reaction in his racially and sexually repressive homeland. He also painted and sketched the bodies of nude male youths who posed for him in Mexico, North Africa and on Ischia, an island in the Bay of Naples. His bare-chested portrait of young Jamaican man, Pat Nelson, another of Duncan Grant's lovers, was included in the Queer British Art exhibition at the Tate Britain in 2017.[9] The male subjects in these paintings mostly appear to be young adults but Wolfe also enjoyed painting and drawing children. As critic John Russell Taylor noted, children 'fascinated' the artist, who made good money selling portraits of them to their loving parents.[10] Wolfe's illustrated letters to Norman Douglas, and a few sketches he sent along with them, indicate that the men shared an erotic appreciation for boys, although we do not know whether Wolfe acted on those feelings.

The four boys painted on the front page and inner pages of Wolfe's letter to Douglas are pictured in his usual style, with large almond-shaped eyes and elongated faces. The figures are distinguishable as boys, not men, by their juvenile musculature and small, nearly hairless genitals. Several of

the boys have curly hair. One, playing a small pipe, evokes the Hellenic pederastic tradition often alluded to in turn-of-the-century queer British literature.[11] Douglas, for example, published a light-hearted catalogue titled *Birds and Beasts of the Greek Anthology* in 1928.[12] (The original *Greek Anthology*, first compiled in the tenth century, was a canonical compilation of classical poetry that included a book entirely devoted to the pleasures of pederasty.) The paintings in Wolfe's letter to Douglas showed his familiarity with the neo-Hellenist aesthetic tradition that also appeared in the photographs of Wilhelm von Gloeden (see Chapter 24).

Wolfe sent Douglas several other erotic sketches of naked boys during the years of their acquaintance. A letter written in April 1925 had a simple pen and ink sketch of a hairless naked boy on its left margin. At some point Wolfe also gave Douglas a humorous pencil sketch of a reclining young man with a large erection being fellated by a small flying curly-haired cupid, who farts while showering a flower with either urine or semen. A mountain, perhaps Vesuvius, rises in the background, giving the sketch a classical aspect. Other Wolfe sketches and paintings among Douglas's papers depict adult women and men masturbating, together and alone, in same- and opposite-sex groups.[13] Wolfe, like Douglas, was primarily oriented towards males but he also had sexual relationships with women. Both Wolfe and Douglas celebrated sexual variety and treated pederasty as one possible pleasure among many.

Attitudes towards intergenerational sex have shifted so radically over the course of the twentieth century that no one would now equate sex between adults with sex between adults and children, at least not publicly. Current understandings of sexual autonomy reject the possibility that children can be consenting participants in sexual encounters with adults, and intergenerational encounters are understood as rape rather than sex.[14] This shift in understanding means there is much to learn from the inclusion of artefacts from older pederastic subcultures in histories of sexual material culture, even though current taboos and laws against the reproduction of child pornography make this sort of work increasingly difficult. Even in earlier times, though, there were limits. Douglas expressed concern about the legal ramifications of receiving letters like Wolfe's that contained explicit pornographic content. In his 1933 memoir *Looking Back*, Douglas mentioned another friend, the pseudonymous 'Edmund Barton', whom he met in Paris during World War I and who sent Douglas letters 'so profusely embellished with coloured nudes in ambiguous poses and in the style of Etruscan wall paintings, that I used to wonder what the Censor thought of them!'. Eventually Douglas asked 'Barton' to stop writing him pornographic letters.[15]

The curly-haired cupid.

FOUR SAINTS IN THREE ACTS

HARTFORD
1934

13. Four Saints in Three Acts

TIRZA TRUE LATIMER

Imagine it is February 1934 and snow blankets the entire north-eastern corner of the United States. Art world figures and socialites from all over New England are making their way to the Wadsworth Atheneum Museum in Hartford, Connecticut, to attend two of the season's biggest cultural events: the first exhibition in the United States devoted to the work of Pablo Picasso, and the opening of Gertrude Stein and Virgil Thomson's opera, *Four Saints in Three Acts*. Many are coming up from Manhattan on a crowded train and extra carriages have been added to accommodate the high demand.

Wadsworth Atheneum's young director, Arthur Everett ('Chick') Austin, has touted Hartford as 'the new Athens', 'a place of pilgrimage for art lovers'.[1] Under his leadership the atheneum has undergone a radical modernisation. This has included the construction of the Avery Memorial Building, one of the first American examples of the so-called International Style. Austin has timed the opera and the exhibition to inaugurate the new building. In the curator's eyes, the two events, and the new annex itself, represent the full spectrum of Euro-American modernism.

Jostled by the crush of guests at the entrance, visitors make their way to the atrium of the Avery Memorial Building and mingle around a shallow reflecting pool. Pietro Francavilla's *Venus*, a mannerist statue, stands at the centre. Sculptures by Constantin Brâncuși, Alexander Calder and Alberto Giacometti stand watch around the courtyard's edges. Upstairs in the modern gallery, the even lighting, white walls and minimal furnishings create optimal viewing conditions for Picasso's paintings. Downstairs in the lounge outside the theatre, champagne corks are popping. This room, with its low lighting, thick carpet and velvet upholstery, has an intimate feel. Guests cluster around the bar talking excitedly about the opera. Virgil Thomson is one of them. A young gay composer living in Paris in the 1920s, Thomson persuaded the lesbian expatriate author Gertrude Stein

The cover of the Four Saints in Three Acts programme, 1934.

GERTRUDE STEIN

VIRGIL THOMSON

A. EVERETT AUSTIN, JR.

to collaborate on the opera. He chose the theme of religious devotion and she proposed Saint Teresa of Avila as the protagonist. Thomson's score supported the religious theme, incorporating melodies from American hymns and spirituals. For several years Thomson courted backers for the opera. The list of patrons included prominent arts advocates and culture brokers from New York to Boston. When Chick Austin got wind of the project he jumped at the chance to host the opera's premiere.

It will be the Wadsworth's first theatrical event and the first opera ever produced in a museum. *Four Saints* is also the first opera for Stein, Thomson and British choreographer Frederick Ashton, and the theatrical debut for director John Houseman. It will break new ground in the arena of stage design. For the first time in the United States a painter, Florine Stettheimer, has been called on to design the opera sets and costumes, and she has chosen to work with playful, campy materials never before used in stagecraft: cellophane, ostrich feathers, glass beads and lace. Of all these firsts, perhaps the most astonishing is that the opera features an all African-American cast.

Even the opera's souvenir programme is out of the ordinary. The ornate Edwardian lettering on the cover in no way echoes the streamlined design of the theatre. The cartouche containing the title in gold letters stands out against a field of black lace overlaid on pink paper. Lace was a favoured Stettheimer medium and pink was a privileged colour in her palette. The rose motif of the black lace border nods at the libretto's author, famous for her utterance 'Rose is a rose is a rose is a rose.'[2] The off-beat aesthetic of the programme's cover invites audience members to suspend their beliefs about what modernism looks like.

Inside, 26 pages map out the production's cultural context and the ambitions of its creators as clearly, for those who can read the queer codes, as if it were a manifesto. Saint Teresa, the heroine of this opera, is the focus of the first spread. A full-page photograph of Gianlorenzo Bernini's Baroque masterpiece, *Saint Teresa in Ecstasy*, faces a verse, 'The Flaming Heart, Upon the Book and The Picture of Seraphical Saint Teresa', by the English metaphysical poet Richard Crashaw, a contemporary of Bernini. This two-page layout, with its historical references to artistic predecessors who have been inspired by Saint Teresa's story, introduces audience members to the opera's mythology.

The next two spreads feature portraits of and by the opera's principal collaborators. Two of Stein's gay male protégés, the neo-romantic artists Christian Bérard and Kristians Tonny, have provided images. These symbolically reconstitute a queer social and artistic network, initially formed in Paris with Stein at its centre. The medallion-like quality of Stein's photograph by Man Ray contrasts with the dynamism of Thomson's and

Austin's, taken by Lee Miller, which occupy the same page. Miller has used studio lighting to full advantage in order to create a sense of drama. She highlights Thomson's pianist fingers and the kerchief that billows from his breast pocket, the lighting strengthens the line of his cheek and jaw, and his gaze, fixed somewhere off to the side, invests the portrait with a cool detachment. The sitters' poses also enliven their photographs. Chick Austin, for instance, leans over the back of his chair, inclining his head somewhat intimately into the space of the viewer and making eye contact from under his brow. The portrait shows his well-groomed good looks – cleft chin, full lips, strong nose, generous forehead and muscular shoulders – to the best advantage, as a Hollywood star's promotional photograph might. The light catches signifiers of class (the expensive watch, the collar clip, the preppy V-neck vest) and signifiers of homosexuality (the foppish pocket kerchief and pinky ring). The portrait exudes casual confidence, charisma and in-born privilege.

The facing page features a headshot of the conductor, Alexander Smallens, and bust-length portraits of Houseman, Ashton and scenarist Maurice Grosser, who is also Thomson's lover. Miller shows each sitter in his best light while accentuating, with pose and illumination, diverse effects of masculine privilege that collapse the visual codes of class, queerness (three out of these four sitters were gay) and aestheticism into prevailing 1930s conventions of celebrity portraiture.

The next spread has a very different feel. Devoted to the opera's principal performers and the 'choir mistress', Eva Jessye, these photographs by Miller have not been taken in a studio, but at St Philip's Episcopal Church in Harlem, where Thomson auditioned Jessye's chorus and where the performers rehearsed.[3] All the chorus members, clad in saintly robe, have their eyes turned towards the heavens or the ground. This pantomime of prayer is in keeping with both the vocation of saints and the stereotypes of African-American piety. At the same time, the cast members manage to resist the camera's intrusion. Unlike the captions on other pages, here the names are accompanied by the sitter's role. No one in the audience needs to be told that Gertrude Stein is an author or Virgil Thomson a composer, but who has heard of Altonell Hines, Abner Dorsey or Bertha Fitzhugh Baker? Although both sets of photos fall within the parameters of playbill conventions, these differences in presentation hint at the asymmetrical racial relations that structured this alliance between Eva Jessye's chorus and the opera's white artistic directors. The white collaborators are known personages; these images of costumed players collapse the performer into the part.

The photo labelled 'Eva Jessye, Choir Mistress' strikes a discordant note. Jessye's self-possessed regard, her opening-night attire and her status as

ALTONELL HINES
Commere

ABNER DORSEY
Compere

BERTHA FITZHUGH BAKER
St. Settlement

choir director all set her apart from the chorus members pictured in this spread. But why does her picture not appear, as her name does, with those of the other artistic directors? Why is it placed here after the images of the principal performers? Aside from the racial bias dictating this situation – the assumption that Jessye, by dint of her race, has more in common with the performers – there can be no doubt the placement of her photograph as far as possible from Thomson's is significant. His written accounts of the making of *Four Saints* do not even mention Jessye by name. Instead he refers to her as 'a Negro woman' who had the best choristers in Harlem 'under contract'.[4] Thomson fails to acknowledge Jessye's exceptional achievements. The daughter of slaves, she graduated from Western University, taught school, worked as a journalist and ultimately flourished as a choral director. She founded the Eva Jessye Choir and secured billings on Broadway, on the radio and in Hollywood for five decades. A year after *Four Saints* premiered, she earned international acclaim as musical director with George Gershwin on his opera *Porgy and Bess*.

A clear sense of Jessye's confidence, savvy and authority comes through in Lee Miller's programme portrait. Unlike the cast members, she turns away from the camera as if loath to give the time of day to the white photographer, directors and audience members. Her singers called her 'Evil' in place of 'Eva' because she drove them hard, imposed exacting standards and competed ruthlessly for contracts. Jessye drove a tough bargain with Thomson too: she insisted that the singers be compensated not only for their hours on stage but also for rehearsal and travel time, an extraordinary demand to which the composer Thomson eventually acceded.

It seems fitting that Eva Jessye's photograph concludes the opera-related contents of the *Four Saints* souvenir programme. For of all the ground-breaking accomplishments represented in these pages, hers are arguably the most impressive. They reflect the boldness of her professional ambition and the odds against her success. Yet for Thomson, Jessye's placement at the tail end of these photographic credits certainly had no such implication. For him, she was no more than a necessary 'Evil', and she remained an irritation for trying, as Thomson put it, 'to insinuate herself into the history of *Four Saints*' even after the curtain had long since fallen on the enterprise.[5]

Thomson wanted the opera to make a difference in the history of modernism, to secure a place in history for himself and for his queer confrères. The idea of recruiting an all-African-American cast came to him at the Hot Cha Club in Harlem where he, Carl Van Vechten, Henry Russell Hitchcock, Phillip Johnson and others of their crowd routinely cruised for young black men. Given the negrophilia of Thomson's gay male milieu, racial difference could be understood as a metaphor for the sexual and artistic difference that contributed to the opera's emancipatory ethos. Race ran

cover for liberated sexuality, especially homosexuality. The hierarchical and stereotypical marking of racial difference in the souvenir programme reassured whites while diverting attention away from the campy aesthetics that made *Four Saints* a queer tour de force.

If we are willing to read it as a kind of manifesto, a statement of difference within modernism and within American society, the *Four Saints* programme shows us that the histories of marginalised communities, including people of colour, women and queers, are neither entirely separate nor chronologically linear. Understanding hidden histories involves looking back with an eye for difference, including differences within difference and taking ephemeral traces seriously as sites of historical transmission.

EVA JESSYE
Choir Mistress

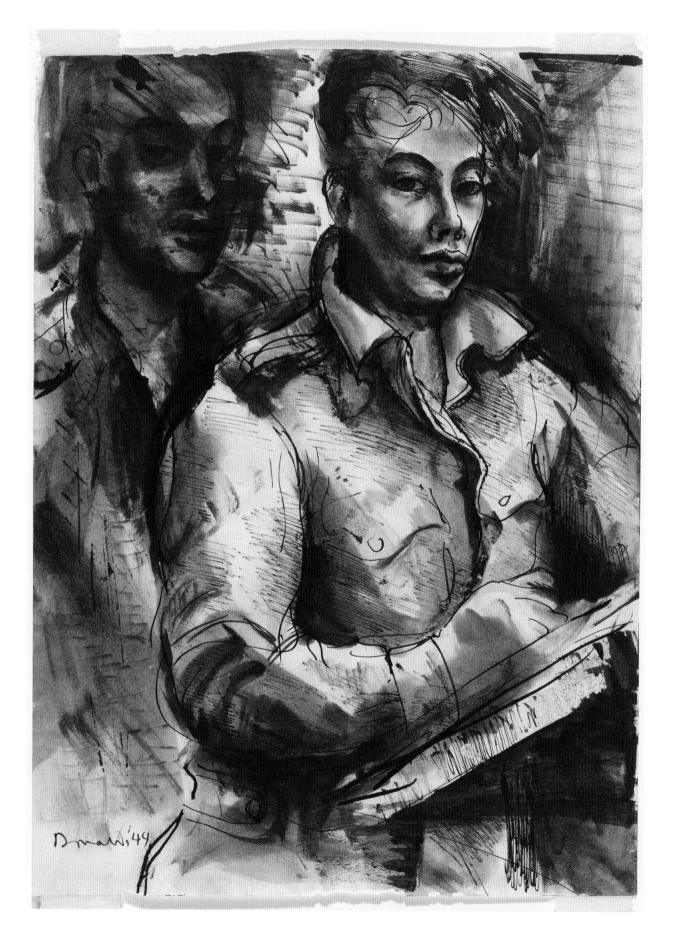

14. Donald Friend's Life in Letters

TIMOTHY ROBERTS

As well as being a painter and a draughtsman, Australian artist Donald Friend was an enthusiastic and prolific writer who penned tens of thousands of pages. He is most famous for the 46 diaries that span over 60 years of his life, but he also wrote many books, notes and letters. From the early 1940s until the 1960s Friend wrote over 40 letters to his confidante, journalist and author Patricia Bennet (née Massey-Higgins). In pointedly articulate and daringly witty prose, Friend reveals his inner musings, recounts charming tales and dabbles in tawdry gossip.

How Friend and Massey-Higgins met remains unknown, though it is possible that they were introduced by artist Wallace Thornton. Friend lived alongside Thornton and other artists in the then dilapidated Elizabeth Bay

Opposite: Donald Friend, a self-portrait from 1944.

ဢ

A missive sent from Donald to Patricia.

House situated in the inner-city Sydney suburb of Potts Point; Massey-Higgins lived a short walk away at 19 Billyard Avenue. Friend initially addressed his letters to both Thornton and 'Chickadee', but after some correspondence he was prompted to inquire, 'And bye [sic] the way my darling Chickadee, some day you must pause in your hectic flight and remember to tell me your name: the nearest I can get to it is Bowes-Lyons.'[1]

The correspondence begins along the 'frangipanni-laden boulevardes [sic]' of north Queensland shortly before the onset of the Pacific war in early December 1941. Friend's semi-itinerant life is evidenced by varied postmarks and return addresses and an assortment of paper, ranging from distinctive blue aerogrammes to the red-ruled stock of the Salvation Army and the YMCA. Friend's rapport with Massey-Higgins developed quickly: even the earliest letters freely discuss Friend's homosexuality. They describe one 'glorious island creature', a 'wild chasse d'amour' through north Queensland and sometimes mention the lack of men with similar proclivities. On one occasion Friend lamented that, 'as far as I can gather, camping in these latitudes only means folding up one's tent & silently stealing away like a subversive arab'.[2]

Friend enlisted in the Australian army on 29 June 1942, trained as a gunner and later served as an official war artist in Labuan, Indonesia.[3] He corresponded frequently through this period; some 23 letters to Massey-Higgins record intimate details of his military experience. Friend wrote a glittering account of a deliriously camp experience while stationed in Brisbane in 1944:

> My dear, the village has become so gay & so Fay, and I've been misbehaving enjoyably. At the moment it is full of Allied Friends from the jungle who seem to suffer badly from a tropical glandular disease known vulgarly as Hot Pants, which drives them to wonderful excesses, vide the last 3 days have been one glorious party after another – Edgar Kauffman & David Asherman are both down, and a glorious naval one, to whose flat we went last night to hear his collection of samba records & watch a Puerto-Rican commander dance the Afro-cubain with a jewelled matelot. I usually get back to camp by Yank staff car around 3 or 4 in the morning, begin wharflaboring [sic] at 7.30, and return to the gaieté Brisbanienne in the evening at 5, stopping by the war memorials Sacred Flame to find recruits if need be – it's all madly wicked.[4]

Friend's 'recruits' were a veritable militia of queens, servicemen and sissies who inhabited Brisbane's streets each night, seeking to meet and entertain one another socially and sexually.[5] He recorded these experiences in

'Darling Chickadee': a map showing Patricia how to get to Donald's place in Hill End, past Sally's Flat village.

Hill End

Darling Chickadee.

 a few last words of instructions
as to how to get here. & don't forget to bring a rug,
and also if you will 2 lbs of coffee beans of
your favorite blend (we grind them on the property in
our own mill). Leave in the morning so you'll
arrive in good time. and here's a map.

Turn Right at Kelso,
which is just 3 miles before
Bathurst. And then its 5-8 miles
to Hill End, you pass through Wattle flat,
Sofala and Sally's flat villages, but
don't let them disturb you.
I've laid in great stocks of goodies
& cookies & am madly excited at
your visit.
 My cottage is right in the
village not far from the Pub
and it looks like this.

and has a huge pinetree
in front of it.
 as sees

Donald.

HILL END.

15 M.

SALLY'S FLAT VILLAGE

15 M

SOFALA

WATTLE FLAT VILLAGE

MTS

30 M.

Bathurst.

KELSO

Sydney Road

numerous diary entries and even created a work of art, *A Brisbane Bedroom*, which alludes to intimate encounters.

Differences between Friend's letters and diaries emerged during the war years. Publisher Sydney Ure Smith edited the diaries to produce *Gunner's Diary* in 1943, the same year in which American architect Edgar Kaufmann Jr purchased one of Friend's diaries for £75.[6] Although Friend may have censored his diary entries knowingly or otherwise in preparation for their publication, his letters were intended to enchant and intrigue. He embellished them with eccentric details appropriate to the taste of his audience.

The disparity between the diaries and letters is evident when the artist accidentally shot his comrade, war correspondent Don Speedy, causing minor injuries. In his diaries, Friend coolly speaks of Speedy without any apparent sexual interest.[7] A few days later he wrote theatrically to Massey-Higgins, 'I'd shot the only eligible bachelor in Labuan, who was making his way to my tent.' He later added, 'Fortunately, when the men of the ranks had killed all the Japanese, they'd not collected their addled wits enough to ask what was the purpose of bachelors lurking about the tent at night.'[8] In fact Speedy shared a tent with Friend in Labuan, so it is unsurprising that he would 'lurk' at such close quarters.

After the war, Friend corresponded with Massey-Higgins from places as far away as Florence, Italy and Brief in Ceylon (later Sri Lanka). In one letter he gossips about the censored books that resulted in the arrest of conductor Eugene Goossens at Sydney airport, another criticises the high society of Ceylon's colonial authorities, and he provides a naïvely sketched map providing directions to his house at Hill End in central New South Wales.[9] As the postwar letters mellow considerably in their colour they reveal a thoughtful and candid friendship.

Donald Friend's personal exchanges with Patricia Massey-Higgins are a detailed, varied and profuse resource for queer history. Not only do they discuss matters that cannot be found in official records, but the homosexual undertones and candid insights that emerge throughout the pages are vital anecdotes that enrich and enliven the portrait of a celebrated Australian artist.

Try it all!

Contact our personal advertisers for the most thrilling experience ever!

Here's how!

1. Each advertisement is followed by its code number. Write the code number in Pencil in the center of the envelope.

2. Write your return address in the regular corner of the envelope.

3. Place your letter in the envelope and seal. Your letter will be forwarded immediately and will not be opened at any time.

4. Place your letters to be forwarded in a larger envelope and address it to:

 KREATIVE PRODUCTS
 P.O. BOX 284, LEMOYNE, PA. 17043

5. Enclose ONE DOLLAR (cash or money order) and a loose 13 cent stamp with EACH letter you wish to be mailed to an advertiser. Your letter will be forwarded the SAME DAY it is received in our office.

15. Dear Dawn, Can I Hold You?

LOREN BRITTON

After I began wondering about the wellspring of trans desire in print I discovered *Transvestia/Transvestia International*, which began in 1960 and ran until 1980 and is one of the first transgender lifestyle magazines. Its publisher was Virginia Prince, a Southern Californian advocate for freedom of gender expression.[1] She is credited with the first usage of the term 'transgender' in the English-speaking west, to refer to individuals like herself, whose personal identities she considered to fall somewhere on the spectrum between 'transvestite', a word coined in 1910 by Dr Magnus Hirschfeld, and 'transsexual', a term popularised in the 1950s by Dr Harry Benjamin.[2] Prince also started the Hose & Heels Club in Los Angeles in 1961, the first cross-dressing organisation to host events. This became the Alpha Chapter for the Foundation for Full Personality Expression and then the Society for the Second Self.

As an activist project, *Transvestia International* offered a material site of solidarity for a trans community in a nascent state of visibility. The magazine changed in form over time, sometimes appearing in print as a glossy magazine, sometimes as a pamphlet and at other times as a sort of newspaper. The periodical included personal advertisements and, as was the case for many gay magazines of the time, anonymity was guaranteed. Each personal ad was assigned a number; interested readers sent a letter to the magazine's office and the staff forwarded it to its new home. Readers connected through letter writing: they shared their experiences and sought friends, partners and community.

Transvestia's images are significant too. As other chapters in this collection also demonstrate, clothes allow their wearers to play with, play up or play down social expectations of gendered

The magazine's instructions to correspondents.

and sexualised bodies. Some figures in *Transvestia* wear kinky and feminine garb on masculine bodies and blur ideas of who she/he/they/it might be getting dressed up for; corsets are not only for cis-women and ball gags are not only for sissy boys. These representations both affirm various modes of desire among *Transvestia*'s readers and challenge conventions of gendered beauty.

In the germinal article, 'My Words to Victor Frankenstein Above the Village of Chamounix: Performing transgender rage', academic and activist Susan Stryker recounts her gesture at Rage Across the Disciplines, a 1993 conference at California State University. Stryker draped her black leather biker jacket on the back of a chair on stage, and every delegate could see it emblazoned with Queer Nation-style stickers reading 'SEX CHANGE', 'DYKE' and 'FUCK YOUR TRANSPHOBIA'. Stryker consciously performed transgender rage and

referred to the potential subversions of power mobilised by those who play with gender and clothing in highly symbolic ways.[3]

For this chapter I have transcribed personal ads from the first issue of *Transvestia*, published in 1960, and responded to them in 2019. As I do so I invite readers into my engagement with this magazine and with the folks looking for love, friendship and more. In this performative gesture of self, I consciously write to my trans elders with respect and tenderness. I wonder what is the possibility of trans*lating experience?[4] Can we hold each other's experience and respond to each other across time? Where are the limits of coded language? And as Brian Kuan Wood of E-Flux has remarked: 'Over the past few decades, it has often been said that we no longer have an addressee for our political demands. But that's not true. We have each other.'[5]

AL-TV: Loves all swinging activities and will play female all the way. Your ideas will be welcomed no matter how far out. I will play male or female role with singles, but travel is limited and discretion a must. All sincere swingers answered. Does recent photo suggest fun? T501

Dear T501,
 Recent photo does suggest so much fun! Yes I'm not a single but maybe you will still consider travelling for me ... Imagine where we could go? You will play female, well player — that's good to hear because it's all drag anyway, isn't it? I'm sincere, promise.
 Sincerely yours,
 Velvet Play
P.S. What's in it when you say the thing, but don't define what you mean by saying that?

AL-TV: Decatur area, middle-aged and ready. Enjoys French and Greek cultures, Polaroid parties and all adult desires. Let's go both sexes. Frank letters appreciated. T602

Dear T602,
Dear Frank,
Dear French,
Dear Greek,
 *Your material is so ready to share. Your desire affects me with a sensation so reformulated I want to make it chemical physical polaroid **snap**! Isn't Decatur affectionately known as THE RIVER CITY? How would you want me to answer you if I was Frank?*
 With Respect + Curiosity,
 Your Favourite Whip

LOVELY TV
MI-TV: 24 year old would like to correspond with same and perhaps exchange thoughts, ideas and photos. T9876B

TV DEVOTEE
PA:-TV: Single male 40, very lonely, interested in hearing from other males, females, also TV's and fetishists. Special interests are nudism, TV's, fetishism, photography, plus drive-in movies. Photo, phone preferred. Will answer all. T541

WRITE ME!
NY-TV: Male, TV, will answer all letters from dominant and agressive people. T579

CORRESPONDENCE ONLY
CA-TV: With those females classified as TV-oriented GGs; female TVs; female TSs; straight GGs interested in male TVs, TSs, or interested in female TVs and TSs. Love chatting on fashions. Haved sizeable wardrobe. T531

PRINTED IN U.S.A.

Back cover of the first issue of Transvestia.

MALE TV DESIRES CORRESPONDENCE ONLY

CA-TV: With those females classified as TV-oriented GGs; female TVs; female TSs; straight GGs interested in male TVs, TSs, or interested in female TVs and TSs. Love chatting on fashions. Have sizeable wardrobe. T531

Dear 'Male' TV,

I'm so glad you desire correspondence only ... because honestly, that's the only thing I can truly give you. But furthermore, will you understand me? At this point, there is so much and so little to say — I'm tempted to use an untranslatable word like Koi no yokan — it's a Japanese word to describe the feeling upon meeting someone that falling in love will be inevitable. Do you know this feeling? I think I do, I felt that way when I met my wife. Funny to think we've been married a year now. I'm classified as a GQ NB GNC Trans Man but that's not how I feel, how do you feel? Do classifications create space for you to feel? How do you know what your sexuality

is when you're chatting on fashions and gender, isn't it all just a hoax? I like clothing too — maybe we should draw pictures of ourselves dressed in our ball attire and send them back and forth. I'm happy I met you here. Let's keep in touch. Won't you please write?

> *Till soon,*
> *A Desirous Messy Pen*

FEMININE 'MISTRESS'

CA-TV: Seeks attractive women 22–35 for creative and mutual fantasy fulfillment. Also want to work as secretary or cocktail waitress. Will respond to all women who send explicit letter with photo. T683

Dear Feminine 'Mistress',

If I'm not a 'woman' will you still respond to my explicit letter and photo? Asking for a friend.

> *Yours truly,*
> *X*

1 LETTERS TO BE FORWARDED

2 YOUR PAYMENT AT RATE OF $1.00 FOR EACH LETTER TO BE FORWARDED

Kreative Products
THREE

3 LOOSE POSTAGE STAMPS

4 INSERT LETTERS IN LARGER ENVELOPE

THEN SEAL and MAIL TO:
KREATIVE PRODUCTS
P.O. BOX 284 / LEMOYNE, PA 17043

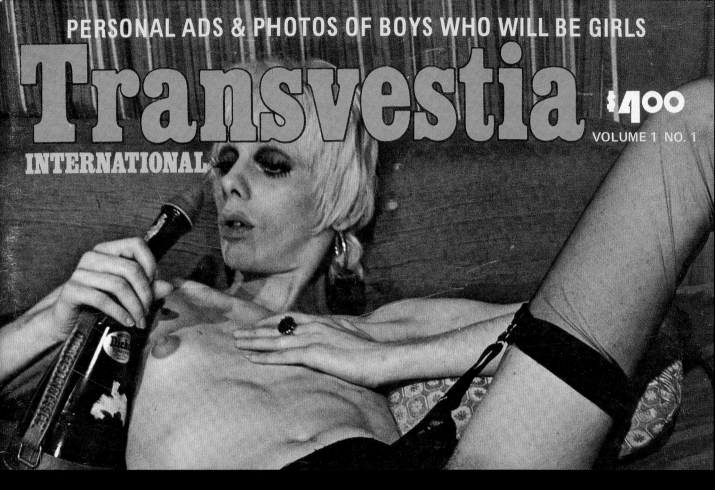

PERSONAL ADS & PHOTOS OF BOYS WHO WILL BE GIRLS

Transvestia

INTERNATIONAL

$4.00

VOLUME 1 NO. 1

L.A. DOCILE TV

CA-TV: Seeks dominant mistress, also young attractive bi-gals and TVs who share interests. Love giving and receiving all cultures, bare bottom domestic discipline. T565

Dear L.A. Docile TV,

How docile are you? I'm not a mistress but I can switch on when asked to. What's the cost if you don't find me attractive? Can you give and receive difference and different modes of approach? I'll be your domestic babe, baby.

Ever Yours,

A Flip Switch

WANT CORRESPONDENCE

CA-TV: TV interested in hearing from males and females. Send photo with letter. Travel extensively. T585

Dear CA-TV: TV,

*Are you also interested in hearing from people who don't identify with binary gender? I also travel extensively, and doing that while looking gender*fabulous gets me into trouble sometimes.*

I'm happy to send a photo, if you like patterns.

Till soon,

N/Either OR

Warsaw during the 1980s.

16. A Gay Magazine in Communist Poland

LUKASZ SZULC

'Dear reader, we present you a one-of-a-kind publication. Possibly, it won't bore you and, who knows, it may even catch your interest. What you have in front of you is the magazine of Warsaw gays (or faggots, if you prefer).' These words start the first issue of the gay magazine *Efebos*, published in Poland in June 1987, two years before the fall of communism.[1]

The magazine was neither the only nor the most successful Polish gay and lesbian magazine created during the Cold War. There were two more: *Biuletyn* (later renamed *Etap*), published in Vienna and distributed in Poland between 1983 and 1987, and *Filo*, published in Gdańsk between 1986 and 1990.[2] Both started as one-man projects: Andrzej Selerowicz set up *Biuletyn* and Ryszard Kisiel began *Filo*. Over time these magazines gathered a group of enthusiasts and fostered the emergence of the first informal homosexual groups in Poland.

Efebos, however, followed the reverse trajectory. It was created by members of an already existing gay and lesbian group called the Warsaw Homosexual Movement (WHM). Its initiator was Waldemar Zboralski, then a nurse in his mid-twenties who had just moved to Warsaw from Nowa Sól, a small town in Western Poland. Back in his hometown, Zboralski was one of the victims of Operation Hyacinth. Conducted by the Polish police forces in November 1985, and aimed at detaining, interrogating and registering actual and alleged homosexuals, Operation Hyacinth created a kind of state homosexual inventory.[3] Outraged by this experience of harassment, Zboralski decided to devote himself to activism. As he recalled in an interview, 'I thought that now [after interrogation], when everybody knows everything about me, I need to put all my anger, rebellion and energy to good use.'[4]

EFEBOS

DROGI CZYTELNIKU

Proponujemy Ci lekturę jedyną w swoim rodzaju, może Cię nie znu-
dzi, a kto wie, czy nie zaciekawi. Masz przed sobą pismo warszawskich
gejów (albo pedałów, jeśli wolisz).

The masthead and salutation from Efebos magazine, 1987.

Waldemar Zboralski and Sławomir at a meeting of the Warsaw Homosexual Movement in 1987.

In the spring of 1986 Zboralski started to make contact with other homosexuals based in Warsaw, and WHM organised its first meeting in January 1987.[5] The activists set a number of objectives: promoting safer sex, offering personal support and providing community information. At the same time, the group aimed to promote a more positive image of homosexuals in society at large. Its members began to give interviews to mainstream media, although most of them used pseudonyms and kept their backs to the camera. In March 1988 WHM submitted an application for official registration to the Warsaw City Council and received support from prominent public figures including Mikołaj Kozakiewicz, a social scientist and member of parliament; film director Jerzy Kawalerowicz; sexologist Kazimierz Imieliński; and journalists Barbara Pietkiewicz and Daniel Passent. The group never received a formal reply from authorities but *Polityka*, a popular weekly newspaper, claimed that WHM 'was refused registration because its activity would violate the rules of public morality'.[6]

In spite of all this, it would be erroneous simply to label communist authorities in Poland as homophobic.[7] Poland had decriminalised same-

sex acts in 1932 and homosexuality was not illegal in the country under communism. Besides, the Polish United Workers' Party did not have a clear stance on homosexuality and dealt with it in contradictory ways.[8] On the one hand, the party authorised Operation Hyacinth and sometimes used homosexuality to blackmail people into cooperation. On the other hand, WHM was allowed to meet in the premises of the Patriotic Movement for National Rebirth, an organisation created by the party to undermine Solidarity, the increasingly popular opposition movement. WHM also received support from the Ministry of Health and Social Care for its fight against the spread of HIV.

The idea of creating *Efebos* arose at a WHM meeting. Paweł Fijałkowski, one of the editors, remembers the difficulty in picking the editorial team: the problem was not a lack of volunteers, but too many.[9] In the end, the team consisted of four men: Fijałkowski, a 24-year old archaeology student at the University of Warsaw; Adam, a philosophy student at the same university; Grzegorz, a student at the Warsaw University of Technology; and Sławomir, a film director. They met in their own flats where they wrote texts on a typewriter, cut them out, created mock-ups and made copies at

Paweł Fijałkowski at an editorial meeting of Efebos in 1987.

the General Public Prosecutor's Office, on a photocopier made available by an ally who happened to work there.[10]

Harsh communist censorship law imposed strict controls on publications, but *Efebos* and the other two Polish gay and lesbian magazines were actually published legally.[11] Kisiel, the founder of *Filo*, had familiarised himself with censorship regulations while working in a printing house and a copy shop. He discovered that Polish law exempted from censorship all self-published materials of fewer than 100 copies, so the magazines' authors either published under that total or publicly claimed they did.[12]

The first issue of *Efebos* consisted of two A4 pages folded in half, giving a total of eight pages. The title was suggested by Fijałkowski, who was inspired by a book with the same title written at the end of World War I by famous Polish composer Karol Szymanowski. Szymanowski's *Efebos* praised the ancient Greek model of a homosexual relationship between an older man, a teacher and a handsome, youthful boy, an ephebos.[13] In fact, all Polish gay and lesbian magazines of the 1980s referred to Greek relationships and these provided activists with a powerful resource for conceptualising homosexuality as natural, transhistorical and transcultural.[14] *Etap* used the word 'ephebos' multiple times, *Filo* published a two-page article on Szymanowski and his book, and *Efebos* included a Polish translation of the epigram written by ancient Roman poet Martial:

A sketch of Michaelangelo's David from *Efebos*.

If someone by chance would give one to me when I asked,
I'll tell you, Flaccus, what kind of boy I'd ask for.
First, let this boy be born on the banks of the Nile:
No country knows better how to get up to mischief ...

And let him fear boys, and often shut out girls;
A man to the rest, let him be a boy to me alone.
'Now I know, and you're not wrong; for in my judgement
⠀⠀⠀it's the truth.
Just such a one,' you'll say, 'was my Amazonicus.'[15]

Discussions about homosexual organising in Poland dominated *Efebos*'s content. On the cover page the authors published a WHM manifesto that listed the group's objectives. The majority of these focused upon issues related to HIV and AIDS. WHM aimed, for example, to protect homosexuals against HIV, promote monogamy and safer sex, and support sick and lonely homosexuals. *Efebos* shows that the discourse of HIV and AIDS was prominent in Poland in the second half of the 1980s. This was strategically employed by homosexual activists to frame their demands for recognition, even though rates of HIV infection had not reached an epidemic level in their country.[16]

Efebos furthered another key objective of the movement: promoting a positive image of homosexuals in society at large. The authors of the WHM manifesto had expressed the need to fight against stereotypes that equated homosexuality with perversion. They wanted to 'show society the true image of a homosexual: a normal person, a participant in social life who differs from the rest of society only in his sexual orientation'.[17] They complained about 'the dregs of our group', including both 'indecent middle-aged or old men' and 'feminine-mannered homosexuals', whom they assumed irritated the general public and dominated its ideas about homosexuality.[18] *Efebos* employed a strategy we might refer to as 'visibility policing': the magazines embraced assimilationist ideals of respectability in order to curb those types of homosexual expression that threatened the positive image of homosexuals in society at large.[19]

After creating the first issue of *Efebos*, most of its authors — mainly students — went back home for the summer holidays. This was one of the key reasons the magazine did not survive. Fijałkowski also recalls that the editorial team could not agree on the vision for the magazine and that he wanted to devote his energies to writing up his own master's dissertation.[20] A second issue of *Efebos* was published but it was created solely by Sławek Starosta, another WHM member, and consisted of only four pages. All copies of this second issue seem to have been lost.

Ephemeral as it was, *Efebos* played an important role in expressing the aims, views and identity of WHM. The story of this and the other two Polish magazines published under communism, *Biuletyn/Etap* and *Filo*, points to the importance of understanding queer objects as objects that bring queers together. The magazines created a space within and around which emerged the first more systematically organised homosexual groups in Poland: Etap in Wrocław, Filo in Gdańsk and WHM in Warsaw. This trio became the founders of the first officially recognised Polish gay and lesbian organisation, the Association of Lambda Groups, which was registered soon after the fall of communism, on 23 February 1990.[21] Despite being informal and having limited reach, the earlier groups and their magazines played a fundamental role in founding the homosexual — later gay, lesbian, bisexual and transgender — movement in Poland.

The witch from the front page of Efebos.

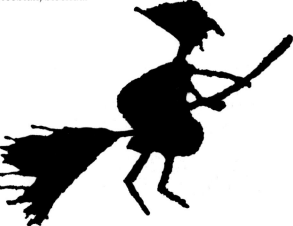

Tee A. Corinne, self-portrait

17. The Cunt Coloring Book

MARGO HOBBS

The Cunt Coloring Book has inspired queer, creative, open-ended use since its publication in 1975. It comprises 41 full-page black-and-white drawings of female genitals by the author, Tee A. Corinne. Each is unique. My own copy of the book, purchased a few years ago, came ready to use with a box of crayons in a range of skin tones from ivory to ebony. Where, I wondered, are the roses, the corals, the violets? The colour selection was politically correct, to be sure, not limited to the peachy Crayola 'Flesh'-coloured option of my childhood. But had whoever chosen the crayon box ever seen labia? Or read *Rubyfruit Jungle*? In any case, I didn't want a prescribed palette. I wanted the whole spectrum, the 128-crayon tray with the sharpener, to colour my cunts. They will be crimson and garnet, or turquoise and teal if I choose.

The book was made to please and educate the viewer. Corinne writes that in the early 1970s she counted herself among the women who were 'working to open the boundaries of lesbian sexual words and images'.[1] When she conceived the colouring book, Corinne was working at the San Francisco Sex Information Switchboard, an organisation that provided non-judgemental answers to queries about all aspects of sex and sexuality. Her switchboard training gave her access to sexual images and inspired her to produce her own.[2] Before you turn to the colouring pages, there is a cunt labelled with the anatomical names, from the mons veneris at the top to the anus below. The introduction by Corinne and lesbian activist Martha Shelley assures the reader that 'the drawings in these books are of real women's cunts'.

An undated self-portrait of Tee A. Corinne.

When the book was published, there were few images of women's genitals other than in pornography marketed to straight men. The Boston Women's Health Collective published *Our Bodies, Ourselves* in 1969 to empower women by educating them about their bodies; it included small drawings of vaginas to show anatomical variations and there was a chapter on lesbians written by a lesbian collective. Suzanne Santoro's *Towards New Expression/Per una Espressione Nuova*, published in Rome in 1972, paired photographs of female genitals with classical sculptures that established

Pages from The Cunt Coloring Book.

formal comparisons between labial forms and the folds in carved drapery. Betty Dodson lectured on 'Liberating Masturbation' and showed 'slides of women's genitals: large, vividly coloured slides', in Corinne's words, to feminist groups around the United States.[3] Dodson's book of the same title came out in 1974 and was illustrated with a detailed anatomical drawing. Encouraged by Dodson, Corinne asked other women working for the switchboard for permission to draw their genitalia: 'The first time I asked a woman to model I rehearsed the words I was going to say for weeks if not months. I don't know what I was so afraid of: that she would turn me down? that I would feel embarrassed? She said yes. We set a date and time.'[4]

According to her account of the session, Corinne felt inhibited making her first drawing. She consciously ignored all she had learnt about the impropriety of looking at genitals and tried to exercise formal control – even as internal voices questioned her sanity and called her a 'pervert'. The first attempt was constrained and lacked confidence. Corinne refocused, and this time her efforts satisfied her. 'The difference was dramatic. The forms were clear and the delineation sure.'[5] The vividness with which Corinne recalls this initial venture at drawing labia nearly 20 years later reflects the intensity of the experience. Her concentration is materialisd in the striking differences among the colouring book plates: she starts afresh with each encounter to produce renderings that are looser and more elaborate than the opening formulaic diagram.

Comparing the third and fourth plates illustrates the difference within similarity among vaginal forms that Corinne explores throughout the book. The shapes in the first example are lace edged or smoothly contoured with lines that vary in weight. A pair of curves suggest buttocks at the lower edge of the page, the crease of the thigh is indicated by a line on the right and the pubic hair at the top of the page is a tangle of stippled lines. The illustration on the opposite page is composed of dark hatches enclosed in sections. The labia fan outward with folds indicated by tapering lines and there are no indications of adjacent body parts. The larger than life-size scale of all the drawings subtly increases the graphic intensity of the rendering, so that the representations are more felt than seen as strictly lifelike.

Once the first modelling session concluded with viable drawings, Corinne pursued her '[reclamation] of labial imagery' with enthusiasm: 'Using soft pencils, I did drawings of every woman who would let me, then I used tracing paper to translate them into easy-to-reproduce ink drawings.'[6] The linear designs presented are abstracted from the original drawings; they are revisions in which the artist has flattened and simplified the initial sketch. She removes visual information, such as shading, and creates space for the viewer to add it back in with colour. The relationship between Corinne and the book's audience is collaborative and intimate. Furthermore, the

abstraction that slows the artist's progress towards a finished work by adding an extra step also slows the viewer's experience looking at it: she takes in the plate as a cunt, a graphic composition and a set of shapes to be coloured in. Rather than absorbing the picture at a glance, the viewer expansively engages with it in different registers.

Women took pleasure in Corinne's designs. 'I made copies on card stock and sold them through local women's bookstores. Women really liked them, liked to hang them on their walls and give them as gifts.'[7] The drawings were affirmations of women's bodies that were otherwise subject to censorship or exploitative consumption, and the nascent women's publishing movement and a network of women's bookstores were crucial to the book finding its audience. It was first published as feminists were mounting critiques of the representation of women in advertising and pornography, and Corinne intended her work to provide a positive alternative to mass media sexism. Still, the name of the book and the content of the illustrations drew censure. The title was admittedly problematic: Corinne was not enthusiastic about using the word 'cunt', although she liked the alliteration and 'the idea of combining a street term for genitalia with a colouring book, since both are ways that, as children, we get to know the world'.[8] She had the first edition produced at a women's print shop, and returned to them for a reprint when the first 2000 copies sold within a year. She was devastated when they refused with the explanation that there had been misgivings about the first run because the book reduced women to a body part and objectified them. Corinne eventually located another women's press willing to take on the next print run. Some years later Corinne worked with the Naiad Press to bring out an edition that was renamed *Labiaflowers*. The new title was expected to be more palatable, but 'It took the whole of the 1980s to sell 2000 copies.'[9] *Labiaflowers* was a misleading name, of course. While Corinne, Dodson and others used flowers as metaphors for female genitalia in other contexts, *The Cunt Coloring Book*'s illustrations are exactly what the title advertised. And yet they are somewhat other than straightforward in the ways they communicate queerly with the viewer.

The book offered its audience a queer viewing experience by refusing to conform to heteronormative conventions of looking. Theories of the gaze articulated in the decade following publication established what Corinne already knew: existing images of women's bodies and genitals neither satisfied her sensual desires nor reflected the way she, as a lesbian, saw women. The available mass market images invoked patriarchal codes that mastered the female body by exercising an objectifying and consuming gaze. Corinne's book eschewed hierarchies and established intimacy between viewer and image: the viewer's tactile senses were engaged by looking.[10]

There can be no doubt the book has an appeal to queer readers. Two aspects are especially pertinent: many of the drawings show fingers, and the viewer is meant to tactilely engage with the book by colouring its pages.

When Corinne draws her model's fingers touching her genitals they are often not immediately obvious because they are essential elements of the composition. For example, in the second plate four fingers and a thumb part the pubic hair and labia and pull back the clitoral hood. Three oval fingernails outlined in black rhyme with the glans between them, as does a white oval outlined in black. Ten plates later, in a spare rendering, two fingertips are outlined with an economy that unifies them with the inner lips they touch. On the following page, Corinne makes the hand stand out: a thatch of dark pubic hair is interrupted by a hand descending from the top of the page; the index and middle finger lightly touch the labia. There is an unresolved tension in the composition between the dense hatch marks that render the hair and shade the area above the clitoris between the fingers and the contrasting white outlined hand. The hand gestures in these examples seem natural, as though the model has responded to the artist's request that she adjust herself to be seen more easily. They convey a sense of trust between Corinne and her subject that extends to the viewer.

Corinne's book undermines taboos against masturbation and lesbian sexuality. As the model touches herself, animated by the artist's assurances, the viewer is encouraged to replicate the gesture on her own body. Furthermore, the tactile experience suggested by the fingers' presence in the drawings is made tangible on the viewer's own hand when she picks up a crayon or marker and applies colour. Her hand makes idiosyncratic gestures and marks as she colours. As she does so, she inserts herself into the artist/model relationship recorded in Corinne's drawing, and establishes an imaginative relationship with the graphic image. These cunts want to be looked at, to be touched, to be the site of creative exploration. This lessens the distance between the viewer and the object of her gaze in order to create a queerly intimate viewing experience. Colouring the cunts may be taken for a metaphor for masturbation or lesbian sex, but it is also a sensually expressive activity with no stipulated outcome beyond the viewer's own satisfaction.

Opposite: Cover of The Cunt Coloring Book, 1975.

CUNT COLORING BOOK

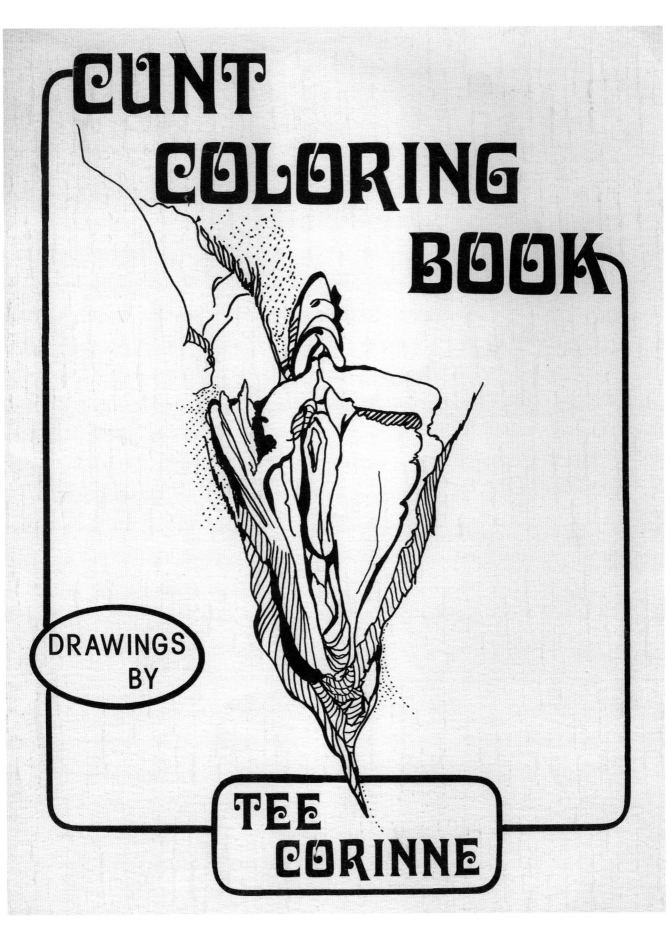

DRAWINGS BY

TEE CORINNE

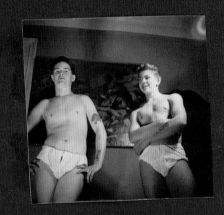
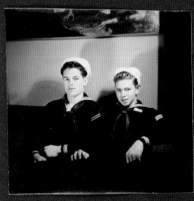

18. Henry's Albums

BARRY REAY

Some lives do not lend themselves to the accumulation of objects. The artist Henry Faulkner, who lived in New York in the 1940s and 1950s, and in Florida and Kentucky in the 1960s and 1970s, had a habit of acquiring (not always honestly) and then abandoning possessions. And yet many of his photographs survive, mementoes of a lost sexual history involving sailors, toughs, boxers, assorted hustlers, and — after the sexual revolution of the 1960s — hippies. His albums and their contents are scattered: the Kinsey Institute in Bloomington, Indiana, has 200 of Faulkner's photographs, but the Faulkner Morgan Pagan Babies Archive, a private queer collection in Lexington, Kentucky, has around 2000 more, including about 400 from the 1940s and 1950s.[1]

Henry Faulkner played a kind of cameo role in American queer history. He was a friend and roommate of artist Edward Melcarth and of Thomas Painter, who was one of sex researcher Alfred Kinsey's main informants on queer sex in New York.[2] He had a fairly fractured relationship with the playwright Tennessee Williams, who reputedly based his 1982 play, *The Lingering Hour*, on Faulkner. He also knew the writer James Herlihy of *Midnight Cowboy* fame. He gets a whole chapter in a not-very-queer memoir of visitors to a villa in that queerest of European places, Sicily's Taormina.[3]

Painter regaled Kinsey with stories of Faulkner's sexual exploits in New York in the 1940s and 1950s, including the fact that his address book contained up-to-date details for 500 male sexual contacts. 'Henry is a fellator deluxe, par excellence, by preference and great delight,' Painter wrote. 'He ... takes on groups of youths with gusto.' Rejected for service during the war, Faulkner still managed to have more sailors than he would have if he had been in the navy.[4] Painter and Melcarth marvelled at 'the steady stream of his trade coming up to be fellated, and the telephone ringing like the best whore house in town Saturday night'. But, as Painter told Kinsey, 'it is not his insatiable appetite so much as his incredible success, and the ease and speed with which he propositions anyone he sees — and gets affirmative results ... If he says he averages 7 cocks a day he will

Henry Faulkner appears in his scrapbook of photographs, New York, c. 1940s.

not be exaggerating at all. Twice as many at times, probably.'[5]

Faulkner was crazy about photographing his trade. In the page of pictures shown here, taken from an album dated 1949–50, he features in the large, dominating photograph on the left. He is dressed smartly, even formally, in a white shirt, tie and jacket. Smaller images of younger men, presumably sexual contacts, are positioned around the edges of the page. They are clad only in their undergarments, which is not much of a guide to occupation or social origins, but the picture in the far-left bottom corner reveals that they are indeed sailors.

The larger photograph in this chapter probably dates from the late 1970s.[6] We know it was taken in Faulkner's Key West home. His painting of a goat hangs on the wall, a reminder of his artistic prowess. Clothed but barefoot, he appears with seven other men, eight if the photographer is included. Where is the clothing of the undressed and half-dressed men? Have they come into a room not normally used? What were probably cover sheets for the furniture have been discarded: one is on the floor and the sailor with his cap on his knee sits on the other. It is tempting to see this as the beginning or aftermath of one of Faulkner's fellatory parties.

His preoccupation with sailors is well represented: one of them leans against the doorframe, incongruously clutching a doll, while others loll about. Faulkner was said to arrive home in Key West every morning, like the milkman, with a jeepload of young sailors: perhaps this was one such

A young Henry Faulkner.

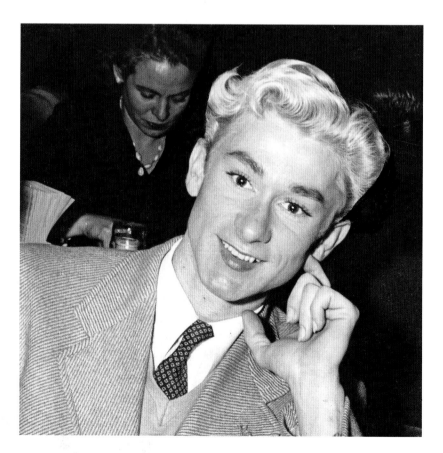

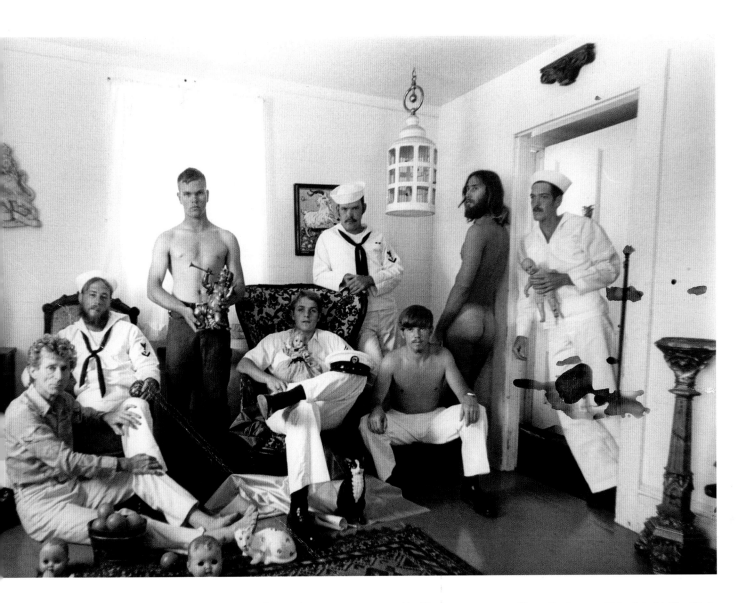

delivery.[7] A more recent interest also makes an appearance. Herlihy once observed that Faulkner identified strongly with the hippies' revolutionary spirit, especially in a sexual sense: 'he had all these beautiful young allies in his war against the status quo'.[8] Here the hippy is represented by the naked, long-haired, bearded man in the corner by the door. The photo also contains other, more curious elements: the bowl of apples seems out of place, while the large doll heads, empty birdcage and china cats add a Southern Gothic ambience. The crease on the bottom left of the print and the purple stain on the other side – is it ink or wine? – imply that the photograph has been passed around, that it has not had, so to speak, a closeted history. There is no doubting the image's queerness.

Henry Faulkner and friends in his Key West home during the late 1970s.

19. Sammy's Stud File

BARRY REAY

Yale University's Beinecke Library houses the archives of Samuel Steward, which include explicit Polaroids of group sex, a box of whips and other BDSM paraphernalia, plus Steward's notorious Stud File. This is a green metal box drawer containing typed A–Z file cards with coded details of hundreds of his sexual interactions.

The card file is not intrinsically a queer object. Scholars and students in pre-computer times routinely used index cards for bibliographical information, notes and rudimentary statistical work, and filed them alphabetically in metal or plastic boxes. Much like Samuel Steward's sexual contacts, these containers came in different sizes. Utilitarian rather than decorative, they were also employed by small businesses to file details on stock or customers.

I first heard about the Stud File many years ago from Laura Accinelli, a journalist friend in Oakland who recalled drinking martinis with Steward, in Berkeley, when she was a student there in the early 1980s. She met him several times and he told her about both the file and his links with sex researcher Alfred Kinsey. She urged me to follow it all up, but many years in fact went by before I actually held the file in my hands at the Beinecke.

Little about Steward is not already covered in Justin Spring's exemplary 2010 biography, *Secret Historian*,[1] but a brief context is required here, since Steward has played many roles in the queer past. He was a friend of Gertrude Stein and Alice B. Toklas. He swapped sexual partners, photographs and intimate recollections with photographer George Platt Lynes. He was a Kinsey Institute informant who was filmed having sex. He was an early practitioner of BDSM in Chicago, hence the whips, and he produced what Jennifer Burns Bright has termed a 'lived archive' of sadomasochism.[2] Under the name of Phil Sparrow, he became a tattooist, a job that gave him access to sailors and rough trade. He wrote about these exploits in journals for Kinsey. As Phil Andros, he was a pioneering writer of gay pornographic literature. He was also an imaginative user of the sexual potential of Polaroid camera technology: hundreds of his explicit black-

An undated placard for the Phil Sparrow
Tattoo Parlour.

and-white photographs still exist.[3] After his death Steward's archive was
consigned to a friend's attic until Spring facilitated its eventual procurement
by the Beinecke Library.[4]

Steward was already recording his sexual contacts before he met Kinsey,
but his documentary activities drew the researcher to Steward in the early
1950s.[5] In 1954, at the age of 45, Steward calculated that he had had 2200
sexual contacts, over a half of those since his late thirties.[6] Years later the
total approached nearly 5000 sexual meetings with over 800 different
partners.[7] He moved in a sexual world where 'trade', the sexually accessible
heterosexual, was an object of homosexual desire, and where large numbers
of working-class men might engage in what we, though not they, would call
homosexual sex. Hence Steward's recorded encounters with sailors, body-
builders and other various hustlers, as well as the working-class patrons of
his tattoo parlour. 'Norm ... came over, wanting me to do the silhouettes of
two dog heads for him, which I did, grumbling,' he wrote in 1955 in one of the
journals he kept for Kinsey. 'But then he paid for it by letting me give him a
blow job as usual. He continues to excite me – big and low-class as he is – and
a punchpress operator at Bell and Howell [a manufacturer of motion picture
machinery].'[8] Ironically, a publicity placard for Sparrow's (Steward's) tattoo
shop, the caricatured heterosexual promise of the busty redhead and the
muscled sailor – 'The Girls All Go For The Man With A Phil Sparrow TATTOO'
– may well have been the prelude to the customer's not exactly straight sex
with the designer of the lure and owner of the parlour.[9]

Steward's index cards represent his incessant sexual counting. On the
back of several he kept samples of the pubic hair of some of his lovers
as DNA reminders.[10] Unlike the monstrance reputedly holding the hair of
Rudolph Valentino, the samples on the back of the cards are unglamorous,
little clusters or strands underneath yellowing transparent adhesive tape.
But they stand in for absent bodies both desired and attained.

The apparent detachment of Steward's sexual encounters contrasts with
the permanency of his cataloguing.[11] Men are named in his Stud File: from
Anonymous to novelist and playwright Thornton Wilder. There are coded
details of the precise sexual acts and the number of encounters. Individual
index cards list daily or thrice weekly blowjobs, over many years, at $3
each, from a toothless provider, with breaks only when that man was in jail.
Steward had regular sex with hustlers and body-builders, $5 and $10 a time
with one favourite. Even the 29 daisy chains (group sex) were quantified,
the participants named and the events dated in precise detail, from 16
September 1949 to 24 September 1957. There are cards for threesomes
and for voyeurism. The file contains a key to the bodily dimensions of
his partners (long, short, medium, thick, thin, etc) and the type of sexual
activity engaged in (feet, trade, mutual, several mutual, browned, brown

and suck, masturbated, whips & sadism, ropes, games, and so on, and the intriguing category 'jackpot').[12]

Occasionally the cards are cross-referenced to Steward's journals and the latter provides details that build on the raw data shown on the card. For example, Bob Berberich, who has a place in the file, along with his hair, also features in Steward's journal:

> Early in the day, about one o'clock, while things were still dull, I looked up and there was Bob Berberich, having just come from a truckdrivers' union meeting, and all dressed up fit to kill: soft grey hat, pink necktie, grey suit. He came in; I drew the curtains and stood him with his back against Randy's trunk, and went down on him. He came rather quickly.[13]

In a long passage Steward contrasted the swish homosexual elegance of what he called a 'bitch party' with the slender, muscled, pale-skinned masculinity of the truck driver Berberich, whom he intended to blow after that social engagement. He imagined Berberich standing there with his 'cock uplifted' and hands behind his head, detached, fearful that, as Steward put it, 'some of my queerness will rub off on him', and he left with a handshake as soon as he had been satisfied. With his 'poor grammar, his limited view, his total and utter absence of "culture" in any form', he is 'the "pure trade" — no foolishness, very business-like and matter-of-fact. He comes to see me to get his nuts off, and there's an end on it.'[14]

In part the Stud File represents sexual archiving in the sense of sexual research — the Kinsey connection — but the index cards and other material traces of Steward's life were also mementoes of pleasure. The Giard photograph reproduced here, from Steward's later years, shows him seated amid such souvenirs, including, for the sharp-sighted, a hand-designed lampshade with male figures engaged in sexual congress. As Steward observed in a 1948 essay on keepsakes in, of all publications, the *Illinois Dental Journal*, 'Our pleasant or sad or gay memories revive when we touch these magic things, and for a little while we escape from the present into the golden past, where we lie bound, gagged, and deliriously drugged among our souvenirs.'[15]

The Stud File, with its catalogued sexual encounters and actual bodily remains, was a memory chamber for the erotic reliving of a personal past. However, Tim Dean has made even grander claims. He suggests we might see Steward's pornographic traces, including the Stud File, as part of an 'archive of presence', a queer archive, a 'memorializing of same-sex relations'.[16] If Dean is right, and I think he is, then we are a long way from a simple, green, metal box.

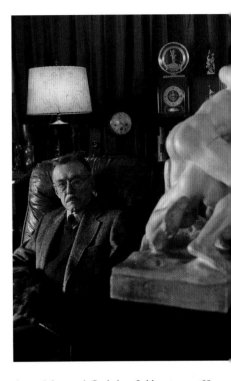

Samuel Steward, Berkeley, California, c. 1988.

Softee DONG™

8 INCH

PVC

DOC JOHNSON®

Softees, the incredibly soft and supple material that you can't stop touching, is now available in a compact 8 inch dong. Softees...in a variety of beautiful colors that are hard to resist.

- • 8 INCHES • SOFT TO THE TOUCH •
- • FIRM YET FLEXIBLE •
- • PHTHALATE-FREE BODY-SAFE •
- • PROUDLY MADE IN AMERICA •

 Perfect for any kind of play. Made in the USA. Phthalate-Free. PVC.

 Parfait pour tous les types de jeux. Fabriqué aux Etats-Unis. Sans phthalates. PVC.

 Geeignet für alle Liebesspiele. In den USA hergestellt. Weichmacherfrei. PVC.

 Perfect voor elk spel. Gemaakt in de VS. Ftalaatvrij. PVC.

 Perfecto para cualquier tipo de juego. Fabricado en EUA. Sin ftalato. PVC.

 Идеально подходит для любых игр. Сделано в США. Не содержит фталаты. PVC.

Socialize with the Doc
www.docjohnson.com/social-media

0255-01-CD
MR. SOFTEE LAVENDER
7 82421 55190 2

0255-02-CD
MR. SOFTEE BABY BLUE
7 82421 55200 8

Designed by Doc Johnson® in Los Angeles, California.

DOC JOHNSON.com

20. The Proverbial Lavender Dildo

ERICA RAND

This chapter concerns the proverbial lavender dildo — proverbial in the multiple senses of historic, famous and legendary. To people who remember its heyday in the 1980s and 1990s, it is all of those. To my much younger research assistant Grace Glasson, it was an unexpected relic, a queer oddity unearthed while working on a project for me. I'd been hearing rumblings among lesbians, dykes, queer women and other queerly gendered people of a certain age that sex and porn are different these days, more cock involved. Actually of various certain ages. 'What's wrong with fingers?' a thirty-ish genderqueer butch recounted lamenting with a friend, both plenty fond of cocks, after they had dated around with young twenty-somethings. I had some relevant anecdotes and memories myself, including from a recent stint on the editorial board of *Salacious*, which advertises 'radically sex-positive thought-provoking super-hot porn' and a queer, feminist and anti-racist mission. In the magazine, cocks figured much more prominently than I remembered from earlier porn with comparable politics.

So in 2017, when Grace was in her mid-twenties and I was in my late fifties, I sent her to the Brown University archives to study *On Our Backs* (*OOB*), a well-known sex magazine with the tagline 'Entertainment for the Adventurous Lesbian', which ran from 1984 to 2006. I asked her to look at the years 1990–95, when I'd subscribed to it, hoping to check my memory and meagre, haphazardly culled evidence. I hadn't expected the lavender dildo to emerge as a historical marker until Grace texted me from the archive: 'Apparently 90s dykes who are into dildos are into lavender dildos. Who knew.'

The lavender dildo mass-marketed today. Although the manufacturer Doc Johnson sells it as the Softee, the author bought it as Mr. Softee from DearLady.us.

The lavender dildo emerged in the era of the rabbit vibrator, far right, made famous by Sex and the City in 1998.

The text exchange between Erica and Grace.

Grace was definitely onto something. Consider an ad in the November/December 1991 *OOB* for 'a silicon dildo by Scorpio in lavender, cream or chocolate'.[1] The order of options suggests that lavender was a popular choice, and the ad bears multiple signs of editorial endorsement. A subheading in bold announces, 'Now you can wear the dildo and harness that Sharon Mitchell wears in SUBURBAN DYKES', referencing a popular 1990 lesbian sex video.[2] It also boasts the intimate involvement of *OOB* staff: 'Designed by On Our Backs based on office tests and consumer requests, this dildo's style and durability is the best ever (no veins!).'

Although parenthetical, 'no veins!' tells a lot about the history, context and appeal of the lavender dildo. Early feminist sex toy purveyors like Dell Williams, who started Eve's Garden in 1974, and Joani Blank, who opened Good Vibrations in 1977, did not want to sell dildos at first. They tried to promote clitoral orgasms, busting the myth that women – more precisely cisgender women – primarily climaxed vaginally. Who needed to insert something anyway and why did it have to look like a penis?[3] But eventually they responded to consumer demand. Williams collaborated on dildo design with Gosnell Duncan who, after an accident left him paralysed from the waist down, had been trying to design better dildos than those already on the market.[4] The ones Williams sold came in colours like pink or lavender. Blank warmed to dildos, too, partly through the encouragement of Susie Bright, *On Our Backs* co-founder and editor.[5]

The *On Our Backs* lavender dildo could signify feminist and lesbian desires in multiple ways. By avoiding a penis colour and improving on the penis shape, it worked against the myth that people with a clitoris need a penis inside them to orgasm – then phrased, with cisgender presumption, in terms of women needing men to orgasm. Lavender also had general queer associations and a radical feminist pedigree. Recuperated from its first infamous use by Betty Friedan in 1969 to describe the lesbian movement she felt was threatening mainstream feminism, the term 'lavender menace' continued to circulate as a shorthand for the radical potential of dykes and other queer people to disrupt heteropatriarchy.

The notion that lavender signifies a menacing queerness circulates still, as do lavender dildos, but not in the same contexts or with the same currency. The web retailer Dear Lady, which boasts 'over 3 million sex toys sold', markets a lavender version of the Doc Johnson Mr Softee Pastel Dong.[6] But feminist sex shops rarely carry them. A friend thought she had seen a dildo on sale at Toronto's Come as You Are, an 'anti-capitalist and feminist' sex shop, in its lavender version only.[7] She had remembered correctly. Worker-owner Jack Lamon told me that Come as You Are customers do not want lavender dildos; the distributor had mistakenly shipped two unordered cases, which the retailer discounted in an attempt to get rid of them.[8] A

worker at Nomia, in Portland, Maine, described the same lack of interest.[9]

What changed? How did lavender dildos, once sold primarily in feminist sex shops, relocate to the mainstream? The answer is partly, I think, that the lavender dildo always carried more fraught associations than my account of *On Our Backs*' enthusiastic endorsement might suggest. In a 1995 essay about the lesbian 'dildo wars', Heather Findlay recounts that many lesbians at the time rejected dildo use altogether, and not only for themselves. They argued that feminist and/or lesbian women did not, could not or should not want one.[10] Wanting one meant wanting maleness or masculinity, a penis on or in you, heteropatriarchal sex where a man fucks and thereby dominates a woman. Jill Posener told me a striking anecdote about how intense hostility to dildos could be. With Susie Bright she coedited *Nothing But the Girl: The blatant lesbian image, a portfolio and exploration of lesbian erotic photography*.[11] When the book came out in 1996, well-known lesbian artist Tee Corinne — whose work features in Chapter 17 of this collection — emailed the editors an itemised list of images with dildos and protested their prevalence. Even though she was a featured artist in the book, Corinne considered lesbian desire largely ill represented there.[12] In this context, as Jack Lamon put it, lavender was often a 'safe' choice as opposed to an exciting or beloved one. 'If you wanted to have strap-on sex (which was pretty subversive at the time) but didn't want anyone to accuse you of re-enacting oppressive heterosex, your dick better be an appropriate non-realistic colour. As such, there were a lot of lavender cocks kicking around our feminist sex shop.'[13]

There were also troublesome implications when it came to what we might call racial non-content. A white friend remembered lavender dildos as 'anti-racist' which, from some perspectives, makes sense. Anti-realist colours side-stepped white-designating ones, including what Bright called 'DOA Caucasian'.[14] As with stockings or bandages, Caucasian colours sometimes circulated as the normative or only option. But avoiding an approximation of one's skin tone might have different implications for those whose skin made them an object rather than agent of racism. In 'What's Race Got to Do with It?', a 1991 editorial for the black lesbian erotic magazine *Black Lace*, Alycee J. Lane recounts that a friend seeing her mauve dildo screamed, 'Eeek!! What *race* issues do you have???'[15] When Lane tried to buy a brown dildo at a 'well-known, respectable sex shop' to photograph for the magazine — 'what would women think, seeing this used mauve dildo strapped to brown thighs? Honey, *please*' — the 'flesh-coloured' ones came in white-person, ordinary size only. There were no insertable sized dildos in brown, and the salesperson could direct her only to a box of two-foot-long '*monstrosities*' marked 'Big Black Dick'. What was missing and what was available — which did not include a Big White Dick counterpart — point to the fetishising of black cisgender men as outsized, hypersexual, exotic and dangerous. In

discussing Lane's account of this incident, Kai Green writes that 'Black lesbian sex toy shopping was not just about a sex act; it was also political, entangled with capitalism and labour. The black or brown dildo was not just a dildo; it could not be detached from the black body ideologically, the cisgender stereotyped mandingo figure.'[16]

Although no single cause explains the decline of the lavender dildo, its diminished presence among feminist sex-product purveyors today often comes with a rejection of judgement and shaming about dildos and a proactive commitment to, as the store Come as You Are puts it, people of 'diverse genders, orientations, sexualities, and life experiences — rather than just one person's idea of what sexuality and sex products should be about'.[17] The one business I found that prominently features lavender dildos, although labelled 'purple', supports this correlation by contrast. Wet for Her was founded in 2009 to provide sex toys created by and for lesbians. Advertising 'unique 100% lesbian certified products for lesbian couples', the company's vision and products, like a lavender finger-extender dildo, might seem to harken back to the *On Our Backs* ad. But in 2018, with broader recognition of support for queer, trans and gender-nonconforming embodiments and identities, the company's self-description and name, doubling down on the female with a traditionally female-gendering pronoun and common slang for vaginal lubrication, might also be seen to suggest a biologistic gate-keeping around femaleness, lesbianism and partnering.

Genitals do not make gender identity. People with clits and vaginas are not always female. Women and lesbians sometimes came into the world with cocks. Some retain, acquire or enjoy them in flesh, silicone or other materials; they may call themselves 'wet' or 'hard' regardless of what their physical bodies have on offer. Then again, we should neither count out the lavender dildo nor cement meanings to it. Like dildos and cocks, meanings can be detached, tucked away, adorned, repurposed and differently embodied. Besides, shades of purple continue to please. Back at *Salacious*, where my inquiry started, there is a hot touch of lavender around the edges of that dildo on the home page going right into a happy mouth.[18]

One of five rotating images on the home page of Salacious Magazine, a queer feminist anti-racist sex magazine. This is a detail from face-fucking is one of our favorites, a 2010 drawing by KD Diamond.

❧

Opposite: The proverbial lavender dildo as advertised in a prominent lesbian magazine On Our Backs, November/December 1991.

Celebrate Sex!

Give her a special gift of lust and love.

Now you can wear the dildo and harness that Sharon Mitchell wears in SUBURBAN DYKES!

Silicon Dildo

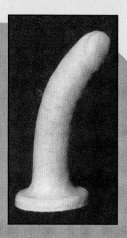

Finely crafted silicon dildo by Scorpio in lavender, cream or chocolate. Optional style: wavy dildo (pink only). Designed by On Our Backs based on office tests and consumer requests, this dildo's style and durability is the best ever (no veins!). Measures 7″ long by 1 1/2″ in diameter. Fits harness below.

Dildo (Specify color and style) $39

Texas Dildo Harness

Stormy Leather's most popular all-leather dildo harness adjusts to any size. Comes in black or purple and is ready to go!

Harness (Specify Color) $42

Lesbian Erotic Talk Tapes

Erotic Audio's ability to arouse your clit may surprise you. Our selection of tapes at such an affordable price is a fun treat before bed, in the car, at parties or anywhere you go with your walkman.

- •Be Dawn's First Woman
- •Come Play With Us
- •Be My Good Bottom
- •Black Leather Dykes
- •Lipstick and Lace Femme
- •Hot Woman For Hire
- **NEW**
- •Let Me Watch You Do It

Talk Tapes (Specify Titles) $7.49 ea.

Safe Sex Kit

Latex love! Like other forms of erotic dress up, eroticizing safe sex is fun! The kit comes in a black bag and contains 10 condoms, 10 gloves, 10 finger cots, 10 dams and 5 lube pacs. Put the risks, denial and old-fashioned attitudes away and LOVE SEX. BE SAFE. USE THE KIT.

Safe Sex Kit .. $19.95

Back Issues Collector's Volume

Hours of exciting reading and beautiful women, all at a great value. Stock your bedside with a long-lasting supply of rare lesbian erotic material.

The ABC's of fisting •Innovative sex toys • Gay Day Bikers • Pleasures of public sex • Leather gang bang • Enjoying gay men's porn • Tantric orgasms • Lesbians with AIDS • Bisexuals • Sexy at sixty pictorial • What butches want in bed • Love in a wheelchair • Dildo ettiquette • How to pierce your nipple • Gay girl's guide to phone sex • Lusty pictorials, sexy fiction, entertaining and informative columns in each issue.

Collector's Volume (19 issues) .. $75

Susie Bright's Lesbian Sex World

Hang on world! There's a hurricane of steamy sexuality headed your way by the woman who helped put lesbian sex on the map! This compilation of Susie Bright's Toys For Us columns from On Our Backs will make you laugh, make you cry, make you think. A must have!

Sex World $9.95

Julia called herself a "roller" and hung out in a few working class bars on the west side. Several of her boy friends were west side hustlers.

JF 1999

21. Amos's Chair

BARRY REAY

Amos Badertscher has been photographing queer Baltimore since the 1960s, cataloguing the lives of male sex workers and their girlfriends, 1990s club life, trans history, crack and heroin addiction and the impact of AIDS. His is the largest extant photographic record of the short lives of hustlers that I know of. After labouring for years without any sort of recognition, Amos enjoyed a brief period of academic fame with the publication of Duke University Press's *Baltimore Portraits* in 1999. Then in 2016 his work featured in an exhibition titled 'The 1970s: The blossoming of

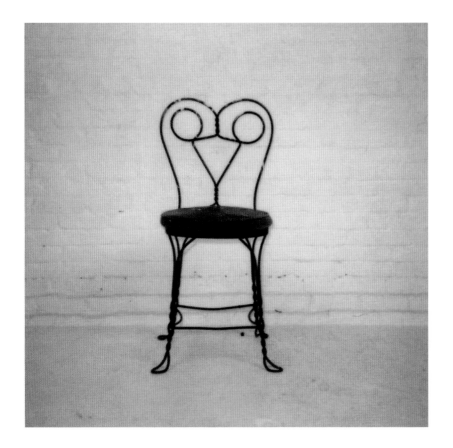

Opposite: Julia, 1999.

∾

A polaroid of Amos's chair, 1960s.

a queer enlightenment' in New York's Leslie–Lohman Museum of Gay and Lesbian Art, where much of his collection now resides.[1] But he could not exactly be described as famous. When my colleague Branka Bogdan and I first visited him in his studio we noticed the wire chair that features in so many of his photographs. Branka photographed me sitting astride it.[2] This chair has accommodated many a derrière of varied gender identity and has presumably been involved in diverse sexual scenarios. What was its place in the photographer's project?

Actually there are two identical chairs, and their history is bound up with their owner's. Amos purchased them in the 1960s when an art teacher friend said that his first apartment badly needed a couple of chairs. He went shopping with his mother and persuaded a furniture dealer to sell him items from his own house. 'The chairs were snatched from the kitchen of the furniture dealer's wife. She squawked but a sale overruled everything.' Amos took Polaroids of his new acquisitions, faux art catalogue style, chairs 'masquerading as art', as he describes them.[3] The photographer then slowly discovered the furniture's versatility: 'they were handy, could be easily covered with a white sheet, were minimal distraction. I was not interested in chairs but only the model. I sat on them as much as my models did. It was all dictated by Fate.' Amos recalled hustlers smoking dope while sitting on them and Polaroids of an explicit sexual nature that peripherally involved them. But he thought the chairs had not really been involved in too much sexual action: 'there were a thousand other places for sex better than these chairs'.

These are ice-cream parlour chairs, objects found in the drug stores of Amos's childhood. Surely it would have appealed to his subversive nature that objects so much a part of 'American folklore' and associated with 'kids and drugstores and old people', would contribute to the mise-en-scène for such a queer project. The queerness of the object is heightened by the purity of its original associations: Mom-and-apple-pie, traditional wholesomeness meets paid sex, drug culture, BDSM and a very queer incarnation of Batman.

It is true that the chairs do not appear in all of Amos Badertscher's work. In the early days of his photographic life he lived near the Hippo, Baltimore's famed gay club, and also the Mount Vernon meat rack, where young men waited for a trick. After evenings out with hustlers they would stay overnight and Amos photographed them in the morning in the natural light of the window. Later, when he moved house, the chairs came into their own in the studio and darkroom in his basement where he used artificial light, white backdrops and mirrors. In the early 2000s they were used less when he turned his attention to the disused and decaying areas of post-industrial Baltimore. Instead, under freeways and in urban wastelands, Amos used debris, abandoned sofas, industrial relics and miscellaneous cast-off homeware as props. Still, the chairs are almost as iconic to his work as the

Barry Reay in Amos Badertscher's studio, June 2016.

❧

Opposite: Billy, 1997.

abandoned by his mother. He has survived in a world of abuse and absolute neglect. Billy is frequently homeless plus endless

Billy probably didn't know his father and when he was very young,

problems with alcohol and heroin - in and out of rehab. In august of 1998 he was serving a sentence for prostitution and other offences. He does each day whatever it takes to survive.

1997

handwritten text around his black-and-white photographs.

'Billy 1997', a photograph of one of the young men whom Amos paid for sex or just to pose, is part of a portfolio that includes the post-AIDS and post-crack-cocaine generations. The young man is wearing boxer shorts and his unclothed chest reveals a tattooed torso. He grasps the photographer's thighs as Amos captures their pose in a mirror, simultaneously turning the camera on the viewer. No detached, hidden presence, Amos is frequently present in his photographs, naked apart from his camera and footwear, entwined with his subjects and reflected back to the viewer. The chair in this image is put to good use, seating both the cameraman and his subject. Amos's text tells the brief life histories that add to the force of the visual representation and form an integral part of the photographic affect. The written border on this artwork says: 'Billy probably didn't know his father and when he was very young, abandoned by his mother. He has survived in a world of abuse and absolute neglect. Billy is frequently homeless plus endless problems with alcohol and heroin – in and out of rehab. In August of 1998 he was serving a sentence for prostitution and other offences. He does each day whatever it takes to survive.'

The young hustlers appealed as ostensibly straight men who were homosexually available – although, in retrospect, their photographer has often pondered their queerness. They were young men with girlfriends, some of whom also hustled to survive. Textual references to a sexual interest in women, or even photographs of girlfriends, reinforced what Badertscher once termed an 'aura of straightness'.[4] Naked male flesh and homoerotic interaction combined with heterosexual sex, and female bodies anchored desired males to their required straightness – yet queerness still lurked.[5] But there was more to Amos's female portraits than supplementarity. He was genuinely attracted to female androgyny. 'Julia 1999' is not a picture of a female sex worker: as the picture's text tells us, she had boyfriends who were hustlers. The boots, socks and open jacket highlight her nakedness while the tilted cap, the posture of her head and the accentuated jaw all indicate an attitude of independence. The leather might also signify queer sex. The chair offers nothing in the way of concealment, conveying an image far removed from its ice-cream parlour origins. To add further insult, an American flag lies discarded on the floor.

The final image, 'Fred B. Merry, 1997', conveys a different aesthetic. Merry was a Baltimore lawyer whom Amos met in a gay bar on the 'Block', the name given to 'a large collection of strip clubs and sex book galleries, random prostitutes, dancers and B-girls and bouncers'.[6] The lawyer, who for some reason reminded the photographer of the *Iliad*'s Nestor 'in drag' – presumably because of his age and wisdom rather than his warrior past – had a shoe fetish and liked to dress as a rather queer, decidedly unmuscular,

high-heeled Batman, who wore suspenders and women's stockings. He seems more Batwoman than Batman, though the comic book female character was in hiatus during the 1990s. As Amos explains, 'in front of my camera he insisted on wearing a mask to ensure anonymity and I guess this is "Batman", his favorite maquillage. He had a large collection of black shoes with heels impossibly high on which he was wobbly.'[7] Another of Amos Badertscher's photographs, not included here, shows Merry with a pile of his shoes. In this photo, however, he is reclining. The black crispness of his costume and its accoutrements is accentuated by the whiteness of the sheet over the chairs and the white painted walls in the background. The lack of any framing reinforces the starkness of the imagery, forcing the viewer to focus, undistracted, on the central figure. And our queer object reminds us of its hidden presence with the metal frame revealed by the slipping sheet, a chair striptease.

Fred B. Merry, 1997.

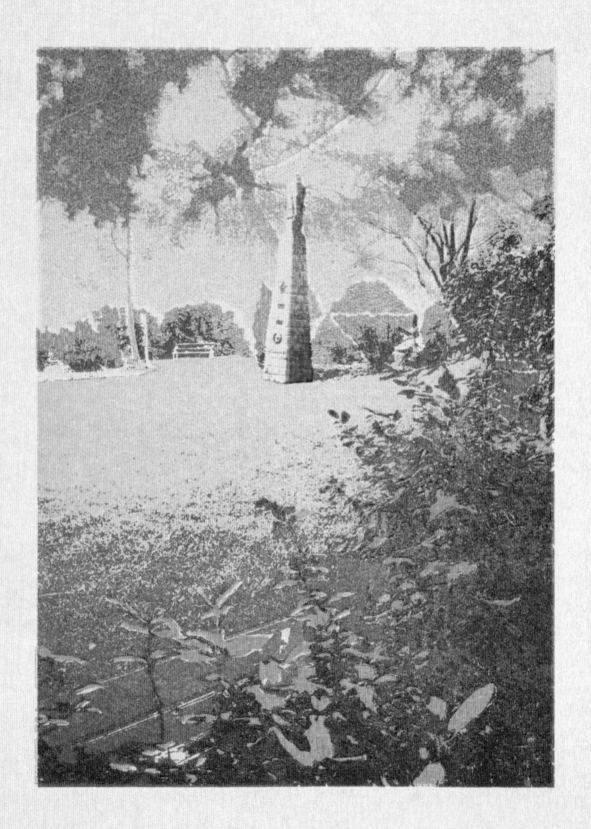

22. Cruising Masculine Spaces

JUDITH COLLARD

[habit@t] is a print installation by Neil Emmerson that challenges ideas about masculinity and plays with notions of space and location. Emmerson uses the interior space of the Newcastle Art Gallery in New South Wales to evoke the nearby Civic Park, and he deals with secrecy, codes and insider references that need explanation even though they seem to be self-explanatory. On the surface *[habit@t]* is innocuous but its meaning is subversive.

The work consists of 21 combination woodblock and lithographic prints conventionally framed in a gallery with a window overlooking Civic Park. At the edge of the park sits a memorial dedicated to Australian servicemen who died at war, an obelisk surmounted by an eagle. Emmerson's images show an identical landscape scene depicting the obelisk framed by shrubs and trees. They deliberately invoke the repetitions found in Monet's impressionist paintings: the *Haystacks* series of 1890–91 or *Rouen Cathedral* from 1892 to 1894. They also tell of the postmodern fascination with the serial: Andy Warhol's series of screenprints of Marilyn Monroe or Elvis from the early 1960s. The series also references the tradition of repetition embedded in the conventions of printmaking. Each print is presented in a range of different hues; the colours change even though the imagery remains the same. Ross Moore has described these as 'a heady polychromy of poisonous pastels'.[1] The palette in each print is restricted to three colours, the result ranging from soft essays in yellow and green to more intense combinations of blues and reds; they vary in tone from hyper-sweet sentimentality to brooding darkness. The prints also evoke the shifting qualities of light over a 24-hour period. The sequence provides a formalist essay on the visual language of printmaking, exploring the impact of different values of colour on perception.

A straight reading of the work, with its formalist play, provides the

One of 21 prints from Neil Emmerson's [habit@t] series.

seasoned gallery visitor with an aesthetically pleasing sense of recognition; the work nods to the history of art. At the same time, the installation deliberately toys with the differing expertise of its audiences and their relative levels of insider and outsider knowledge. As soon as one enters the gallery the formalist subject matter of the work is undercut by a soundscape that disrupts the pristine purity of the white space. A looped tape combines ambient noises recorded in the park over 24 hours: traffic, the bats in the Moreton Bay fig trees and the sounds of men moving through the bushes. These are juxtaposed with music drawn from gay porn movies of the 1980s and 1990s. This recording immediately signals that Emmerson's work is not as straightforward as it seems.

The ostensible subject of this work — an obelisk in a park — is not in fact the subject at all. Instead Emmerson brings into the gallery the hidden lives experienced in the spaces outside. This Newcastle site is a beat where men cruise, that is, search for sexual partners. The work is a sly nod to other gay men in the gallery, communicating to them through the formal trope of a generic subject of a structure in a landscape. In an earlier series, *IWYS (I Want Your Sex)* from 1998, Emmerson explores a similar theme.[2] He uses

The Beverly Hills toilet that George Michael made famous.

the image of the Beverly Hills toilet block where singer George Michael was arrested for performing a 'lewd act'. Michael's fame as a musician meant images of this toilet block were broadcast around the world.[3] The toilet is disguised, blending into its suburban neighbourhood; it is built in the form of an adobe-style modernist suburban house in a garden setting usually associated with the nuclear family. It even has a driveway leading up to it. The domesticity of the space is made even more appealing to those in the know because what takes place here is an inversion of that image. It threatens everything this building seems to promise: this is a place where husbands can go to have sex with men.

The theme of secret knowledge and gay signs recurs in Emmerson's *[habit@t]*. In his 'Artist Statement' for this exhibition, Emmerson, writing in the third person, ends his text with an extract taken from an essay by D.A. Miller: 'Secrecy can function as the subjective practice in which the oppositions of private/public, inside/outside, subject/object are established, and the sanctity of their first term kept inviolate. And the phenomenon of the "open secret" does not, as one might think, bring about the collapse of those binarisms and their ideological effects, but rather attests to their fantasmatic recovery.'[4]

A shoe in the gallery.

An abandoned shoe lies on the gallery floor close to the low seating provided for visitors. It is a brogue, a formal male shoe of the kind worn by civil servants and other white-collar workers. Emmerson found the shoe while making recordings in the park over three days.[5] It acknowledges the visual street codes of the type explored in Chauncey's *Gay New York*, an

examination of the sites and fashions of male homosexual life.[6] At the same time this unclaimed shoe provides a reminder of the subterfuge and risk inherent in seeking anonymous sex in sites such as Civic Park. As well as loss and flight, the abandoned shoe evokes possibility. It recalls the promise found in fairy tales such as Cinderella, and figures such as Dorothy in *The Wizard of Oz*.

Public gardens are contentious sites. In cities they are places where you can take a friend or lover when you have nowhere else to go, to be alone in public. Many gardens were founded on high ideals, to provide civilising spaces and a healthy green respite from the noise and grit of urban life. Although their founders saw them as vehicles for conservative social reform, some — including Frederick Law Olmsted who designed New York's Central Park — had trouble reconciling their genteel visions and the uses the public wished to make of these spaces.[7] In his essay on 'The Recreational Spaces in Worcester, Massachusetts', Roy Rosenzweig wrote about the clashing expectations of working-class and middle-class cultures. He focused on Elm Park, in 1854 one of the first areas in the United States set aside as a public park. Here two contrasting uses of public spaces collided. Some desired a quiet and peaceful setting with its 'Keep off the Grass' notices, but others wanted to play sport and use these places more actively.[8] The policing of parks also revealed their other uses. In Piedmont Park in Atlanta in the early 1950s, for example, the lighting set up to contain and control the behaviour of heterosexual couples parking in cars also flushed out homosexual uses of the space.[9] Parks and gardens have resonated with sensuality.

Historically the lives of gay people were more likely to be played out in public. This was especially true of those still living in the family home or in communal spaces: colleges, group houses, apartments or boarding houses. Their lack of privacy restricted their options, but in this gay people were not alone. Working-class life was also a life of the street. Chauncey has traced the interactions of gay and working-class people in New York during the early decades of the twentieth century, and he underscores the importance of public spaces in their lives.[10] Like New York, Newcastle is a port city with a large working-class presence. Its port is vital to the region's coal-mining industry. Civic Park, like many such public parks, was a venue where the range of workers in the city — public servants, tradesmen, dockworkers and sailors — could meet up and embrace the possibility of sex, romance and community.

Newcastle's war memorial is layered with meaning. On the one hand it is a tribute to the dead who have come to represent a heroic masculine ideal of service and sacrifice. Every year on Anzac Day, 25 April, a commemorative service is held here, as at other memorials, to remember all war dead and especially the Gallipoli campaign of World War I, when

soldiers from the recently formed Commonwealth of Australia fought alongside New Zealand and British troops.[11] As a place of remembrance this is also a feminised space, a civilising garden created as a focal point for the grieving women who lost husbands, son, lovers and brothers. War memorials frequently list the names of local men who died and, as Andrew Stephenson has demonstrated, the language of commemoration and the environments created for this purpose were directed to the bereaved, usually women, even though such places quickly became well known as beats.[12] The symbolically complicated site of the war memorial is subverted by the homoerotic encounters that take place there.

Even the techniques used to create the image allude to Emmerson's layering of interpretation. The prints combine woodblock printing, the surface of which brings out the graininess of the wood, and a layer of photographic lithograph. The photograph itself, with its association with truth and truth telling, contrasts with the romantic, almost-too-sweet rendering of the colours. The treatment of this scene, with its references to art historical explorations of landscape and colour, tells us little about the real subject of the work. Although the prints draw on the cultural and aesthetic meanings of art history to create a work satisfactory for general consumption, the subject matter remains hidden from those not in the know. Emmerson has created a coded site recognisable only to the initiated who can read its private signs. He brings into the space of the gallery the open secret of queer presence.

The gallery overlooking Civic Park.

❧

Opposite: The war memorial in its grassy setting.

23. The Stuff of Cruising

JOHN HOWARD

Ten years in the making, my documentary project *Cruising Ground* examines queer terrain – contested, hard fought, maintained.[1] Queer cultures of cruising have long re-appropriated communal lands around the world, but outdoor recreational sex sites proliferate in Iberia, thanks to warm weather and post-dictatorship nudism.[2] The digital colour photographs presented here depict ordinary outdoor areas repurposed for sexual pleasure. Busy on recognised holy days, when family gatherings often exclude queer kin, the spaces are collectively secured for sexual communion. My project references the Gregorian calendar and Catholic saints and commemorates the dangerous desires of dissident sexualities over time. The images illustrate the stuff of cruising: material artefacts of bodily intimacies. They attempt to reveal customary procedures, agreed practices, polite comportment and rowdy disruptions. Shot across all 17 autonomous communities of Spain and beyond, the photos document alternative rituals in conflict with orthodox traditions.

Skilled photographers have captured queer cruisers in action since the 1970s, if not earlier. They include Kohei Yoshiyuki, who produced a series on Tokyo parks at night, and Alvin Baltrop, who depicted New York piers by day. Daring and audacious, the two projects broke new ground in elite realms of art photography. Despite their radical differences – from each other and from my own work – they inform and influence *Cruising Ground*.

Initially 'shocked' by sex in city parks after dark, Yoshiyuki utilised infrared technology to expose heterosexual trysts and homosexual hook-ups.[3] His photos of men having sex with men are segregated in the second part of his photobook; they are entirely long shots that signal a clear distance from, if not a fear of, his homosexual subjects. These explicit portraits, taken with no one's permission, constitute a photographic archive of anonymous bodies exposed, clothes dishevelled and queered objects on shocking display. Alvin Baltrop, by contrast, was part of the queer cultures he documented. Baltrop created warm individual, dual and group portraits of men of all colours sunbathing, chatting, looking for and having sex. As an insider's 'archive of feelings', his compendium of photographs documented

The cruising ground at Arraijanal, Guadalmar, photographed on St Valentine's Day in 2010.

community rituals and consensual sex.[4] Scholar Fiona Anderson suggests that derelict waterfront buildings along the Lower West Side piers enabled queer cruising and emboldened queer artists like Baltrop.[5] Reversing the stark exposures of Yoshiyuki's dark parks, which yield scandalised flash-white figures on black grounds, Baltrop snapped black-and-white images with available daylight. He honours the pier queers in all their individual particularity and group solidarity as they pursue myriad pleasures.

Although Yoshiyuki highlights human interaction and sexual intercourse, and park grounds, shrubs and trees are of secondary interest, his photobook cannot help but illuminate benches, handbags, shopping bags, umbrellas, handkerchiefs, fenced perimeters, distant city lights, blankets laid down, newspapers spread out and improvised tree-stump seats that facilitate blowjobs. For Baltrop, the piers' abandoned buildings are important props. Crumbling architecture creates or obstructs sightlines and large holes in walls produce crucial shortcuts. My own photographic project adopts more naturalistic full-colour imagery and tries to pay closer attention to the material culture of cruising in smaller cities, towns and rural spaces.

My project began in Andalucía, on a 1.3-square-kilometre landscape

Crow Mountain, Longroño, photographed on St Josemaría Escrivá Day, 2011.

between Málaga and Torremolinos that has held out against the forces of development. Flat and sparsely vegetated – bounded by a golf course to the south, suburbs to the north, coastline to the east and highway to the west – the tract is not a roadside rest stop reclaimed late at night, a rural 'equivalent' of the congested city's repurposed park. Rather, it is a 24-hour, seven-day sex scene situated on under-utilised private property. Construction was halted and the land left idle after Roman ruins were discovered there. With its conceptual link to archaeology, my project first looked down at the discarded packaging of Christmas Day 2009, then at a hectic wet-sand intersection on St Valentine's Day in 2010. Following in the footsteps of Opus Dei founder Josemaría Escrivá, I too had an epiphany in Logroño, on Crow Mountain, where I discovered an illegal dumpsite's unexpected beauty and queer ingenuity: a cast-off mattress perfectly placed in a clearing in such a way that a car parked alongside would shield the alfresco bedfellows from view. Those who cruise in the lightly trafficked countryside wait longer than those who 'loiter with intent' along the busy city piers.[6] They can more fully contemplate the natural, built and ruined environments. Thus I noticed the significance of the tyre-track traces which, like the criss-crossed tracks of Andalucía, imply whole worlds of queer bliss.

Valencia, Spain's third most populous city, is much smaller than London, New York or Tokyo, but nevertheless generates queer critical mass, including numerous cruisers who come together at the juncture of the Royal and Turia gardens. My photograph from the latter, taken on Three Kings' Day in 2011, records a lamp-post graffito of uncertain origin, translated roughly as 'Here you meet / here you fuck / here you suck / until the grave'. Like toilet stall scribbling or cruising app geo-positioning, this rhyming quatrain suggests 'you' have arrived: for good or ill, you've found the place.[7]

We know queer cultures often survive and thrive by re-appropriating unloved perilous places, nuclear wastelands as well as the Crow Mountain garbage dumps. At the site of 'the worst nuclear weapons accident in history', on the beach where American servicemen amassed their radioactive rubbish and where queer communities have gathered for decades since, I met Alejandro.[8] At the far end of this low-budget nudist beach, under cover of low trees, surrounded by used tissues, condoms and wrappers, Alejandro is well prepared for fun, and his arrangement of accessories shows forethought and deliberation. He has unrolled his rattan matt and stripped off, shirt and shorts at left, taking from his backpack two essential items: a tube of lube and a roll of toilet paper. His old-rugged-cross tattoo, long since faded to dull blue, is superseded by his erect nipples and – fantasy of fantasies, frozen by the camera click – his perpetually erect dick, now and forever more. Amen.

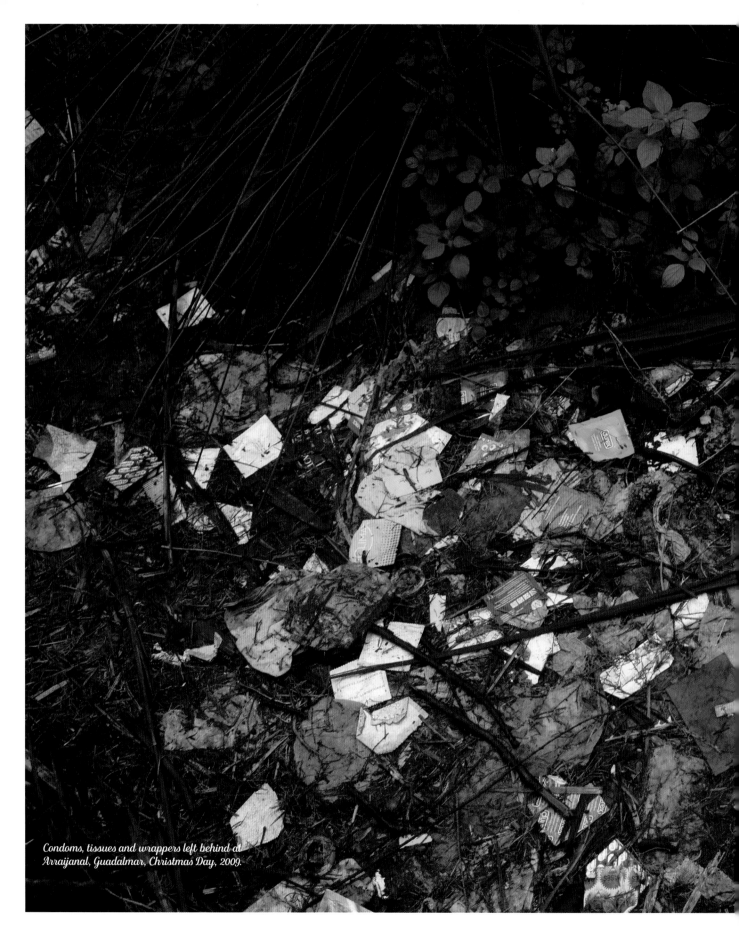

Condoms, tissues and wrappers left behind at Arraijanal, Guadalmar, Christmas Day, 2009.

Bringing radical utopian visions of gay casual sex back down to earth, theorist Richard Hornsey finds liberating relational possibilities in 'awkwardness':

> an unstable, uncomfortable, but typically goodwilled negotiation in which biography, tastes, and political opinions are maneuvered in line with a constantly changing set of perceptions ... Friendly but ultimately indifferent, the participants inhabit a certain mutual insincerity even as their words and actions express a real, if expendable, desire to be together. The transient terms of this relationship, if it is to work, demand a certain type of lying.[9]

Among lies of omission in the contest of wills between this portraitist and Alejandro, his subject, was a refusal, on either side, to discuss the region's history of plutonium contamination. A pleasurable here and now overrode it, suggesting that even the dirtiest, deadliest sites may not impede queer desires but instead advance them, however worrisome the implications.

In crisis-era Spain the home-leaving age is high and household size large. Few have a room of their own. Cruising grounds therefore constitute both a societal safety valve and a crucial site of sexual initiation, experimentation, queer communion and perhaps liberation. Awkward kindnesses – sharing tissues, mentioning neither radiation nor condoms – create a physical co-presence rife with possibilities: the more the merrier. To better position a

The cruising area at Turia Gardens in Valencia, Three Kings Day, 2011.

tree-trunk stool, to lay out a rattan matt, to offer lube, perhaps to inscribe a lamp post: all these acts mobilise queer objects in order to claim space for queer pleasure.

Attuned to the documentary genre's problematic truth claims and reality effects, its often undisclosed processes of selection and emphasis, this project nevertheless asserts the importance of photographically recording cruising grounds (following Yoshiyuki, Baltrop and others) while expressing my own political and aesthetic impulses.[10] As becomes apparent, outside the metropolis, and depending upon the weather, cruising grounds offer a range of experiences. These include long solitary walks and waits, enjoying a picturesque view or wandering disconsolate in filth. Some spots become so heavily frequented they reproduce the ruthless competition and choosy hierarchies of urban for-profit venues, queer or straight. But just the right number and assortment of people can enable an egalitarian environment of ecstasy. The accumulated detritus is a tribute to crafty collectives that refashion wastelands into pleasure gardens.

Alejandro at Palomares Beach, October 2014.

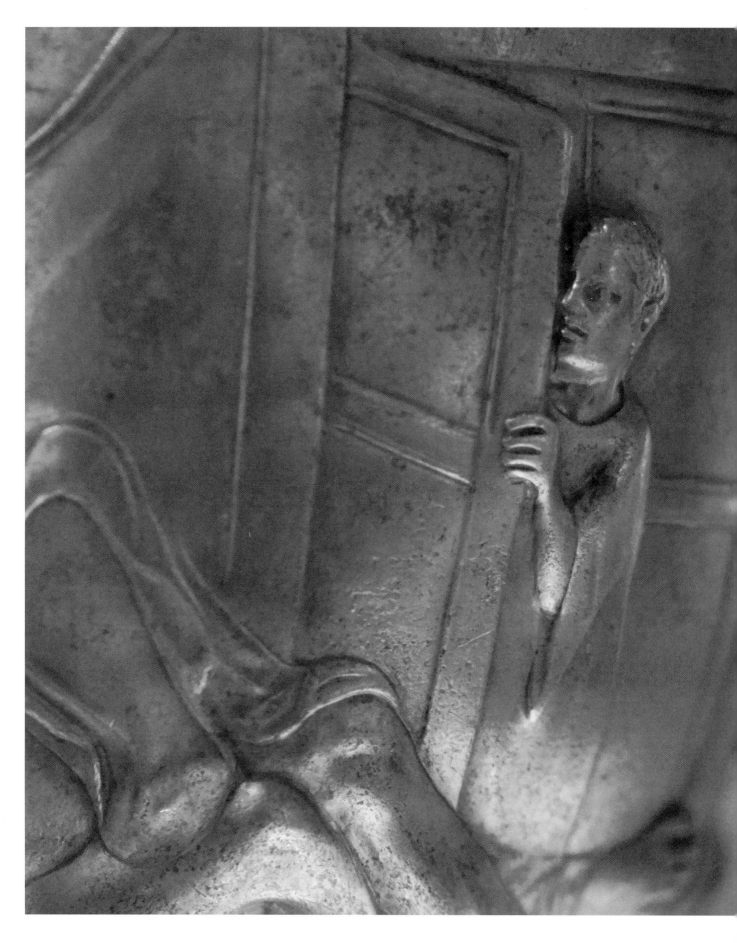

24. The Warren Cup

CHRIS BRICKELL

The Warren Cup, a Roman artefact 11 centimetres high, was probably made as a special commission for a private buyer at some time between AD 5 and 15.[1] An inner lining of silver was bent over at the top to form the lip of the cup; a foot was made separately and then soldered to the cup's base. A silversmith used a small hammer to fashion its elaborate decoration, working from the inside of the cup. The item has taken a bit of a battering over the years. Originally it had two handles, both of which are now missing, and the noticeable lean may have been the result of a cleaning accident: the bottom of the cup was pushed down into the foot.[2]

One side shows a bearded figure and a youth aged around 17 or 18 engaged in anal sex. The younger partner hangs onto a strap for support as he lowers himself onto his partner. A young slave appears to the right of the scene and gingerly opens a door into the chamber. The scene on the other side shows a youth aged about 16 and an even younger boy of 12 or 13, also in a sexual embrace. Both encounters are accessorised by a range of objects that suggest a cultured setting: furniture chests, a lyre and rich draperies.

The cup is something of a puzzle. Roman sexuality is widely presumed to have been hierarchical: older men were the insertive partners and women, boys, younger men and those who were not free citizens – including slaves – took a receptive role. Social rank, not gender as such, was the basis of Roman sexuality. The passive partners in this instance may or may not have been young slaves, but either way the cup's scenes are far from stark expressions of brute hierarchy.[3] Classical scholar John Clarke remarks that the artist renders 'the male who is in the receptive position as dignified and attractive as the insertive partner'.[4] Dyfri Williams goes a little further when he suggests 'the overall effect ... is one of gentle, restrained pleasure – civilized and calm – and of understanding and experience'.[5] There is certainly a degree of tenderness: the younger partners, for instance, clasp hands.

Williams considers that the artist imagined the figures to be Greek rather than Roman, since the garment and lyre are Greek in style. Perhaps the cup's scenes depict not the citizen–slave relationship but the Greek distinction

Opposite and following pages: The faces of the Warren Cup.

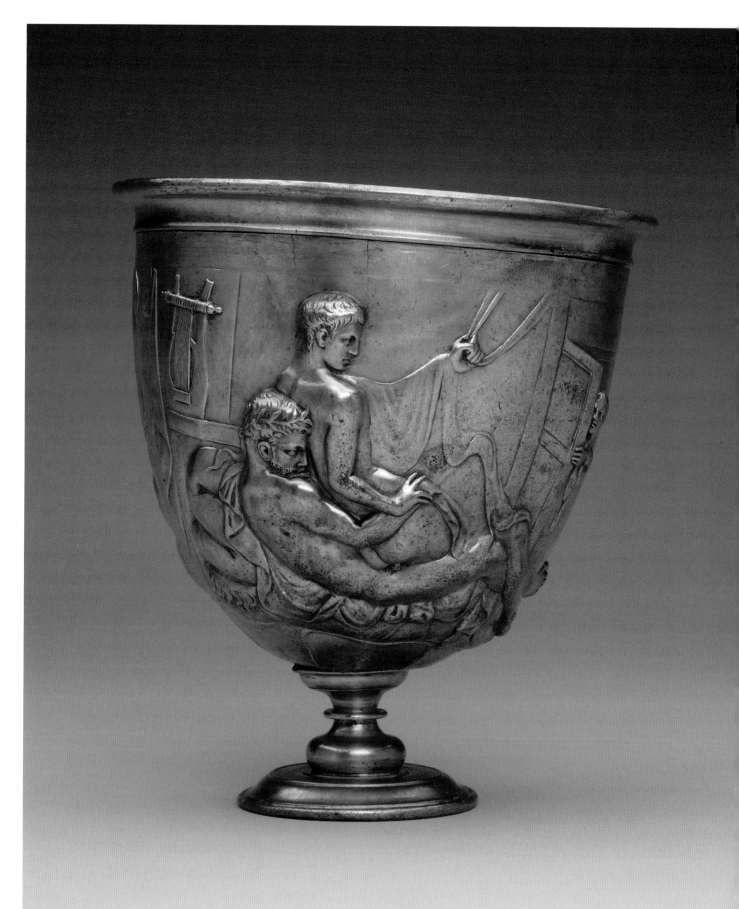

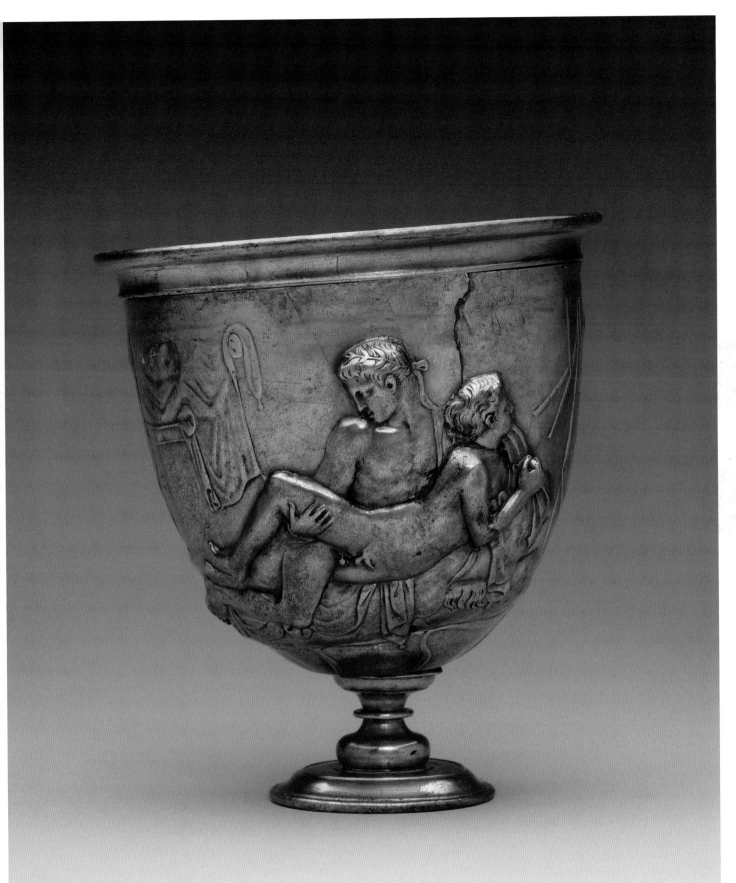

between the erastes, an older, active lover, and the eremenos, a free-born male adolescent who was not yet a full citizen.[6] Many scholars suggest this type of pederastic relationship involved mentoring — training young men in the ways of Greek manhood — as well as sexual activity.[7]

The relationship between the cup's early-twentieth-century owners is less of a puzzle. Ned Warren was the son of a wealthy American paper manufacturer. He was an idiosyncratic child with an early appreciation of the ancient world: as a youngster he ran about in a Roman-style toga while his siblings played cowboys and Indians.[8] He had crushes on other boys at school and wrote a poem comparing one of them to Antinous, the young lover of Roman emperor Hadrian. In 1884, aged 25, Ned moved to Oxford to study classics and there he met fellow student John Marshall, the son of a wine merchant. The pair became lovers, and in 1890 they set up house together in the Sussex village of Lewes. Lewes House, a three-storey brick residence of some size, was a spartan, monastic place with hard beds, firm chairs and few soft furnishings. There were statues of classical male nudes, however, and these gestured towards the social life of the house. Lewes House was home to more than just Ned and John. It operated as a tight community of like-minded men who embraced a spirit of comradeship and sexual bohemianism. The small bathroom, for instance, 'was a highly communal space, and, despite the fact it could only fit two bodies easily, it was not uncommon after riding sessions and sporting activities to find the room overcrowded with several men. On the departure of any man from the house, he was usually bid farewell with the following: "We shall miss you from the bathroom".'[9]

Homoerotic classical tropes have a fascinating history. Wilhelm von Gloeden's photographs of young men, taken in Sicily at the turn of the twentieth century, included classical themes: columns, ivy and animal skins.

❧

Opposite: Marcus Bunyan's untitled image from 1994 is inspired by Michelangelo's early sixteenth-century Ignudi paintings in the Sistene Chapel. Michelangelo's imagery was itself classically derived. This gelatin silver print is from Bunyan's 'Ignudi' series.

The nude statues were not the only objects Ned and John collected: they also sought out Greek and Roman antiquities.[10] In 1911 Ned travelled to Rome to buy the silver cup for the enormous sum of £2000. He was hugely proud of his acquisition, having considered it something of a 'Holy Grail'.[11] Its scenes apparently inspired him to write 'A Defense of Uranian Love', a manuscript that described a moral sort of relationship between an older man and a youth in which the older partner gave 'without return' and provided guidance to the younger. Ned also made the broader point that homosexuality should be accepted in his own society.[12] He was far from the only homosexually inclined man of the nineteenth and early twentieth centuries who looked wistfully towards the Mediterranean. Some men visited Greece and Italy, others collected Greek and Roman imagery and read the classics, and a considerable number did all of these things (see Chapters 27 and 39).[13] Ned gave the name Thebes to his own study at Lewes House, in tribute to the Greek band of soldier lovers of the same name from the fourth century BC.[14]

The Warren Cup allows us to glimpse, 'rather like its peeping slave, the diverse attitudes to representations of sexual acts of different societies over two thousand years'.[15] After Ned Warren and John Marshall died the cup

was bought by one private collector, then another, and finally in 1999, when it was no longer consider too obscene for a public institution to buy, the British Museum purchased it for £1.8 million. Today the museum's visitors can gaze at the cup for themselves and ponder the ancient world from which it came.

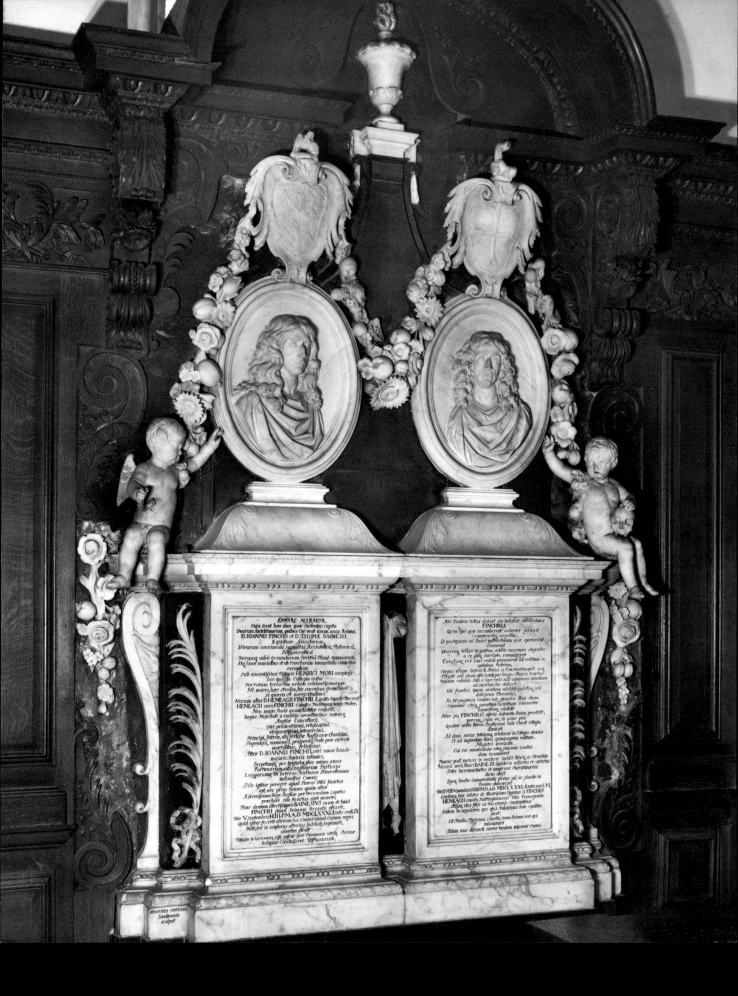

25. Monuments

PETER SHERLOCK

The monument of Sir John Finch and Sir Thomas Baines, erected in 1684 in the chapel of Christ's College, Cambridge, has become an object of queer fascination. The tomb is a remarkable early modern representation of a loving relationship between two people of the same gender, a powerful testimony to the endurance of their friendship, affection and companionship.[1]

Finch and Baines, born into aristocratic families in the 1620s, met as students at Christ's College in the 1640s, a tumultuous period of English history. They formed a lifelong partnership and shared a keen interest in medical science, music and diplomacy. After graduating from the University of Padua in 1656, they were made members of the Royal Society and fellows of the Royal College of Physicians. Finch held diplomatic postings at Florence during the 1660s and was ambassador to the Ottoman Empire from 1672 to 1681. In both postings, he was accompanied by Baines, in Italy as his physician and in Constantinople as his partner. Baines died in 1680, embraced on his deathbed by Finch, who then had his partner's body embalmed and returned to England for burial. The directions he left in his will, that his body was 'to be putt in one common Chest together with that Sir Thomas Baines his Corps and to be interr'd according to our Discretion in the Chapell of Christ College Cambridge',[2] were followed when Finch died two years later.

Their shared lives over four decades, and the absence of marriages, partnerships or children, were remarkable enough; their monument remains an extraordinary object. It was crafted within accepted idioms – it presented plaques bearing epitaphs, busts of the deceased and floral decorations, and was erected in a consecrated place of worship – but it used these conventions to transgress contemporary and dominant gendered notions of commemoration.

Normally, land, lineage and titles determined the location, heraldry, imagery and words used on tombs, and these were accompanied by statements of piety, virtue and honour, which reinforced the rationale for the exercise of power and authority by the subjects represented. Gender boundaries were rigid: English monuments separated husbands, wives and children according to gender, either on opposite sides of a prayer desk, or

Who having been 57 Years
a Commissioned Officer,
died the 21st of January 1759
aged 79 Years.

Body. is interred close to that of
Friend Lieut. Genl FLEMING
d near to this Monument.

Roubiliac in et se
MDCCLVII.

TO PRESERUE
AND VNITE THE
MEMORY OF TWO
FAITHFULL FRIENDS,
WHO LOST THEIR
LIUES AT SEA TOGE
THER MAY XXVIII
MDCLXXII.

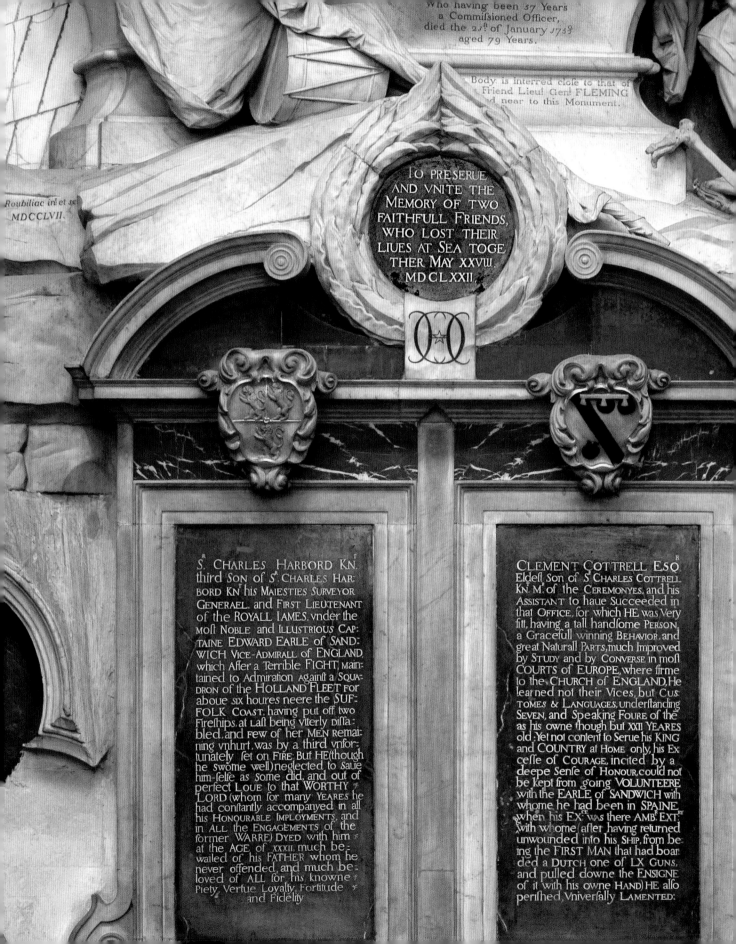

Sr CHARLES HARBORD KNt.
third Son of Sr CHARLES HAR:
BORD KNt his MAIESTIES SURVEYOR
GENERAEL, and FIRST LIEUTENANT
of the ROYALL IAMES, vnder the
most NOBLE and ILLUSTRIOUS CAP:
TAINE EDWARD EARLE of SAND:
WICH VICE-ADMIRALL of ENGLAND,
which After a Terrible FIGHT, main-
tained to Admiration against a SQUA:
DRON of the HOLLAND FLEET for
aboue six houres neere the SUF-
FOLK COAST, having put off two
Fireships, at last being vterly dissa-
bled, and few of her MEN remai:
ning vnhurt, was by a third vnfor:
tunately set on FIRE. But HE(though
he swome well) neglected to saue
him-selfe as some did, and out of
perfect LOUE to that WORTHY
LORD (whom for many YEARES he
had constantly accompanyed in all
his HONOURABLE IMPLOYMENTS, and
in ALL the ENGAGEMENTS of the
former WARRE) DYED with him
at the AGE of XXXII. much be:
wailed of his FATHER whom he
never offended, and much be:
loued of ALL for his knowne
Piety, Vertue Loyalty, Fortitude
and Fidelity

CLEMENT COTTRELL ESQr.
Eldest Son of Sr CHARLES COTTRELL
KNt M. of the CEREMONYES, and his
ASSISTANT to haue Succeeded in
that OFFICE, for which HE was Very
fitt, having a tall handsome PERSON,
a Gracefull winning BEHAVIOR, and
great Naturall PARTS, much Improved
by STUDY and by CONVERSE in most
COURTS of EUROPE, where firme
to the CHURCH of ENGLAND, He
learned not their Vices, but CUS:
TOMES & LANGUAGES, vnderstanding
SEVEN, and Speaking FOURE of the
as his owne though but XXII YEARES
old: Yet not content to Serue his KING
and COUNTRY at HOME only, his EX:
cesse of COURAGE, incited by a
deepe Sense of HONOUR, could not
be kept from going VOLUNTEERE
with the EARLE of SANDWICH with
whome he had been in SPAINE,
when his EXcy was there AMBr EXtr
with whome (after having returned
vnwounded into his SHIP, from be:
ing the FIRST MAN that had boar:
ded a DUTCH one of LX GUNS,
and pulled downe the ENSIGNE
of it with his owne HAND) HE also
perished, Vniversally LAMENTED:

in two separate lines, women behind men. The Baines and Finch monument thoroughly reworked this imagery. The dual monument showed a partnership of equals: two men, with matching epitaphs on matching plaques, beneath two busts. Above the whole, a single urn drew attention to the union of their mortal remains, suggesting a reunion of their bodies and souls in the life to come.

The Latin epitaphs explained this imagery, drawing attention to the rare and intimate nature of their relationship. The purpose of the monument was to commemorate their friendship, as if the two men were a household unit like a husband and wife: 'Show forth, marble, who are these two whose heads you bear? Tell of two most devoted friends, who had but one heart, one soul.' The epitaph concluded by explaining how the men's families had consented to the couple's wish to be buried together 'so that they who whilst living had mingled their studies, fortunes, counsels, nay, rather, souls, might in the same manner, dead, at last mingle their sacred ashes'.[3] Even more remarkably, the monument was erected in a bastion of male power, an Oxbridge college, with the agreement of academic colleagues and family members. And yet it was precisely this academic context that made the monument possible, since in this period college chapels included very few monuments to women. These same-sex communities were reserved to male students and fellows alone.

The Baines and Finch tomb is not the only example of a same-sex monument in early modern England. A predecessor of sorts is found at Westminster Abbey, Britain's most prominent and influential commemorative site. This is the monument to Charles Harbord and Clement Cottrell, who perished at sea in the battle between the British and Dutch naval forces at Sole Bay off the Sussex coast on 28 May 1672. This memorial was erected around a decade before that of Finch and Baines, probably at the initiative of their fathers, Charles Cottrell, who was master of ceremonies in the court of Charles II, and Sir Charles Harbord, the king's surveyor general and a commissioner to his queen. At first glance, this is a standard form of commemoration for the period. Gentlemen of high standing with access to the court and the royal church of Westminster Abbey erect a monument to their dead sons, expressing grief at their untimely and violent deaths while also recording for posterity their pride in the young men's achievements in battle. These elements are evident in the military decorations on the tomb, including a central relief depicting the conflict at Sole Bay and the sinking of the *Royal James*, the ship on which Cottrell and Harbord served. The memorial is probably a cenotaph, an empty tomb, as the pair were most likely buried at sea.

The monument to Charles Harbord and Clement Cottrell, c. 1672, Westminster Abbey

What is striking here is the decision to commemorate in one tomb two men who were united not by blood or marriage but by friendship and companionship in battle. The monument's central purpose is to remember two people of the same sex, much as the Baines and Finch tomb does. This intent is proclaimed by a text at the summit of the edifice, 'To preserve and unite the memory of two faithfull friends who lost their lives at sea together', surrounded by a laurel wreath. The equality of the pair is represented in the elements of the monument. Although there are no portraits, the epitaphs are of identical length, surmounted by heraldic crests of equal size.

Cottrell's epitaph describes his physical power and attraction, 'having a tall handsome person, a graceful winning behaviour, and great natural parts'. This drew on the classical tradition of seeing the body as a mirror for the inner qualities of the soul. His honour is represented by his heroism in volunteering for diplomatic and military service, and his leadership as 'the first man that had boarded a Dutch [ship] of LX guns and pulled down the ensign of it with his own hand'. Harbord's epitaph echoes Cottrell's, describing how he participated in the 'terrible fight', at the end of which '(though he swam well) [he] neglected to save himself as some did'. Harbord is described as laying down his life, not for Cottrell, but for the commander, the Earl of Sandwich, on account of 'the perfect love to that worthy lord (whom for many yeares he had constantly accompanyed in all his honourable imployments, and in all the engagements of the former warre)'.[4] Curiously the Earl of Sandwich, who also died in the conflict, was himself buried in Westminster Abbey, although without a monument.

The expression of two sailors' partnership in battle and in death is facilitated by the use of traditional forms of commemoration, based on classical and biblical precedents praising the self-sacrificing love of warriors. These themes of loyalty, honour and friendship are drawn out in the context of virility and service. The sepulchral styles and codes of the late seventeenth century enabled the presentation of the pair's qualities and behaviour, and moved beyond the mere recording of names, titles and blood relationships typical of earlier generations. These visual and cultural codes meant that English society in the 1670s and 1680s could erect and maintain monuments to male couples who were united by love and affection in both life and death. The fact that both the Baines and Finch tomb, and that to Cottrell and Harbord, were erected by relatives and friends, not by the men for each other, demonstrates that same-sex friendship and intimacy could be acknowledged in public with neither shame nor fear but as attributes worthy of transmission to posterity.

A detail of the Harbord and Cottrell monument.

S.^R CHARLES HARBORD KN.^T
third Son of S.^R CHARLES HAR:
BORD KN.^T his MAIESTIES SURVEYOR
GENERAEL. and FIRST LIEUTENANT
of the ROYALL IAMES. vnder the
moſt NOBLE and ILLUSTRIOUS CAP:
TAINE EDWARD EARLE of SAND:
WICH VICE-ADMIRALL of ENGLAND,
which After a Terrible FIGHT, main-
tained to Admiration Againſt a SQUA-
DRON of the HOLLAND FLEET for
aboue six houres neere the SUF:
FOLK COAST. having put off two
Fireſhips. at laſt being vtterly diſſa:
bled, and Few of her MEN remai:
ning vnhurt, was by a third vnfor-
tunately ſet on FIRE. But HE(though
he ſwome well)neglected to ſaue
him-ſelfe as ſome did, and out of
perfect LOUE to that WORTHY ſ
LORD (whom for many YEARES he
had conſtantly accompanyed in all
his HONOURABLE IMPLOYMENTS, and
in ALL the ENGAGEMENTS of the
former WARRE) DYED with him ſ
at the AGE of XXXII. much be=
wailed of his FATHER whom he
never offended, and much be=
loved of ALL for his knowne ſ
Piety, Vertue Loyalty, Fortitude ſ
and Fidelity

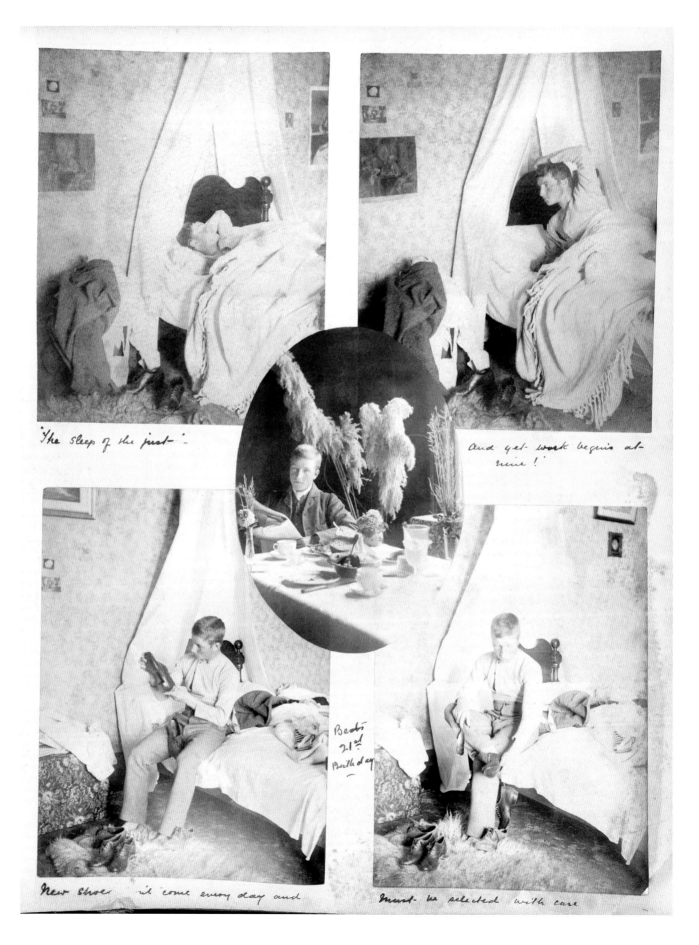

"The sleep of the just ."

And yet work begins at nine !

New shoes it come every day and

Must be selected with care

26. Robert Gant's Shoes

CHRIS BRICKELL

The cover of a burgundy-red album bears the words 'Ferns of New Zealand'. There are no ferns to be seen on the inside pages, though; instead there are many pairs of shoes. Some are disembodied pictures of footwear tightly cropped into squares a few centimetres high and pasted in between other images on the album's pages. Other photographs show Oxford shoes, various styles with buckles, or boots, attached to the lithe bodies of handsome young men who pose in a range of nineteenth-century New Zealand settings. These cricketers, footballers and amateur thespians lived in Masterton, then a small settlement of some 2000 folk. Their

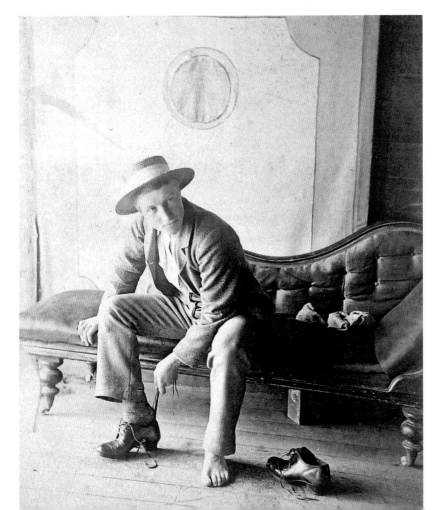

Opposite: Bert's birthday and his new shoes, 1889.

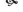

'Never mind, it's the way I get dressed.'

photographer, a chemist by the name of Robert Gant, delighted in his subjects and gave prominence to their footwear. Two of these photograph albums from the late 1880s, which between them contain 200 albumen prints, form part of the collection of the Alexander Turnbull Library in Wellington. The Wairarapa Archive also has a loose set of early-twentieth-century prints of Gant's work.

A four-paned panel, a creative layout from one of the albums, shows young school teacher Bert Erskine getting out of bed on the morning of his twenty-first birthday, after waking from 'the sleep of the just'. The comic-strip style story has him carefully inspecting a pair of shoes before putting them on, and the handwritten captions read: 'New shoes don't come every day ... And must be selected with care.' This was not Erskine's only foray into footwear. Another page of the album has him sitting barefooted on a chaise longue and putting on his shoes. The enigmatic caption says: 'Never mind, it's the way I get dressed.'

Raising a shoe, 1910s.

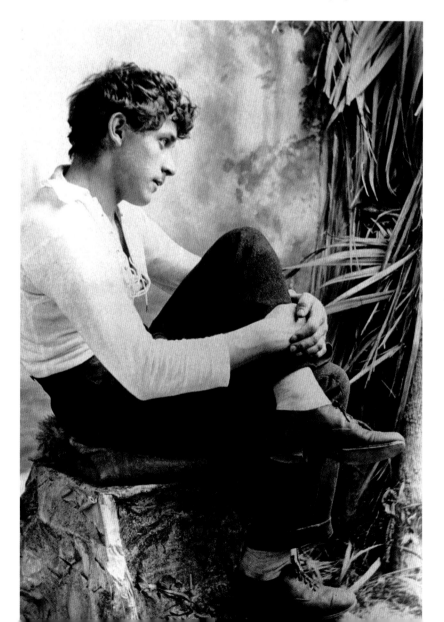

Did Robert Gant have a foot or shoe fetish? This seems an obvious question to ask because calves, ankles and feet are famous in popular discussions of the Victorian period. Rumours suggest the Victorians insisted on covering the lower portion of table legs lest gentlemen become excited by their sensuously turned shape. The legendary ankle fetish seems to have some basis in fact, but usually women's ankles, not men's, were the focus of attention. One of Gant's New Zealand contemporaries, 20-year-old law student Charles McKnight, wrote in his diary about a boat trip where he met a young woman who 'possessed a neat ankle which she seemed to take pride in showing'. She had, he noted, an eager audience among the men on board.[1] New Zealand's doctors had little to say about men's fetishes for women's ankles or shoes, but their international counterparts started to write about the topic.[2] French psychologist Alfred Binet used the word 'fetishism' in its modern sense in 1887, and the 1892 edition of Austro-German psychiatrist Richard von Krafft-Ebing's famous book, *Psychopathia Sexualis*, mentions two cases of men overcome by their desires for women's footwear. One of Krafft-Ebing's case studies risked embarrassment in the main street because 'shoes displayed in shops sufficed to excite him intensely'. His tastes included women's shoes of 'the French style, with heels' and 'he would even blush when boots were talked about'.[3] More interested in women's shoes than their wearers, another man had trouble in the marital bed. His doctor encouraged him to imagine his wife as a shoe, and life apparently improved.[4] Psychiatry was still in its infancy during the 1880s and 1890s, though, and few practitioners joined Krafft-Ebing's nascent attempts to explain fetishes in psychological terms.

Nineteenth-century commentators, and many since, have suggested that most fetishists are male, and the objects of their desires are coded female.[5] Gant, however, was interested in men. Although nothing is known about his loves during the late nineteenth century, he lived with a male partner for 25 years from about 1910. Gant's keen queer eye – as we might say now – is clear to the viewer of his photographs.[6] As well as shoes, his camera focused on men's facial features and necks, the sunlight falling on shoulders and torsos, and sometimes directed the viewer's eye to thighs and crotches.

What other clues do we have? Gant also left behind one piece of writing, a short story titled 'At the End of a Holiday', which was published in a chemists' magazine in 1894. The story mentions men's shoes, of course, but it takes a very different line from Krafft-Ebing's research. Gant begins by describing the physical attributes of the tale's two main characters in some detail. Albert is 'a quiet youth of eighteen, with his father's form and his mother's face, combined with some original beauty of his own', while Edwin, an equally attractive fellow in his twenties who had gone missing in China, 'has a handsome gentle face. It is browned by the sun, but his neck,

Robert Gant (left) and a friend, c. 1889.

which is bare and long, is white. His eyes are deep set and close together; the lashes are long and curling ... his mouth is beautifully shaped.'[7] When a séance is held in an attempt to ascertain Edwin's fate, with Albert as the medium, he puts on a half-worn pair of the older youth's Oxfords, and the next minute he is channelling him: 'He held himself upright from the knees, his neck stretched and his chin raised. His face was ghastly in its pallor, and yet there was a weird half smile on his lips. "To be beheaded!" he said, in a loud hissing whisper. "Who would have thought it?".' Moments later, Albert reveals that Edwin has been executed by members of the Black Flag Army, fighters against the French colonial forces in Asia. 'Oh, what anguish – beheaded!'

What does this strange story tell us? The writer's eye for a handsome man is obvious, but there is something else here too. Spiritualism was then at the height of its popularity and *Holiday* suggests some tantalising connections between sexuality and the séance. Several late-nineteenth-century writers, including Walt Whitman and Edward Carpenter, hinted that those with a 'homosexual temperament' were the most likely to possess a kind of 'cosmic consciousness', a privileged access to the secrets of the universe.[8] The doctor Havelock Ellis talked to several such men who saw themselves as 'mystics', the possessors of special powers of perception.[9] Some homoerotically and spiritually inclined men displaced their socially transgressive desires onto an outer-worldly plane, while others, like Gant, were content to wrap them in spiritualism's concealing code. As the popular saying suggests, walking in another's shoes is a way to gain empathy. But is that all? Wearing another man's shoes is a way of becoming him and being with him, but not only that: when one attractive young man put on another's Oxfords he entered him, in a sense. Robert Gant's shoes refracted homoerotic desire through the medium of clairvoyance. Homoerotic symbols and pleasures were not yet medicalised: for Gant, at least, a love of men's shoes spoke of a desire understood in mystical rather than psychiatric terms.

The same love of footwear, and the complex and often campy masculinity in which it was entangled, also appeared in Gant's photographs from the early years of the twentieth century, when understandings of homosexuality changed significantly. One photo shows a youth holding up a leg with both hands, a gesture that emphasises his shoe for the viewer. We do not know what Gant, who died in 1936, thought of new developments: the psychoanalysis of Sigmund Freud and his successors, or the interwar notion that same-sex desire was a symptom of nervous irregularity. There can be no doubt, though, that shoes, and the male bodies they were attached to, were a continuing source of inspiration.

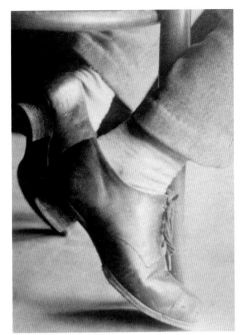

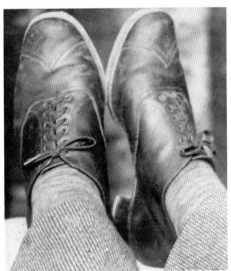

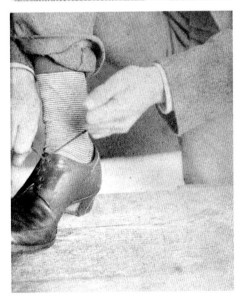

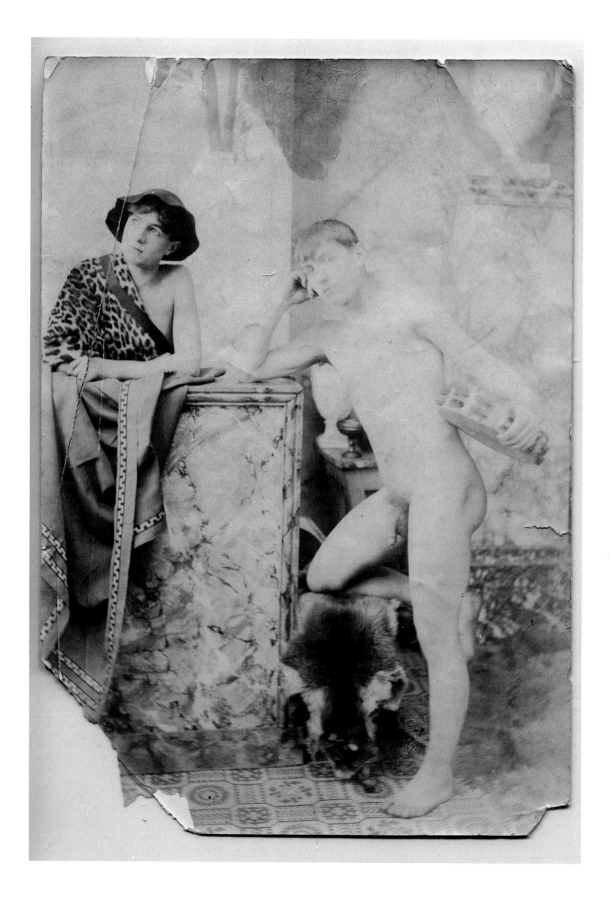

27. Oscar's Photograph?

NEIL BARTLETT

This now fragile photograph was almost certainly taken and printed somewhere in Mediterranean Europe between 1890 and 1900. During those years, a German called Wilhelm von Gloeden started selling his work to tourists in the picturesque Sicilian city of Taormina. Most were straightforward commercial souvenirs in the form of plein-air studies of ruins, landscapes and locals dressed in traditional clothing, but some of his pictures – the images for which he is now best remembered – were intended for a much more specialised market. They featured young Sicilian men and boys in various states of provocative undress (see Chapter 24). Although none are by modern standards explicitly or heavily pornographic, they are always erotic, and clearly intended to arouse the customer. Gloeden's work in this style was widely imitated and images such as this photograph, which may or may not be an original by Gloeden himself, were soon circulating in the homosexual subcultures of most major European cities. Perhaps surprisingly, not all of this circulation was clandestine; a less explicit Gloeden male nude study appeared in *The Studio* magazine in London as early as June 1893, alongside equally explicitly homoerotic work by Frederick Rolfe, the author of *Hadrian the Seventh*.

This particular photograph offers two very different but classic variations on what might make a young man potentially attractive to a homosexual viewer. One of the two models is draped, coy, young and pretty; the other, in contrast, is older, more butch – and very definitely available. But this older model is far from being simply naked. The fur, the marbling, the 'classical' drapery and the studio props that frame his well-displayed body (note the linoleum flooring, carefully chosen for its 'mosaic' patterning) all announce that this is a study 'after the Antique'. These elements carefully distance the image from the necessarily illicit world of actual pornography and flatteringly align both the photograph and its intended buyer with the more public, respectable and elevated worlds of connoisseurship and the artist's studio. They also – and this is too easily overlooked or dismissed by the modern viewer – endow the image with a genuine emotional charge. The

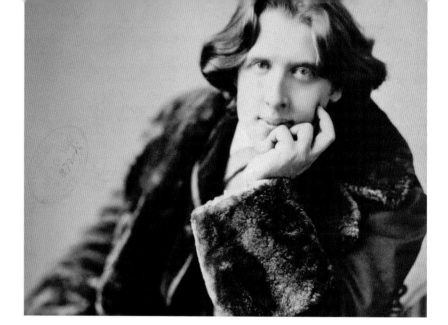

historic classical world which these two boys are being paid to dress up and re-embody functioned as a fantasy location of very real resonance in late nineteenth-century homosexual subculture. No matter how kitsch, this kind of re-enactment claimed a living kinship between the models and a Hellenic culture that had once openly celebrated homosexual desire and practice. Some queer citizens of the late nineteenth century were already beginning to dream hungrily of this kind of culture for themselves.

The back of the photograph carries a hastily scribbled pencil inscription. It identifies the models by their full names and gives their ages as '18 et 15 ans' respectively. Sadly, the names are now illegible, apart from the fact that one boy was called Charles, but what is readable is significant. The fading pencil scrawl tells us that whoever originally sold this image marketed it as a picture of two actual – and therefore potentially knowable – individuals rather than two anonymous fantasy figures. This impression is reinforced by what is surely the oddest, and most beautiful, thing in the picture, the expression on the older model's face. For one thing, this young man is entirely unashamed. His 100-year-old gaze abolishes both time and distance as he stares straight into the camera. The photograph invites viewers to consider what would happen if they were right there in the studio with him. It makes that viewer's desire as real, as material and as frank as the sitter's own candidly exposed flesh.

This haunting image came into my possession in the summer of 1994. It was given as a house-warming present to my partner – the queer historian and archivist James Gardiner – and me when we set up our first home together. The gift, from our friend British art historian and HIV/AIDS activist Simon Watney, came with quite a story attached. Simon told us that he had been given the photograph by the Bloomsbury painter Duncan Grant, whom he had come to know in the early 1970s, when the latter was in his eighties.

Grant still lived at Charleston, the country home he had created with painter Vanessa Bell, which served as an important out-of-London focus for the radical art, lives and loves of the Bloomsbury group. Simon was studying for a degree at the nearby University of Sussex while establishing one of the earliest regional British branches of the Gay Liberation Front. Despite the 60-year difference in their ages, the two men established a close friendship, and Duncan Grant delighted in letting Simon use Charleston as a place to take his boyfriends. There they could make love in beds once occupied by the house's famous inhabitants.

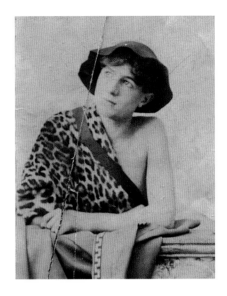

Grant told Simon that the photograph had come to him from Robert Ross, the openly homosexual art dealer and critic who had assembled an important friendship network of younger gay artists and authors, including Grant, before and during World War I. Ross, of course, had once been the lover of Oscar Wilde, and later the famous playwright's literary executor, and Grant claimed the photograph had originally been in the possession of Wilde himself.

The story is unprovable but entirely credible. Photographs by Gloeden and his imitators were on sale in both London and Paris in the years before and after Wilde's arrest in 1895; Wilde visited Taormina for himself in 1897, and surely would have encountered Gloeden's work there; and he certainly owned other homoerotic work by the likes of Simeon Solomon, a contemporary of the Pre-Raphaelites, whose work was often explicitly homosexual in content. If the photograph *was* originally owned by Wilde, then Ross would have had every reason to preserve it after the writer's death, both as an intimate reminder of an ex-lover and as a memento of the man whose literary reputation he worked so hard to defend. Skipping forward a decade a two, what better way to impress (and possibly woo) a handsome and radically minded young gay man like Duncan Grant than to pass on to him such a scandalously personal souvenir of the already iconic Wilde? Grant, in his turn, would have had every reason to preserve the fragile image for the next half-century. He was both a lifelong connoisseur of the male nude and a consistent and open champion of the radical and the queer in art and life. And who better for him to eventually pass it on to than another beautiful young gay man, hungry for any evidence of the radical queer past?

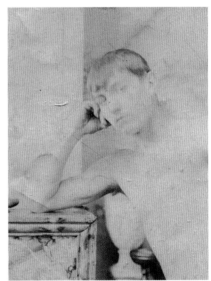

Another 25 years later, when Simon Watney gave the photograph to us, it acquired another and very particular layer of meaning. This was a time of full-on attack on gay men in Great Britain; AIDS and state-sanctioned homophobia were combining to make the queer body, especially the sexual or pleasurable queer body, an abomination. In giving us this picture when he did, Simon was asserting that we should take courage from the fact that our newly cemented relationship was part of a long and creative chain of such unions. In spite of all efforts to erase or silence us, this chain has love, friendship and sexual pleasure as its binding and enduring links.

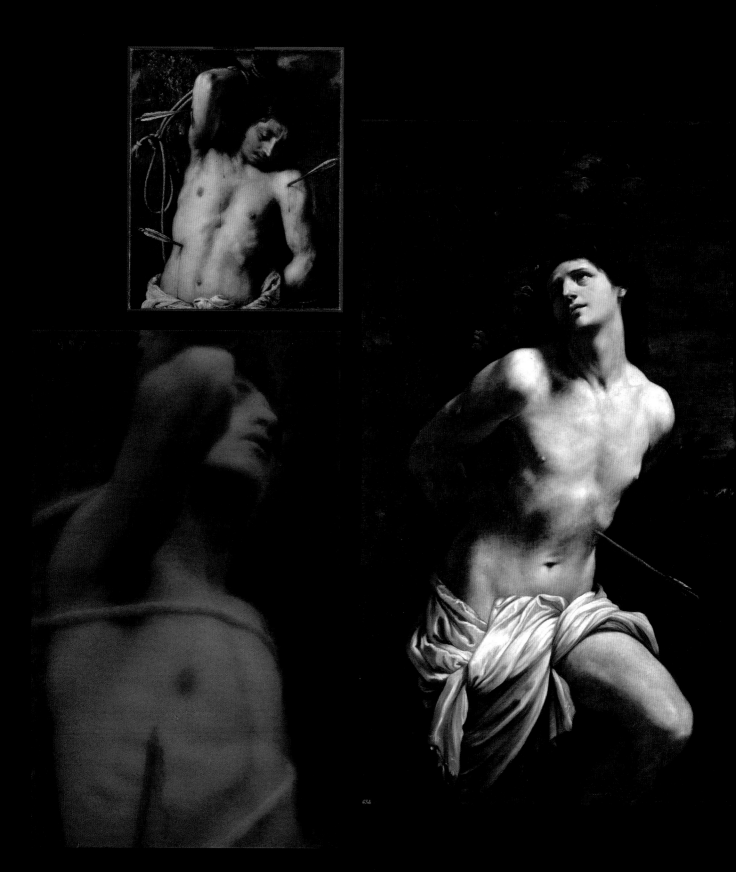

28. Saint Sebastian

CHRIS BRICKELL

Saint Sebastian was an ancient Christian saint and martyr who died about AD 288, when the Roman emperor Diocletian, a persecutor of Christians, ordered him to be shot through with arrows and then bludgeoned to death. Many paintings and statues of Sebastian have appeared over the centuries: here are four. Guido Reni, the painter of the first, was born in 1575 in Italy, and his eclectic body of work included seven Saint Sebastians. Not always, though, was the young Sebastian portrayed as slim: the Spanish painter Juan Carreno de Miranda produced two beefier examples during the mid-seventeenth century. Hermann Stenner, the German who painted the third, a colourful and decidedly waiflike Sebastian in 1914, died at war the same year aged only 23.

Why have homoerotically inclined men been so interested in these kinds of portrayals? Charles Darwent suggests that 'Sebastian's appeal to gay men seems obvious. He was young, male, apparently unmarried and martyred by the establishment ... He also looks good in a loincloth and tied to a tree.'[1] New psychological ideas emerged at the very end of the nineteenth century and Sebastian's plight spoke to these strongly: the true homosexual self was announced and then punished. Many men identified with Sebastian's religiosity and eroticism too.[2] This is clear in Fred Holland Day's portrayal, the fourth shown here, a photographic print on which silver pencil depicts the blood running from the wound.[3] For Day, the 'eroticism of the male body was not an end in itself but a means of embodying spiritual ecstasy', and images of Saint Sebastian allowed him to 'show the male body in a nearly nude state and at the same time express spiritual fervour'.[4] Others saw in Sebastian a gateway to sadomasochistic fantasies.[5] Whichever interpretation wins out, there is little doubt Saint Sebastian has become a very gay symbol.[6]

Opposite page, clockwise from top left: Juan Carreno de Miranda; Guido Reni; Fred Holland Day.

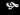

This page: Hermann Stenner.

29. Tender Buttons

JANE TRENGOVE

Author and poet Gertrude Stein wrote *Tender Buttons* in 1914. She had just met Alice B. Toklas, her great love and long-time companion, and they set up house together. In *Tender Buttons*, under the headings 'Objects', 'Food' and 'Rooms', Stein told a story of a shared domestic life. Her use of metaphor conjured the comfort of enclosed spaces and intimate encounters. No domestic item was innocent: the softness of home furnishings, pleasures tasted by mouth, and the folding and pleating of fabrics invoked the sensual touch and feel of things – including Alice. The title *Tender Buttons* implied a sense of ordinary daily housekeeping infused with feminine desire.

In 1993 I was invited to make a work based on Stein's *Tender Buttons* for the project series *E/sensual Fragments*, curated by Juliana Engberg and Rachel Young at the Australian Centre for Contemporary Art in Melbourne. I created an installation of paintings that revealed a selection of domestic objects – cushions, shoes, hats, umbrellas – taken from the Stein text and my own home. I painted the works in a palette of heightened flesh tones and arranged them on the gallery wall to form two entities. I stencilled the other three walls with a stylised rose motif that resembled wallpaper, and low lighting enfolded the viewer within the room.

It is interesting to look back on the project a quarter of a century later. Many of us have lived contentedly together among the democracy of objects, as Stein and Toklas did, but it seems incredible that it took another 24 years for same-sex marriage to be legislated in Australia. Stein's text seems fresh to me in light of the recent political mess of the Australian marriage debate. Would I make the work now the same as then? Who knows, but the desire remains.

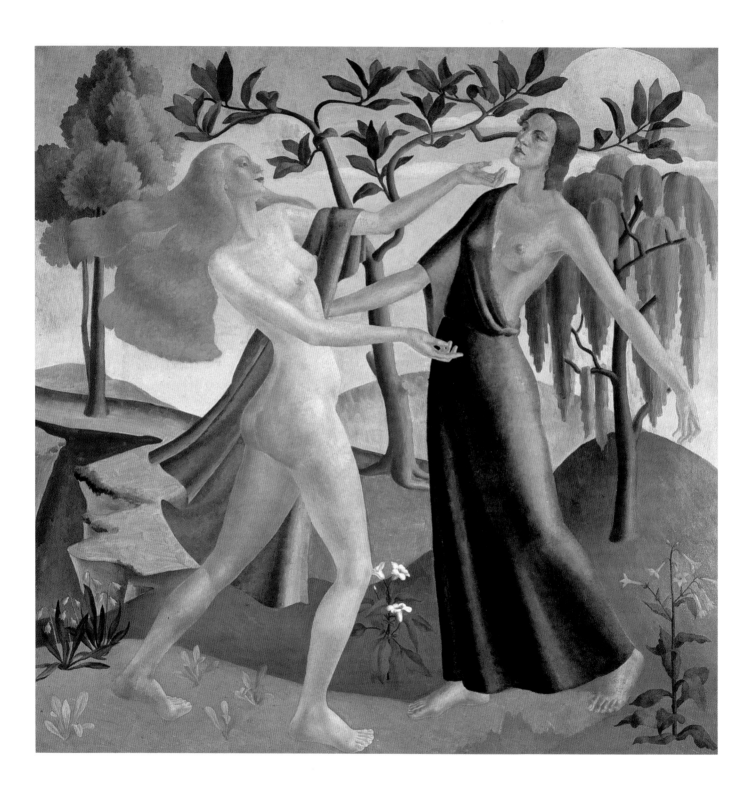

30. The Paintings of Lois White

JUDITH COLLARD

Anna Lois White's painting of *Persephone's Return to Demeter* is one of the more overtly lesbian paintings produced in New Zealand in the first half of the twentieth century. And yet, at the same time, it is not. It shows two women, one mostly naked, the other with her breast exposed, stepping forward to embrace one another. This represents a scene from Greek mythology that celebrates the temporary return of Persephone to her mother, Demeter, after Persephone's kidnap by Hades, God of the Underworld. The painting is about the reunion of mother and daughter and the return of spring.

Art historian Nicola Green suggests that the two figures depict the idealised versions of Lois White, as she was widely known, and her friend, Winifred Simpson.[1] The pair had been very close since their first year together as students at the Elam School of Art in 1923. The painting also demonstrates the use of classical mythology to disguise a range of other meanings. It was an acceptable way to show the female nude and present the homoerotic. Reviewers of the 1930s described White's work as essays in decorative patterning, but they rarely discussed the subject matter or what was depicted.[2] 'Just as classical stories justified nudity, so they could provide the pretext for a same-sex embrace that would never otherwise be represented so overtly and on such a grand scale,' writes art historian Roger Blackley.[3] In her Art Deco approach and more erotic stylings, Lois White was producing work reminiscent of other artists such as Thea Proctor in Australia.[4]

Lois White's love of the female form is a consistent theme. Her 1949 painting, *Bathers*, used in the publicity material for the 1994 exhibition *By the Waters of Babylon*, tackles a more modern subject, but there is a similar pleasure in its curving female bodies. The work presents a real symmetry in the depiction of the two women and of the fish and birds that accompany them. The figures are stylised, but White pays attention to the appearance of

Persephone Returns to Demeter, 1933.

BY THE WATERS OF BABYLON
THE ART OF A. LOIS WHITE

DUNEDIN PUBLIC ART GALLERY 17 SEPTEMBER - 13 NOVEMBER 1994

AN EXHIBITION ORGANISED BY THE AUCKLAND CITY ART GALLERY
PROUDLY SPONSORED BY **ER** *ERNST&YOUNG*
TOURED NATIONALLY BY EXHIBITOUR NEW ZEALAND

nipples, the shape of the groin and the lower back.

Both *Persephone* and *Bathers* raise interesting issues for those thinking about homoeroticism in art. Does an artist have to be queer to make queer art? I have no evidence about White's sexuality beyond the art she made, and I am reluctant to impose a sexuality on a silent subject. There are few facts to support the idea that White was a lesbian. Nicola Green does briefly address the artist's sexuality, but her discussion is speculative. White's nephew, for instance, remembered that she described other members of her community as 'gay'.[5] But some clues lead in the other direction. Another work, *The Fleet's In* from 1943, probably owes more to the Paramount musical than to Paul Cadmus' famous and controversial 1934 painting of the same name, which depicts sailors carousing with prostitutes and a queer man with a red tie.[6] In contrast, the mood of White's version appears thoroughly heterosexual, with its dancing sailors and young women. I cannot prove that White knew Cadmus' work, although stylistically they had much in common.

Lois White's letters are held in Te Papa, New Zealand's national museum, but are currently unavailable to researchers because her family wishes to preserve her privacy. We cannot know whether this

correspondence contains any clues about the artist's sexuality. We do know White was a single woman, a 'spinster', a state that has sometimes been used as evidence to suggest a lesbian disposition. This is not in itself compelling evidence although, as Hilary Lapsley has shown, speculation is often all that is available for women from the recent past. 'Ordinary women, rather than bohemians, did not think about themselves in terms of sexual identity until well after the middle of the twentieth century, and for a woman to indicate that she knew anything at all about sexuality in those earlier times placed her at risk of being considered immoral.'[7] Still, there was a range of views about the spinster during the 1930s. Some people made the anti-feminist assumption that such women must be unfulfilled and sexually repressed, while others asserted that they could lead fulfilling lives focused on their work and female friendships.[8] In 1933 the British-American psychologist Esther Harding described such women as 'the most vital and enterprising, the ones with the greatest intelligence and initiative'.[9]

Was White's spinsterhood a reflection of her sexuality or the result of other demands on her time? Her wider family certainly depended on her economically. Her father, an architect, had died when she was in her second year of high school.[10] She went on to support her mother and her sister by teaching at both Elam School of Art and Takapuna Grammar in Auckland. Although her sister Gwen worked part time at Epsom Girls' Grammar School, Lois White was the family's principal wage earner. It was not at all unusual for working women not to marry in New Zealand during the 1930s: during the Depression the law allowed boards of education to fire married teachers, and the Canterbury Unemployment Committee insisted that no work should be offered to married women. White's status as an unmarried woman worker was consistent with the expectations of the time.[11]

Lois White remains something of an enigma. There is no doubt that her primary personal alliances were with women. Her two unmarried aunts were role models, while her strong Methodist social circle also provided moral guidance and a sense of propriety. Winifred Smith, who later married, was one close friend; Ida Eise was another. Like White, Eise was a teacher at Auckland's Elam School of Art. The pair never lived together but they travelled through the Americas and Europe and spent five months in Britain in 1961. A detailed diary of the trip is held at Te Papa and is available to researchers. White and Eise remained friends until the latter's death in 1978.

The matter of White's sexuality is opaque indeed. She clearly had an appreciation for the female form, but there is no concrete evidence of her personal desires. Her work was not seen as 'lesbian' at the time of its production and none of her paintings was censored. At the same time, in its sensuality and lack of prudishness, it does not conform to common expectations of the work of spinsters.

Lois White, self-portrait, c. 1933.

Opposite: A 1994 exhibition poster featured White's painting Bathers from 1949.

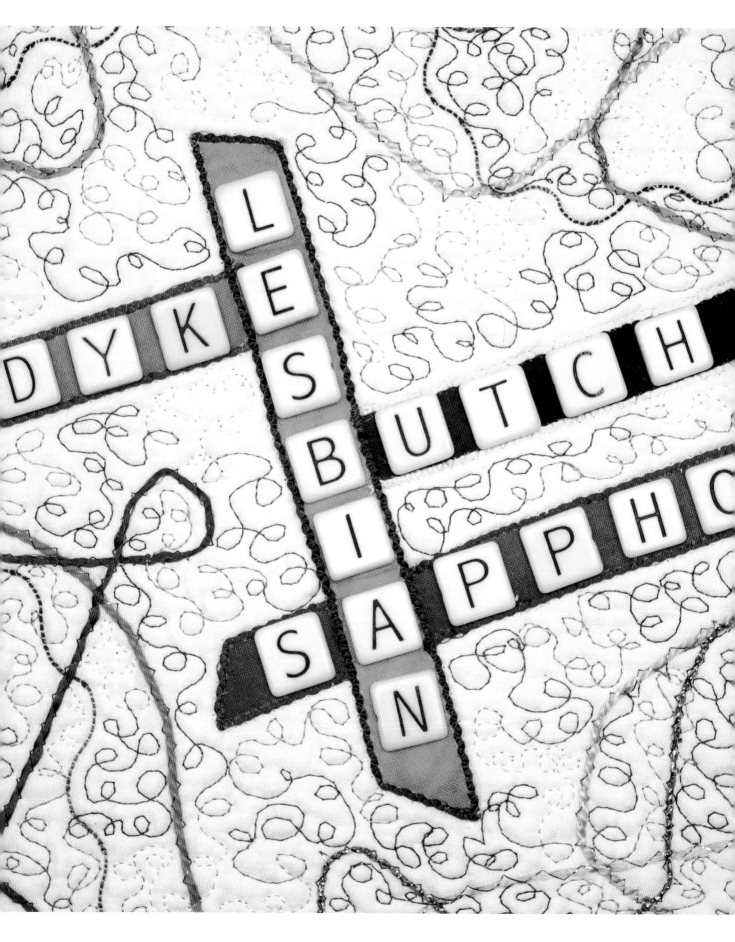

31. The L Word Quilt

AMANDA LITTAUER & DIANE JOHNS

Amanda: When Diane Johns first learnt to cross-stitch as an elementary school Girl Scout in the early 1960s, she never imagined that 40 years later her lesbian-themed quilt would ignite a local controversy. Featuring words such as 'dyke,' 'femme,' 'Sappho' and 'queer' in a colourful crossword design that Diane described as 'whimsical', *The L Word* reflected Diane's mid-life coming out and her immersion in lesbian culture. When a local quilt guild labelled the quilt offensive and rejected it for their show, however, Diane embraced the opportunity for education and activism. Quilts have long been associated with normative femininity and domesticity, but many scholars have shown that domesticity has long held a range of queer possibilities.[1] *The L Word* documents a moment in American lesbian popular culture and speaks of the ongoing everyday activism of LGBT people living in towns like DeKalb, Illinois. Its playful linguistic and material reappropriations, juxtapositions and design also reflect the historical and contemporary phenomenon of queer domestic world-making. The quilt demands attention and respect as it toys with lesbian desire and celebrates lesbian community.

Diane: I made my first quilt in 1974 during my senior year in college and became enthralled with the craft from then on. I married my college sweetheart, a union that spanned 20 years and produced two daughters. In the late 1990s I relocated to Little Rock, Arkansas, with my then partner, but left after a few months when the relationship soured. In 2003, through contacts I had made in Little Rock, I was invited to participate in the quilt show, *Out of the Sewing Closet: Quilts by gay, lesbian, bisexual, and transgendered (GLBT) artists*. When I learnt that the curator, Sabrina Zarco, had received only a few submissions, I decided to make a quilt that

would literally *and* figuratively 'come out of the closet' and – in a humorous vein – celebrate my identity as an out-and-proud lesbian/bisexual quilter.

The L Word's title, chosen before I even began designing the quilt, was based on a cable television show I had never seen about a group of lesbians and their entangled relationships. It catalysed my artistic vision for the piece, which incorporated language and visual images. This was an exciting quilt for me to make, in several ways. As a former writing teacher, I love to play with words. I wanted to nudge people to think while encouraging them to smile.[2]

The L Word is a 60 x 60 centimetre machine-pieced and machine-quilted wall hanging made of assorted solid-coloured hand-dyed and commercial cotton fabrics. A white centre square is offset by two pieced patchwork borders on the left and bottom, suggesting an 'L'. It is embellished with hand-stitched buttons, beads, charms, glued ribbon and plastic tiles, and computer-printed historical, contemporary and original phrases and quotations from singers and writers on specially treated white cotton. It is stipple-quilted and couched with various rayon, metallic and polyester threads.

Examples of historical and modern phrases include 'lavender menace', 'purple star', 'lipstick lesbian', *Desert Hearts* (a 1986 film title), 'gold star lesbian', 'lesbian chic' and 'soft butch'. I made up 'leather & lace' and 'Famous Lesbian Quilters' (the title of an imagined one-act play). There is also a typo: 'lesbian ladybug' was meant to be 'ladybug lesbian', honouring my mother's childhood nickname for me, but I found the image of queer insects amusing, and I left in the mistake as my own private joke. 'Yes I Am' is a song and album title by rock musician Melissa Etheridge, as is Ann Reed's 'Power Tools are a Girl's Best Friend', which is set to the tune of 'Diamonds are a Girl's Best Friend'. I included the chorus of folk singer-songwriter and lesbian activist Alix Dobkin's song 'View from Gay Head', from her 1973 album, *Lavender Jane Loves Women*: 'Lesbian, lesbian, any woman can be a lesbian.' Finally, I included a favourite rule of Shelly Roberts: 'If male homosexuals are called "gay", then female homosexuals should be called "ecstatic".'[3]

On the patchwork borders of the quilt I used a black sewing machine button and silver scissors charm to represent 'femme' domestic tools, and a green tractor button to signify its 'butch' counterpart. I added a dark red ladybug button as my personal totem, and a bright red lips-shaped button to resonate with the 'lipstick lesbian' phrase. I stitched a purple star button to match the printed phrase 'purple star', and a heart button and small white beads with black hearts to represent *Desert Hearts* and love in general. I spelled out 'queer', 'lesbian' and 'femme' with black-and-white alphabet beads. The quilt generated lively discussion in the exhibition.

After moving to DeKalb in 1985, I became involved in the DeKalb County

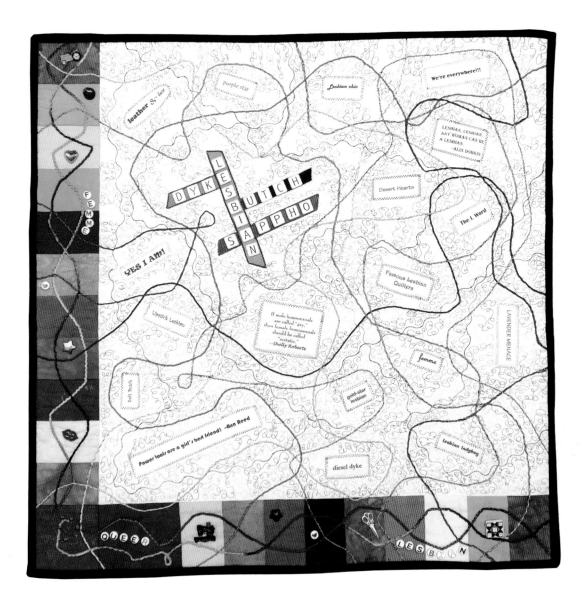

Quilters Guild and served as newsletter editor, secretary and then president. My leadership waned after I met my partner, Jeanne Meyer, and I came out as a member of the LGBT community. I felt self-conscious about the fact that I was in a committed lesbian relationship and could not bring myself to get up in front of the entire guild and announce milestones such as our holy union ceremony.[4] In May 2004, however, I renewed my membership and entered *The L Word* in the biennial autumn quilt show with a small Polaroid photo. When the quilt show committee viewed the full quilt they deemed it 'inappropriate' for display. Guild leaders found the words dyke, butch and queer 'highly offensive'. They worried about offending attendees and risking their relationship with the administrators of the elementary school where

the show would be held. The show committee chair insisted that the guild was 'formed to promote quilting, not to be a showcase for controversial art' and that the same criteria would apply to a quilt with 'explicit profanity or racial slurs'.[5]

Alhough I saw myself as introverted and private, I quickly mobilised my local and virtual networks. Identifying myself as a 'lesbian/bi quilter', I asked members of online quilting listservs to share their opinions with guild leaders and to encourage them to reconsider their decision. I concluded with a challenge: 'Last week was Banned Book Week; will this one be Banned Quilt Week?' The message was successful. Supporters near and far emailed me with their analyses, ideas, compassion, respect and shared outrage, and they emailed guild leaders with messages ranging from gentle scolding to strident criticism.[6]

Guild leaders then allowed me to make my case to the full DeKalb County Quilters Guild Board on 5 October, which I did, despite having spent the afternoon in the emergency room with a panic attack. But the 'rather hostile' group of women returned repeatedly to their fears about how people might react to the quilt and penalise the guild. Despite my offer to write an explanatory statement identifying the quilt as a work of gay pride, and my observation that it included many positive and affirming words and symbols, the board upheld the show committee's decision. Ironically, they cited the need for the show to be 'inclusive of all visitors', a statement to which Frank, a member of the LGBT Quilters online community, responded: 'All inclusive? My dimpled furry a$$!' In an open letter, I rejected the guild's logic of inclusivity and argued that the real problem was the 'exuberant and openly gay content of the quilt as a whole' and the guild's failure to live up to its own mission of 'encouraging the art of quilting through education [and] public awareness'.[7]

The next day I began planning an alternative and competing Banned Quilt Show, which featured seven quilts pulled from the guild show along with *The L Word*. I created flyers inviting the public to come view the 'censored quilt' and decided that all proceeds from the show would be donated to the Questioning Youth Center, a regional organisation that held weekly drop-in meetings for LGBT teens. The Banned Quilt Show was held in the Unitarian Universalist Fellowship's library on 9 and 10 October 2004. Several visitors expressed surprise that *The L Word* was so small; somehow they expected to see a quilt as large as the controversy itself. An acquaintance strode into the library, both hands covering her eyes, and exclaimed dramatically, 'I'm shocked – shocked, I tell you!', then burst into laughter. One teen earnestly explained to a small knot of adults that the board member who did not want her young daughter exposed to the language on *The L Word* did not realise her child was going to hear all those words and more as soon as she entered

Flyer for the banned quilt show.

public school. Many attendees at Sunday morning's service commemorating National Coming Out Day stayed afterwards to view the quilts.

Over 150 people attended the show and we raised $100 for the Questioning Youth Center. Comments from the guest book included the following: 'I'm really not sure what's so offensive. Or maybe I was just raised to be a person who respects others' feelings and work'; 'Thanks for your courage and integrity and for finding a way to share your glorious work, despite the barriers'; 'I love the quilts – keep your sense of humor and keep on pushing the edge'; 'You can never censor art – you can't censor the heart'; 'We need to claim negative words. Co-optation of hate language is a powerful way of transforming it into something positive.'

Amanda: Local newspapers, including the *Northern Star* and the DeKalb *Daily Chronicle*, recognised that the controversy raised important questions about speech, art, censorship, gay rights and the politics of language. A reporter from the *Windy City Times,* Chicago's gay and lesbian newspaper, published an interview with Diane and a follow-up on the success of the Banned Quilt Show. Online gay newsletters excerpted the articles under such humorous titles as 'Quilting grannies ban "diesel dyke"'. The *Daily Chronicle*, in contrast, conveyed the seriousness of the controversy in an editorial entitled 'Quilt controversy offers a chance for understanding'. The editorial board called for another exhibition designed to showcase 'quilts with messages', and the *Chronicle* even offered to sponsor it: 'Quilts, like any form of art, clearly have the ability to convey strong messages, in addition to skill and beauty. Who knew? We're embarrassed to say that we didn't. Now we do.'[8]

Since 2004 *The L Word* has been recognised as a politically significant work of fibre art. *Quilter's Home* magazine featured it in a 2009 article on 'Shocking Quilts', and Northern Illinois University's Pick Museum of Anthropology included it in their expanded exhibition of Michigan State University's landmark Quilts and Human Rights collection in 2017.[9] With its distinctive textures, colours, words and objects, the quilt evokes both the intensity and the ordinariness of queer life in contemporary Midwestern United States.

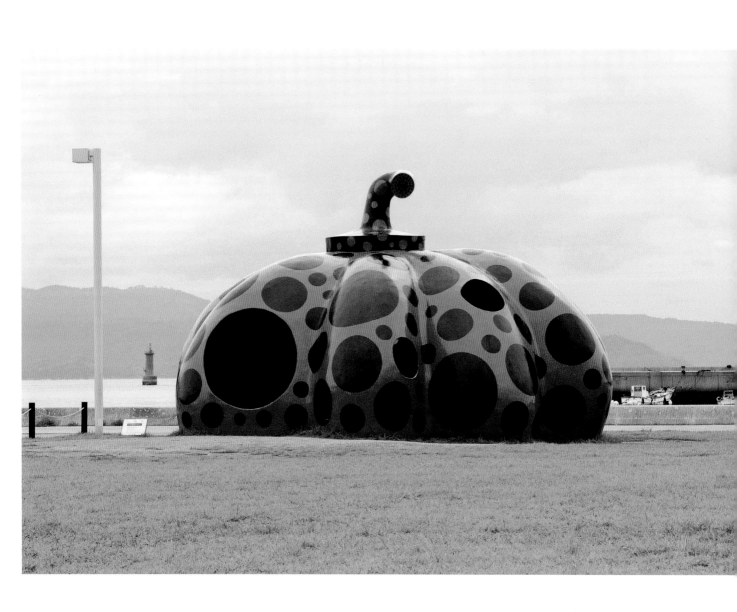

32. The Queen of Polka Holes

KATSUHIKO SUGANUMA

Yayoi Kusama is famous in the world of contemporary art. The global popularity of her work has grown exponentially since the turn of the new millennium: her exhibitions at major galleries and museums around the world consistently draw hundreds of thousands of viewers. In 2017 Kusama created a private museum in a Tokyo suburb in order to showcase her own art, and fans have clamoured for admission. At nearly 90, she continues to work and shows no sign of letting up.

Despite the wide range of styles that feature in Kusama's art over an impressively long career, the recurring themes include repetition, pattern and infinity. Kusama is also recognised as the queen of polka dots. Her iconic works include a series of pumpkin sculptures, their surfaces covered with numerous round spots of different sizes and shapes. But what does the adding of polka dots do to certain objects? Do we interpret the objects differently with or without those spots? What are their queer potentials?

Art critic and academic Jo Applin considers that, 'For Kusama, the polka dot is a formal means of flattening out difference and uniting diverse bodies, objects and surfaces – a mode of being together that ... has the potential to be both utopian and dystopian, unifying and destabilizing, political and playful.'[1] Building on that view, I want to suggest that Kusama's artworks, including her pumpkin sculptures with spots, can be read as queer objects. If queering involves the destabilisation of established norms and conventions, then the audiences of queer objects are always met with a sense of confrontation. Kusama's art is popular and marketable, yet it continues to invite a critical line of queer inquiry.

Whether as a dot point or as part of a pattern, the polka dot is widely assumed to exist as a thing. It is existential. This thingness of the polka dot is further emphasised by the Japanese translation of the term, *mizu tama*. This is a compound noun consisting of 'water' and 'ball', which could also refer to a dewdrop. Terms like polka dot or *mizu tama* imply round and full objects, and the dots in Kusama's art are usually seen in this way. By perceiving Kusama's polka dots simply as objects, though, we might be

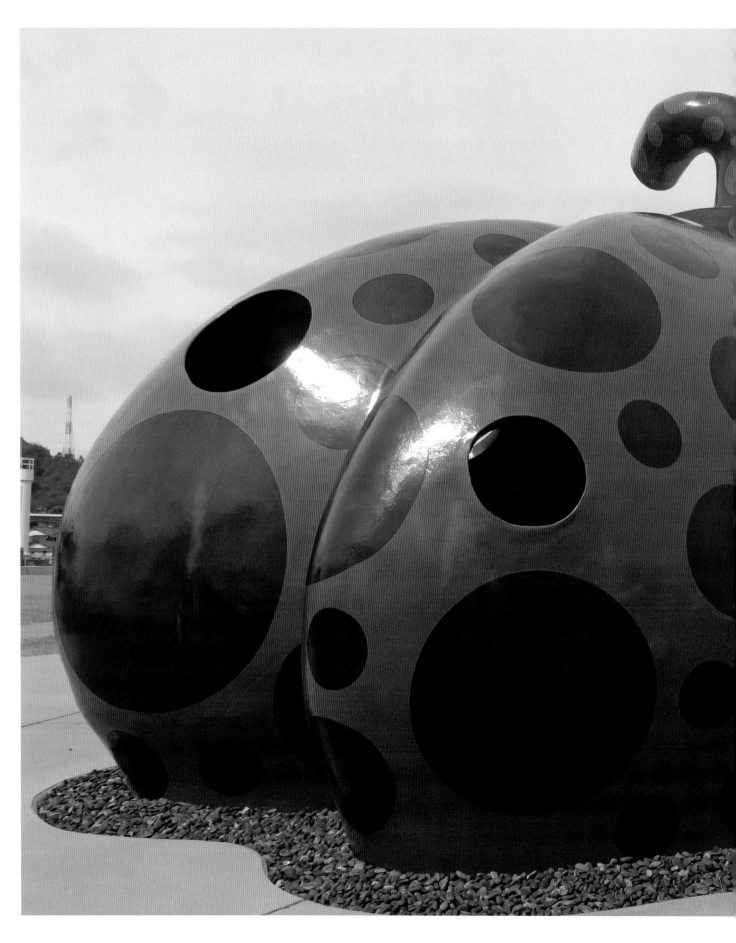

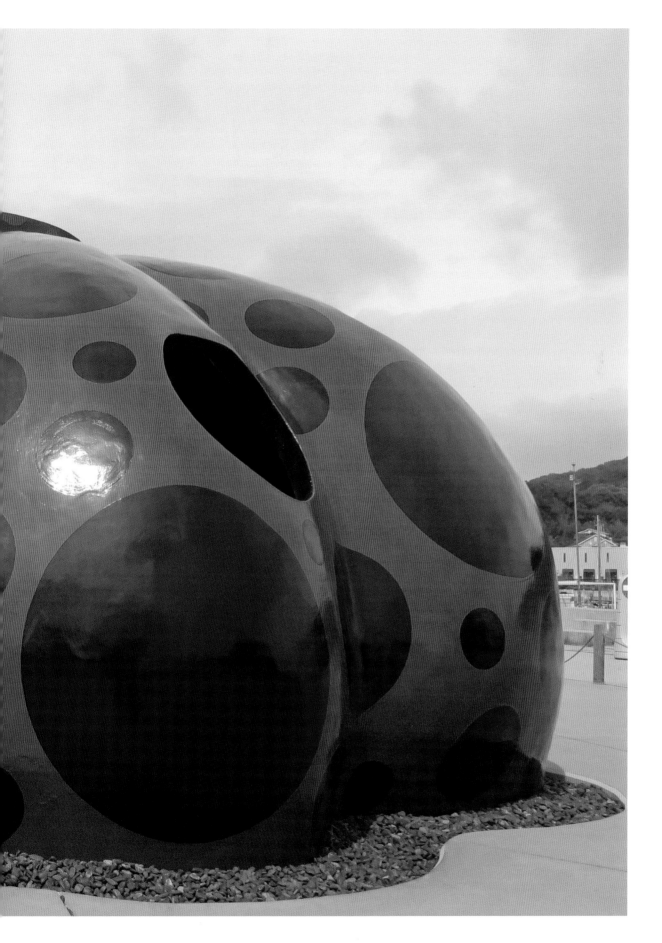

hindered from understanding her work in a queer way.

What if, instead, we interpret Kusama's polka dot as a hole? The existence of a hole suggests incompleteness, and the holes in certain objects imply vulnerability and instability. One of Kusama's earliest works, from the late 1950s, was a series of abstract oil paintings on canvas titled *Infinity Net*, which has 'hundreds of thick, stubby interlocking licks of paint that conjoin into a continuous lateral spread'.[2] Between those licks are holes. Nets and holes are mutually constitutive, but there is an irony here: nets require holes to pass through space, but holes remind us of the incomplete nature of the object nets attempt to create. The *Infinity Net* paintings encourage us to realise that the objects we see are always unfinished and fragile, despite their pretence of being otherwise.

One needs to be careful when discussing the metaphor of holes in objects. Those informed by feminism might remind us that in androcentric societies femininity or the female body is often perceived as an empty hole or vessel to be filled by the masculine phallus.[3] In such a situation, a hole becomes an object to be consumed by the male gaze. The hole is already visible to the patriarchal and heteronormative view. The holes in Kusama's works are *invisible*; they are normally relegated to a realm of impossibility and unintelligibility. Judith Butler suggests that, in order to perfect its own self-image, heteronormativity masks and does not allow grieving for the loss of queer desire.[4] Conversely, an encounter with queer desire inevitably disorients and questions the premise of heteronormativity. Sara Ahmed suggests that queer objects invite a disorientation of our spatial and ideological relationships with certain materials.[5] Kusama's pumpkin sculptures do this boldly, by accommodating countless holes. The marks of a loss or impossibility of queer desire are there for all to see in the very object that is supposed to undermine them. The holes in Kusama's works blur the boundaries between foreground and background, reality and fiction. They evoke the existential premise of an object queered and destabilised.

Let us think about vegetables. If you wished to select a pumpkin at a supermarket for cooking, how would you pick one over the others? Some shoppers might purposely choose those with holes bored by bugs, on the assumption that these pumpkins have not been heavily sprayed with insecticide. But such pumpkins are increasingly difficult to find in major supermarkets. Either sprayed or genetically modified, they are made to look spotless. Customers want vegetables without holes. They want to purchase vegetables with a 'perfect' shape and colour, just as they appear in advertisements. In some urban areas vegetables are now only a click away, available through a delivery service. To avoid customer complaints, staff must pick those items that resemble the online images. Vegetables become fictitious items: they represent only what customers want to see.

As journalist William Leith reflects, 'We used to live in a world in which we didn't need an inner no, because no was all around us. Now we live in a world designed to give us what we think we want. Now yes is all around us.'[6]

Queer lives, especially in the developed west, used to bear numerous 'nos', imposed upon them by heteronormative society. 'Yes' campaigns for same-sex marriage have been successful in many countries. These achievements are hard won, the result of countless initiatives undertaken by queer people who have been denied access to the institution of marriage. At the same time, queer communities can be marked by instances of racism, sexism and classism. There are still holes in visions of queer inclusiveness.

Yayoi Kusama has adored pumpkins since her childhood: 'With their enchanting and ever-evolving appearances, you discover something new about pumpkins every time you see one. What a charming shape! I've been attracted to its genuine appearance and broadmindedness, as well as its sheer spiritual strength contained within.'[7] I share Kusama's fondness for pumpkins. They are stout but relaxed. Unlike cylindrical possibly phallic vegetables such as carrots and cucumbers, they are rarely implicated in sexual contexts. But those of us who have cooked pumpkins or carved them for Halloween know they can sustain their own shape even when full of holes. Kusama's pumpkin sculptures invite us to pause for a moment, to look at objects and then dwell on them. They caution us against any force that presents objects with a fictitious view of perfection.

Kusama's pumpkin sculptures are exhibited in contemporary art museums around the world, but her red pumpkin sculpture in Naoshima, Japan, sets itself apart. Painted black spots feature on the pumpkin's surface, but some of these are more than they seem: they are, in fact, holes carved through the skin. Viewers can enter the sculpture through those holes, only to realise the object is, in fact, empty.

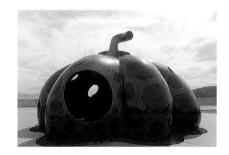

This pumpkin, like all the others, sits calmly on the ground, laying bare rather than hiding its own shortcomings or vulnerabilities. To me, Kusama's pumpkins with holes are part of our persistent collective consciousness-raising of queerness: we are here, we are queer, we are not going anywhere. So let us sit down and take a good look. Those who think pumpkins with holes are appetising know how to appreciate and learn from queer objects.

33. Queer Dogs

HEIKE BAUER

A photograph taken at England's famous Crufts dog show on 1 February 1923 features Radclyffe Hall (1880–1943) and Una Troubridge (1887–1963) with two of their dachshunds. The picture's appeal as a queer object is in many ways obvious: Hall and Troubridge are one of the most recognisable couples of modern English lesbian culture, and Hall's creation, Stephen Gordon, the first self-declared 'female invert' of English fiction, has also come to play an important role in transgender history.[1]

In the image on the next page, Troubridge, on the left, and Hall are dressed in the kind of attire — big coats, fedoras, ties — that critics have embraced as evidence of the couple's norm-defying masculinity.[2] In a ground-breaking article, Esther Newton argued that Hall and Troubridge's personal style has helped to shape the popular image of what she memorably calls the 'mythic mannish lesbian', a modern creature characterised as much by gender as by sexual transgression.[3] Yet their sense of dress was informed not only by the fashions of contemporary queer subcultures. As Laura Doan has pointed out, 'Hall rarely wore trousers in public': this is the only image she could find of her wearing them. Doan describes Hall and Troubridge's outfits as 'their dog-show gear', typical of the practical outdoor get-up worn by dog enthusiasts.[4] If Hall and Troubridge play an important role in the modern history of sexuality, their public association with lesbianism happened only in the wake of the publication, and subsequent obscenity trial, of *The Well of Loneliness* in 1928, when Hall was 48 and Troubridge 41. The Crufts photograph is a reminder that in the early 1920s the pair were equally at home in the world of dog shows as in the Sapphic subcultures of their day.[5]

By 1923 Hall and Troubridge's efforts as dog breeders were well under way. After six years of living together they moved into 10 Sterling Street in London's affluent Knightsbridge. They found their first London residence rather small compared with the big country house of Chip Chase in Hadley Wood, Hertfordshire, where they had lived with many breeds of dogs. Troubridge wrote about griffons, a spaniel which they rehomed for being too indiscriminately affectionate, a great dane and Hall's long-dead but

Radclyffe Hall.

Overleaf: Radclyffe Hall (right) and Una, Lady Troubridge with their daschshunds at Crufts, February 1923.

fondly remembered childhood dog, Rufus, 'a big sable Welsh collie rescued from Battersea dogs home'.[6] However, it was for their dachshunds that they became famous, establishing in the early 1920s the 'Fitz-John' line that became well regarded among Kennel Club members.

The 1923 photograph was taken on a Thursday, the day Crufts reserves for the judging of working breeds such as the dachshund. Although the image is not annotated, contextual evidence from private papers and the contemporary press suggests that the dogs are Fitz-John Wotan and Fitz-John Thorgills-of-Tredholt. According to the *Tatler*, Wotan, who had made his show debut in November 1922, had already won over 40 competitions by February 1923.[7] If this is correct, it was a considerable number of dog shows in a short time. Both women were dedicated to the sport and entered both small rural and major shows. By the 1920s such events had become well established. Originally a country pursuit that focused specifically on gun dogs, the shows gained a more elite reputation with the founding, in 1873, of the Kennel Club by a group of upper-class men interested in dog showing and field trials. In 1894 wealthy aristocratic women established the Ladies Kennel Association, in order to open dog shows to women. By the early twentieth century, dog shows of all kinds proliferated and breeders from different backgrounds exhibited a wide range of fashionable breeds, including European imports as well as so-called sporting dogs.[8]

Both from upper-class backgrounds, Hall and Troubridge fitted well into this world. They made 'many good friends in the dog world of dog shows'.[9] That this part of their life was not separated from their artistic and feminist pursuits is indicated by a *Tatler* review of Hall's novel, *The Unlit Lamp*, written by Carlo F.C. Clarke for his 'Ladies Kennel Association

Notes' column.[10] Clarke, who together with his wife was a well-known bulldog breeder and a regular at sporting events around the country, was full of praise for *The Unlit Lamp*.[11] Describing it as 'essentially a "woman's book" that will nevertheless appeal to a wide readership', Clarke recommended *The Unlit Lamp,* arguably Hall's most overtly feminist novel, to his readers, but concluded, 'My only regret is that Miss Radclyffe Hall has no "doggy" character like the dear dachshund in *The Forge*.'[12] Clarke's review provides unique evidence of Hall's reception beyond explicitly literary and political audiences: it is the shared interest in dogs that piques Clarke's interest in Hall's work. This allegiance went beyond sexual politics. *The Forge*'s 'dear dachshund' was based on a real dog, Champion Brandesburton-Caprice, known as 'Thora the Fairest of Women', a red dachshund given by Hall to Troubridge. According to Troubridge, Thora 'crept into *The Forge* under the name "Sieglinde", though some of that lady's adventures were imaginary'.[13] It is perhaps no coincidence that Clarke's review was published on 21 January 1923, the week before the annual Crufts meeting, thus bringing the writings of the well-known dog breeder to the attention of non-literary audiences.

Hall and Troubridge considered themselves to be at the forefront of canine welfare. They advocated a modern, kind approach to dog ownership, which made them unpopular with some of the more traditional breeders. As Troubridge noted, such people 'thought us cranks' and 'resented our championship of the exhibits as sentient creatures and our unrestrained denunciation of certain inhuman practices and of those exhibitors who, provided a dog could win for them, thought it quite permissible to leave the shivering beast deserted and lying on a bed of scanty straw through the long winter nights of a "three day" Crufts or Kennel Club show'.[14] It is not surprising that Hall and Troubridge eventually stopped their efforts as breeders. The reason they gave for this decision was not that they saw a problem with breeding dogs per se, but that they found it too hard to part with the puppies. They alienated many potential buyers by putting them through lengthy interviews and imposing stringent conditions on them.

The 1923 photograph of Hall and Troubridge at Crufts is one of many that show them, individually and together, with their dogs. It is fair to say that critics tend to acknowledge the presence of the dogs largely in passing. If we look more closely, however, we see not only the humans who have become iconic figures in queer and trans histories. Queerness is not tied just to the vagaries of human bodies, desires and gender expressions. Capturing something of the complexity of their lives, this photograph, and others like it, reminds us that queer history exceeds the study of gender and sexuality and that queer lives and histories encompass all kinds of close relationships, including those between humans and animals.

Radclyffe Hall holds a French bulldog, c. 1930.
❧
Opposite: Una Troubridge.

Nᵒ VIII. SOUTH ELEVATION.

SCALE. IV FEET TO I INCH.

The cottage for Mesdames Drysdale and Newcomb, south elevation.

34. Our Own Dear House

BEV ROBERTS

Coriyule is in many ways an extraordinary house. It is even, in at least one sense of the word, a queer house. Built in 1849 on a sweeping stretch of farmland overlooking Corio Bay on Australia's Bellarine Peninsula, it has been regarded as something of a curiosity: a gingerbread Gothic villa quite out of context, as if transposed from an urban milieu to a windswept and isolated sheep run. The house seems the antithesis of the plain Georgian dwellings and low, sprawling homesteads that typify Australian colonial architecture. With its solid stone construction, Coriyule has defied time and weather and is now well into its second century, although it gradually fell into some disrepair under a succession of owners and tenants. Not surprisingly, this strange house, with its steeply pitched gables and diamond-paned windows, became the perfect haunted house in local folklore, complete with ghosts, spectral piano music and lurid rumours about the use of the enormous cellar.

The current owners have carried out extensive restoration and renovation work on the house and its surrounding gardens and Coriyule has become a regional showpiece. But the property is of more than local interest and importance. It is included in the Victorian Heritage Register, which describes it as one of the 'earliest and finest homesteads in Victoria', with a Gothic Revival style uncommon in the state, a notable early design by the famous colonial architect Charles Laing, and 'historically significant as a reminder of the partnership of the women squatters Anne Drysdale and Caroline Newcomb, who were important in the history of squatting in Victoria. It

is a remarkable reflection of the close involvement of women in a pioneering pastoral enterprise.'[1] This last point was the most extraordinary thing about the house: it was built for two women and is now their memorial.

Anne Drysdale and Caroline Newcomb each made the long voyage to Australia alone, for different reasons and at different stages of their lives. Anne, a 47-year-old Scot from a well-connected Fifeshire family, set off in 1839 with the unusual aim of becoming a sheep farmer. She had previously leased and managed her own farm and saw herself as no different from the many Scottish men of her class who sought land and fortune in Australia. A month after arriving at Port Phillip in March 1840, the formidable Miss Drysdale had acquired Boronggoop, a 4000-hectare run near Geelong, and a flock of 2000 sheep. Fellow Scottish pioneer Dr Alexander Thomson organised the land and livestock for her, drawing upon his own extensive holdings. The Thomson family invited her to stay at their home in Geelong while her own cottage was being built. There she met the young Caroline Newcomb. Little is known about Caroline's early life, although she was described by a contemporary as 'of education and good breeding'. She left England in 1833 at the age of 21, possibly for health reasons, and sailed to Tasmania. In 1836 she left for the mainland, becoming one of the first women to arrive in Port Phillip. The following year she moved to Geelong to live with the Thomsons as governess to their daughter.[2]

During the year they were together at the Thomson house the two women became close friends, and Anne invited Caroline to join her as a partner in her new squatting venture. They moved into the four-roomed timber cottage at Boronggoop in 1841. Trading as Drysdale & Newcomb, the women ran a successful pastoral and farming business for nearly a decade. Despite their 20-year age difference, they worked well together. Anne had the capital, the social connections and the confidence of her class and farming experience. Caroline had little money of her own, but she contributed her considerable practical skills and energy toward managing the property. 'Tell me what a man can do that I cannot,' Caroline is said to have declared.[3] Anne described her as 'the best & most clever person I have ever met with' and boasted in a letter to her brother that 'Miss Newcomb ... has a head equal to 10 men at least.'[4]

The pair played an active part in Geelong's social scene. They exchanged calls with the 'respectable' families of the district, provided hospitality to visitors and travellers and were involved in the affairs of both Wesleyan and Presbyterian churches. Their small house was usually filled with people, including many visitors and guests from England and Scotland, who brought

letters of introduction from relatives or friends. According to one local, 'The novelty of two lady squatters attracted considerable attention, and whilst it drew many to them whose acquaintance ultimately grew into a lasting friendship, it was not unattended at times by inconvenience. Many persons on visiting Geelong out of mere curiosity to see the lady settlers, obtruded themselves upon them at most inconvenient times.'[5]

After eight years the Boronggoop cottage was deteriorating and the women decided to build a more substantial house on land they had acquired on the Bellarine Peninsula. Construction began in early 1849 and they moved in later that year, with Caroline recording in her diary, 'My dear partner and I, through the kind mercy of our God, came in safety to our new abode …' The 'abode', named Coriyule, was designed and decorated to their specifications and soon became a home with spacious, comfortable rooms and furnishings ordered from England. On the 400-hectare estate the pair scaled down their pastoral business and concentrated on farming, growing fruit and vegetables and raising Clydesdale horses. Their new home was the fulfilment of their long-held wish, recorded in Anne's diary, 'to have a piece of land & a stone cottage', and the women became very attached to it. Once, after they had spent a month away, Anne wrote, 'We returned to Coriyule happy to get back to our own dear house.'[6]

In May 1853, after only four years at Coriyule, Anne died and was buried on the estate. Caroline inherited the property and continued to manage it alone until 1861 when, at the age of 49, she married the Reverend James Davy Dodgson, a Methodist minister 12 years her junior. She leased out the house and land and spent a decade moving around Victoria with her husband on his various postings. When she died in Melbourne in 1874 she was buried at Coriyule beside Anne.

Do the 'lady squatters' belong in a book on queer objects? They would undoubtedly be deeply shocked by their inclusion. Both were ostentatiously pious: Anne Drysdale a Presbyterian, Caroline Newcomb a fervent convert to Wesleyan Methodism. They had 'family prayers' every night; clergymen were frequent visitors to their home and sometimes held services there. Caroline believed she was 'called to a high state of holiness' and felt 'a clear conviction that the Lord has prepared great things for me'. Neither woman believed in indulgence in fashion or luxurious living; both dressed plainly and lived simply. They enjoyed music but not 'a certain kind of song-singing in company that could result in trifling conversation'.

Despite their piety they were regarded as unconventional, deviating in many ways from the norms of femininity that prevailed in the hyper-

masculine world of early colonial Australia. They were independent, unmarried, forthright and outspoken; they engaged in male occupations and in local affairs; and they lived together in a partnership and close friendship. Their relationship was the subject of local interest and speculation. Even in Caroline Newcomb's obituary, a Geelong newspaper referred to her connection with Anne: 'On Miss Drysdale talking up her residence on the coast near the township that now bears her name, [Caroline] went to reside with her as lady's companion. A firm and lasting friendship became established, and the two ladies lived like sisters till the death of Miss Drysdale ...'[7] Later, James Dodgson offered a surprisingly fulsome description of the women's friendship: 'Though diverse in temperament, they beautifully dovetailed into each other. What one lacked the other supplied; they were linked in the closest affection.'[8]

This friendship was probably neither romantic nor physically intimate. Still, the women were quite firmly a couple. Anne's diary during those years was always written in the plural: not just 'we did' or 'we went', but also 'we think' and 'we feel'. 'How dismal it would have been to have been always alone & I have great cause to be thankful for having such a friend as Miss Newcomb,' she wrote. Another diary entry reads: 'All the comfort I enjoy is principally owing to my dear Caroline, who contrives to smooth all my difficulties.' Caroline was rather more emotional, sometimes even effusive. She described her friend's death using the strangely passionate language of Methodism: 'The Lord has cut off the desire of mine eyes with a stroke. My dearest and much-beloved Anne quitted mortality for life on Wednesday the 11th of May. She has entered into rest and is now in the full fruition of perfect love ... and I am left to mourn the loss of her.' A letter written to one of Anne's brothers two years later is slightly less flowery: 'Nothing but a clear Providential direction will induce me to quit the spot where the remains of my Miss Drysdale lie, as I look at her tomb from my parlour window, I seem not quite to have lost her. While gazing upon it, I seem to realize her actual presence.'

Loving, sometimes intense, female friendships were common and unremarkable during the nineteenth century. In an 1858 essay, popular English novelist Dinah Mulock Craik emphasised the depth of feeling between two women and compared it to marriage: 'to see two women, whom Providence has denied nearer ties, by a wise substitution making the best of fate, loving, sustaining and comforting one another, with a tenderness often closer than that of sisters, because it has all the novelty of election which belongs to the conjugal tie itself — this, I say, is an honourable and lovely sight.'[9]

It is difficult, if not pointless, to try to define or categorise such relationships in modern terms such as lesbian, gay or bisexual. The term 'same-sex love' is probably more useful. Claire Hayward suggests that this

broader formulation enables us to recognise the range and diversity of love and shared affection between people of the same sex, and she argues for recognition of the 'bigger picture of the history of same-sex love'. This history has so far been 'symbolised by the fight for visibility and equality', but it is also 'about loving relationships'.[10] In these terms Anne Drysdale and Caroline Newcomb certainly merit a place in our history.

A few mementoes of their lives remain in both the State Library of Victoria and Museums Victoria: four volumes of Anne Drysdale's diary, a mourning brooch made from both women's hair, the architect's plans of Coriyule and an engraved silver teapot. This last was a trophy awarded to Caroline Newcomb at an agricultural show for her 'Potatoes, Cauliflowers, Asparagus & Turkeys etc'. It seems fitting, though, that the remarkable house they built is the most enduring monument to their life together.

The two women's teapot and the mourning brooch made from Anne and Caroline's hair.

35. An Attic Apartment

CHRIS BRICKELL

In 1947 David Wildey, a returned soldier and schoolteacher, took an apartment in an old house in inner-city Christchurch, New Zealand. Tucked up on the first floor, the single room felt like an attic. It was the prototypical artist's garret, with timber panelling extending up the walls and into the space underneath the pitched roof. The privations of a garret were apparent too: there was no kitchen or bathroom; for those David had to descend the stairs to shared facilities on the floor below. We know something of the layout because he jotted details in his diary. An inveterate hoarder, he retained copies of letters from friends who visited and kept a series of photographs that show his arrangements of domestic objects that gave shape and meaning to the space.

A set of shelves held books on a range of themes, including music, biography, art and indoor plants. A large radiogram took up the space nearby. There were two daybeds with cushions. A table held a lamp, a crystal bowl, a decanter, a smaller radio and a selection of photographs; a tasteful sculpture sat on another table; more pictures hung on the walls. The selection and arrangement of items seems purposeful, a reflection of the

The tasteful arrangement of David Wildey's apartment.

wider significance given to domesticity. In their writing on queer interiors, Matt Cook and Andrew Gorman-Murray suggest that choices of furniture and décor are both personal and social: they demonstrate their owners' taste and sophistication, and an attachment to a particular community. The domestic interior, they add, 'provides a means for the queerly identified individual to couch and present their difference while also showing a conventional investment in the culturally central space of the home'.[1] David Wildey curated culture as he assembled his interior from a range of household items.

The apartment was also a place where men socialised and bonded. It was occasionally home to Keith Hulme, David's partner from the early 1950s, although the couple did not often live together. David was also a member of a sizeable gay network. 'I have memories of gay parties and riotous fun in the fifties in Christchurch,' he later told friends.[2] One day in 1951 David ran into an old military pal and his lover in town, who 'were staying at an awful bed-and-breakfast in Bealey Avenue. I of course invited them to my beautiful aerie [sic] on Park Terrace.'[3] David rescued John and Bert from their ordeal of anonymous tastelessness and brought them home to his den of queer comfort. Many other men visited his apartment. Denys lived in the same street and turned up from time to time; Geoffrey, who lived in Nelson, some 280 kilometres away, would 'ask for a blanket' whenever he visited Christchurch.[4] David also mentored men who were less certain where their erotic interests lay, and the apartment – and its contents – assisted in his tutelage. Frank, another friend, wrote to him years later: 'I hope you realise how much I enjoyed your attic and the stimulation of your company amid fine books, good music and a comfortable bed.' Somewhat cryptically, he added: 'I was very inhibited in lots of ways but you were a great help to me in self-realisation.'[5]

As Frank's letter shows, there is no doubt that David Wildey's records, books and beds played an important role in his and others' developing erotic sensibilities. Although many of his books were about music and art, a diary records the titles of those that dealt with sexuality. Gore Vidal's *The City and the Pillar* (first published in 1948), Donald Webster Cory's *The Homosexual in America* from 1951 and John Rechy's 1963 *City of Night* were three of many gay titles.[6] Perhaps these influenced Frank's 'self-realisation'. The privacy of the apartment also allowed David and his guests to take off as many clothes as they liked. In one photograph David, dressed only in a posing pouch, lies on a pile of cushions and props his feet on the back of a wing chair, hanging upside down. In another he wears the same minimalist outfit at afternoon tea time. He had a caller, presumably the photographer: tea awaits in two tasteful flower-patterned cups. Hospitality, domestic objects and cosy pleasures gave meaning to each other in David's attic apartment.

Not everyone, though, viewed the flat as a haven, and sometimes one particular kind of domestic pleasure caused conflict. David's music set the tone for socialising as well as time alone – a friend told him in a letter, 'I have a reasonably happy life, I think music makes up for a great deal' – but others in the building felt differently.[7] In 1959 the landlord's representative passed along a letter of complaint. The music was not in itself offensive – it was mostly opera and classical, LPs played from a large collection that lived in one of the bookcases – but the volume and duration caused concern. The other tenants 'do not intend to put up with excessive and loud playing of your tape recorder and radiogram until the late hours of the evening and early hours of the morning ... Would you therefore please endeavour to keep your radiogram and tape recorder at a reasonable volume.'[8] One person's comfort was another's source of irritation.

Sadly, it was not only the neighbours' response to David's music that took the shine off the apartment. In 1964, the same day that he had his friends Derrick and Ron over for lunch, another acquaintance of theirs, a draper named Allen Aberhart, was beaten to death in nearby Hagley Park, a popular cruising spot. Several youths set out to 'belt up a queer', and Aberhart got in the way.[9] The apartment's value as a retreat had been compromised by this nearby event: David later described it as a 'beautiful/tragic environment'.[10] He spent more and more time living in Auckland, although he kept the lease until the house was demolished in 1968. For 15 years, though, his 'aerie' – an eagle's nest filled with books, music and social opportunity – had been a happy place that David Wildey and his guests made their own.

A bookcase and a radiogram.

⮞

Opposite: Geoffrey visits the attic. David poses before a cup of tea.

36. The Rotary Dial Telephone

MATT COOK

My first memory of a telephone is of a paint-splattered black rotary dial model that sat on a stool at the foot of the stairs in my childhood home near Burton-on-Trent in the middle of England. The design had changed relatively little since the 1950s, though the one we had was made of plastic rather than Bakelite and was more curvaceous than some of those earlier models. It stayed with us well into my teens and for most of that time was one end of a party line. This meant you had to press an extra button at the top of the phone before you started dialling. Sometimes you caught snatches of conversation from our mysterious phone partners and they, presumably, caught snatches of ours. This odd incursion into our home was not the only way in which this phone felt less than private. Positioned in the most accessible part of the house, it was a functional object rather than one for intimate conversations you might not want overheard. My mother invariably appeared, wanting to know who was calling, and phone time was also curtailed: she wanted the line kept free so others — especially my five older siblings — could call in. They often called from public payphones (also black back then and with a rotary dial like our domestic model) and reversed the charges. The phone introduced a certain anticipation and anxiety into our home. I remember being excited when it rang when I was little — was it one of my big brothers or sisters? — but I also remember my mother's worry when my sister called in the evening from a payphone in Leeds in the late 1970s. Having no phone in her house, she walked between home and the call box at a time when the Yorkshire Ripper was still at large.

In the early 1980s, when my brother returned from university in Manchester, he stuck a 'Rock Against Racism' sticker over the disc in the middle of the dial. It fitted perfectly. Other stickers followed, overlaying those that went before. In my early teens I remember a smiley yellow 'Nuclear Power? No Thanks' sticker looking back at me as I chatted,

Opposite: Dirk Bogarde in the film Victim, 1961.

sometimes awkwardly, to new friends. I had begun to realise that I fancied one or two of them, and in those phone conversations I doodled on that sticker as I guarded my enthusiasm. The sticker gained glasses and the sunny smile soon turned down: I wonder how that conversation had gone? In 1986 the 'Don't Die of Ignorance' AIDS leaflet landed on our doormat. I was 16 and there was one piece of information I took note of immediately: the number of Gay Switchboard in London. This time privacy was imperative and I waited until I was home alone to make the call. Although I do not recall exactly what we talked about, I feel I do remember the voice of the real live London gay man at the other end of the phone. On my visits to my oldest brother's flat in London I had surreptitiously checked out the bars and clubs in the capital, and the attractions of Brighton in the lesbian and gay section of *Time Out*, a London listing magazine. I imagined the faceless, nameless, but seemingly self-assured Gay Switchboard volunteer to be part of that scene. London already had a queer appeal to me.

Our black stickered telephone was an emotionally charged object, especially for me as an uncertain, naïve queer teen. The phone was both a hub in a familial network of support and a tenuous link to a thrilling, and terrifying, queer world beyond. My subsequent historical research has alerted me to the ways my domestic experience of that object in the 1970s and 1980s touched broader queer cultures, networks and politics. The phone I am remembering is a kind of queer source. Even though it was quite ordinary in and of itself, it sits at the heart of my queer memories and opens lines into the queer past.

In the early 1950s in rural Dorset the teenager Rex Batten had a short-lived but passionate affair with Ashley, a man in his thirties. A couple of years later Rex moved, with a different boyfriend, to a bedsit in Camden, north London. The payphone in the communal entrance hall brought news of Ashley's arrest for having sex with another man. Rex's rendition of this saga in his fictionalised memoir, *Rid England of this Plague*, pivots on that payphone.[1] It becomes a totem of anxiety as he recounts incoming calls, messages taken by the landlady and discreet or evasive conversations. Phone numbers recorded in address books or passed on on scraps of paper could be incriminating and Rex feared that the phone might bring alarming news. Was the net that snared Ashley closing in on him too?

Sometimes home did not seem the safest or most relaxing place to be, and Rex and his boyfriend would go to the local cinema in order to escape the phone and what it might portend.[2] There he recalled seeing *Victim*, the 1961 Dirk Bogarde film of queer blackmail.[3] The movie stayed with him, probably

The author as a teenager.

because it was among the first overt and sympathetic films about queer life, and perhaps also because it touched on the particular anxieties that often accompanied such lives before the partial decriminalisation of sex between men in England and Wales in 1967. In the film the telephone communicates those feelings and brings them home. The blackmailer threatens his victims from payphones; one of these is later depicted anxiously calling his wife, who waits uncertainly at home. The phone also communicates a sense of loneliness as isolated figures are shown talking fearfully into black mouthpieces. The telephones in *Victim* are a means of conveying the complex knots of emotion that then characterised queer lives.

Phones could be both lifelines and love lines. Rex recalls whispered conversations with his boyfriend and reassuring calls with his parents. Some 30 years later, during the early 1980s, the photographer and queer archivist Ajamu X used to wait outside a payphone in his hometown of Huddersfield, Yorkshire, to speak to his first boyfriend – the only other black guy he encountered at the Gemini club, Huddersfield's local gay venue.[4] Professionally printed and also handwritten cards were often jammed into the window frames and around the phone in these phoneboxes, at least in bigger British cities. These mostly advertised female escorts, but some were placed by rent boys and men seeking casual sex with other men. This

ephemera heightened the sense of the phone and the phonebox as conduits of erotic and monetary exchange. The rotary dial domestic phone and the payphone came to symbolise multiple dimensions of queer life. They were folded into lived experience, bringing other places and people to bear on (and challenging) an insular sense of locality.

Payphones, and the distance between them and my sister's shared all-women house in Leeds' Chapeltown area was, as I have said, a source of real anxiety for my parents. The appalling attacks and murders of women in that area and beyond added an urgency to local feminist activism against male violence. Organised resistance included one of the first Reclaim the Night marches in the country, arson attacks on porn shops and a raid on a misogynist exhibition. Activism was mobilised through telephone trees: each woman related the planning, details and consequences of actions to a designated list of others, who would in turn pass information on to the women on their lists. In this way, waiting for, receiving and then making calls from pay and home phones was an integral part of feminist and lesbian politics, as it was of radical action more broadly. During the early 1980s a group of would-be lesbian mothers in Leeds also relied on the phone. A go-between collected sperm from donors, some the members of an anti-sexist men's group, and phoned ahead to tell recipients it was on its way.[5]

Lesbian Line began operating in Leeds in 1978. It had been initially intended that Gay Switchboard, established around 1974 in 'a really grotty basement' owned by the university students' union, would cater for gay men *and* lesbians. But many lesbians felt women should be able to call and know they could speak to another woman. As one volunteer remembers, some had 'terrible terrible stories: it was important to recognise that gay men's agenda was not our agenda'.[6] Leeds Lesbian Line ran from that same phone and the same basement on a Tuesday evening. It was an uneasy cohabitation. Some gay male callers felt they were treated roughly when they called on the wrong day. One 'heard quite a few stories that if they rang up on Tuesday, they really got a bollocking from the women'. A former volunteer, though, said men were 'politely asked to ring on another night'. 'The fact that we had one night and they had six nights meant that those two hours were kind of precious.'[7]

Manchester's Gay Switchboard was also set up in 1974 at the students' union and then moved to a cramped basement in Waterloo Place. Manchester Lesbian Group, a TV/TS group, Manchester Campaign

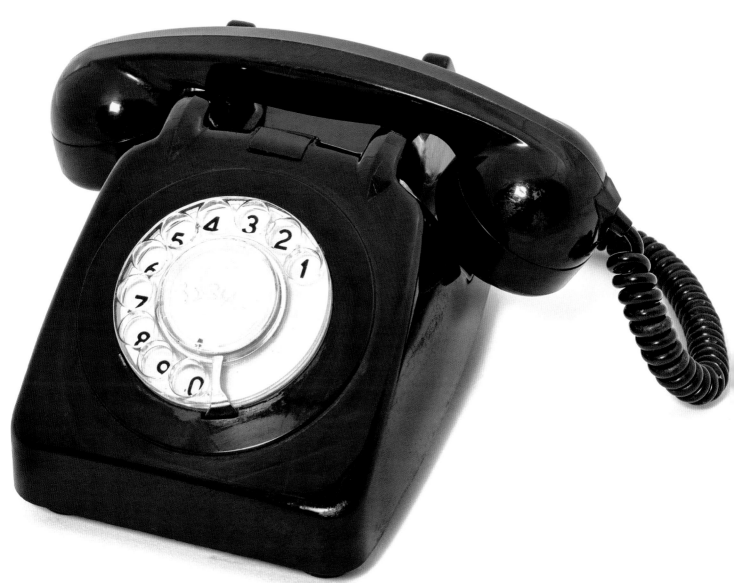

for Homosexual Equality, and Friend, the associated lesbian and gay counselling service, also moved in. Together they formed a gay centre that has endured until the present in three successive venues. The lines out of the centre offered advice and information on a scene that was still often difficult to access: *Gay News* tended to be London-centric; *Mancunian Gay* was not launched until 1982. In its first year Manchester Gay Switchboard received around 1200 calls; by 1988 it took about 18,000 a year. Callers sought information, support and respite from the isolation many felt when living or arriving in the city.[8]

Other cities' phone lines were attuned to specific local and particular queer dynamics. Tipped off by callers, local phoneline volunteers passed on news of one-off or last-minute events, protests and marches, or spates of arrests in particular places. Prudence de Villiers helped set up the Lesbian Line in Plymouth in 1984 after reading a letter to the feminist magazine, *Spare Rib*,

from a woman who had no one to turn to in a city better known for its sailors than its lesbian scene.[9] In Plymouth, as in other cities, bands of volunteers were needed to answer calls. They trained, socialised and fundraised together; phonelines spawned friendships, relationships and communities beyond the commercial scene. And I now imagine the phones and grotty offices of these various gay and lesbian helplines being covered in stickers like the ones in the middle of my family's old rotary dial, marking connections between gay and lesbian and other movements and causes.

Volunteers on the phone lines were especially attuned to virulent and escalating homophobia during the 1980s. People would ring up 'and abuse us, tell us what poofs and perverts we were,' said one Leeds volunteer.[10] Volunteers were also at the coalface as the AIDS crisis hit. They could be the first point of contact for many people with the virus and others who were worried about catching it. When the Don't Die of Ignorance campaign was launched in 1986 London, Gay Switchboard lines collapsed under the weight of calls; I probably had not helped. In Manchester in 1984, switchboard volunteers set up a dedicated AIDS Line to deal with the demand for information on the subject. Demand grew, and AIDS Line became the George House Trust, Manchester's main AIDS advice and support charity. Less formally, telephone trees like those deployed radically in Leeds and elsewhere in the 1970s were used to share news of sick or dying friends, and to pass on details of funerals and memorials. The phone was an ambivalent object for Derek Jarman in the late 1980s; sometimes he let it 'ring off the hook' rather than face the news it might bring.[11] Early in the epidemic he recounted the experience of being the caller rather than the called – spending 'an anguished night … making telephone calls' to the lover and parents of a newly diagnosed friend who had six months to live.[12]

By the time I was in my late teens it was easy to install extra phone sockets and extension cables. My parents replaced our old phone with three white push-button models in plastic wall-mounted cradles, in the kitchen, in their bedroom and in the hall. I could now retreat with a phone, but I was always alert to the possibility that someone might pick up elsewhere in the house. I was more confident in myself by now and perhaps because of this, and because phones had become more ubiquitous, this new generation of equipment has less of a place in my queer memory or nostalgia. When I bought a phone for our new home in London a couple of years ago I chose a

replica of the rotary dial model from my childhood. This version has a kitsch twist: it is sprayed silver. It recalls those queer telephonic dynamics of my early years and speaks to the wider place of such phones in queer networks and emotional landscapes of the 1960s, 1970s and 1980s. That campy silver, not available back then, marks the distance travelled since. I barely use this pseudo-model. Unlike my smartphone, it does not move with me, does not have those apps and does not hold my calendar or photos. All those things are part of a different queer telephonic culture. As an object in my living room, though, my silver dial phone glances at the past and draws lines of connection to and between queers across the country.

The classic British telephone box, 1960s or 1970s.

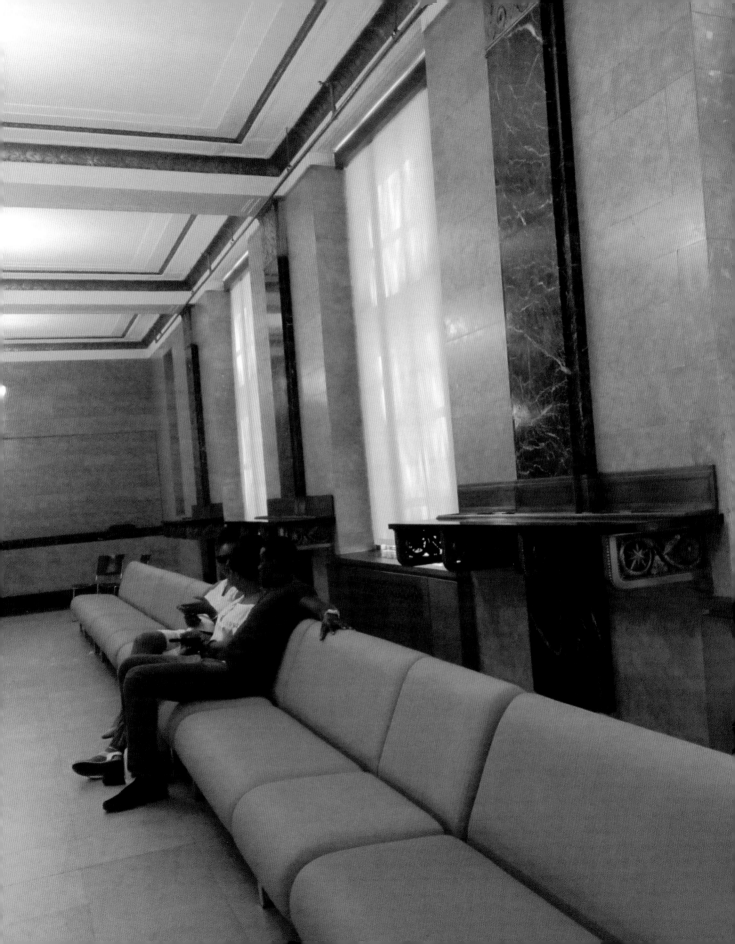

37. C734

CHRISTOPHER CASTIGLIA & CHRISTOPHER REED

C734 is printed in big type on a small tab of paper. Above it, in smaller type, is this:

> Office of the City Clerk
> The City of New York

And below:

> Welcome 1:57PM
> Please have a seat

We followed the instructions. Having pulled this tab of paper from the machine in the Marriage Bureau of the Office of the City Clerk of New York in Manhattan, we waited our turn. What could better represent our induction into a state-sponsored, ruled and regulated institution of marriage than this flimsy receipt?

We worry. We worry we've let everyone down. We've certainly let down Michael Warner, whose well-known 1999 essay, 'Normal and Normaller', warned: 'If the campaign for marriage requires wholesale repudiation of queer culture's best insights on intimate relations, sex, and the politics of stigma, then it is doing more harm than marriage could ever be worth.'[1] Even worse, we've let down Michel Foucault, who contrasted the conventional heterosexual emphasis on the promise of anticipated sex implied in 'courtship' with a gay sensibility so nostalgic that 'the best moment of love is when the lover leaves in a taxi. It is when the act is over and the boy is gone that one begins to dream about the warmth of his body, the quality of his smile, the tone of his voice.'[2] Heather Love describes the 'dreamy and rueful' mood Foucault ascribes to gay men as something he 'would not easily give up' for 'the daytime love and easy intimacies of a domestic partner'.[3]

At least we didn't go full frontal, as in Laura Kipnis's description of the conventional marriage ceremony:

> those that play by the rules will be community-sanctified with champagne and gifts in the expensive over-rehearsed costume rituals of the wedding-industrial complex (its participants stiffly garbed in the manner of landed gentry from some non-existent

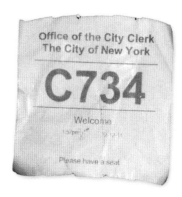

Ticket C734.

❧

Opposite: The waiting area in the city clerk's office.

❧

Overleaf: Shadowbox of Valentines and souvenirs.

epoch: clearly, playing out unnatural roles is structured into these initiation rites as a test of the participants' stamina for role-playing as a social enterprise and as a measure of their resolve and ability to keep doing so in perpetuity).[4]

We had, of course, already been waiting a while. As Warner documents, same-sex couples have been lining up to be formally married in the United States at least since 1970, when two lesbians in California and two gay men in Minnesota had their applications for marriage licences denied by their respective states. We had watched with ambivalence the fitful, sometimes temporary legalisation of civil unions and marriages in a few smaller states, as well as the backlash of homophobic legislation through which many other states prohibited recognition of same-sex marriages. In 1996 we had seen Congress pass, by an overwhelming majority, the Defense of Marriage Act, which prohibited the federal government from recognising same-sex marriage and flagrantly overrode the Constitution by allowing states to ignore marriages legalised in other states. We waited for the outcome of this collision between Congress and Constitution. Finally, in June 2011, the State of New York, which has a population of almost 20 million, legalised same-sex marriage. The fact the resulting unions might be unrecognised in other states added an urgency to the cases wending their way toward the Supreme Court, and we wanted to help ratchet up that pressure.

We picked up the licence at 2pm on Friday and waited until 1.57pm on Monday, 12 December 2011 to get married. We had been together since 1982. We could wait a little longer. Waiting produces its own ambivalent emotions. On the one hand it is an injunction to order, a call to conformity, proof that one is just another in a series of the same. On the other hand, waiting offers the promise of fulfilment: 'good things come to

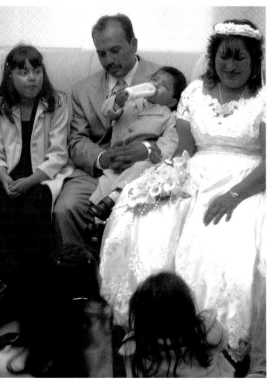

those who wait', or so they say. Waiting seemed to be on the mind of those who lingered before us in the Marriage Bureau. Since 2009 the Marriage Bureau of the Office of the City Clerk has occupied the marbled ground floor of an Art Deco office building near City Hall. The amenities make the wait feel more like a celebration. There are elaborate restrooms with full-length mirrors, and a store selling such props as fresh flowers, wedding rings, commemorative mugs ('I got married in New York City') and T-shirts ('SPOUSE A' and 'SPOUSE B'). Interior designer Jamie Drake, a self-described 'fixture in New York's glittering social scene', oversaw the renovations. He had previously overseen home remodels for Madonna and Mayor Michael Bloomberg.[5]

The surge of weddings meant we waited quite a while. But the wait offered its own reward as we witnessed the spectacle of celebratory urban diversity performed in the liveliest part of the waiting area: the space in front of a mural-scale photograph of New York's cupola-topped City Hall, where couples and wedding parties pose for pictures. Foucault's critique of governmentality comes to mind: this is, after all, a picture of a seat of government. But the city hall looks diminutive in relation to the scale of the posing people; it is a mocked-up model of a New York monument we could climb if we chose, like King Kong on the Empire State Building. Moreover, this civic backdrop authorises contradictory ideas about state regulation and internalised control. It endorses the rebellion of a local government's doubling down on the state's challenge to national law while furthering the ideals of unruly urban diversity that feminist philosopher Iris Marion Young celebrates as 'the politics of difference'.[6] Gathering couples, straight and otherwise, represent a spectrum of New York's social, racial and linguistic demographics. Employees of the city clerk speak a wide variety of languages; the happy couples exhibit a wide diversity of outfits and expressions.

We waited with a serious Chinese family; a Latina in full bridal regalia attended by a bevy of children in matching formal attire; hipsters in dreads and expensive drab sweaters; a lesbian couple in matching sequinned vests with a large entirely female wedding party (whom we cattily identified as all their exes); a tall blonde bride in a blush-making mini-dress (we blushed – she seemed perfectly happy with her even taller beau); and other male couples in suits that ran the rainbow range. The mood was celebratory. Everyone seemed to enjoy the unexpected spectacle of which we were all a part.

At last our number flashed on an electronic screen and we were rushed into one of two secular 'chapels', each decorated with a

large abstract painting and glass shelves displaying heavy leather marriage registers dating back to the last century. The presiding judge was kind, funny and efficient. She said some words neither of us can recall. We affirmed and kissed. What we do remember are the leather-bound ledgers and the slip of paper numbered C734. Both are bureaucratic records, evidence of institutional authority beyond our control. Over the long haul, though, time draws some of the sting from institutional power. Institutions rise and fall. Ledgers full of signatures recording acts that carry the force of law are transformed by the passing of generations into relics of the past. The authority of marriage seems blunted by the endless pages of data. All those varying handwritings record a plethora of names, ethnicities and human stories. Some of these marriages must have been long, some short, some happy, some tragic, but the state had limited power to determine those outcomes.

There is something powerful about imagining our names added to the roster, just as there was something joyous about the waiting room where so many couples in various familial configurations celebrated an occasion that clearly meant many things. The numbered ticket that marked our entry into that waiting room asserted the regimenting authority of the state but it also seemed like a key to a Magic Kingdom, a city part Disney, part Oz that made a mockery of order and sameness, solemnity and power. At the same time, it reminds us of similar tickets we've pulled from other dispensers when we waited for meats and cheese at delicatessen counters, associating the power of the state – including the marriage rights long denied by that authority – with the rhythms of everyday domesticity that queer folk managed on our own before officially sanctioned marriages came along.

Now the wait was over. Our deed was done. We left City Hall with our 'best men', one of whom had introduced us 35 years earlier. Somehow in the timeless time of waiting we never planned what to do next. So we bought a hot dog from a street vendor – no line there – and ate it together, each starting from an opposite end, a tasty, sexually suggestive travesty of the ritual of sharing the first slice of wedding cake.

The tab of paper is now part of a shadowbox that hangs over our bed, otherwise filled with valentines we've saved through the years. Some of those were good years, others maybe tense. Hallmark cards nestle alongside homemade valentines that register, in their craftiness, a willingness to give time. Feminism taught us long ago that the personal is the political, so it seems right that in this collection of attestations of personal sentiment we feature a state-issued ticket that links our personal affiliation with a celebration of secular urban values, marked by an appreciation of the density of human history and delight in diversity. Maybe we delude ourselves, but by framing our wedding this way this slip of paper signifies our belief that we can have our queer (wedding) cake and eat it too.

Groups at the New York City Clerk's Manhattan Marriage Bureau, 2011.

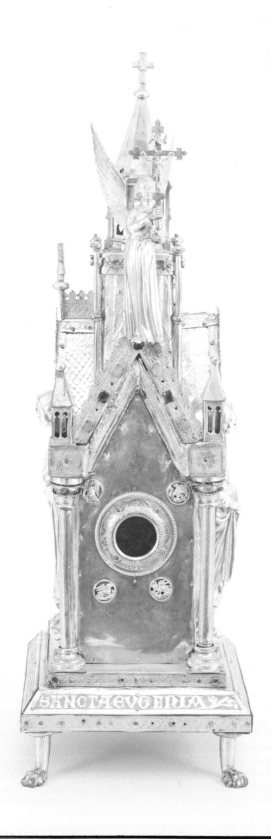

38. Saint Eugenia's Relics

ROBERT MILLS

Secreted away in the treasury of the church of Saint-Pierre in Varzy, a provincial town in Burgundy, France, is a small but elaborately decorated medieval reliquary fashioned as a miniature sanctuary complete with a spire, turrets, columns and gem-encrusted gables.[1] The four sides of this churchlike structure take the form of architectural niches. Three of the four niches are decorated with human figures in high relief; the fourth features a circular glass aperture with a decorative, gilded frame. Hovering at the corner of the roof above the opening is a statuette of a winged angel bearing a crucifix. By peering through the glass below it is just possible to make out the reliquary's contents: one or more grey-brown objects, perhaps pieces of bone, along with a slip of white paper or parchment. Mounted on clawed feet, the base is inscribed with four names — Agatha, Cecilia, Eugenia and Agnes — which presumably correspond to the three figures and the opening respectively. The Latin word *sancta*, which prefixes each name, signals that the individuals in question are saints. As a grammatically feminine term, *sancta* also indicates that these are holy women. Yet all is not quite as it seems.

Since the Middle Ages the bones in the reliquary have been thought to belong to the early Christian martyr, Saint Eugenia. Legend suggests Eugenia was the beautiful and intelligent daughter of a man called Philip, who was sent with his family from Rome to Alexandria to serve as the city's prefect during the reign of Emperor Commodus (AD 180−92). In Alexandria Eugenia discovered Christian teachings and resolved to find out more. When she came of age, having refused a suitor in marriage, Eugenia left the city with her two eunuch slaves, Protus and Hyacinthus, and encountered a band of singing Christians. This only increased her zeal to pursue the faith. With the slaves' help she donned male attire and had her hair cut short. Subsequently she met a devout bishop, who admitted her to a monastery despite seeing through her disguise. Dressed as a man and calling herself Eugenius, he

The reliquary of Saint Eugenia that dates from the first half of the thirteenth century. Photograph taken in 1965 by Luc Joubert in conjunction with the exhibition Trésors des Églises de France at the Musée des Arts Décoratifs, Paris.

– for no one but the bishop suspected that Eugenius was a woman – was eventually elected abbot of the house. He was praised for his piety and humility. Melantia, a rich widow of Alexandria, came to Eugenius to be cured of an illness but, taking him to be an attractive young man, fell in love with him. Eugenius turned down Melantia, who took revenge by accusing Eugenius of raping her. The case was brought to trial in the presence of Eugenia's father, Philip, who failed to recognise the defendant. Eventually, in desperation, Eugenius/Eugenia tore open their tunic, displayed their breasts to the judge and spectators and revealed their identity as the prefect's daughter. Eugenia later returned with family members to Rome, where her missionary work meant she died a martyr's death.[2]

The pronouns used to refer to Eugenia in the preceding synopsis shift between 'she', 'he' and 'they'. Hagiographers of the Middle Ages who recounted the saint's legend mainly referred to the saint using female pronouns, even after they described how Eugenia entered the monastery wearing male garb. In my own retelling, in a nod to the narrative's queer potential, I occasionally refer to Eugenia using the more equivocal 'they' or 'their'. This genderqueerness casts its shadow during Eugenia's

The reliquary of Saint Eugenia, made from silver, gilded and silvered copper and glass over a wooden core.

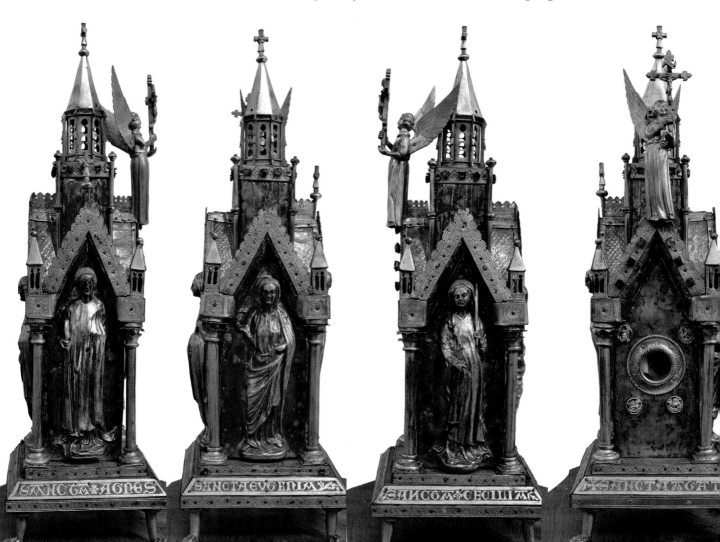

trial. One Latin version of the text has the saint declare in court that just as loving God is a 'manly' (*uiriliter*) pursuit, so they have 'performed the perfect man' (*uirum gessi perfectum*) by wearing male clothing and maintaining chastity for Christ.[3] The saintly protagonist does not perceive their maleness as merely an effect of costume and outward appearance; it also extends to their inner disposition as a God-loving, virginal subject. In other words, Eugenia's gender crossing does not just entail acts of 'cross dressing': virginity and piety are themselves perceived as virilising qualities. The 'perfect man' performed by the saint is implicitly Christ, whom Eugenia wants both to be and have.

In 1920 the American classicist Campbell Bonner published an article on the legend's sources, which reduced Eugenia's story to a formula: 'A young woman who has been led by some stress of circumstances to adopt male attire is accused of immoral conduct and obliged, in order to establish her innocence, to disclose her sex to her judges.'[4] Rendering the legend formulaic has the effect of lessening or containing its queer potential; the abbreviated summary begins and ends with clear statements about the saint's true 'sex' and relentlessly reiterates Eugenia's overriding femininity. These statements echo most surviving depictions of Eugenia in medieval and Renaissance art, which present the saint as an unambiguously female figure. A statue from around 1500, also in Varzy, shows Eugenia dressed as a late medieval noblewoman who wore her hair long. Lengthy hair and feminine clothing also characterise the saint's portrayal in a late fifteenth-century stained-glass roundel now in the town museum.[5] These and other Eugenia-related objects, including the reliquary, are believed to have originated from another church in Varzy, the Collégiale Sainte-Eugénie, which is thought to have acquired Eugenia's relics in the tenth century.[6]

The collegiate church was largely destroyed during the French Revolution and today just a few architectural fragments remain. Before its suppression the church also owned a celebrated sixteenth-century triptych, and this currently sits above the high altar in the neighbouring church of Saint-Pierre.[7] The left-hand panel of the altarpiece shows the saint disrobing during the trial, seemingly caught in a moment of transition between male and female. Melantia points accusingly at the abbot whom she thinks is a man while a strappingly muscular Philip sits in judgement, seemingly directing his gaze at the disrobing of the man whom he will soon discover is also his daughter. Eugenius/Eugenia is shown with a prominent tonsure, their shaven head surrounded by a ring of cropped blond hair. Meanwhile, they pull open their monastic habit to reveal a white undergarment, out of which emerges an uncovered breast. One nineteenth-century censor sought to conceal the exposed breast beneath black pencil or paint.[8] As this was positioned on the saint's right side, however, viewers steeped in depictions of Christ's passion

may have been reminded of the wound in Christ's side.[9] The panel also chimes with some earlier renditions of Eugenia. These include a twelfth-century carved capital in the nearby abbey church of Vézelay, which also depicts Eugenia as an ambiguously gendered or bi-gendered figure.[10]

Visual and verbal representations of Eugenia locate the saint within specific interpretive grids or frames. These frames determine whether the queer possibilities of the story are rendered intelligible or foreclosed by emphasising Eugenia's femininity. Do these frames generate fertile ground for queerness, or do they end up restricting or suppressing that queer potential?

At first glance, Eugenia's bodily remnants have been constrained by the reliquary-as-frame. The relics are linked, through juxtaposition, with three other virgin martyr saints: Agnes, Cecilia and Agatha. These linkages locate Eugenia in a community or genealogy of female sanctity. It is worth noting, however, that the way gender operates in each of these other martyrs' legends is complex. There is no straightforward or unambiguous binary. Agatha's breasts were removed and then miraculously restored during her torments, an ordeal that resonated with Eugenia's transition between genders. While Eugenia protected her chastity by dressing as a man and dedicating herself to Christ, Agnes safeguarded her virginity by spontaneously sprouting an exuberant head of hair that cloaked her from head to foot. Cecilia, for her part, is said to have forcefully persuaded her husband Valerian not to consummate their marriage, and she boldly preached and taught the tenets of Christian faith.[11] What may appear at first glance to be a resolutely 'feminising' representational framework turns out to be more ambivalently gendered. In each instance virginity is inflected with virility in some way.

The words 'Sancta Eugenia' currently appear below a long-haired figure swathed in drapery, carrying a rectangular object, possibly a book, in her right hand. This, however, does not conform to earlier records of the reliquary that show a different arrangement in which the name 'Eugenia' is identified not with a figurative image of the saint but with the side featuring the glass aperture. Photographs taken in conjunction with an exhibition of church treasures in Paris in 1965 indicate that this is how the reliquary appeared earlier in the twentieth century. A coloured lithograph by the sculptor and scholar Jules Dumoutet, who in 1859 embarked on a project to produce a comprehensive and lavishly illustrated study of the Collégiale Sainte-Eugénie, similarly shows Eugenia's name at the base of the side featuring the aperture.[12] Indeed, the reliquary has been identified since the nineteenth century with Eugenia specifically. Although one seventeenth-century report suggests it also contains fragments from the skulls of Agnes, Agatha and Cecilia, it seems likely, given the reliquary's provenance, that Eugenia's relics had special significance for the inhabitants of Varzy. Viewers

were not asked to contemplate only the figurative images of female sanctity displayed on three of the reliquary's four sides, but also the fragments of bone within, and were encouraged, in turn, to meditate on the saints' status as intercessors living in heaven, ready to lend help to their earthly devotees. Their heavenly status is announced by the reliquary's precious metals, gems, glass and architectural form. These recall the Heavenly Jerusalem as described in the Book of Revelation.[13]

This arrangement has important consequences for the ways viewers 'see' Eugenia. The reliquary conveys Eugenia's identity in an indirect, perhaps even abstract manner. Beholders look through a glass darkly, as it were, at the physical remains of a woman called Eugenia, but any anchoring image of that sacred body is withheld from view. Viewers are not simply afforded a vision of Eugenia as a crowned, long-haired woman, as in the statue at Varzy, or as a tonsured male with an exposed breast, as in the sixteenth-century altarpiece. Instead, the emphasis is placed on Eugenia's heavenly state and alignment with Christ. This is announced by the emblems of the

A polychromed statue of Saint Eugenia, c. 1500.

four evangelists that encircle the glass opening. Evangelist symbols were commonly included in medieval representations of Christ in Majesty or Christ as Judge. Seated enthroned and enclosed by a round or almond-shaped aureole, the glorified Christ was shown surrounded by a winged man denoting Matthew, a winged lion for Mark, a winged ox for Luke and an eagle for John. Indeed, on the reliquary itself a different vision of Christ is also afforded by the inclusion of the tiny figure of Christ crucified, carried by the angel above the aperture. As figurative and symbolic devices, these supplements frame the relics' reception as holy objects. They point to Eugenia's transcendent state and align with the man she aspired in life to be.

Two early church fathers, Saints Jerome (c. 347–420) and Ambrose (c. 340–397), expressed the view that religious women could effectively transition from female to male. Ambrose asserted that 'one who does not believe is woman and still designated by the name of the sex of the body, whereas the one who believes progresses to the perfect man, to the measure of Christ's adulthood'; Jerome argued that 'so long as woman serves for birth and children, she is as different from man as body is from soul'; but if she turns herself away from the world to devote herself to Christ 'then she will cease to be a woman and will be called man, because we all wish to attain the perfect man'.[14] There is a palpable sexism in such statements that link womanhood with fleshly worldliness and manhood with spiritual vocation, but they do point to the possibility that some women could transcend their earthly sex through the medium of virginity.

The spectrum of experiences now gathered under the umbrella category of transgender do not neatly align with this idea of spiritual transcendence of bodily sex. The paradigm of 'sex change' that has, until recently, predominated in accounts of efforts to redraw the body's sex contours, began to shift following the emergence of the critical transgender movement in the 1990s. Today, at least in theory, the trajectories for making and remaking trans bodies have proliferated: the existence of women with penises or beards, pregnant men or men with breasts disturb a binary system that insists sex and gender are brought into neat alignment.[15] Eugenia's example likewise renders intelligible some of the other possibilities for doing sex and gender.

Finally, it is worth acknowledging the subjective dimensions of perceptions of queerness in medieval and modern material culture. There is no queer essence to Saint Eugenia's relics: their queerness is fundamentally in the eye of the beholder.

My own personal encounter with the relics of Saint Eugenia was in June 2016 when Jean-Michel Roudier, a conservator at the Musée Auguste-Grasset in Varzy, kindly arranged to open the treasury and remove the reliquary so I could examine it and take photographs. I had passed through Varzy

three years earlier but at that time the museum was closed and I could only photograph the statue through the iron gates that separate the east end from the nave. During my more recent visit, when I had specifically arranged to see Eugenia's cult at close quarters, it seemed as if I might be unlucky once again. The lock to the cabinet in which the reliquary is stored would not open, despite the best efforts of various people, including church officials. Although I could glimpse the reliquary behind security glass I was not able to obtain decent photographs or see it from all angles. I retreated to the museum to inspect other Eugenia-related items, only to receive the news an hour or so later that the reliquary had finally been released from its confinement. This seemed like a small act of providence, though I still only had the opportunity to view the relics themselves through the opaque glass opening.

It was in many ways the continually deferred nature of my encounter with these objects that fuelled my perception of their queer potential. Something about Saint Eugenia always seems to slip from view. We can only speculate about how individual viewers experienced Saint Eugenia's relics in the Middle Ages. Certainly, it is tempting to imagine some of them finding in Eugenia's example a resource for thinking outside the normative sex-gender system. In truth, as with the relics that most faithful could not see and grasp in the cold light of day, such possibilities will rarely be amenable to the scholarly protocols of transparent objectivity and documentary proof. To glimpse the relics' queerness is to bear witness to their excessive temporality and enduring presence as things in the world.

Evangelist symbols surround the opening of the reliquary of Saint Eugenia.

39. A Tram Ticket, an Egyptian and an Englishman

ROBERT ALDRICH

A 'stiff brown notebook, possibly Egyptian, containing EMF's memoir of his Alexandrian lover' is in one file, according to the shelf list for the archives of King's College, Cambridge; '2 visiting cards and a tram ticket' are in another; several 'studio photos' and letters are elsewhere in the collection. These are mementoes of Edward Morgan Forster's relationship with Mohammed el-Adl during Forster's sojourn in the Mediterranean port city of Alexandria when the British writer was engaged in non-combatant service during World War I.

Photos and letters are omnipresent mementoes of loves treasured, rediscovered, lost or wilfully destroyed. Transport tickets are also not uncommon in the curiosity cabinets of lovers. They are souvenirs of an assignation or escapade, a honeymoon or a holiday. Such documents allowed someone to cross a city or the globe to meet a desired friend or to search for one. Anonymous e-tickets and downloaded travel passes now annul the visual and tactile textures of older-style tickets, differently coloured, inscribed in unfamiliar languages and scripts, often torn or punched with a hole, dog-eared, wrinkled and faded from being stashed away in pockets or drawers.

Forster's yellow tram ticket resembles many others, with its numbers and lists of stops, a red pencil mark and figures in blue indicative of its cancellation. The name of the issuing authority, the Société Anonyme des Tramways d'Alexandrie, has been torn off as it was ripped out of a ticket book, but regulations warn in French — the international language of Alexandria — that the holder must present the ticket on demand and should destroy it after the trip's completion. The price is marked, five millemes, a

E.M. Forster's tram ticket.

The column in Alexandria.

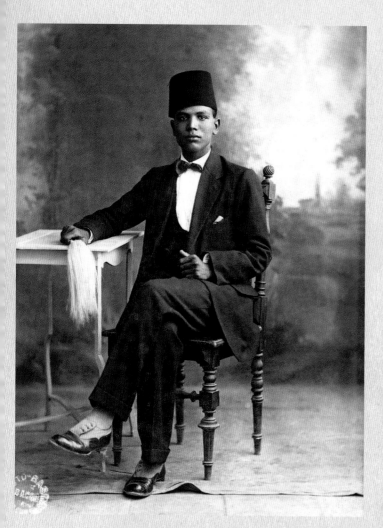

Mohammed el-Adl.

❧

*Forster depicted in a 1920 oil painting by
Dora Carrington.*

paltry sum for an Englishman as a milleme was one-thousandth of a pound
in 1916. The stops printed on the ticket provide markers in Alexandria's
modern history and culture: the fifteenth-century fortress of Qaitbay at
Anfoushy; the Ramleh station where the first tram line was inaugurated
in 1863; Raghis Pasha, named for a Greek slave who rose to become prime
minister of Egypt in the 1880s; the cotton exchange at Minet-el-Basal;
the British wartime training camp and military prison at Gabbari; and the
cemetery at Hadra where 1700 World War I soldiers were interred.

Forster, well into his thirties, was shy, sexually inexperienced and
emotionally dépaysé when he landed in Alexandria from London. Whether
he realised it or not, his travels took him to the same places as those who
journeyed from northern Europe to the Mediterranean or North Africa
in search of new erotic experiences.[1] Seeking liberation from hometown
mores, and drawn by the lure of real-life ragazzi, many travellers actively

sought cross-cultural liaisons. Forster was more reticent. He complained in a letter to poet and philosopher Edward Carpenter about his loneliness when he first arrived in Egypt, and he mentioned the paralysing sexual solitude from which he had long suffered in England. He noted, with mixed yearning and fear, that young men were on offer in an Alexandria hashish den. Forster had his first sexual encounter in Alexandria – his first true experience – with a soldier.[2]

Mohammed el-Adl had moved to Alexandria from the Egyptian countryside. A darkly handsome fellow in his late teens, he wears a natty three-piece suit and tarboosh in one of the studio photographs preserved in the Cambridge archives. A tram conductor, he was finding his way towards adulthood and a career in a cosmopolitan city where British authorities exercised colonial authority and stationed thousands of troops among a population of Arabs, Italians, Greeks, Jews and others.

Forster worked at the Red Cross hospital, and during his tram trips Mohammed el-Adl caught his eye. Forster also noticed that the young conductor was treated badly, on two occasions physically struck by other Europeans, and he made a point of being polite. As he wrote to Carpenter, 'The tram-conductor I had often noticed for his quiet movements and refined yet merry face – unusual in Egyptians. One evening he said when I offered my fare "You shall never pay" – an agreeable opening', a gesture el-Adl explained was a response to Forster's courtesy.[3] Forster contrived to take el-Adl's tram regularly. The men began conversing and arranged to meet in the Municipal Gardens.

On the back of the ticket, written in pencil, are the directions Forster followed to his rendezvous with el-Adl. He took the tram to the Mazarita stop near the Municipal Gardens and then walked to a Ptolemaic column flanked by statues of the ancient Egyptian goddess of war. Crease marks show that Forster perhaps folded and unfolded the ticket in nervous anticipation. On their third meeting the pair had sex, fumbling but fulfilling. By July, Forster noted, 'My Egyptian friend and I now know one another well.' In October he told Carpenter, 'We are now wholly devoted to one another ... I am freed forever from the burden of loneliness.'[4] The tram took them to el-Adl's modest room or Forster's lodgings – they generally travelled separately for discretion – or sometimes just to the gardens where they strolled and chatted. In his little notebook Forster quoted from el-Adl: 'Life from the tram is like pictures. First one passes me, then another.'[5] The physical relationship was short-lived, but the emotions were deeply felt and long remembered. Forster reminisced about el-Adl when he was in his eighties. He wrote that, with one exception, an intense friendship with Syed Ross Massood, his relationship with Mohammed el-Adl was 'the greatest thing in my life'.[6]

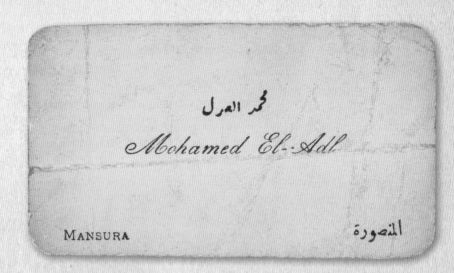

Forster returned to England in January 1919, by which time el-Adl was living in his native Mansourah, struggling to establish himself as a cotton trader. He had married before Forster left Egypt, and Forster had visited el-Adl and his wife several times before he was repatriated. El-Adl was increasingly ill, and the next years saw a rapid decline in his health and his business. He was even briefly imprisoned for several months after being wrongly charged with trying to buy a weapon from Australian soldiers just as Egyptians were staging a rebellion against the British. El-Adl also grieved at the death of the infant son whom he had named Morgan in honour of Forster. The two men saw each other in 1921, and again had sex, when Forster was on the way to India to see his friend Masood; they met one last time when Forster was returning home the following year. El-Adl died from consumption a few months later, aged about 23.

For Forster the intimacy with el-Adl was the first time that affection, burning sexual desire and its consummation had come together, and friends back in England applauded his pleasure. The two men remained in contact by letter once el-Adl had married and moved away from central Alexandria. Their correspondence was complex. El-Adl was sometimes 'cold', and in one letter he insisted he must remain independent and meet Forster only when he wished to do so, but his missives also expressed warm appreciation for gifts from Forster. El-Adl continued to sign off 'I love you' from 'your ever friend'.

Forster began writing about el-Adl, in the form of a letter, in the stiff brown notebook: 'Dear Mohammed, this book is for you and me.' He added sentences over the years and finally concluded the memorial in 1929. Many years later, in 1960, Forster returned to the notebook to copy out el-Adl's letters to him. This completed what he labelled his 'tribute' to the long dead friend from Alexandria, the place Michael Haag calls the 'city of memory'.[7]

Today, in an age of instant hook-ups with mobile phone apps, and with gay marriage legal in many countries – though violent homophobia infects Egypt – Forster's experiences, sentiments and melancholy still touch readers. And who does not possess some keepsake linked to a past lover, so ephemeral but with long-lasting significance? Forster's tram ticket is a small, cheap bit of paper. Like thousands of others issued by an urban transit authority, it was meant for a single use. Valid for one journey in the brief life for which it was designed, it gave Forster the right to travel from one tram stop to another, but it was also the compass leading him to someone he loved. This quotidian ticket is a witness to a chance encounter, moments of physical and emotional ecstasy, lingering bonds of amity across time and distance, and the memory that outlasts everything else. In its afterlife, tucked into a memorial notebook, the ticket provided a passage back to Egypt, a youthful friend, the pleasures of body and soul.

A dedication from Forster's notebook.

> To Mohammed el Adl:
> who died at Mansourah shortly
> after the 8th of May, 1922, aged
> about twenty three: of consumption;
> his mother, father, brother and son
> died before him, his daughter has
> died since, his widow is said to
> have married again:
> and to my love for him.

40. To My Friend from His Friend

GRAHAM WILLETT

In about 1975 Alan Smith, a student at La Trobe University, was browsing in Penn's Bookshop in Melbourne's Little Collins Street. He had developed an interest in antiquarian and second-hand books and was just starting his collection of nineteenth- and early twentieth-century books with coded allusions to homosexuality. In a pile, probably from a deceased estate, a small volume caught his eye. It was A5 in size, hand bound, and contained 58 pages of handwritten verses dated between 1906 and 1919.[1] An envelope affixed to the cover bore a 1½ penny stamp and was addressed to Mr Stuart Hunter, Box 19, Lakes Entrance. Inside the volume an inscription read:

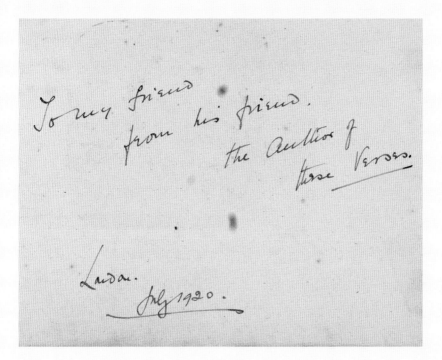

Opposite: The cover of the book of poems.

And there was a photograph of the author, Arthur R. Groves, who looked, Smith thought, like a matinee idol.

Intrigued, Smith paid the $10 asking price and took it home for safekeeping. It sat on a shelf for many years until he passed it on to the Australian Lesbian and Gay Archives. This little volume of verses is riddled with intriguing, coded references to homosexuality. The expressions 'my friend' and 'his friend' in the inscription were widely used by male homosexuals in the early twentieth century to signal their attachment. A clipping from Charles Kingsley — what a 'blessed thing it is ... to have a friend ... who loves us in spite of all our faults' — has been pasted in as an epigraph. Then there is the portrait of Groves. The tilt of his head to his left and the demure sideways and downward glance of his eyes is a feminine pose rather than a masculine one. It looks as though his eyebrows are shaped, his hair permed and his lips rouged. The boa he appears to be wearing, though, is almost certainly a flying jacket.

Groves' self-presentation was not idiosyncratic. In fact, it seems to be an expression of its time — specifically of early twentieth-century homosexuality. But which homosexuality? In Chapter 45 Wayne Murdoch describes various ways in which same-sex desire between men was publicly displayed in Melbourne during the 1920s. The term 'trade' denoted men who presented themselves in conventional masculine terms and took a sexually dominant role, while 'queans' were recognisable by their defiance of contemporary gender norms. Queans were flamboyantly effeminate, used female names among themselves, and wore cosmetics and colourful clothes; their hair was stylishly cut and permed. The point of all this was usually to attract trade.[2] Perhaps this photograph suggests Groves was a quean. Or maybe terms like 'dandy' or 'aesthete' might serve us better. In *Children of the Sun*, a history of interwar decadence, Martin Green describes a generation, the Sonnenkinder, whose revolt against the seriousness of their parents led to a preoccupation with 'ornament, splendour, high manners and so on'.[3] Exemplified by the characters in Evelyn Waugh's novel *Brideshead Revisited*, and its subsequent adaptations for television, the aesthetes were a more complex phenomenon than the queans. The aesthetes' appreciation of the male body sometimes took 'higher' — that is, 'Hellenic' or 'Platonic' — forms and they admired male beauty without carnal entanglements. At other times, though, their appreciation was more obviously erotic.

The aesthetes were mostly a post-World War I phenomenon, but Green notes their (selective) harking back to the Victorian aestheticism associated with Oscar Wilde. Groves' poetry certainly reflects an aesthetic sensibility. His poems are grouped into several sections: 'War Verses', 'In Lighter Vein' and 'Post-War Verses'. They are formal in structure; they scan and rhyme as poems ought to do. There is no hint of the modernism embraced by

Arthur Groves in matinee idol mode.

❧

Opposite: The effete theatrical and the early twentieth-century aesthete were overlapping types.

the aesthetes, but rather an adherence to Victorian poetic norms. Groves'
poems are full of words like 'loveliness', 'unloveliness', 'pleasure', 'Truth',
'Virtue' and 'lips all laughter'. Flowers and plants abound: lilies and roses
and cypresses. But it is impossible to read some of the verses without
detecting a homosexual intent. In the love poems, Love, when personified,
is always male. This is 'Love's Way':

> O cover me with lilies! In the day
> Love came with splendour and a sweet surprise,
> And took my hand in his, and stole away
> My heart with his unfathomable eyes.
>
> O cover me with roses! All the night
> Love stayed with me and taught me all his lore;
> And with him was a wonder and delight,
> And there was no more night for evermore.

Love's Way.

O cover me with lilies! In the day
 Love came with splendour and a sweet surprise,
And took my hand in his, and stole away
 My heart with his unfathomable eyes.

O cover me with roses! All the night
 Love stayed with me and taught me all his lore,
And with him was a wonder and delight,
 And there was no more night for evermore.

O cover me with cypress! With the dawn
 Love had arisen, and had gone away.
Into the fray and lonely we with drawn,
 I know no longer night or glorious day.

Paraguay 1912.

In a war poem titled 'To G.F.B., Killed Sept. 16 1916', Groves writes that 'Death took you from my side' and speaks of the 'severance of our brotherhood' as well as 'all the love you gave me', 'your dear comradeship' and 'ties which bound us'. He looks to a time 'Wherein we may go hand in hand together'. In 'Sonnet', again among the war verses, he addresses his beloved and speaks of 'our love' and 'Tears, born of love you could not quite withhold'; he reassures him that 'Though Death comes/Our love persists.' His beloved speaks to him: 'I will be bold/Your love shall make me strong.' There is much more in this vein.

So we have a collection of verses in which love comes to the narrator in male form, carefully written out and bound as a book to be sent from one

man to another – 'friend' to 'friend' – in which the author is pictured in a distinctly feminine manner. This volume is a very queer object. But what do we know about Hunter and Groves?

In 1920 Hunter was living in Lakes Entrance, Victoria, and working as a farmer; he died of a kidney infection in 1946, aged 71. If he received the book of verse in the early 1920s, as the inscription suggests, he would have been in his thirties or forties. He died unmarried and left a substantial estate of some £4000, worth about $250,000 today. Groves is a shadowy figure. There is no record of birth or death in Australian records, or in England, but we know he lived for a time in Sydney and was well travelled. From the dates and places mentioned alongside the poems we can tell he was in Argentina in 1909 and 1910, Paraguay in 1912 and England in 1914, and that he served in France and Italy during World War I before returning to London. He managed a few adventures along the way. In 1912 he wrote about the Paraguayan civil war and published a piece in *The Boy's Own Paper* titled 'The Man and the Horse', in which he imaginatively places himself in the mind of both the gaucho and the horse he is breaking in.[4]

Groves appeared in print as a poet. In 1910 his poem 'Love's Burden', which is in the Hunter volume, was published in both *St James' Budget*, a London newspaper, and *Nash's Pall Mall Magazine*. But all was not as it seemed. In 1918 *Nash's* printed 'A Correction':

> In our September issue we published a poem entitled 'Love's Burden' by Arthur R. Groves. We have since learned that this poem is an exact copy of Mrs M. Hedderwick Browne's poem 'Love's Guerdon' which appeared in *Chambers's Journal* for 1902. Mr Groves, with whom we have communicated, now admits that the poem was not his work.[5]

'Love's Burden' is probably not the only example of plagiarism in the Hunter collection. The first part of Groves' poem titled 'To G.F.B., Killed Sept. 16 1916' has been recently published in Richard Edgar's 2015 book, *Lost Words: The great war poets of Portadown and Lurgan*, where it is credited to Rifleman G.A. Rowles. If these verses were plagiarised, how many of the others were? And how much of what we think we know can we be sure of? Groves' war experiences? His name? Maybe 'Groves' is a pen name? Historians work a bit as archaeologists do: sifting through the available clues, we bring our accumulated knowledge to fragments of the past that do not, in and of themselves, tell their whole story – or sometimes very much of it at all.[6] Groves' and Hunter's lives require further research but, in the meantime, we have an object and two lives that throw some light on Australia's very queer history.

A trio of soldiers from the First World War.

41. The Story of a Locket

PETER WELLS

A locket is a kind of link: a memory link, possibly a love link. It is not unusual for a locket to open and reveal a lover's face. A locket can contain a lock of the loved one's hair. It is personal, intimate, secret. A locket is, at the same time, a public piece of jewellery, a kind of proclamation. It asserts something. It speaks of a connection, maybe a private connection but one that can be commented on. Otherwise why wear something so intimate in public?

These thoughts are prompted by a locket I eventually inherited from my mother's grandfather, one William Purvis. I never met my great-grandfather. He was born in 1850 in Scotland, on the Borders. I was born a century later, so I missed my long-lived ancestor by eight short years. There were some things I knew about him. One was his hair. He wore his auburn hair high on his head, with a very special, almost artificial, roll at the top. It was a confection of a hairstyle, not at all natural. It was hair as adornment. He is wearing it in a tiny carte-de-visite he gave to my great-grandmother, Betsy Bartlett, when they met as fellow servants in Bath in the 1870s. This is when they fell in love. William looks conceited, and interestingly, without the cover of a beard, alarmingly weak chinned. He looks rather vain, even possibly supercilious, though that is the false spell of photography.

This is taking me a long way from this artificial roll of hair on the very top of his head – a sight so unusual that local men would call out to him, commenting, caustically, with masculinist contempt, 'Purvis, show us your hair.' My mother, Bess, remembered hearing this as a child, perhaps registering it as unusual without being able to work out what it meant. The past reproduced itself in a later period: my mother recreated it on my own and my older brother Russell's heads when we were children in the 1950s. In the absence of brothers and other male role models, Bess cut straight back to the late nineteenth century and proudly awarded us an 1870s dandy's artificial curl at the top of our heads. It was like a mini-coronet, a frail nineteenth-century fantasy that landed on our heads in the prosaic sputnik world of the 1950s.

William as the foppish manservant.

Opposite: Peter Wells (right) and his brother Russell, both wearing dandy's curls.

William's portrait in the locket, and one of his rings.

Hair was one of William's abiding feminine fascinations. Among his scrapbooks there was a lot of attention paid to hair tonics and lotions. But this brings me to another unusual aspect of his personality: his love of jewellery, including costume jewellery. This included a sizeable diamond ring that he wore on his little finger, the diamond raised on claws. My grandmother (his daughter), aunt and then oldest female cousin inherited the ring in turn and it appears gender neutral, although it is still relatively unusual for a man to wear a diamond ring. But there were other things as well, personal things. (Isn't jewellery always personal?) There was the cat's eye stud, which features in the carte-de-visite shown here and which I callously lost one morning when I was suffering an obliterating hangover. There was also a watch chain, heavy and golden. When tests were done to work out its insurance value after my mother inherited it, they showed it was pinchbeck, an alloy of copper and zinc. It looks like gold, feels like gold, but it is not gold. All his life William wore this gold chain in public life, knowing it was counterfeit. What does that say about him? There was also an emerald tie pin. An elaborate golden button, its pattern worked over in Puginesque interweaving. These are unusual things for a young servant to wear because William, in his earliest incarnation, in Britain, worked as a groom.

These adornments would be regarded as 'flash', the possessions of a young working-class dandy. Or could he have been — and it is me asking the question — effeminate? Not exactly a nancy boy, a homosexual, but rather a

man who stood in an indeterminate relationship to masculinity? I think this is right — the curl on the top of his head points to this. Those men calling him out were asking: 'Are you a pansy, William?' Two photographs illustrate his dilemma. In Britain we have the foppish manservant dressed to kill. Then, in New Zealand he converts to the vast sprawl of a beard that hides his weak jaw and enforces a masculine identity that all but says 'pioneer'. Was he burying an identity? Hiding a past self? Here one enters the space of supposition. It is always the role of the 'gay child' to look back at the supposedly entirely heterosexual family tree that produced him and ask the question: who else was like me? Surely there were others? William liked to bake, was exceptionally good 'around the house' and he loved jewellery. Is this enough for me to claim he was 'like me'?

One piece of jewellery is particularly suggestive: the locket that I now own, made of 18-carat rose gold, hinged at the side. One of the things that makes it attractive or unusual is the fact that the glass covering the images is crystal. This gives the locket a glassy allure. It has a sheen of magic. Interestingly, it also makes it hard to see what you are looking at. You have to angle it just so in order to make out the two faces. And the really interesting thing is that the locket shows two men. On one side is my handsome great-grandfather, beard bristling, aquiline-nosed, a fine figure of a man, even with his curl of auburn hair. On the other side of the locket is a younger man who appears to represent another generation. He wears a drooping Edwardian moustache and his looks are fresh. Perhaps the fact that his face is in profile also adds to his mystery. What is he looking at?

When I asked my mother about the story of the locket, she shrugged as if I were obtuse. 'Oh,' she said in her special faraway voice in which she seemed to vanish into an entirely satisfactory past from which I was forever excluded: 'Oh, that was a man Grandpa rescued when his balloon went down in a swamp. Grandpa saved his life and the man gave Grandpa the locket.' The story was complete in her eyes, self-evidentially true. Who was he? What was his name? Where did this happen? When did this happen? My mother shrugged. 'I never thought to ask; well, you don't when you're young, do you?' she said, overlooking my youthful face and the quiet passion behind my enquiry. In the end, in answer to my repeated questions, she said she thought the incident had happened at Takapau in southern Hawke's Bay, where William had worked when he first arrived in New Zealand. He was an indentured immigrant and had to go where he was told.

It was many years before my hands closed around the locket, feeling its weight on my palm. It was mine at last. When I opened it I realised the men stood back to back, so to speak, looking out at the world. They might have been soldiers guarding each other's back. The man my great-grandfather rescued is portrayed by a cheap form of photography — a tintype — and

William in pioneer mode.

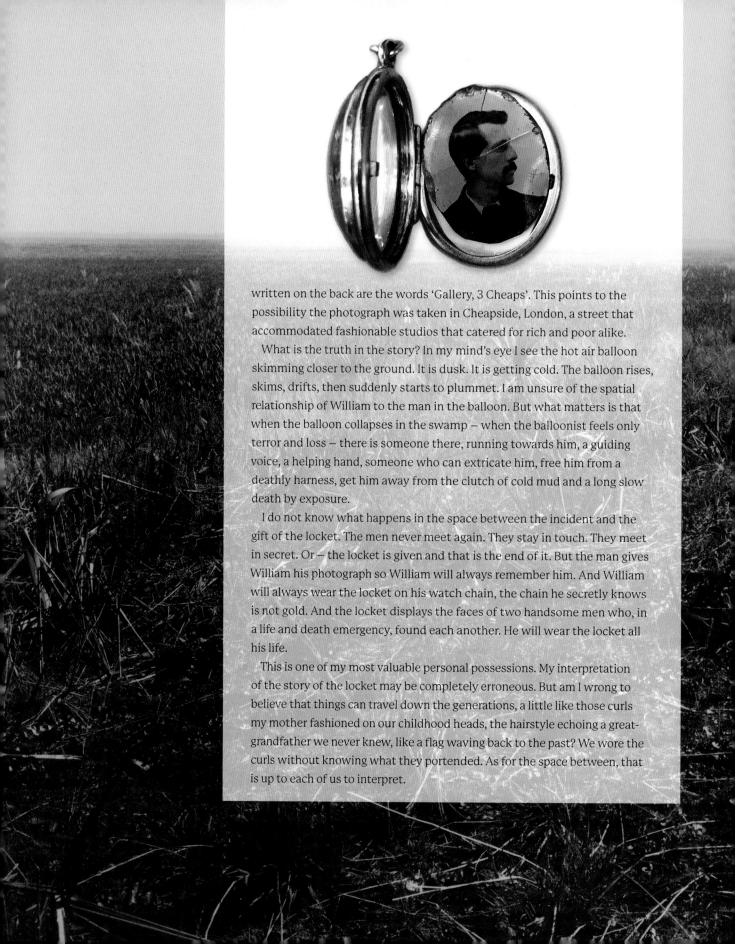

written on the back are the words 'Gallery, 3 Cheaps'. This points to the possibility the photograph was taken in Cheapside, London, a street that accommodated fashionable studios that catered for rich and poor alike.

What is the truth in the story? In my mind's eye I see the hot air balloon skimming closer to the ground. It is dusk. It is getting cold. The balloon rises, skims, drifts, then suddenly starts to plummet. I am unsure of the spatial relationship of William to the man in the balloon. But what matters is that when the balloon collapses in the swamp – when the balloonist feels only terror and loss – there is someone there, running towards him, a guiding voice, a helping hand, someone who can extricate him, free him from a deathly harness, get him away from the clutch of cold mud and a long slow death by exposure.

I do not know what happens in the space between the incident and the gift of the locket. The men never meet again. They stay in touch. They meet in secret. Or – the locket is given and that is the end of it. But the man gives William his photograph so William will always remember him. And William will always wear the locket on his watch chain, the chain he secretly knows is not gold. And the locket displays the faces of two handsome men who, in a life and death emergency, found each another. He will wear the locket all his life.

This is one of my most valuable personal possessions. My interpretation of the story of the locket may be completely erroneous. But am I wrong to believe that things can travel down the generations, a little like those curls my mother fashioned on our childhood heads, the hairstyle echoing a great-grandfather we never knew, like a flag waving back to the past? We wore the curls without knowing what they portended. As for the space between, that is up to each of us to interpret.

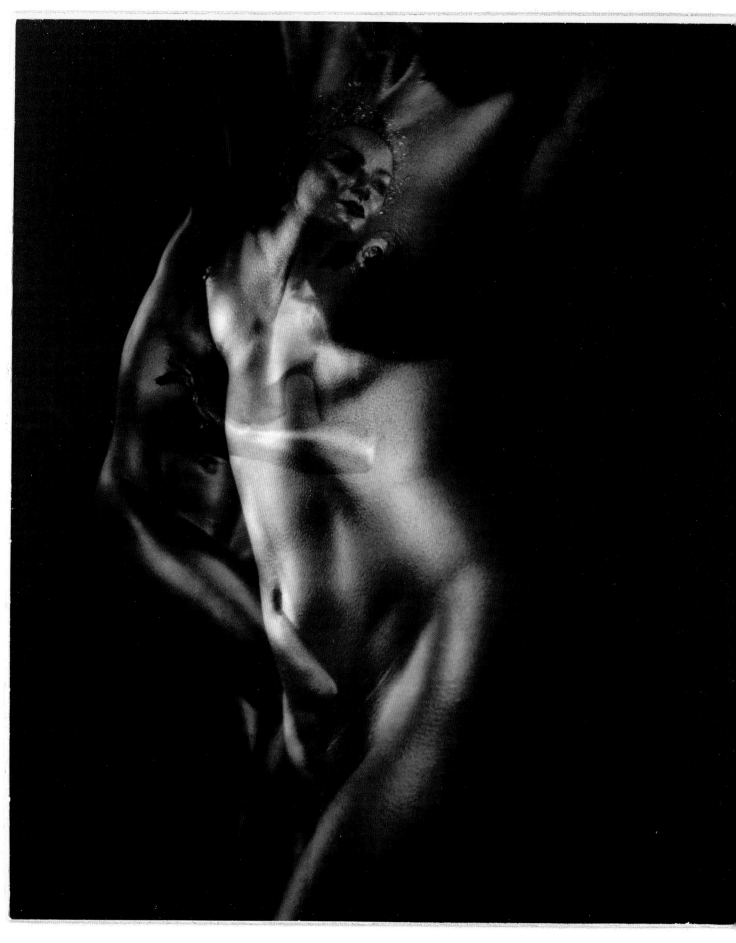

42. Waiting Till We Meet Again

JOANNE CAMPBELL

The simple headstones that commemorate the lives of actress Thelma Trott and dancer Freda Stark at Waikumete Cemetery in Auckland, New Zealand, belie the dramatic events in which the two were embroiled during the 1930s. It is telling that the first person interred in the grave, Thelma Trott, who died in 1935 aged 29, is buried under her maiden name. Her husband, musician Eric Mareo, was found guilty of poisoning her. Freda Stark, her 'bosom friend', was the star witness for the prosecution's case.[1] This has been described as one of New Zealand's most scandalous murder trials. Although he was twice convicted, and the trials were the subject of a government review, Mareo's guilt is still being debated decades later.[2] He told police that his wife was fonder of women than she was of men, and that she and Freda had been lesbian lovers. Although they were indeed lovers, Mareo's revelations may have negatively affected his case: he was seen to have blackened the name of his dead wife.[3] Conversely, some have suggested that Thelma and Freda's relationship was publicly perceived as a 'romantic friendship'. Both women were feminine in appearance and did not fit the contemporary stereotype of lesbians. They did not, for instance, look like Radclyffe Hall, the author of *The Well of Loneliness*, who favoured a more masculine style of dress (see Chapter 33).

The primary headstone is fairly traditional in format:

> *In loving memory of our beloved daughter and sister*
> *Thelma Clarice Trott*
> *Died 15th April 1935*
> *Aged 29 Years*
> *At Rest.*

Freda Stark in gold paint, taken by celebrity photographer Clifton Firth, 1947.

However, there is a smaller inscription below: 'Waiting till we meet again Freda.' These words highlight the significance of the women's relationship, and they prefigure Freda's eventual interment with Thelma 64 years later. Was the inscription, including the use of Thelma's maiden name, an effort by the family and Freda, who together paid for the headstone, to posthumously expunge Mareo from Thelma's life?[4] The family made clear their feelings about Mareo's guilt by including the terms 'daughter and sister', and not using the married name. Perhaps, given the publicity surrounding Mareo's trial, they also wanted to keep the grave private. As they dealt with death, Thelma's relatives attempted to create a memorial that summed up her life. To create a kind of symbolic immortality, they have shown the deceased in a favourable light, and their choice of inscription is both personally meaningful and socially acceptable.

Freda's headstone is even simpler. It features only her name, birth and death dates, and the inscription 'L'Etoile d'Or', golden star, which refers to her life as a dancer. The two graves highlight some of the stylistic and social changes that occurred in the twentieth century. Although it lacks figurative decoration, Freda's grave marker is consistent with postmodern trends in funerary memorials: its meaning is individualised and moves away from the more traditional modes that dominated the earlier years of the twentieth century.[5] The focus is solely on her; there is no reference to familial, community or religious affiliations.

Thelma Trott's life is remembered mostly for the manner of its ending, but there was more to her than that. She was an intelligent and talented woman who graduated with honours in English and French from the University of Queensland when only a few people undertook tertiary studies and women were very much in a minority.[6] Like most female arts graduates of her era, Thelma had intended to take up a teaching position, but her plans soon changed. She entered a singing competition, won the mezzo-soprano prize and was asked to join the Humphrey Bishop Company, with which she toured New Zealand in 1926 and again in 1930.[7] Then, in 1933, she joined the Ernest C. Rolls Revue as lead soprano. When the revue toured New Zealand at the height of the Great Depression, Eric Mareo was its musical director.

In the early 1930s Freda Stark regularly appeared in the society pages where she was praised for her performance in various dances and pantomimes. When she joined the Rolls Revue as a replacement for an injured acrobatic dancer, she shared a dressing room with Thelma, who was the star of the touring show.[8] Thelma looked after Freda, who saw herself as a 'greenhorn', and the women soon fell in love. Freda described Thelma as 'beautiful' and 'loaded with talent'; she 'absolutely doted on her'.[9] Thelma gave Freda an opal ring as a symbol of their passionate relationship; Freda gave a nude photograph of herself, which Thelma kept in her bedroom.[10]

This sheet music from 1925 includes a photograph of Thelma.

The Depression took its toll. By 1933 it has been estimated that up to 30 per cent of New Zealand's potential workforce was unemployed, and women were not eligible for an unemployment benefit.[11] After the touring show collapsed, Thelma married Eric Mareo, probably because she could no longer support herself financially. He formed the Mareo Symphony Orchestra and early performances garnered considerable praise. Then Mareo branched out and formed an operatic society. Its first major production, the comic opera *The Duchess of Dantzic*, starred Thelma as the lead. Freda, a dancer in the chorus, once again shared a dressing room with her lover.

Reviews were positive – 'Thelma Mareo was in every sense a charming success. Her sprightly personality and graceful portrayal of … Sans Gene captured the audience, and the heavy vocal burden imposed on her was carried with gusto'[12] – but they disguised a series of financial challenges. Mareo and his orchestra were forced to take on regular work playing before

film screenings at the St James Theatre in Wellington, but by early 1935 Mareo had lost his job. Only weeks later his wife was dead. She spent a weekend in bed lapsing in and out of consciousness and a doctor was eventually called. He diagnosed Veronal poisoning and called an ambulance, but Thelma died in hospital a couple of hours later. Mareo was arrested. His first trial caused a sensation and the journalists, referring to the lesbian nature of the relationship between Freda and Thelma, described the former as an 'abnormal girl'.[13] There was considerable doubt, though, about the accuracy of the jury's guilty verdict and a second guilty verdict handed down at a subsequent retrial. Some experts in law and toxicology believed Mareo could not have been the poisoner: the barbiturate Veronal was used for insomnia, and some suggested Thelma had taken an overdose.[14]

Thelma had married out of necessity, not love, and at Mareo's first trial a Dr Walton testified that she 'seemed to be unhappy in her married life. She said that her husband had made to her some unjust charges – untrue charges of some kind of perversion. She denied it.'[15] During Mareo's second court appearance, however, he referred to Thelma as a lesbian and noted that Freda kissed her and slept in her bed.[16] Thelma did not seem comfortable with her own sexuality – she sought Walton's advice for her 'nervous condition' – but that is hardly surprising, given prevailing attitudes to homosexuality. The newspapers disparagingly claimed 'homosexualism' was prevalent among those who moved in artistic circles, and many New Zealanders believed nervous problems were the basis of same-sex desire.[17] Still, Thelma's apparent reticence did not prevent her from having relationships with other women. She had a liaison with a Frenchwoman called Billy in Sydney before she met Freda. In her letters to Thelma, Billy referred to translations Thelma had made of Pierre Louys' erotic lesbian poems, *Les Chansons de Bilitis*, which she showed to friends who 'practise the gentle art of Lesbos in a modern setting, they were quite enthusiastic about them'.[18]

Freda was devastated by Thelma's death, and in the subsequent years she repeatedly emphasised that Thelma was the love of her life and insisted she wanted to be buried with her.[19] Freda busied herself with dance and her career flourished in the 1940s. She became known as 'the fever of the fleet' for a routine she performed for American GIs who spent their leave in New Zealand while they were deployed in the Pacific. She danced naked but for a tiny G-string, and her body was painted with a metallic solution that appeared gold under the spotlight's amber beam. Freda moved to London and married another New Zealander: the gay dancer Harold Robinson, who was nine years her junior. Having become somewhat notorious in New Zealand after the trial and her dancing at the Civic, Harold's offer to change her name appealed to her. After being known as Mrs Robinson for a few years, she ultimately reverted to Freda Stark and accepted her infamy. She

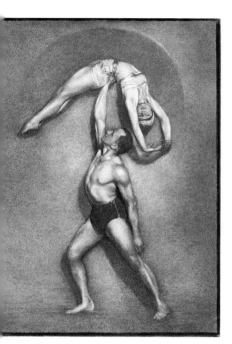

A Herman Schmidt bromoil of Freda and her dance partner Len Wilson, 1930s.

had many 'wonderful love affairs' with women, as Harold Robinson did with men, and spent her Fridays and Saturdays at the celebrated lesbian club Gateways in Chelsea.[20] Freda eventually returned to New Zealand in 1970 and although she and Harold divorced in 1973 they remained close friends.

Freda died in 1999 and was laid to rest with Thelma. A shared grave for a lesbian couple is not without international precedent. American writer Gertrude Stein shares her grave at the Cemetery of Père-Lachaise in Paris with Alice B. Toklas, whose name is engraved in gold on the back of Stein's famous headstone. Although it is hidden from obvious public view, Thomas Dunn suggests this shared grave is an important rhetorical gesture that 'immortalise[s] lesbian love and secure[s] a queer afterlife'.[21] He also comments that such a gesture is the exception rather than the rule: 'Even today, dying is perhaps the most efficient and totalizing way in which an otherwise out and proud gay man or lesbian person may find themselves normalized — queerly forgotten — by a heteronormative culture.'[22]

Fortunately this is not the case for Thelma and Freda. The contentious murder trial and Freda's later celebrity ensures their story still features in tours of the cemetery where they are buried. Freda's positive attitude to being a lesbian, along with her fascinating life story, made her an obvious role model for younger gay people. In the words of writer and director Peter Wells, 'For an entire generation of lesbians and gay men, Freda became an "ancestor". We were all born to parents, most of whom were heterosexual. As gay men and women we have to recreate our own families including chosen ancestors. For me, Freda was a favourite.'[23]

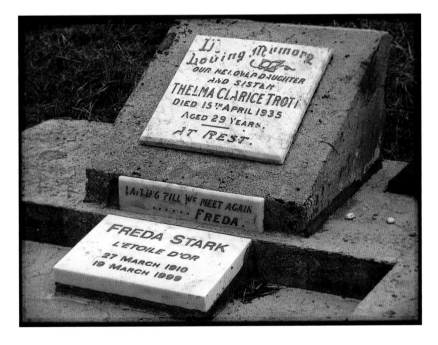

The shared grave of Thelma Trott and Freda Stark, Waikumete Cemetery, Auckland.

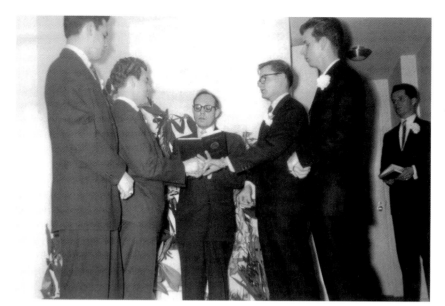

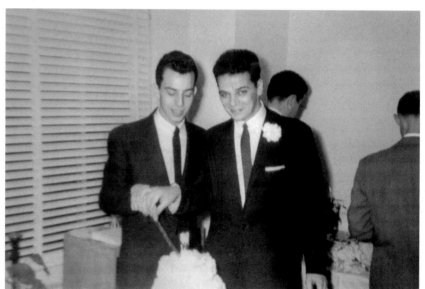

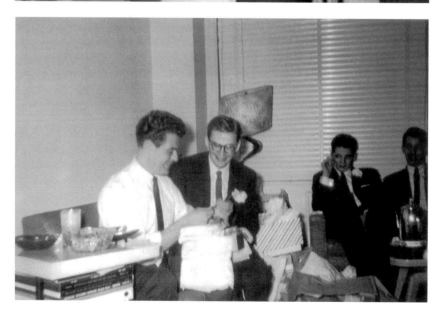

43. A Set of Wedding Photos

ELISE CHENIER

Sometime in the late 1950s two couples wed in a double ceremony in Philadelphia, Pennsylvania. The event bore all the markers of a typical postwar American wedding. Guests arrived bearing gifts wrapped in white paper, every dark suit was brightened by a boutonnière, and a solemn officiant stood before the gathered dearly beloved and led the ceremony. Heartfelt vows were made and witnessed, rings exchanged. Afterwards the newlyweds took turns cutting a two-tiered cake. Music was played, everyone danced. And someone took photos of it all.

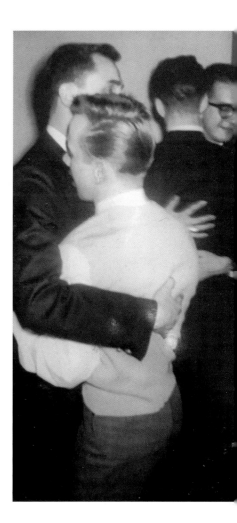

The couples who wed that day never saw those photographs. The black-and-white images would never be organised sequentially and carefully placed in an album to be taken out from time to time to share with friends, and they never inspired reminiscence. These newlyweds never got to do any of these things because the manager of the shop where the film was dropped off to be developed deemed the photographs immoral and confiscated them. Despite the officiant, the witnesses, the suits and the cake, what the photographer documented was not a 'normal' wedding. The couples who married that day were gay, and in the United States after 1945 it was everyone's civic duty to save the nation from the threat of sexual deviancy. Confiscating the photos was an act of patriotism.

We cannot know what happened when the photographer returned to collect the prints, but we can guess he found out he was not getting them back. We also cannot know how he responded to the theft of his personal property, but we can be certain that the more loudly he demanded his negatives be returned, the more likely it would have been that the shop owner would call the police. Had that happened, the police might have pressed charges against him for disorderly conduct. They might also demand he identify the men in the photographs and, under the pretence of protecting male youth from the supposed danger posed by male

homosexuals, launch an investigation into the 'ring of sexual deviants'. And then each man's landlord, banker and employer would probably have learnt about it. Most, if not all, would find themselves without a job or a place to call home. Better the photographer cut his losses and walk away.

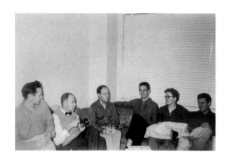

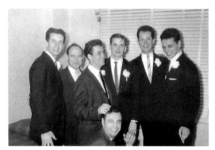

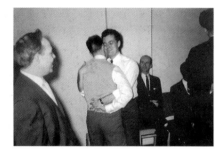

Like queer people themselves, these photographs were not meant to survive, but they did. A female heterosexual employee who objected to her employer's – and most Americans' – view of homosexuals quietly tucked away the snapshots in the hope their owner would claim them during one of her shifts. Unfortunately that never came to pass, but two remarkable things did: instead of disposing of them, she stored them with the rest of her family snapshots where they remained for half a century until her daughter, sorting through her parents' belongings, learnt from her father of the photos' origin. Having no special connection to them herself, and recognising their unique historical value, she put them up for sale on eBay. Equally remarkable is that the buyer requested she provide the ONE Archives Foundation in Los Angeles with copies before shipping him the originals.

These happy snapshots tell several queer stories. First, they provide rare visual evidence of one of the ways same-sex love, intimacy, desire and friendship flourished in hateful times. That the state did not recognise the marriage of people of the same sex did not stop thousands of lesbians and gay men from declaring their love for each other in ceremonies just like this one. Same-sex couples claimed for themselves the most iconic ritual celebration of romantic love and fidelity, a ritual that saturated virtually every corner of American life.[1] Second, that the negatives and prints were so easily snatched from the hands of their owner is a testament to the way marginalised people are subject to the cruel whims of the majority and how such acts of cruelty have contributed to the erasure of queer dignity, cultures and histories. Now accessible to all, the photos remind us of the vital role played by queer archives in opening up the past, and enabling us to imagine different futures.

These photographs also queer lesbian and gay history itself. History has rightfully characterised women and men who dared pursue same-sex intimacy as sexual rebels, even radicals. It took considerable courage to defy a society so fearful of same-sex sexuality that it created elaborate means to eliminate or at least contain it. It seems a contradiction, then, that rebels and radicals would gladly participate in one of the most conformist, normalising rituals of their time, and yet an abundance of records show just how common same-sex wedding ceremonies were. In an interview with lesbian archivist Joan Nestle, Mabel Hampton describes how, during the 1920s and 1930s, a respectable African-American Christian minister often performed same-sex wedding ceremonies, sometimes even in his church in Harlem.[2] In a 1943 issue of *Psychoanalytic Review*, Bernard

Robbins describes two gay male patients, both of whom sought treatment following the dissolution of their same-sex marriage, which they described 'as a unique and exalted experience, totally unlike all other intimate relationships, and vastly superior to heterosexual unions'.[3]

A 1950 investigation into homosexual activity on the Fort Myers Women's Army Corps base pressed women to confess to committing homosexual acts. 'Did you kiss her on the lips?' 'Did you touch her genitals?' 'Do you know what muff diving is?' investigators demanded. But what made a woman a lesbian was more than sex. WACs described couples who wore wedding bands. Some even possessed marriage certificates. One private surprised investigators by announcing that not only was she a lesbian, but she and her civilian lover were to be married in a week. And so they were, in a formal dress ceremony held in a hotel room and attended by eight of her closest WAC friends. Asked by a military officer why they bothered, another private explained, 'Just to make things a little better.'[4] Weddings were a radical affirmation that queer love, desire and intimacy were worthy of celebration. They were a practice of love-politics.[5] They assert a fundamental sameness, the human capacity to love, the sharing of pleasure and intimacy with a lover and with friends, while simultaneously affirming difference.

Wedding rituals made things a little better precisely because their meaning was clear to everyone, even if the desirability of participating in them was not. The elements of the ceremony are widely known, even to those who have never attended one, and can be enacted without any formal expertise. They are meant to engender specific feelings: joy, pleasure, happiness, love, as well as a sense of community, belonging and recognition. As virtually every American understood, a boutonnière made a plain suit a wedding outfit, guests affirmed the community's role in recognising and legitimising queer intimacy, the officiant lent authority to the occasion, the rings provided a material symbol of a sentiment, and the cake meant celebration.

Whether wedding rituals made things better was a matter of opinion, and views varied widely during the 1950s and 1960s. Articles, poems and readers' letters in homophile magazines debated whether the romantic ideal and a life of domesticity was desirable, or whether being gay meant liberation from the oppressive monotony of monogamy and every other lousy social norm. Many objected to wedding rituals because, as David Sonenschein wrote in 1968, they were a tawdry 'imitation of the heterosexual marriage ceremony' that included the adoption of 'a romantic conception of ideally unending love' and dichotomised social roles.[6] Deemed déclassé, and for some women patriarchal, same-sex weddings offended the sensibilities of lesbians and gays whose strategy for social acceptance was to prove to the homophobic majority that they were not a destabilising threat, but law-abiding, conforming citizens.

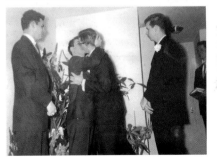

These snapshots allow us a momentary glimpse into the lives of gay men for whom the wedding ritual posed no such problem. In the first photograph, the grooms, both in their late twenties or early thirties, conventional in appearance, one northern and the other possibly of southern European heritage, stand before a third man, also white, who holds a book, possibly a Bible or a book of poetry, from which he appears to be reading. Beside each groom stands his best man, a role typically given to one's closest friend. Between the five men and the wall behind them are potted plants. Further in the background, down a short hallway, stands a sixth man, also white and of the same age, whose finger holds open the book in his hand, presumably marking a page from which he will shortly read. He also sports a wedding band, as do other guests, indicating that the ceremony was not novel among this group of friends.[7] The photographer has successfully captured the most important moment: the placing of a ring on the hand of one's beloved that accompanies the making and taking of vows. The serious, perhaps even nervous, expressions on the faces of every person in the frame illustrates the earnestness of the participants.

The second photograph was, by the 1950s, de rigueur: the newly-weds cutting the wedding cake, both smiling, no longer engaged in a private, intimate moment but now posing for the camera, presenting themselves as one, or at least two people joined in the same task.[8] The third photograph shows the newly-weds opening their gifts. Both the cut crystal bowl in the foreground on the left, and a beautiful coffee pot in the centre on the right-hand side, are intended to enhance and beautify the couple's home. Guests in the background look on in enjoyment. Finally, in the last photo, two lively, happy guests, also young and white, hold each other closely and smile warmly for the camera. The close proximity of the newly-weds, who are holding each other as you would when slow-dancing – one with his arms around the neck of the other, the other with his arms around his partner's waist – suggest The Platters' 'Only You' or Elvis Presley's 'Love Me Tender' issuing from the record player.

Through the ritual of marriage, lesbians and gay men used a familiar cultural practice to speak back against the photo shop owner and the military investigator, and to proclaim the authenticity and dignity of queer love.

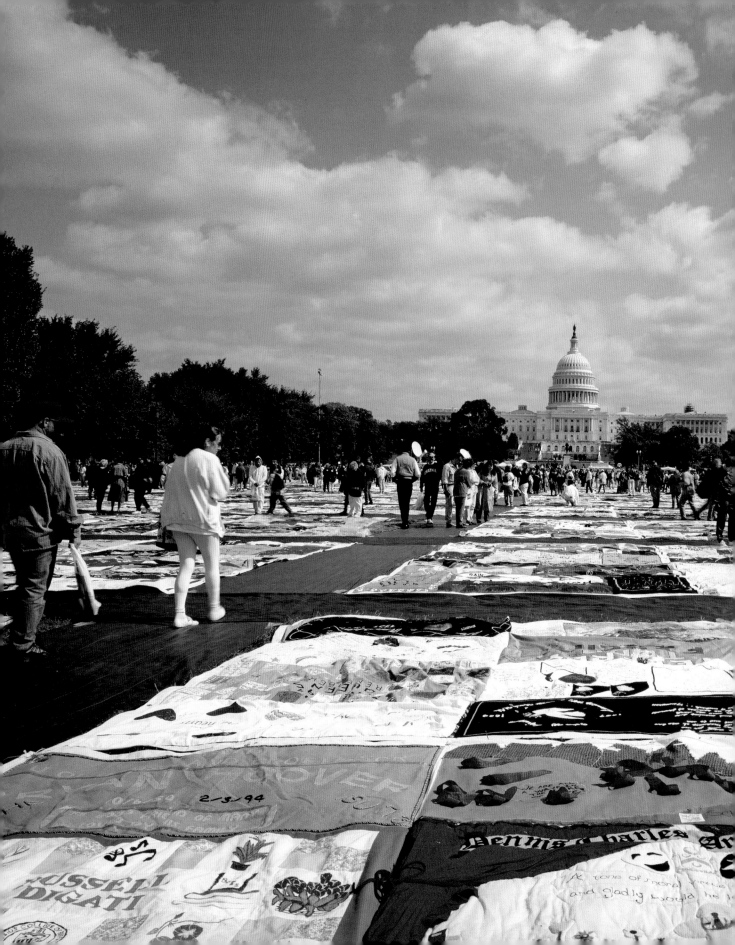

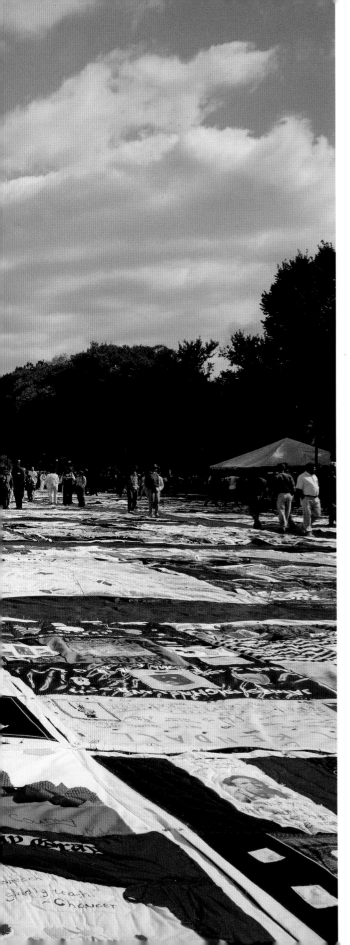

44. Carl Wittman and the AIDS Quilt

AMANDA LITTAUER & DIANE JOHNS

The AIDS Memorial Quilt is composed of over 48,000 individual 90 x 180 centimetre panels created by friends, lovers and family members to memorialise loved ones lost in the HIV/AIDS epidemic. In 1987, San Francisco gay rights activist Cleve Jones made the first panel in memory of his friend Marvin Feldman and worked with others to create the NAMES Project Foundation. People from cities around the United States contributed panels and supplies, and the quilt was first displayed in Washington DC as part of the March on Washington for Lesbian and Gay Rights on 11 October 1987. In 1989 the quilt was nominated for a Nobel Peace Prize and became the subject of an Academy Award-winning documentary. In 1996, the last time it was displayed in its entirety, it covered the entire National Mall. The quilt is an educational tool, a memorial, a fundraiser for AIDS service organisations and a unique work of community art on a scale that remains unprecedented and unsurpassed. As described by the National Park Service, 'The quilt creates a visual landscape where viewers are surrounded by the names of the thousands lost to this epidemic, as well as the

overwhelming sense of love and connectivity inherent in the tradition of quilt making.'[1]

One of those remembered in the quilt is Carl Wittman (1943–1986), a pioneering activist in progressive causes and in the world of dance. He was an historian and teacher of Scottish and English country dancing, which he revolutionised with unique interpretive changes that eliminated traditional gender-specific roles. In the late 1970s he mentored Diane Johns, a feminist dance teacher whom he met when she was living in Eugene, Oregon. After Wittman's death Johns made a panel that incorporates two original quilt blocks depicting country dances.

As a young adult in the early 1960s, Wittman participated in a range of left-wing movements, including those for gay liberation and against war. He soon, however, rejected what he saw as their narrow-minded attitudes about gender and sexuality. He moved to San Francisco in 1967, came out and began writing political essays about the relationship between gender, sexuality, draft resistance and radical social and political transformation. Among his most influential writing was the 1970 piece, 'Refugees from Amerika: A gay manifesto', in which he argued 'that gay liberation required deep transformation in structures of power'. Wittman made blunt but powerful analogies between race and sexuality: 'Chick equals nigger equals queer. Think it over.'[2]

In 1971 Wittman and a lover purchased land in what became the Oregon commune of Wolf Creek. This was home to the first sanctuary of the Radical Faeries, a collective of gay men who embraced and politicised gay male effeminacy.[3] The property included a farmhouse where Wittman lived and a small barn where he held weekly dance gatherings and the occasional weekend workshop. He introduced a pioneering and liberating approach by breaking away from the heteronormative terminology of 'men' and 'women' and replacing it with the unrestricted dance roles of 'reds' and 'greens'. His inclusive approach to forming sets left no one out. It was traditional for the men to ask the women to dance; the pair would then move onto the dance floor and form a set with other couples. Because there were often more women than men, this arrangement meant the more popular women never lacked for male partners and the less popular women ended up dancing with each other, one of them taking on the 'man's' role. Wittman looked beyond the unit of the couple to focus instead on the community aspect of country dances. Sometimes he had everyone join hands in a circle and then reconfigured its shape into two parallel lines so that people standing opposite each other became partners for that dance. In 1977 Wittman published the *Country Dance Manual*, a book of 168 dances from the seventeenth to the twentieth century, using his new gender-neutral terminology.

Carl Wittman, 1985.

❧

Previous pages: The NAMES Quilt on display in Washington DC.

❧

Opposite: Wittman in action.

In 1975 Diane Johns moved from the East Coast to Eugene. The following year, when she began teaching Scottish country dancing, she sensed there had to be a more equitable way of thinking about the dancers. An acquaintance suggested she should meet Carl Wittman, and in 1977 she made the two-and-a-half-hour drive to Wolf Creek, where the pair quickly bonded over their passion for country dancing and social justice. Johns immediately adopted Wittman's gender-neutral terminology and set-forming methods in her own group, the Eugene Country Dancers.

Wittman moved from Oregon to Durham, North Carolina, in the early 1980s, where he lived for a time with lesbian feminist activist and writer Mab Segrest, who later described how members of the community supported Wittman during the last month of his year-long fight with AIDS. At home on 22 January 1986, surrounded by friends, he committed suicide by lethal drug overdose. Allan Troxler, his former lover, wrote that 'when the prospect of productive living grew dim, he ended his life with unerring grace'. At the time of his death Wittman was working on *Sun Assembly*, a compilation of 200 Scottish and English country dances that contained historical notes, music commentary and gender-neutral instructions. Troxler agreed to take on the task of completing the book, assisted by several of Wittman's friends.[4]

Diane Johns was unable to travel to Durham to say goodbye to Wittman, but she sent a letter to be read at his memorial service. She began working on her quilt panel for him and completed it in 1988; it was allocated NAMES Project Panel Number 00962. Since Johns knew Wittman as a teacher of revolutionary ideas about dancing, she concentrated on this aspect of his legacy in her panel. It spells out 'Carl Wittman, Dance Master' in capital letters above and below a triptych of three blocks. The centre block is a 25 x 45 centimetre rectangle, hand-worked in blue and peach cotton embroidery thread on an off-white cotton background. Framed in solid brown cotton, it consists of the following quotation from Wittman's introduction to his *Country Dance Manual*:

The country dance form can be thought of as an exquisite vessel, in itself beautiful in shape, highly abstract. We can choose to fill this vessel with whatever meaning we like. If we like, we can pursue a particular friendship; we can rejoice in a sense of community; we can see in the music and the dance the highest of spiritual values; we can see it as good fun. The dance is all of these, and greater than all of them.

The wider block of the quilt of which Wittman's square was a part.

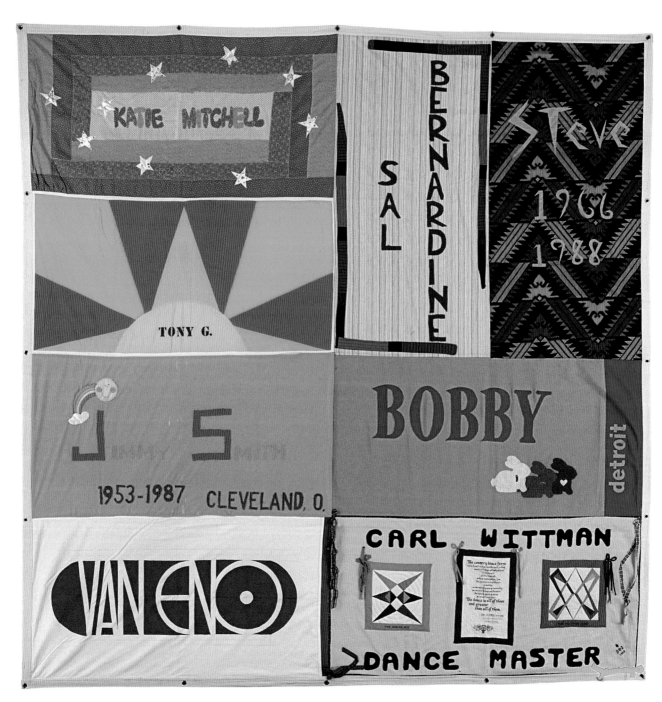

The two blocks flanking the central quotation are hand-quilted original 30-centimetre quilt squares, each representing a country dance Johns closely associated with Wittman. Each piece in the blocks represents a dancer; the shape of each piece depicts movements of the dance and relationships of the dancers to one another at various points. The dance on the right, in warm colours with an orange border, is 'The Tenth of June', a sprightly Scottish jig for eight that Carl wrote in 1977 to celebrate the date when Allan Troxler moved to Oregon. On the left, in cool colours with a blue border, is 'The Beggar Boy', a slow, contemplative English set-dance for six from 1651. In 1989, when the quilt was displayed on the National Mall, Johns met up next to her panel with Allan Troxler and four others who had known Wittman. In silence they danced 'The Beggar Boy' in honour of his life and legacy.

A work of personal and collective significance, Diane Johns' AIDS Memorial Quilt panel represents how Carl Wittman applied his philosophy of gendered and sexual freedom to Scottish and English country dance. Although he was best known for his writing and activism, the quest for liberation suffused Wittman's life work, including his documentation, teaching and (re)creation of this distinctive dance form.

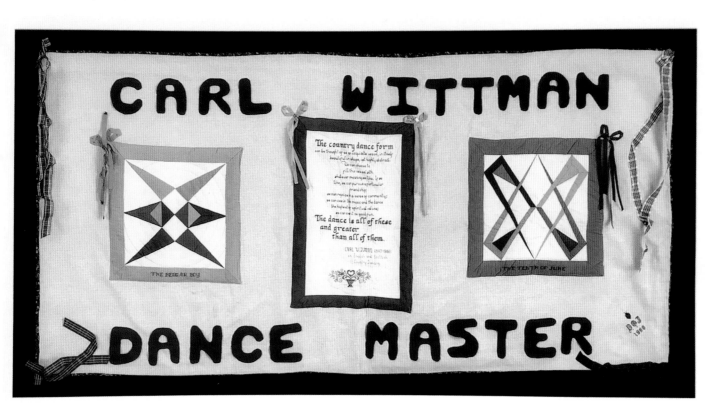

Carl Wittman and the AIDS Quilt 279

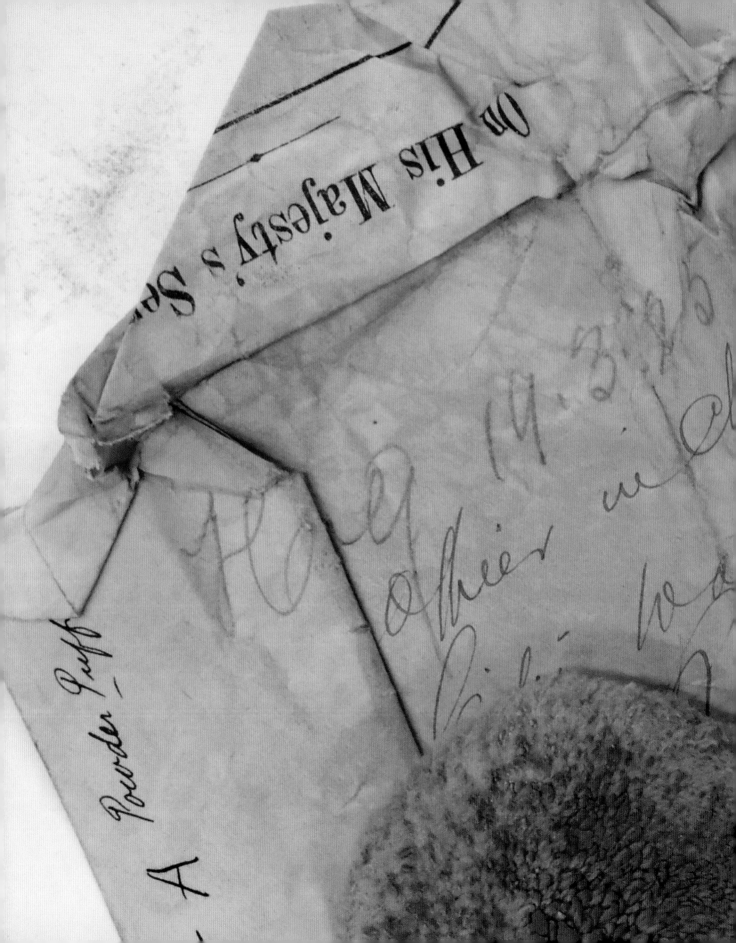

45. Exhibit A: The Powder Puff

WAYNE MURDOCH

Some amazing things turn up in the criminal trial files at the Public Records Office in Melbourne, Australia. As well as witness statements, judges' case notes and correspondence relating to cases heard in the Supreme and General Sessions courts, there are items used as evidence in all sorts of trials, from murders to burglaries, fraud and homosexual offences such as buggery, indecent assault and gross indecency. Evidence of transgressive sexual acts, including love letters, appointment diaries, photographs and plans of public toilets, have been taken and kept by the state. Many of these items still manage to give researchers a frisson of excitement when they fall out of the files where they have been kept for many decades.

One of the most deeply personal items I ever found in the trial files was a humble powder puff: Exhibit A in an attempted buggery case of 1925. This small piece of cloth, with rouge still adhering to it after nearly a century, is the only surviving witness to the events of a Saturday night in March 1925. It is the sort of object that could only have survived as a piece of evidence. Its presence damned two men to prison, brought social disgrace and ruined lives. It is also symbolic of early twentieth-century attitudes to masculinity, effeminacy and homosexuality.

The powder puff was found in the pocket of Selwyn Lindsay, a 34-year-old actor, when he was arrested around midnight on Saturday 21 March 1925. Lindsay was discovered in a dark doorway in Wrights Lane, central Melbourne, with his trousers down and the 'person' of 33-year-old wharf labourer James Gaw deep in his 'back passage'. A night watchman caught the pair and reported them to police. Arrested and taken to the Melbourne watch house, the two protested their innocence. Lindsay said that he was in the doorway adjusting a new pair of braces he had bought that day which were too tight. Gaw claimed he had stepped into the doorway to 'have a leak'. Although Lindsay protested that, as an actor, the powder puff

was a legitimate part of his professional equipment, and that he had put it in his pocket when hurriedly packing after performing in a stage show the previous Thursday evening, the police took the item as evidence that he was a 'quean'. Lindsay and Gaw were both charged with having committed an act of gross indecency, found guilty and sentenced to 15 months in Pentridge Prison.

Powder puffs and cosmetics played an important role in early twentieth-century thinking about homosexuality, especially the division between 'normal' men and 'queans'. The first were masculine fellows who occasionally took an active sexual role with the relatively more feminine 'queans'. Police looked for material objects to substantiate their enquiries, and the powder puff operated as a proxy for the quean.[1] As historian Matt Houlbrook has said of London in the 1920s, 'In a deeply gendered

Previous pages: On His Majesty's Service: the front of the envelope.

Photographs of Lindsay and Gaw from the police register.

consumer market, the use of cosmetics was unambiguously coded as womanlike.'[2] As it was in London, so it was in Melbourne. Numerous cases of men being caught in beats and cruising for sex make mention of the fact that the accused were carrying cosmetics or powder puffs. In 1916 it was reported: 'A powder puff, a piece of chamois leather such as women use for rubbing powder, formed part of the equipment of a repulsive looking creature named Thomas Farrington.' Farrington tried to pick up a soldier in Swanston Street, but the soldier objected and bashed him before calling the police.[3]

There were other cases too. In 1918 the tabloid newspaper *Truth* complained of 'Powdered and Painted Perverts' infesting Melbourne.[4] In January 1929, Clyde Sinclair, arrested at the Melbourne docks while orally servicing two youths (who ran away and eluded police) was found to have face powder, a pocket mirror and mercolised hair wax in his possession. He tried unsuccessfully to jettison these by throwing them into the roadway while being escorted to the police station.[5] Eight years after that, under the headline 'Powders and Rouges — Police Allegations Against Young Man', *Truth* informed its readers that Stanley Hillyer, an unemployed waiter, 'powders his nose and rouges his lips and waves to motorists as they pass along St Kilda Road at night'.[6]

Selwyn Lindsay wrote a letter from prison to the judge who sentenced him. He knew how his possession of a powder puff would have been interpreted by the police, the judge and the jury:

> Your honour laid particular stress upon the fact that I had a powder puff in my pocket; I can only ask that your honour will accept my statement regarding the circumstances by which it came there, ie I put it in my pocket after everything else was packed after the performance at Wonthaggi and then again if the puff in question was examined it will be found to be covered in grease paint and the powder used by most actors is ordinary cornflour, it is so palpable that the puff in question would never be used by anyone for ordinary use — the procedure an actor goes through when preparing for a show is that he first covers all his face with Lard then he applies flesh colour grease paint and numerous other greases then he finally finishes off by powdering down. I think that the majority of the jury would be ignorant of this procedure and would be likely to misconstrue the colour on the puff. I therefore submit to your honour they should have been given the knowledge as to the use of a puff. It is as important to an actor as a hammer is to a carpenter.

Before his arrest the handsome Lindsay had a successful career in several touring theatrical troupes dating back to before World War I. He served with distinction in the Middle East, France and Britain, and upon returning to Australia in 1919 once more trod the boards throughout Victoria and South Australia. He always garnered good reviews in the newspapers of the small towns where he played. Following his release from Pentridge he returned to the theatre, but his criminal past made it harder for him to get roles and by the end of the 1920s he was no longer working. He slipped into alcoholism, was repeatedly arrested for drunkenness and in 1968 died alone in the Repatriation Mental Hospital in Bundoora. It was a sad, lonely end to once-promising careers in the theatre and the army. Without doubt, Lindsay's descent into drunkenness and madness started in that doorway in Wrights Lane in March 1925.

If Selwyn Lindsay was a good man whose life was ruined by his prosecution, his partner in the doorway was a very different character. Already a violent drunk, James Gaw was a married wharfie with a four-year-old son when he was arrested. He had already done jail time: in 1920 he received six months' hard labour for receiving the linen stolen from a commercial laundry, and in 1922 he was sentenced to two and a half years for wounding with intent to do grievous bodily harm after taking a tomahawk to the head of a neighbour following a drunken disagreement.[7] Gaw never went back to prison after serving his time for attempted buggery, but in 1927 he was fined £25 for sly grogging, and four years later he was acquitted of assaulting a man with a bottle in a drunken brawl. Gaw died at the age of 56, after a Melbourne wharf crane accidentally crushed his leg.

How did the two men understand their sexual characters and motivations? James Gaw almost certainly saw himself as a 'normal' man taking advantage of a sexual opportunity that presented itself. He was married, a father, a manual labourer, a hard man with a criminal record; he would not have seen himself as homosexual, a quean or sexually deviant. Lindsay, the actor and the passive partner whom police marked out as a quean, may – or may not – have seen himself in those terms. Either way, it was his possession of the powder puff that 'proved' it to society.

Today the only witness to the events of that night in March 1925, the night that saw Selwyn Lindsay's life begin to spiral out of control and James Gaw's life become even murkier than it already was, is a simple circle of chamois leather, caked with greasepaint, that rests in a tattered enveloped labelled 'Exhibit A'. It is the sole survivor of all the powder puffs used by Melbourne queans in the 1920s.

Flinders Lane, although more impressive than Wrights Lane, gives a good idea of the laneways of 1920s Melbourne. The lanes were designed to allow deliveries to the rear of main street businesses and often formed their own small worlds.

46. Neil McConaghy's Penile Plethysmograph

KATE DAVISON

Save for the last sentence, the following description could evoke a hobby-craft project:

> The blind end of a fingerstall was cut off and the cut end stretched over the open end of a cylindrical tin of approximately 2¼ in. diameter and 3½ in. length. A nipple was soldered into the closed end of the tin and connected by a plastic tube to a standard Grass pressure transducer. The penis was inserted into the tin through the open end of the fingerstall, which maintained an air-tight connection.[1]

This was a set of instructions for how to construct a machine that measured changes in the penile volume of males receiving aversion therapy for homosexuality. The patient was seated in a darkened room and asked to put the device on his penis. For the next 15 minutes he was shown a film: a rather dull travelogue of London, complete with swans in Hyde Park, interspliced with 10-second segments of nude men and women. The nudes were immediately preceded by static geometric shapes: a red circle before the women and a blue or green triangle before the men. As the patient watched the film, changes in the volume of his penis were transmitted from the cylinder down the tube to the pressure transducer and recorded with a needle-and-ink polygraph machine. Zig-zag ink lines would appear on long reams of paper marked with time intervals, allowing the investigator to pinpoint which moments in the film provoked stimulation. This was the science of phallometry, and the machine was the penile plethysmograph.

The instructions outlined above were presented at a conference in Brisbane in 1967 by Dr Neil McConaghy, an Australian psychiatrist based at the University of New South Wales and the best-known practitioner of homosexual aversion therapy in Oceania. From 1964 to the mid-1970s McConaghy conducted clinical experiments using this method at the Prince Henry Hospital in Sydney. By 1973 he had 'treated' more than 200 patients seeking help for homosexual feelings, including many who were bisexual.[2] All of his patients were voluntary, in the sense that none had been sent under duress by the police or the courts. Although his published papers only ever reported the treatment of men, his patients did include a small number of women.[3] During the 1970s McConaghy and his team experimented with a device to measure erotic stimulation in women, but there were few female patients and the effort was abandoned.

Aversion therapy was a sub-branch of behaviour therapy, a school of psychological medicine that emerged in the late 1950s and early 1960s among practitioners dissatisfied with 'talking therapies'. This new psychophysiological paradigm was based on the methods of classical conditioning developed in the early twentieth century by Ivan Pavlov

Previous pages: Logbook from Study 1, 1964–66, comparing plethysmograph results following apomorphine and electroshock aversion therapy.

McConaghy's simplified device made from a repurposed Largactil tin.

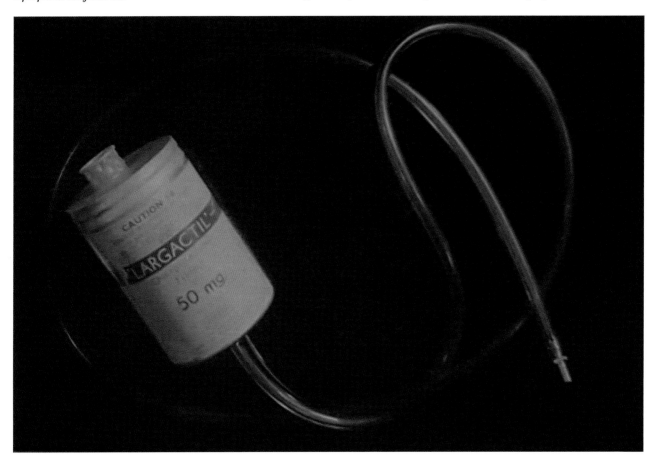

and augmented by modern learning theory. If 'abnormal' behaviours, including homosexual ones, had been learnt, they could surely be unlearnt. This could be done, they supposed, by creating strong associations between certain behaviours and either unpleasant or pleasant physiological sensations. This paradigm offered a compelling therapeutic alternative to the dominant psychoanalytic tradition that critics boisterously dismissed as unscientific, esoteric and too reliant upon vague interpretation.[4] Instead they sought to develop diagnostic and therapeutic methods that incorporated both physiological and mental phenomena.

Neil McConaghy underwent his medical and psychiatric training in this very period. After completing his Diploma of Psychological Medicine at the University of Melbourne, where he began reading Pavlov, he spent 1956 and 1957 in London. He worked at the Maudsley Hospital under Hans Jürgen Eysenck, the leading advocate of behaviour therapy. But it was not until 1962 that McConaghy became aware of the plethysmograph and began fully exploring his interest in treating sexual 'disorders'.

This device was not McConaghy's invention. It was first developed in the mid-1950s by Kurt Freund, a psychiatrist in the sexology and psychiatry clinics of Charles University in Prague, where, from 1950, Pavlovian psychophysiology enjoyed the status of Soviet-preferred doctrine.[5] That year Freund began a pioneering longitudinal study that investigated the nature of homosexuality, which included a clinical experiment to treat it using aversion therapy.[6] By 1957, Freund and his team had seen more than 270 'exclusively or almost exclusively homosexual' patients, at least 67 of whom were treated with aversion therapy.[7] It became apparent that a method for accurately measuring sexual arousal was needed to select patients, analyse data and to test the effects of treatment. Freund published the first description of the penile plethysmograph in 1957 in Czech and the following year in English.[8]

Although it was developed within the context of aversion therapy, the plethysmograph had no role in the behavioural conditioning itself. It was a purely diagnostic tool, designed to establish what visual, textual or ideational stimuli would provoke erotic responses in male patients, in order to empirically determine their sexual orientation. Patients' claims were considered untrustworthy for a variety of reasons: a longing to please the therapist, a wish to survive court proceedings, or an ambition to shirk military duty. The new psychophysiological diagnostic framework sought to measure *involuntary* physiological responses thought to reveal deeper, more 'genuine' attitudes and feelings that were difficult to conceal or suppress. Among males, the involuntary penile reaction to sexually arousing images was considered the quintessential physiological response. Freund even conducted a special experiment to see whether it was possible for subjects to 'fake it'.[9]

Openly sympathetic to communism, McConaghy followed developments in Eastern Bloc psychiatry with interest. He was deeply impressed with Freund's invention and its proven clinical validity but felt it was cumbersome and needed simplification.[10] It required numerous special parts: a glass cylinder, a resin ring, a metal air inlet tube and so on. McConaghy was resourceful: for the 'cylindrical tin' he repurposed a container used for the common anti-psychotic drug Largactil. McConaghy's recycling effort demonstrated that elaborate, expensive and specially manufactured parts were unnecessary. A further advantage of his version was that it was 'robust and capable of being put on by the patient without supervision'.[11]

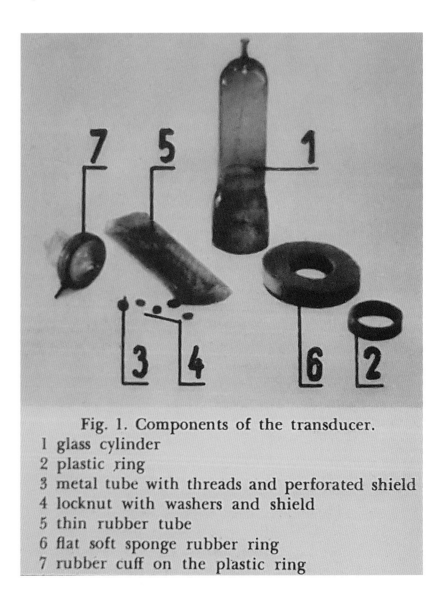

Fig. 1. Components of the transducer.
1 glass cylinder
2 plastic ring
3 metal tube with threads and perforated shield
4 locknut with washers and shield
5 thin rubber tube
6 flat soft sponge rubber ring
7 rubber cuff on the plastic ring

In 1964 McConaghy began his own longitudinal experiment with aversion therapy, applying the plethysmograph at every stage of the procedure, both as a diagnostic tool and as 'an index of response to treatment'.[12] He improved on Freund's method by incorporating moving images in order to 'make sufficient use of the erotic effect of movement and behaviour'.[13] But those envisaging a racy porn film should prepare for an anti-climax. The activities depicted, McConaghy explained, were 'not designed to be sexually provocative', as this could 'limit the type of person to whom the film could be shown'.[14] Instead, they included towelling, reading, undressing or lounging on a rug and, in the case of the women, an occasional coquettish pout.[15] Film was used for the plethysmographic assessment; slides and text phrases in the aversion therapy.

There were two main methods of homosexual aversion therapy. The Prague team had used the nausea-inducing drugs emetine or apomorphine as the aversive stimulus, in association with nude male images. The patient would associate these not with pleasure, but with the profound discomfort of nausea and vomiting. In the early 1960s psychiatrists in other countries decided to try substituting emetic drugs with electric shocks. McConaghy felt it necessary to investigate whether emetic drugs or shocks were more effective, and indeed whether either was effective at all. He divided his first treatment cohort of 30 patients into two groups, each of which received one or the other procedure. When the experiment revealed little difference in results, McConaghy adopted the electric shock variant for practical reasons.[16]

Like Freund, he considered the plethysmograph a great clinical success. Because it diagnosed male sexual orientation more accurately than any other method and provided verifiable data, it meant patients' claims about their desires could be assessed. Patients, however, viewed and experienced its use very differently, especially in combination with aversion therapy. They could rarely differentiate between the plethysmographic and aversive elements of the procedure. Fabian LoSchiavo, who was treated by McConaghy in 1973, recounted the following experience:

> In a darkened room I had to drop my trousers down to my ankles and put this metal cup thing on and then put the rubber over the penis. Then [there was] a slide projector and either McConaghy or his assistant was behind me, and then the slide would come up and sometimes there'd be a shock, sometimes there wouldn't. And I had to tell him on a range nought to ten was it this painful or that painful. I remember a group of students coming in; I must have been very upset because they were standing and taking notes and one of them detached himself and he said, 'Are you

okay?' And just those words of compassion made me cry. It wasn't like it was massively painful, it was just the whole thing was so desperately, awfully sad, and I thought this is what I have to do. I'll go through this and then I'll be okay.[17]

Unfortunately for his patients, McConaghy considered these methods compatible with a humanistic approach in psychiatric practice. His repeatedly stated goal was to assist patients to control 'compulsive' homosexual behaviour, not to change their orientation. In any case he knew that to be impossible. LoSchiavo said McConaghy never promised to make him heterosexual, but to inhibit his sexuality 'enough that you won't go looking for sex, and you certainly won't go to places like Darlinghurst and you'll be able to control it'.[18] LoSchiavo envisaged an asexual future in which he 'wouldn't be falling in love with people and getting depressed, and risking getting bashed, and disappointing the family'.[19] But after a follow-up and 'booster session' failed to produce the desired results, McConaghy referred LoSchiavo to a sympathetic and kind psychologist who encouraged him to go out and meet people and find sexual fulfilment. There are likely others whose health and well-being were disastrously affected by McConaghy's treatment.

After homosexuality was declassified as a mental disorder in 1973, and psychiatrists ceased using aversion therapy to treat it, the plethysmograph had little role to play in this context. It had other applications, however, for example in clinical research on male sexual disfunction and impotence. Today it is most strongly associated with the diagnosis and treatment of child sex offenders. A key part of Freund's original study had been to test subjects' responses to nude images representing a range of age categories, including children and youths. He had shown the device's usefulness in determining the 'erotic value of different degrees of sexual maturity' for 123 subjects, 12 of whom (five heterosexual and seven homosexual) expressed a preference for children. Various phallometric devices are still used in correctional facilities housing convicted child sex offenders, although these are usually strain gauges that measure changes in penile circumference, not plethysmographs.[20] From the mid-1970s McConaghy followed Freund in shifting the focus of therapeutic treatment from homosexuality to paedophilia. There are other, more sinister contemporary uses too. Nathan Ha makes the sobering observation that, as recently as 2010, the Czech Republic was criticised for requiring male asylum seekers to submit to a plethysmographic test if homosexual persecution was the grounds of their claim.[21] This harked back to the device's original use in testing 'false' claims of same-sex desire.

The penile plethysmograph has a complex history. Although adherents to the psychophysiological paradigm claimed to abide by a strictly evidence-based therapeutic humanism, their physiological interventions placed patients and their bodies in extremely vulnerable and sometimes humiliating positions.

A response chart.

GSR

[0·5mv

PENILE PLETHYSMOGRAPH

[1·0mv

ECG

10sec

 4 **FEMALE NUDE**

 4 **MALE NUDE**

5 **FEMALE NUDE**

47. A Military Discharge Certificate

SHIRLEENE ROBINSON

On 17 January 1969, 23-year-old Julie Hendy signed the certificate that detailed her official discharge from the Women's Royal Australian Army Corps (WRAAC). The decision to leave was not one she made herself. She was forced out of the military after she was exposed as a lesbian.

The certificate is a small booklet, approximately 10 centimetres high. It is dark brown in colour, printed on heavy card, with a single typed paper insert that lists the details of her service and her discharge. In many ways the object is the standard document issued to all women who left the WRAAC in this era. It notes that she had served a total of four years and 307 days in the WRAAC as an operator (signals), 309 of those outside Australia. This overseas service alone, then unusual for women in the military, makes the certificate of discharge historically significant. What makes it truly distinctive, however, are the 13 typed words written on the insert, which give the reason for Julie Hendy's discharge: 'Retention in the Military Forces not being in the interest of those Forces'. These words rarely appear on such WRAAC documents, and they also make it clear that Julie did not choose to leave. She contrasts her experience with that of another WRAAC member who had been caught in bed with a man: she had been discharged at her own request and her certificate stated this.

Julie Hendy aged about 20.

Lesbianism was never a criminal offence in Australia, although same-sex desire between women was stigmatised and medically classified. During the 1960s military women suspected of being homosexual were considered to be 'defective' and to pose a threat to camaraderie and military morale. In addition, it was argued, they could be subjected to blackmail. This military prejudice and discrimination also echoed the broader position of lesbian women in civilian society. Until the 1970s, lesbian women had to conceal their attraction to other women as exposure could jeopardise family relationships, job opportunities and friendships. The revelation of their sexuality could

also result in medical intervention and religious condemnation. Furthermore, cultural representations of lesbianism were hidden, and many women felt isolated and believed their desire was both unique and wrong.[1]

What kinds of language signify a discharge on the grounds of sexuality? Some military documentation notes that women had engaged in 'conduct prejudicial to the corps'.[2] One branch of the female services, the Women's Royal Australian Air Force, generally issued discharge certificates stating simply that discharge was 'on request'.[3] This vague wording meant women forced out of the WRAAF were more likely to avoid the stigma attached to women in the WRAAC and the Women's Royal Australian Naval Service who were discharged for the same reason. However, this oblique language makes it difficult for historians to uncover traces of lesbian military lives in the archives. A statement that retention was 'not in the interests of the services', as in Julie's case, could have many meanings. It might signify that a servicewoman had transgressed military rules or engaged in criminal conduct in civilian society. It is clear, though, that a woman issued this type of discharge was not leaving willingly. But why, precisely, was the service of this particular individual no longer required? Only those in the military would know the real reason. Carole Popham, a lesbian who served in the WRAAF in the 1960s, notes this was considered 'the worst discharge, the dishonourable discharge'.[4]

The buckram cover of Julie's certificate of discharge, and inside details page.

AAF – A 16
Reprinted June, '67

CERTIFICATE OF DISCHARGE

Register No

Army No Rank Corporal

Name Julie Elizabeth HENDY

Date of Enlistment: 17/1/64 at Sydney NSW

Date of Discharge: 18/11/68 at Sydney NSW

Reason for Discharge: Retention in the Military Forces not being in the interest of those Forces

Army Trade or Posting: Operator(Signals)

Army Trade Qualifications: Operator(Keyboard and Radio) Operator Signals

Types of Employment During Service: Recruit, Corps and Trade training 8 months. Regimental, Mess Steward and Operator(Signals)duties with Medical and Signals units 4 years 2 months.

Total Effective Service: 4 years 307 days

Service Outside Australia: NIL years 309 days

Previous Army Service: NIL

Decorations and Medals: NIL

Service Badge: NIL

General Remarks:

Date 17/1/69 Captain
Records Officer
Central Army Records Office

Signature of Soldier

IMPORTANT

This certificate is issued without alterations, erasures or blank spaces. You should on no account part with this certificate. If using it as a reference you should NOT mail it but should use a copy certified by a responsible person. This certificate will NOT be replaced unless the original can be produced to Army Records in an identifiable form.

WARNING

On leaving Her Majesty's Service you are hereby reminded that the unauthorized communication by you to another person AT ANY TIME of any information you may have acquired which might be useful to an enemy in War renders you liable to prosecution under the Official Secrets Act.

CERTIFICATE
OF
DISCHARGE

PERMANENT MILITARY FOR
COMMONWEALTH OF AUSTR

At a softball match one wintery Sunday morning.

The situation is not without its ironies. Lesbian women were officially prevented from serving in the Australian Defence Force until 1992, when Prime Minister Paul Keating lifted the ban on homosexual service.[5] Unofficially, though, the military was a popular career option for women who were attracted to other women: they could find each other easily and an active lesbian subculture existed. Military service also allowed women to move beyond the narrow career paths available to them in civilian society and the dominant expectations of motherhood and the nuclear family. This was very attractive to those who desired other women.

Knowing that she did not particularly want to be a nurse, the main occupation available to women in her social group, Julie Hendy enlisted in the WRAAC in 1964, at the age of 18.[6] She remembers feeling desire and then love for a woman in the WRAAC and also formed relationships with other servicewomen. Julie moved up the ranks to the position of corporal and gained recognition for her outstanding talent in signals. In 1967 Australia was deeply involved in the Vietnam War and more skilled service personnel were needed. A select group of seven women from 7 Signals Regiment were deployed to Singapore accompanied by a captain, a lieutenant and a warrant officer. As part of this elite group, Julie spent just over 10 months in Singapore. She took her work seriously but also found ample opportunities to meet and socialise with the many other lesbians among the Australians and British women who shared a base. In October 1968, though, Julie's sexuality was exposed. During the course of a relationship with a British servicewoman she fell asleep: 'they did a bed check and there we were ... so I was sprung, seriously stark naked, in bed with another girl, stark naked'.

Julie remembers, 'I was out within a week. And it was shocking, yeah.'

Julie was sent back to Australia so quickly that the documentation regarding the incident had not yet reached her superior when she arrived home. It was clear that there was no possibility that Julie could continue to serve in the WRAAC. The message reinforced to her throughout the entire experience was 'I'm in total disgrace, yes and I've betrayed the country. And I have to be sent home in disgrace.' This was hugely unjust: Julie had proven herself an exemplary servicewoman before her sexuality was revealed, and her contribution – along with that of many other lesbian women – did not receive due recognition.[7] It is a credit to Julie's resilience and capabilities that she was able to move past this military experience and go on to lead a long and successful career in another field.

Julie kept the certificate of discharge as a record of her past, packed away with other photographs and items from her youth. She contextualises her military experience within the broader framework of her life: 'I ended up with another job that was equally as riveting and as exciting, and so it's not as if I look back on that as the peak of my life. It's not. It's not; it was exciting and it was fun and I had a terrific youth, but I had a terrific middle age as well and I'm planning on a terrific old age.'

Julie at work.

MORAL MAJORITY DOTES ON DYKE MUMS AND THEIR KIDS

48. The Moral Majority is Neither

TIMOTHY WILLEM JONES

In May 1982 American televangelist the Reverend Jerry Falwell visited Australia on a four-day speaking tour. He had risen to international prominence in the United States in 1979 when he founded the Moral Majority, a right-wing Christian lobby group. This, along with similar organisations, became known as the New Christian Right. Its supporters transformed American politics by aligning their moral conservatism with the economic conservatism of the Republican Party, and this realignment was credited with Ronald Reagan's election to the presidency.

In Sydney, where he was hosted by the Reverend Fred Nile, a leader of the New Christian Right in Australia, Falwell spoke at a New South Wales parliamentary reception. He also gave an address at the National Press Club in Canberra and preached at a Word of Life rally at Sydney's Ryde Civic Centre. He spoke against abortion, recreational drugs and pornography, and in favour of the 'traditional family', the military and the state of Israel.

At every one of Falwell's public addresses in Australia he was met by well-organised protesters. In fact, Australia's gay liberationists, feminists and humanists had been preparing for his visit for months. Uniting against Falwell and his ideological fellow travellers, they founded the Campaign Against Repression. In January 1982 they registered 'Moral Majority' as their own business name in New South Wales and in most jurisdictions around the country. They printed car stickers that incorporated the trademarked term 'Moral Majority' into a range of slogans, including 'Moral Majority Supports Gay Rights' and 'Moral Majority Loves Blatant Lesbians'. Their badges and brightly coloured pinafores ('pinnies'), worn at demonstrations, featured similar slogans. The Campaign Against Repression also compiled an information kit and press release about Falwell and his agenda, sent it to local churches and invited parishioners to join the protests.

Protesters from Moral Majority.

❧

Opposite and overleaf: Pinnies worn at protests across Australia.

The members of the Campaign Against Repression did not just mobilise on single issues such as gay law reform and abortion access. Rather, they launched a comprehensive critique of the New Christian Right's 'broader political programme for enforcement of a frighteningly repressive and total social order'.[1] Issues included gay rights, Aboriginal land rights, abortion and women's health, childcare, environmentalism, anti-militarism and the rights of ex-prisoners, the disabled, trans people and the unemployed.

Campaigners picketed Falwell's parliamentary reception, disrupted his National Press Club address and blockaded the rally in Ryde. The protests were bold and confrontational but also funny and wonderfully creative. Campaigners came to the National Press Club dressed satirically as Moral Majority followers: as members of the Klu Klux Klan, a priest, a clown and 'a few make-believe pregnant women'.[2] At the Ryde event the Sisters of Perpetual Indulgence (see Chapter 49) conducted an exorcism and held a 'mock moral minority service'.[3] The Gay Liberation Quire sang satires of evangelical church music and preached the foursquare gospel of 'socialism, feminism, gay liberation and ethnic pride'.[4]

The protests were remarkably effective. Activist Ken Davis remembers that only 200–300 people went inside to hear Falwell at Ryde but there were over 500 protesters outside, 'people chanting and all sorts of mad stuff'.[5] Their actions were reported around the world. Back in the United States, the *Boston Globe* reported wryly that Falwell 'did not have a good day in Sydney'.[6] The protesters' clever satire of Falwell's Moral Majority was a prime example of what Melissa Wilcox describes in Chapter 48 and elsewhere as 'serious parody'.[7] The protesters chanted, 'Who's the Moral Majority? It's gays, women and blacks.'[8] In doing so they redefined the very notion of morality and its place in politics.

CAR STICKERS – M

MORAL MAJORITY (REG) supports the call for ABORIGINAL LAND RIGHTS

MORAL MAJORITY (REG) DEPLORES FAST BREEDERS

MORAL MAJORITY (REG) against SEXUAL HARASSMENT at WORK, at HOME, on CAMPUS

MORAL MAJORITY (REG) applauds WAAC's RIGHT TO CHOOSE MAGAZINE

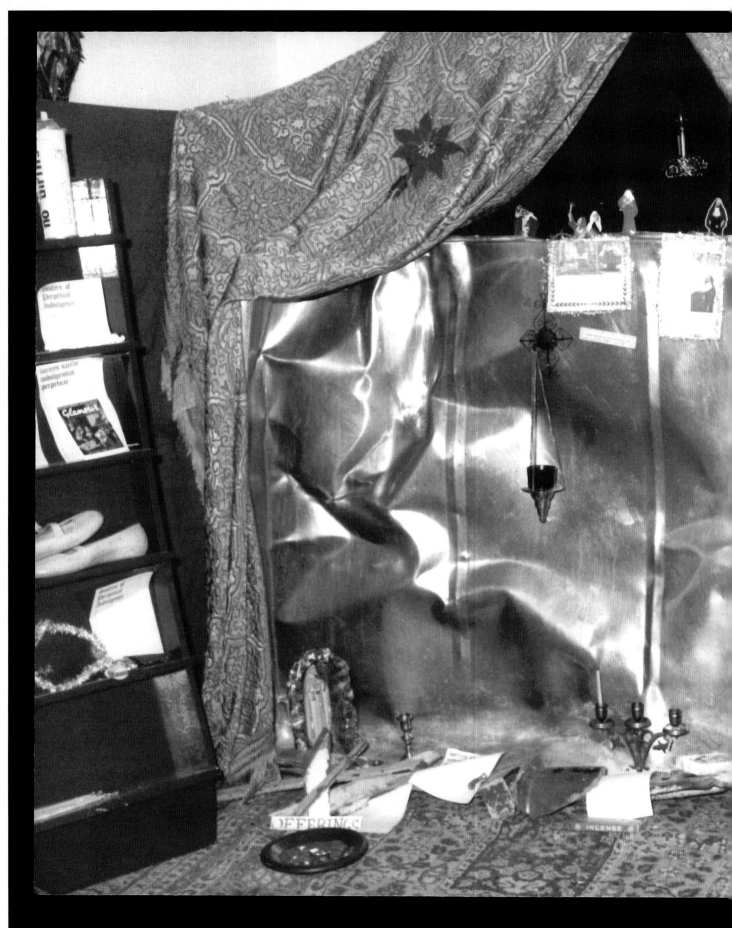

49. Devotional Objects

MELISSA M. WILCOX

How does a urinal become a sacred relic, or a condom the heart of a communion service? Are such repurposed objects part of a farce? Of sacrilege? Mockery? Actually, they are part of the devotional practices of an unusual order of nuns.

The Sisters of Perpetual Indulgence are an international, religiously unaffiliated order of self-described 'queer nuns' of all genders and sexualities. They take their roles as non-celibate nuns quite seriously by serving their communities in ways that range from safer sex education to street protest.[1] Although Sisters take vows for life, their service is part-time and voluntary; in their 'secular' lives, as they call them, they pursue professions, education and even homemaking. Although the order has its fair share of atheists, many of its members consider themselves religious, spiritual or both, identifying with or practising elements of religions ranging from Christianity and Judaism to the Neopagan Radical Faeries and Zen Buddhism. Some consider their work with the order to be an expression of their spirituality; for others, the order itself *is* their spirituality. But the Sisters were founded, and still thrive, on serious parody: a form of cultural protest in which a disempowered group parodies an oppressive cultural institution — in this case the Roman Catholic church — while claiming for itself an equally good or superior enactment of the culturally respected aspects of that institution.[2]

The Sisters did not set out to become an order of nuns. They were founded in 1979 by accident and out of boredom, when three gay men in San Francisco went for a stroll wearing Roman Catholic nuns' habits. Their presence caused such a stir that they did it again several weeks later and soon decided that wearing the habits was more than just a lark. Although they had little idea precisely what was so meaningful about their appearance, they knew they were having an impact in the gay community. One of the founders, choreographer and dance therapist Agnes de Garron, pointed out that it is not unusual for men to wear nuns' habits in celebrations like Mardi Gras and in theatre productions. What would

be new, he suggested, would be an actual order of male nuns. Within six months they had named their group the Sisters of Perpetual Indulgence and designated it 'an order of gay male nuns'. The non-residential order is organised into semi-autonomous chapters known as 'houses'. By 1981 the Sisters had set up houses in Toronto and Sydney. Melbourne soon followed suit, and one of its early members broke the nunly glass ceiling: Sister Very Maculate's vestition as a 'female gay male nun' marked the beginning of what would become a fully gender- and sexuality-inclusive order.

Two founding members of the order, Sister Missionary Position (later known as Sister Missionary P. Delight and then as Sister Soami) and Sister Adhanarisvara (later known as Sister Vicious Power Hungry Bitch and then as Sister Vish-Knew), established the Iowa City chapter of the Gay Liberation Front in the 1970s. Between the often campy street activism of that movement, the playfulness of the then nascent Radical Faeries, and the accidental but serendipitous Roman Catholic symbolism of the order, the Sisters created a form of religious parody that was both intensely spiritual for some members and also sharply, yet campily, critical of the church. A close association with leftist politics in Australia made the order's critique even more provocative and its activist strategies more clearly defined.

This combination of parody, camp, biting critique, public protest and an appeal to spirituality has drawn many to the Sisters, as both members and fans, over the decades since their founding. The Sisters, in turn, have

The Holy Communion Condom at the first manifestation of the Sisters' Paris house at Notre-Dame Cathedral, 11 September 1990.

ॐ

Previous pages: The urinal as a sacred gay relic at the 1984 National Homosexual Conference in Sydney. A set of religious figures is arranged along the top, and a plate for offerings at the bottom.

developed material religion for their communities. Like material culture, material religion focuses on objects that often hold sacred meaning for practitioners.[3] The material religion expressed in the Sisters' devotional objects is serious and parodic, campy, resistant and spiritual in equal measure. There have been many over the years, from the original habits themselves to the San Francisco house's *Play Fair!* pamphlet — the first ever sex-positive safer-sex guide for gay men — and the Sydney house's Sister Azaria, a doll in a nun's habit that represented for them the scapegoating of unpopular groups for the crimes of the dominant society. Among the most memorable of the order's devotional objects, however, are the Green Park relics and the Holy Communion Condom, also known as the Condom Saviour.

Like most cities with a gay male population, in the years before sex between men was decriminalised Sydney had many well-known 'beats' or venues for public sex.[4] The public toilet in Green Park was especially popular. In early 1984 Sydney made plans to tear down the building, and the Sisters, describing the beat as 'one of our community's most holy shrines, the special wedding chapel opposite the Wailing Wall at Green Park', dedicated themselves to salvaging what they could from the city's desecration.[5] Under cover of darkness they sneaked into the building while the demolition was under way and removed a number of 'sacred relics', including pieces of lattice, 'bolts, woodwork, stucco, bricks, pipes, tiles, and metalwork' along with 'bottles of sacred rubble and dust'. The most impressive was 'the stainless-steel altarpiece, the object of intense veneration by thousands of gay men over so very many years': a trench-style urinal.[6] The urinal and some of the other relics were displayed and venerated at the Sisters' events, including as part of a larger reliquary display at the 1984 Sydney Gay Mardi Gras.

A few years later, in September 1987, the Sisters in San Francisco held a papal mass (formally entitled the Mass Against Papal Bigotry) on the occasion of Pope John Paul II's visit to that city. At a press conference before his arrival, Sister Vicious Power Hungry Bitch had 'nailed' to the door of a cathedral (using Lee Press-On Nails) a flyer outlining the protests of queer people against the Roman Catholic Church. Once the pontiff had arrived the Sisters were determined to rid him of the demons of homophobia. They held a mass with an extensive liturgy penned by former Catholic seminarian Sister Missionary Position, in which they exorcised the Pope and canonised Harvey Milk, the gay San Francisco city supervisor assassinated in 1978. (This move was doubly ironic, since Milk was not only gay but Jewish.) During the ceremony the assembled faithful took Communion; round condom packs wrapped in gold foil were distributed through the audience as the Host.

Sisters of Perpetual Indulgence and a human
rights campaign, San Francisco, 2009.

Three years later the Sisters' condoms reappeared in Paris. An image of the first manifestation of the Paris house shows Sœur Rita du Calvaire de Marie-Madeleine-Car-Elle-Aussi-A-Beaucoup-Souffert holding a gold-foiled condom between thumb and forefinger, a pose reminiscent of depictions of Jesus holding the Host in classical Christian paintings. She is accompanied by Sister Psychadelia, Sister X and Sister Vicious, all from the San Francisco house, and Sœur Thérèse and Sœur Plat-du-Jour, from Paris. The June 1991 Investiture Mass that took place the following year for the Paris house — the first house in continental Europe and the second in Europe as a whole — included the first known celebration of the new liturgy known as the Condom Saviour Mass.[7] In the early 1990s that Mass came to be celebrated in San Francisco as well, and the house provided congregants with a prayer card along with a condom. On the inside of the card was printed the Condom Saviour Vow that participants intoned during the Mass. Affirming the sanctity of the love between those taking the vow, and by extension the sanctity of their bodies and their lives, the Condom Saviour Vow also sanctified safer sex. It made what some regarded as simply good advice into a holy and life-saving ritual, and its promise of salvation was probably far more credible to these congregants than the celibate or heterosexual salvation offered by the church.

Are these queer religious objects sacred or sacrilegious? Can they be both at once? Many Roman Catholics, even some who are themselves queer, see only sacrilege and mockery in the Sisters of Perpetual Indulgence. Still fresh in the minds of some Catholics is ACT UP's (AIDS Coalition to Unleash Power) Stop the Church protest in New York City in 1989, during which a member of an affiliated group dramatically crumbled a consecrated Communion wafer in front of the altar. As Anthony Petro notes, many queer and straight commentators have refused to consider this act as a legible or legitimate form of religious protest, even though there is ample reason to interpret it as such.[8] One person's sacrilege is another's sacred resistance.

Examples abound of the campy solemnity of the queer sacred, and not just among the Sisters of Perpetual Indulgence. Although the Sisters are not a religious order, they claim the mantle of the sacred for queer — and especially gay — experiences, desires, bodies and ecstasies. They manifest the sacred by making it present, tangible and material in queer bodies, queer communities and queer objects. When those bodies, communities and even objects are subject to mob violence, police brutality and incarceration, a relatively safe place for encountering one another can indeed be a sacred refuge. When the church, which is enjoined to provide shelter to the stranger, offers only persecution, a beat can become a sanctuary. When that beat is destroyed, its remnants, rescued at great personal risk, become relics, objects of simultaneously serious and parodic veneration. And when

governments and religious institutions turn their backs while a disease ravages communities they would prefer to see disappear, what response could be more powerful than to adapt the sacred imagery of the dominant religion in order to provide succour to the oppressed and to expose the hypocrisy of the oppressor?

What might we learn about religion, community, queerness and material culture if we took objects like the Green Park beat relics and the Condom Saviour seriously as ritual items and took their veneration seriously as religion? What might we learn about the sacred if we accepted that camp and sacredness can go together, that serious parody can be a religious practice? The Sisters of Perpetual Indulgence and their devotional objects have much to teach us about queering religion.

The Holy Communion Condom being distributed by an acolyte at the Mass Against Papal Bigotry in San Francisco, 17 September 1987.

TC Health Care IS a RIGHT!

No condoms? GET OUTTA MY HOUSE!

Support marriage equality? "I do"
www.ido2006.com

safe is sexy.

ACTION = LIFE SILENCE = DEATH

BISEXUAL PRIDE!

JOAN JETT BLAKK FOR PRESIDENT

Q

I WANT YOU, HONEY! LICK BUSH IN '92! QUEER NATION PARTY

50. Political Buttons

KATHERINE A. HERMES

Political buttons capture a moment. Queer buttons capture our zeitgeist. Buttons that now lie in grey archival boxes once lived over someone's beating heart, proudly proclaiming a point of view, an identity, an alliance with a cause. And it is there we must imagine them. For queer people the button's history is the story of our coming out and creating communities. As Steven F. Kruger tells us, buttons situate our 'various stories in a particularized context'.[1]

Queer buttons had their heyday in the 1970s and 1980s when the gay liberation movement was strong. The movement morphed from passionate causes into political strategic plans and was captured in buttons. Those without words were signals of acceptance recognisable to other members of the community; those with words sometimes encoded deeper meanings for people in the know. They carried messages of uplift and pain, and phone numbers for crisis hotlines. Their recent disappearance makes their preservation all the more important. Most archives have taken whatever ephemera was given to them and sorted it by type without paying attention to its messages, but distinguishing these, the audiences at whom they were directed and the contexts in which they were produced, opens a window into queer communities. This chapter looks at the buttons in one collection, the GLBTQ (formerly Gender Equity) Archive at Central Connecticut State University's Elihu Burritt Library, and sets them in the political, social, medical and economic contexts in which they were created, worn and preserved.[2]

Tradition has it that George Washington wore the first political button in 1789 at his inauguration in New York.[3] If you had asked the late Gore Vidal or Larry Kramer, authors of historical novels, they would have told you Washington was gay and his was the first gay button.[4] In the presidential election of 1824 it was the voters, not the president, who started wearing political buttons. By 1868 the celluloid wrapper meant buttons could be mass produced at little expense and cheaply distributed by the thousands.[5] They indicated civic engagement in the electoral process, and their use in

American election campaigns continued throughout the twentieth century. Other countries were slow to adopt political buttons, but occasionally they turned up in Britain, New Zealand and Australia. They were particularly popular during World War I.[6]

In the 1960s buttons began to carry messages beyond electoral politics and attracted the post-war 'baby boom' generation, who added them to their denim jackets. The move to wear buttons on occasions other than elections coincided with the rise of civil rights campaigns and the gay and lesbian rights movement. The queer buttons that abounded in the United States during the 1970s and 1980s were collectible as well as disposable.[7] Frank Gagliardi, the founding archivist of the GLBTQ Archive at Central Connecticut State University near Hartford, gathered together political buttons, T-shirts, bumper stickers and music that carried a queer message. The queer buttons in this archive range from those that explicitly address such political subjects as civil rights, civic issues, legislation and candidates, to those with religious statements, affirmations and funny sayings. Some buttons advertised businesses ('Art Feltman, Attorney at Law') or services ('AIDS Project Hartford 247-AIDS'). When viewed chronologically, they show how issues, attitudes and situations have changed. Many buttons were produced for pride celebrations and others were part of issue-based campaigns, two of which are especially important: community organising during the AIDS crisis and the campaign for same-sex marriage.

AIDS devastated the gay community during the 1980s. Fear and misinformation abounded, and governments were slow to fund research, develop medications and provide health counselling. AIDS buttons tried to calm fears, promote healthy behaviours and stop discrimination. One square button says: 'Support AIDS LIFE Campaign/AIDS Legislative and Funding Effort'.[8] Some buttons reflect the radical, controversial campaigns by ACT UP (AIDS Coalition to Unleash Power) that Larry Kramer launched with the slogan 'Silence = Death', but the other ACT UP slogan, 'HIV is not a crime, criminalizing it is', is not represented in the Connecticut collection.[9]

Love Makes a Family was a major Hartford group that promoted same-sex marriage. Run by local activists with long track records, and supported by politicians who backed queer communities, Love Makes a Family waged a successful campaign for the same-sex marriage bill enacted by the Connecticut legislature in 2008. The buttons in the archive's collection reflect that viewpoint. 'Support marriage equality? "I do!",' said one button.[10] None of the buttons reflects the anti-marriage views held by more radical or more conservative gays and lesbians. The only one that voiced a contrary opinion did so through humour: 'Let gay people marry. They should suffer like the rest of us.'[11] The lack of diverse political stances in the collection may reflect unity in this particular Hartford community, the

archive's collection policy or the various enthusiasms of its donors.

Although most buttons in the Connecticut collection are directed at 'the gay community' or an unspecified queer population, others are more specific. Condoms and safe sex were persistent themes on buttons aimed at men: 'Safe is sexy', 'Safe sex: It does a body good' and 'No condoms? Get outta my house!' Women had gender-specific buttons too, although theirs were less likely to be about sex or sexual orientation. Hartford activist Christine Pattee's collection reflected her intersectional identity as a queer feminist woman. Most of her buttons promoted political candidates ('Bella for Senator' urged people to support Bella Abzug of New York) or addressed women's issues more broadly ('For women's equality/women's lives – Keep abortion safe and legal/Pass the ERA [Equal Rights Amendment]'). Pattee's collection focused heavily on general 'sisterhood' messages, but a few buttons were lesbian-specific.

There are very few 'trans' buttons in the Connecticut archive, and often depictions of transgender people do not have a trans message. 'Joan Jett Blakk for president', with a picture of an Egyptian queen, and 'I want you, honey! Lick Bush in '92! Queer Nation Party', refer to a trans person, but the message is directed at the whole queer community. One button, a picture of famous drag queen Marsha P. Johnson, subtly referenced Johnson's presence at the Stonewall rebellion in 1969. She was known as 'the mayor of Christopher Street' and the button shows her in a big floral hat with a wide smile. Only community insiders would know the meaning of this button. Bisexual buttons are the rarest, although a small one with blue and pink overlapping triangles creating a third purple triangle proclaimed 'Bisexual pride'! Another is divided in half by blue and red and features the slogan 'Bi American', a pun on a popular campaign to 'Buy American'.

Religious organisations produced buttons with social justice messages. A button for the AIDS Ministry of the Archdiocese of San Francisco says: 'The Body of Christ has AIDS'. Occasionally, though, they just announced support: 'United Church Coalition for Lesbian/Gay Concerns' or 'Congregation Am Segulah'. Buttons also offered critiques: 'GOD please save me from your followers.' Dignity, a group for gay Catholics, produced a series of buttons to advertise its conventions in Washington DC (1991), Boston (1997), Chicago (1998), Denver (1999) and Las Vegas (2003). Some of the Dignity buttons show four names, usually common ones, to illustrate that folks with names like Jeff, Kevin, Sue and Marge can be gay or lesbian as well as Catholic.

Pink triangles, which symbolised the oppression endured by gay men in Nazi Germany, were the dominant symbol of the gay and lesbian movement during the 1970s and 1980s. But their prominence would not last. In 1978 Gilbert Baker produced the first rainbow flag in San Francisco, and by the

1990s this had largely replaced the pink triangle as the primary motif.[12] John Bonelli's collection in the Connecticut archive shows the transition. The pink triangle still spoke to issues of discrimination and persecution, but the community shifted to the more festive flag for general use. The shift in symbols meant buttons lost popularity. Some buttons have flags on them, but people wear rainbow colours in different ways as well: headbands, bracelets and flag pins. The rainbow flag has become a dominant symbol at pride parades and protests in all their forms.

Political buttons reflect the aims of activists in the community. They tend towards the aspirational, such as achieving marriage equality or even just acceptance by the straight community, and also reflect immediate concerns like helping those with HIV. As we look at old buttons we need to imagine them worn on someone's clothing, gleaming in the sun, their wearers waving banners, marching and chanting. Those buttons, whatever their slogan, bravely declared that their wearers were out and proud.

Badges worn at Brooklyn Pride, New York, 2015.

51. Plastic Politics

JAMES BURFORD, KATH KHANGPIBOON & JUTATHORN PRAVATTIYAGUL

ID cards are ordinary objects. They fit snugly in a wallet, are flung into a purse or are misplaced over there or under that. Their sheer ordinariness, and the fact they are so routinely woven into the everyday rhythms of life, mean they recede from view as objects that deserve our critical attention. As an object, however, the ID card addresses the problem of how identity may be tied to the body.

ID cards ought to be generic. One card should look just like another, except of course for the unique photograph and information that demonstrates that it belongs to its owner. Despite their promise of straightforward 'identification', ID cards are highly political pieces of plastic that invite questions about national belonging. Although much of the focus on citizenship artefacts is concerned with who is and who is not entitled to obtain them, we should consider the effects such objects may have on the different bodies and identities of the citizens who hold them. For many people the use of an ID card is unlikely to produce much in the way of discomfort, but for others the information inscribed on it can contribute to routine experiences of stigma and discrimination. This chapter examines the experiences of one constituency with stories to tell about using a national ID card: the Thai transgender community.[1]

The current iteration of Thailand's 'smart' ID card comprises just 5.358 grams of plastic and metal. It is only 8.6 centimetres wide and 5.4 centimetres tall. Despite its limited size, however, the card is dense with symbolism. Thailand's national ID card is coloured light blue and features a background of the national symbol of the Grand Palace on both sides. On the front are more symbols of national identity: the Khrut, a mythological half-bird and half-human creature that is the country's national emblem, and the five horizontal stripes of red, white and blue that form the flag of the Kingdom of Thailand. There is also an electrical chip that signifies the card's 'smart' features and its connection to an integrated circuit of citizenship.

The front of each card also includes a unique 13-digit identification number, a title (options include Mr, Mrs or Miss), first and last names, a date of birth, dates of issue and expiry, a residential address, a head-and-shoulders picture with the person's height displayed, a magnetic strip, an IC chip, and holograms and microtexts that serve as additional security features.

Kath Khangpiboon's ID card sitting in her purse, 2018.

༚

Previous pages: Bangkok, Thailand.

Thailand's current 'smart' ID card can store a significant amount of biometric information, including the owner's fingerprint, but its historical antecedents were much less sophisticated. Before 1939, in what was then Siam, tattoos were used to identify and control corvée (unfree and unpaid) labour.[2] For example, the wrist of a *phrai luang*, a commoner who worked for the king, was tattooed in order to identify their place of residence and the name of their master.[3] As Pinkaew Laungaramsri notes, 'by marking the body as *phrai*, it automatically fixed the social status and class and thus prevented the possibility of upward mobility'.[4]

The first artefact recognisable as an ID 'card' was issued in 1943, to residents of two districts in the wider Bangkok area. Consisting of eight pages of paper folded into four quarters, it included such information as the card holder's 'name, date of birth, address, profession, complexion, mark, nationality, ethnicity, name of father, name of mother, photograph, fingerprint, and signature'.[5] The second iteration of the Thai ID card, which emerged during the Cold War period, was issued in border provinces in the north-east and south of the country. It differentiated between Lao, Malay and Thai peoples. Laungaramsri argues that Thai state artefacts have been used as a way for the government to 'circumscribe, register, regiment, and observe people within their jurisdictions' and to create a differentiated form of citizenship that draws distinctions between Thai people and non-Thai others.[6]

Today in Thailand people use the national ID card to receive government services and other entitlements, and to verify their identity while undertaking business transactions. It is required for such ordinary activities as getting care at a hospital, applying for a job, opening a bank account, applying to study or entering a bar. The fact that, currently, transgender individuals cannot change their marked sex on identification documents opens the door to discrimination across multiple fronts. The ID card disables certain kinds of social belonging for Thai transgender people, which has significant impacts.[7] For instance, transgender people are subject to increased questioning by bank staff when undertaking routine transactions, as Keng, a transgender man from Bangkok, relates:

> One bank asked me to prove my identity because they did not believe I was a 'Miss'. They told me to go show my ID card at the branch. I went to have a chat at the branch. The clerk said to me: 'Well, don't use the word "khrap" [masculine politeness particle] then.' My face went white. I thought: 'How can you speak to me like this?' Maybe she just thought it would be easier if I talked like a woman and explained my deep voice with a cold. But why do I need to use special strategies to survive? So I explained that I was transitioning and taking hormones and hence my voice was deep. The clerk still did not believe me but when they saw my face go white they called [the call centre and got confirmation] so it passed.

As Nam, a transgender woman from Central Thailand notes, 'The main problem is my personal title. When I have to deal with the bank, they usually have a problem with my ID card because it still says Mister. The photo is also an old one. They usually feel suspicious and have to investigate more.' Aor, a gay man from Central Thailand who previously identified as a transgender woman, 'had problems conducting transactions … Taking the photo for my ID card was also difficult because I had to bring in my parents to sign [some documents to prove my identity] because the first time I'd taken the photo I was still a man, but during the second time, I wasn't. So even the village head had to have a go at identifying me [laughs].'

Because transgender individuals cannot obtain an ID card that matches their gender presentation, hospitals sometimes require additional proof of identity. This can cause delays and impede access to care. Legal gender status, and its presence on official documentation, has shaped the life experiences of transgender people. 'We really hope,' says Weena, a transgender woman from Bangkok, 'Thailand will allow Kathoey [transwomen] and transgender men to change their sex on all official

records because it links to so many problems. I have undergone sexual reassignment surgery and have lived like a woman all my life, but my passport and ID still say I'm a male person. It was complicated for me to register for medical care, to apply for university, to apply for jobs, because I have male documents.' For Da, a transgender woman from Nakhon Pathom, 'Being addressed with the title *Nai* [Mr] makes me feel like I'm a *tua-talok* (English translation: clown) or freak. I've got no rights, so I've gotta try to get used to it, just have to tolerate, tolerate that people think I'm a freak.' Darat from Pattaya reports: 'My girlfriend [a transwoman] was jailed in a male prison after doing a petty offence, and she was harassed many times there. It would not have been as bad if she was jailed in female prison. But it's impossible because Kathoeys still have male identity by law, so there is no exception.'

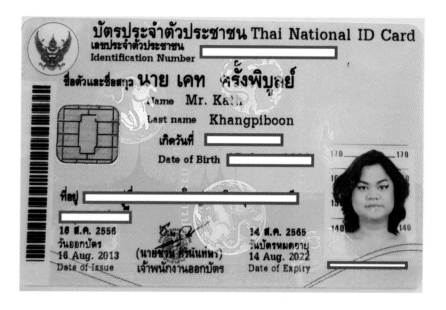

The ID card of Thai transgender activist Kath Khangpiboon juxtaposes the title 'Mr' with Kath's feminine name and appearance.

For Kath, the second author of this chapter, this issue is personal. Kath is a university lecturer and co-founder of the Foundation of Transgender Alliance for Human Rights. Her ID card shows she has been able to change her name and dress in accordance with her gender identity for the photograph, but she has been unable to change her personal title. According to this card, she is 'Mr Kathawut'. For Kath this produces stigma; she wonders, for example, how people will react when she has to produce the card to have a payment processed. Kath is also concerned about the ways the Thai news media use ID cards as a tool to humiliate transgender people. At the age of 20, all those who are assigned male are required to attend the military service drafts, including transgender women. When called up they are subjected to a physical examination in full public view.[8] Often

this becomes an event of media ridicule, and transgender informants are commonly misgendered in newspaper reports. The humiliation is not only for the living: even murdered transgender women have faced the indignity of having their ID cards shared publicly in media reports of their deaths.

For several years transgender activists and non-government organisations, including the Thai Transgender Alliance and the Transsexual Association of Thailand, have lobbied for the Thai government to officially acknowledge transgender identities on national ID cards and other official documentation, including passports. However, transgender identity politics in Thailand are complex, and transgender people's responses to current practices are mixed. These range from strong resistance and advocacy to ambivalence and a defence of the status quo. While activists and advocacy groups are pushing for change, other transgender people in Thailand may not wish to alter their gender identity on their ID card. Some of them believe that transgender people should accept official documentation of their assigned sex, as this is a 'natural' force or karma.

Despite Thailand's international reputation as a 'paradise' for gender and sexual diversity, the ID card is an object that routinely produces discrimination and exclusion for the country's transgender communities.[9] We hope the Thai government will reconsider its current position, enable transgender Thai people to legally change their gender identities, and have this change represented on their ID cards. So how might we configure the words queer, object and ID card in a sentence together? Perhaps, rather than the ID card being 'queer' in itself, it is transgender Thais who queer the object. By creating discomfort about the stability of gender, Thai transgender people unsettle notions of identity that ID cards hope to fix and stabilise.

The title on the card says 'Mr', but the purse suggests otherwise.

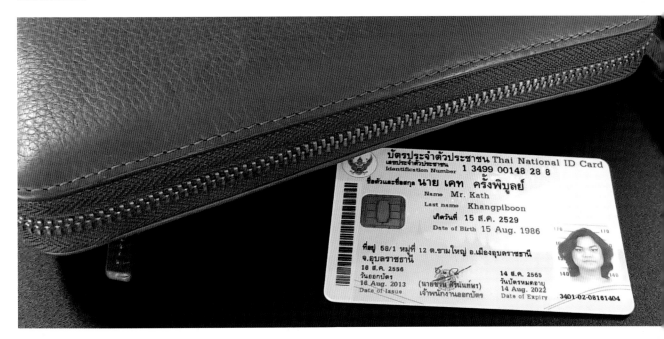

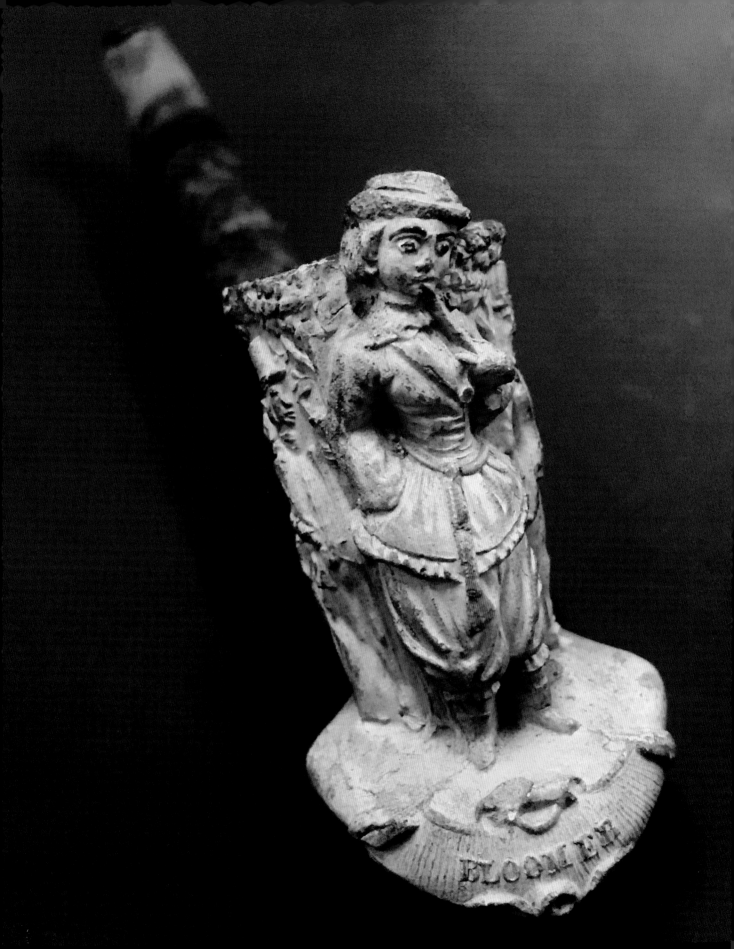

52. Bloomers and Monocles

NIKKI SULLIVAN & CRAIG MIDDLETON

As social history museum curators we document every object that comes into our collection, carefully considering its provenance and significance. This chapter focuses on two objects from the Migration Museum in Adelaide, South Australia: a nineteenth-century meerschaum pipe that features the carved figure of Amelia Bloomer, and a monocle that dates from the first half of the twentieth century. We chose these objects because together they allow us to explore how sartorial codes and conventions have regulated identity and been used to challenge normative ideas and practices.[1] We want to explore the diverse and unexpected relationships between these objects and their interpretations.[2]

The small tobacco pipe is 25 centimetres long and 5 centimetres tall and made from sepiolite. This mineral was highly prized during the eighteenth and nineteenth centuries because it carves easily, and when smoked over a long period it changes colour and becomes glassy in appearance. Intricately carved bowls are a common characteristic of meerschaum pipes, and this one is no exception: both sides of the bowl feature women in elaborate crinolines. The figure of Amelia Bloomer, one of the leaders of the dress reform movement in the United States during the mid-nineteenth century, takes pride of place on the front. Although meerschaum pipes often featured the heads of well-known people or women considered attractive, this one is particularly rare because it profiles such a highly politicised figure. It is unclear who made the pipe and why, and whether its original purpose was to support or to satirise the dress reform movement. Either way, it speaks to us of significant historical struggles around gender and sexuality that still resonate today.

As the carved figure of Bloomer shows, the bifurcated garment championed by dress reformers was distinctly different to the pants worn by men: bloomers were wide-legged trousers, gathered at the ankle, and were inspired by Turkish and Eastern dress. The 'freedom suit', as it was sometimes known, consisted of bloomers paired with a dress that reached about 10 centimetres below the knee. This represented an attempt to

The meerschaum pipe featuring Amelia Bloomer.

free middle- and upper-class women from the constraints of conventional feminine style: 'In mid nineteenth-century America ladies were ensconced in six to eight heavy petticoats, long, dragging skirts, constraining corsets, and tight sleeves – attire admirably suited to life as a decorative toy and little else.'[3] By constricting women's movement, dominant forms of sartorial style firmly placed them in the private realm and reaffirmed the association of men with politics and power. This fettering of women, and their subsequent dependence on men, drew on and reinforced normative notions of gender and heterosexuality. The wearing of pants in public by white, middle-class women also raised the spectre of class and race. Dress reformers were seen to adopt the practices of working-class and black women. In an 1842 report on the coal mines in Staffordshire, England, Samuel Scriven describes men and women working side by side, stripped to the waist and wearing trousers. Likewise, in the same period, poor American women of colour sometimes wore pants. Bloomers were often associated with foreignness, heathenness and, more particularly, with Islam: all that was, by nature, 'other' to white, Christian, middle-class femininity.

Was dress reform an intentional attempt on behalf of women to usurp masculine sartorial style or to blur distinctions between men and women? It was certainly the subject of much virulent criticism by the popular press. Cartoons show that critics of dress reform perceived the movement as a threat to male privilege and its God-given status. Many believed women who wore pants would smoke, drink, congregate in public places, stay out late, read newspapers and discuss politics. Men, in turn, would be reduced to the 'decorative toys', the 'inferior animals' they required

'Something More Apropos of Bloomerism', a cartoon from Punch magazine.

SOMETHING MORE APROPOS OF BLOOMERISM.
(Behind the Counter there is one of the "Inferior Animals.")

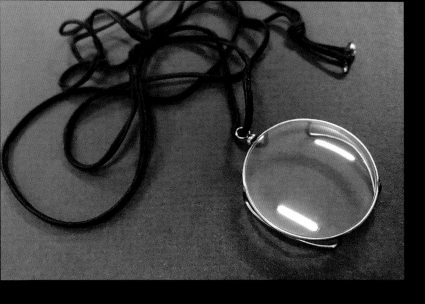

A monocle from the collection of the Migration Museum, Adelaide.

women to be. Bloomers represented a powerful protest against the natural order of things.[4] The donning of such garments by middle-class women challenged the prevailing gendered logic, whether or not that was their intent. Opposition to 'bloomerism' was so vehement that by the mid-1860s many early reformers had relinquished the freedom suit. It would be at least another 70 years before the wearing of pants by women was widely accepted in the United States.

Although corrective lenses can be traced back to pharaonic Egypt and ancient Athens, the monocle did not become popular until the early nineteenth century, when it was worn almost exclusively by members of the British and European aristocracy. It very quickly became associated with fashion rather than function, largely because dandies adopted it. For Charles Baudelaire, who described these immaculately coutured men with aristocratic aspirations as 'disenchanted and leisured outsiders',[5] dandies were the embodiment of the spirit of modernism. They sought to both oppose and rise above the homogenising effects of democracy, and became gloriously 'other' in the process; the dandy was both a privileged man and an outsider. This association of sartorial style with a politicised form of self-fashioning is apparent in the subsequent adoption of the monocle by diverse groups of women during the 1920s and 1930s. Monocle wearing became a craze among young middle-class women in New York and Chicago.[6]

For some the monocle denoted flapperism, with its fastness, raciness and sense of modernity. Other monocle wearers included the mostly British and American expatriate writers and artists who inhabited what Shari Benstock refers to as 'Paris-Lesbos', a lesbian social scene, between the two world wars.[7] In donning trousers along with their monocles, these women

literally broke the law.[8] During the interwar years the Le Monocle nightclub in Montmartre was the centre of lesbian nightlife in Paris. Photographs by Albert Harlingue and Brassaï show that monocles were a common feature of female masculinity in Paris during this period, as were short hair, cigarette smoking, bow-ties, tuxedos and white carnations. As Lillian Faderman suggests, the circle of 'Sapphic modernists' who inhabited the Left Bank sought 'to create a self-image which literature and society denied them'.[9] Some women adopted the male dandy's sartorial style, including the monocle. Among their number were painter Romaine Brooks, journalist Janet Flanner, novelist Colette, poet Natalie Barney and her socialite partner Dolly Wilde, and Marion 'Joe' Carstairs, who went on to become a power-boat racer. All of these figures had relationships with other women and all publicly announced their 'outsider' status. The symbolism was complex: some of those involved in same-sex relationships identified as 'lesbian' but others did not; some regarded the monocle as a signifier of same-sex desire while others saw it simply as modern.

Neither dandyism in general, nor the female masculinity performed by those mentioned, really challenged class structures.[10] Rather, such transgressions were possible largely because of the privileged position of those who performed them: most of these women were independently wealthy. And it is the monocle, with its complex associations with aristocracy and outsider status, along with its 'paradoxical visual effect of making a male dandy seem less of a man and a female dandy more of one', that best symbolises the equivocal nature of gender and sexual identity.[11] Nowhere is this clearer than in Romaine Brooks' portrait, *Una, Lady Troubridge* (1924). A British sculptor and translator, Una Vincenzo, married Captain (later Admiral) Ernest Troubridge, but their marriage ended in 1915 when Una met Radclyffe Hall. The two women were in a relationship for 28 years until Hall's death parted them (see Chapter 33). Brooks' portrait provides a combination of masculine and feminine signifiers: the tailed coat, monocle, earrings, lipstick and the domestic setting. These disturb prevailing assumptions about gender (as *either* masculine or feminine) and of sexuality (as singular, coherent, fixed and so on). Like bloomers, the monocle simultaneously appropriates the male gaze and challenges the assumed naturalness of male privilege.[12]

Laura Doan suggests that the monocle 'at once resists and teases. Like the wearing of trousers, [it] never conveys a single meaning.' It suggests 'class, Englishness, daring, decay, rebellion, affectation, eccentricity – and possibly, but not necessarily, sexual identity'.[13] The symbolic instability of the monocle, much like that of the notorious bloomers, tells us much about the complex ways in which sartorial styles function as regulatory mechanisms and also the means by which such technologies can be queered.

Romaine Brooks' oil painting titled Una, Lady Troubridge, *1924.*

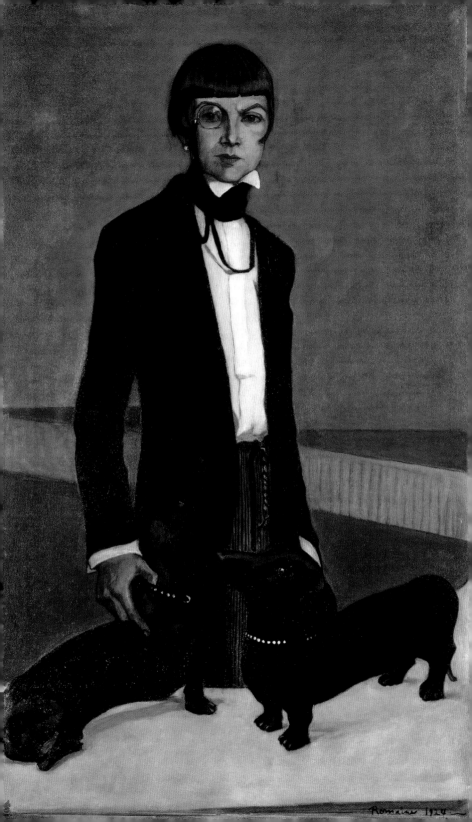

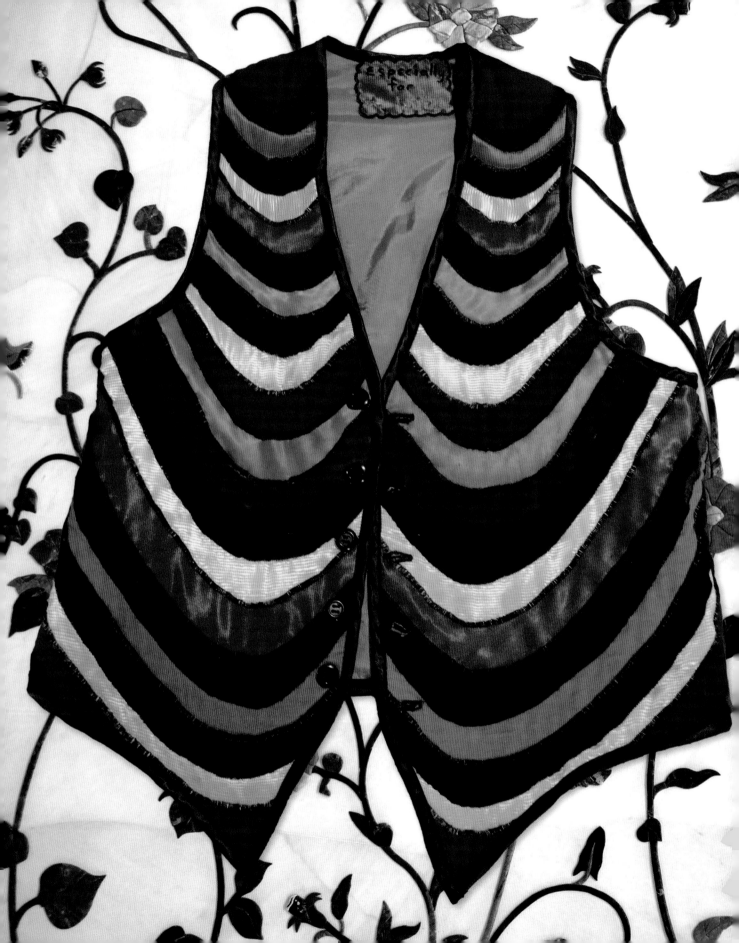

53. A Lesbian Waistcoat

NADIA GUSH

A bright, vibrant waistcoat occupies pride of place in Karen Wilson's wardrobe. The waistcoat has hung in wardrobes at four houses, moving as Karen has moved from home to home across the city of Hamilton, New Zealand. Its carefully selected colours are in sharp contrast to the otherwise subdued hues of Karen's everyday attire.

Cut to the shape of a gentleman's waistcoat, the garment is lined with a viridian green. Bold rainbow stripes, pre-dating the popular association between rainbows and LGBT rights in Hamilton, form riblike tiers across the front. These intensely coloured strips of velvet, satin and cotton are brought into stark relief by the use of a black zig-zag top stitch. The back panel is matt black cotton on which a large double-woman-sign has been pieced together in a patchwork, reminiscent of stained glass in its visual effect. Attached to the lining is a bright pink label that reads 'Especially for Willie', Karen's nickname at the time. The maker, Hamilton designer Yana Lea, has signed the label with a small star, the prongs of which are each a different colour, set next to a hand-embroidered 'y'. Referred to by Karen as her 'lesbian waistcoat', this example of queer clothing was created in the early 1980s, most likely between 1981 and 1983.

In the late 1970s and early 1980s Yana Lea was living as a lesbian separatist, making waistcoats to sell to lesbians in Hamilton and Auckland. Made variously of leather or satin, the waistcoats gave her an opportunity to experiment with fabric and textile design. The use of patchwork and reverse appliqué made for elaborate fabric patterns. Dramatic zig-zag top stitching offered an opportunity to experiment with the possibilities of domestic machine sewing: Yana hoped that the use of zig-zag would produce the same effect as the hand-embroiderer's satin stitch. Because money was short, she made these popular lesbian waistcoats from a range of bits and pieces: ribbons, small lengths of fabric, and old clothing cut apart and repurposed. While the decision to produce waistcoats was determined by the preferences of lesbian buyers, Yana's fascination with clothing and fabric was constant. She was drawn to the possibility of transformation.[1]

During the 1970s Yana's clothing design centred on the traditional women's crafts of knitting and embroidery. This was an extension of the sewing skills her mother and Country Women's Institute-affiliated grandmother had passed on when Yana was young. Following the success of the lesbian waistcoats, Yana's work with leather extended to a BDSM business, Backlash Leathers, which involved the production of cock rings, pants and whips, which she sold to gay men at markets. As a side business, Yana also made leather skirts for straight women. Later, in 1991, when the Hamilton Maori Women's Centre needed someone to teach fabric design and clothing construction for larger-sized women, Yana became the tutor. In 1992 she started a hand-printed textile design business under the name Miro Textiles, and the company became a supplier of fabrics to the New Zealand fashion industry. During the late 1990s Hindu and Buddhist themes influenced Miro's designs.[2]

Karen was living in her own four-bedroom house in Hamilton when she acquired her customised waistcoat. As few women in her circle of friends were able to buy their own homes, Karen rented out rooms to other lesbians. When Yana started Backlash Leathers, Karen rented her some space to use as a leather workroom. By 1988 Karen's house was one of a handful of suburban venues in Hamilton that were regular 'party-houses' where lesbian women would turn up to drink, dance and sing. It was at such events that Karen would wear her waistcoat. Active in the feminist movement, she helped to establish the Battered Women's Support Line and Women's Refuge and worked in Hamilton's Rape Crisis Centre. In 1988 Karen combined her love of socialising and her feminist activism in the Fun Brigade, a social group that raised funds for other organisations by running dances and donating the profits.

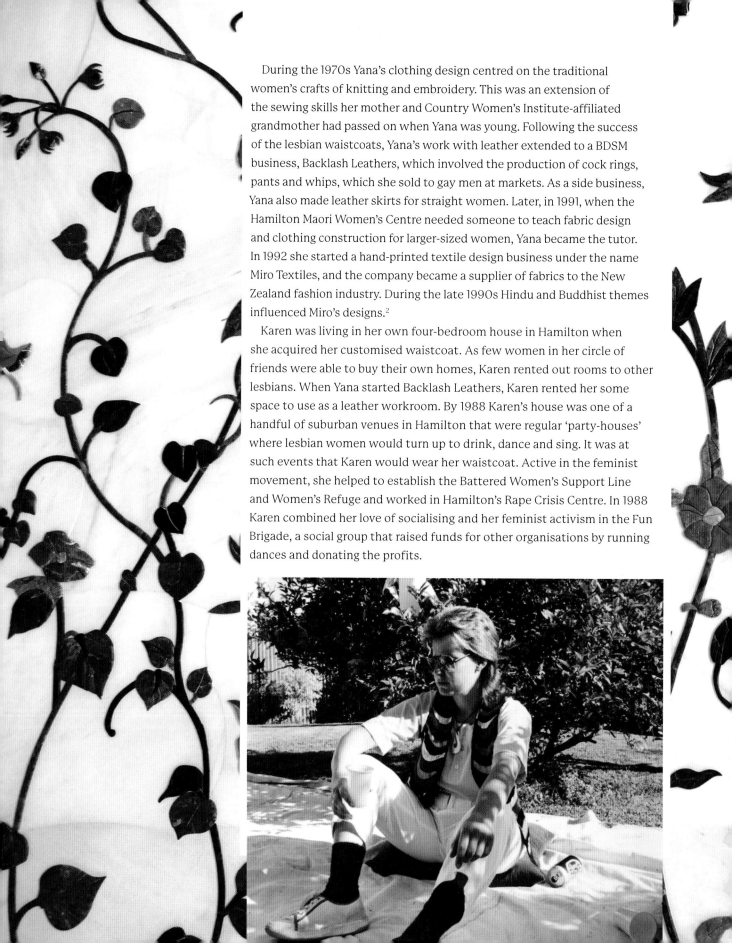

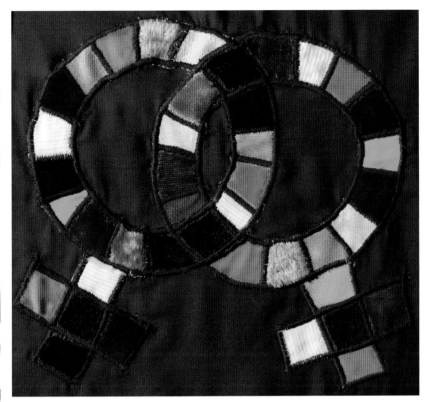

Waistcoats were distinctive pieces of lesbian-specific clothing in New Zealand in the 1980s and Karen describes hers as a lesbian identification marker. 'I don't know where that came from, or why – no idea. Just being different, I think. It was not what straight women were doing; it was just a way of being different.'[3] Despite its association with formal dress, the waistcoat was a casual piece of clothing for Hamilton's lesbians. Karen wore her waistcoat with a 'granny T-shirt', Skellerup sandshoes and high-waisted trousers. Others wore their waistcoats with braces. The colourful waistcoat is the garment that Karen most associates with her lesbian identity.

When Karen asked Yana to make her a waistcoat she did not anticipate receiving the thoughtfully customised piece with which she was later presented. Yana's waistcoats were known to be bright and colourful, but their backs were usually bare. This time Yana created the double-woman-sign as a surprise, especially for Karen. She tailored this waistcoat to fit Karen's lesbian feminist politics and the tight-knit lesbian community from which she drew her friends. But Karen's waistcoat is more than just an example of lesbian-coded dress sense. It is a taonga, a treasure produced by an artist from her own community. The bold stitching and vibrant colours encapsulate Karen's politics, her youth and Yana's generous spirit. As Karen explains, 'To me it's an art piece, it's like any other piece [of art] that I have.'[4]

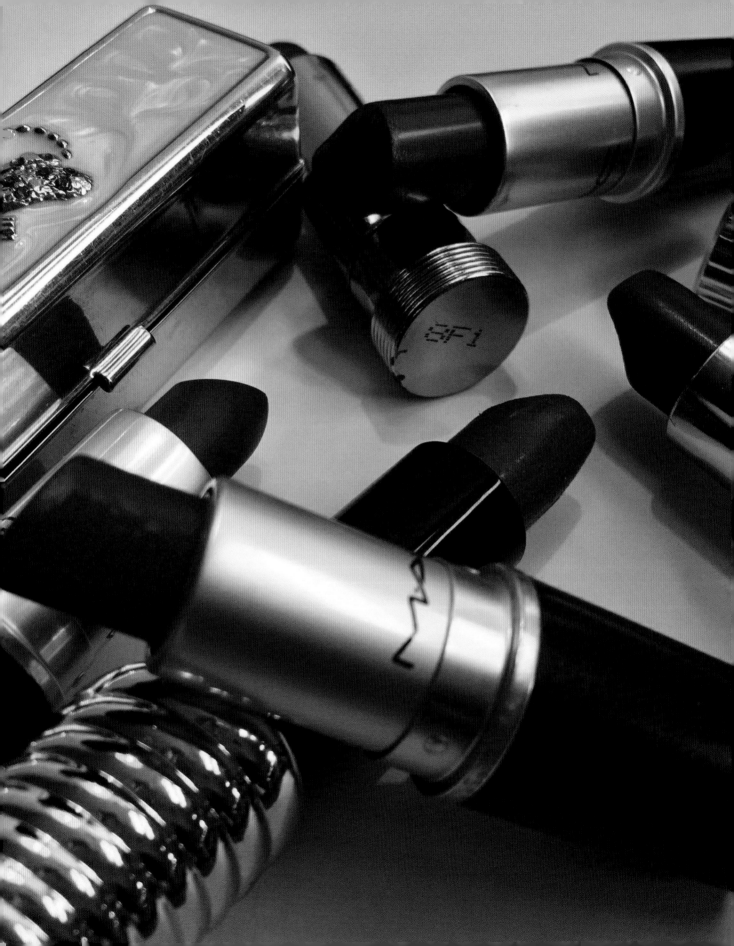

54. Lesbian Lipstick

REINA LEWIS

I learnt to enjoy wearing lipstick because I was a lesbian, not despite it. Lipsticks chart my changing relationships to fluctuating fashion norms specific not just to my version of lesbianness, but also to social factors of age, ethnicity, religion, class, body size and ability.[1] My fashion world, like that of many consumers, is framed by 'mainstream' fashion systems that determine to a large extent the commodities available to purchase and the aesthetic norms against which bodies are judged. I have navigated this in relation to minority or 'alternative' fashion systems whose own, often low-key, highly localised niche markets provided supplementary commodities that were often — self-consciously — not 'in fashion'. One major historical change was the incursion of consumer culture into gay, and later lesbian, life. Queer subjectivities came increasingly to be understood and formed through consumption.[2] Lesbians' relationship to consumer culture has changed markedly since the 1980s: once ignored by advertisers, they are now a sought-after consumer segment. So how has my own life tracked the relationships between lesbians, lipstick and style?

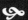

It is 1982 and I have moved to Brighton to do an MA at Sussex University. After a series of intense interviews, during which potential roommates screened one another for appropriate identity politics, I find myself living in a house with two lesbians. I arrive with all the accoutrements of the look I have sported for four years while doing feminist art history in Leeds: coloured leggings, vintage dresses, badges, bangles and beads. In Brighton the look is black denim, buzz cut short hair

and Doc Marten boots – for everyone, not just the dykes. Having spent my undergrad years desperate to get laid by a woman, but somewhat hindered by the existence of my out-of-town boyfriend, I discover that sexual politics are less doctrinaire in Brighton than in Leeds and there are women who will take me on while I make the transition. Within months I have arrived in lesbian heaven. But there is a cost: the lesbian style mafia has cut my hair and my nails, put me in black denim and persuaded me to get my ear pierced for the pre-requisite labrys earring. This is very definitely a pre-lipstick time.

Wearing only her black denim jeans and her Docs, my uber-cool flatmate chooses her outfit for our favourite lesbian disco. Laid out on her futon are four vests, all black: 'Which one?' she asks. 'But,' I query, 'aren't they're all the same?' 'No!' she cries. 'This one has four buttons, this one is ribbed with no button, this one is plain with two buttons, and this one, my best one, is ribbed with three buttons.' This is my introduction to that all-important lesbian dress concept: the Best Vest. As someone not inclined to less is more, I am beginning to understand the niceties of the carefully casual.

I had to learn the nuance of this particular presentation of lesbian visibility and desire. Becoming competent in this cultural code was not, however, a key to the lexicon of all lesbian looks in all times and all places. As many sexual minority subjects know from experience, looking like what we are has been highly significant. But we cannot always recognise one another. We need cultural and subcultural competencies to comprehend the historical variables that make queer genders visible and invisible.[3] As Laura Doan has demonstrated in her work on the *Well of Loneliness* trial of 1928, women wearing masculine-style attire before the trial were not seen by the general population in terms of same-sex desire. Instead they figured as part of a mainstream modernist fashion for boyish style.[4] This changed as a result of the trial and as fashions shifted towards an overtly feminine look. There was then, and has been since, a mutually constitutive relationship between majority and minority fashion.

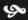

In summer 1988, still in Brighton, I am standing in the communal changing room of high street store Wallis, trying on a navy blue, lace linen, pencil skirt – lined, knee length with a short slit at the back. Rachel, my relatively straight woman friend, is sitting on the floor in her Doc Martens, black jeans and leather jacket while we debate the ideological significance of buying this dubious garment. Eventually we decide that it could be okay if worn with Docs and a loose 'protest' T-shirt, probably with an anti-section 28 slogan on it.[5] I won't look too recuperably het. I have just started to wear a bra again, after years of feminist bralessness: it is, needless to say, a sports bra. I am

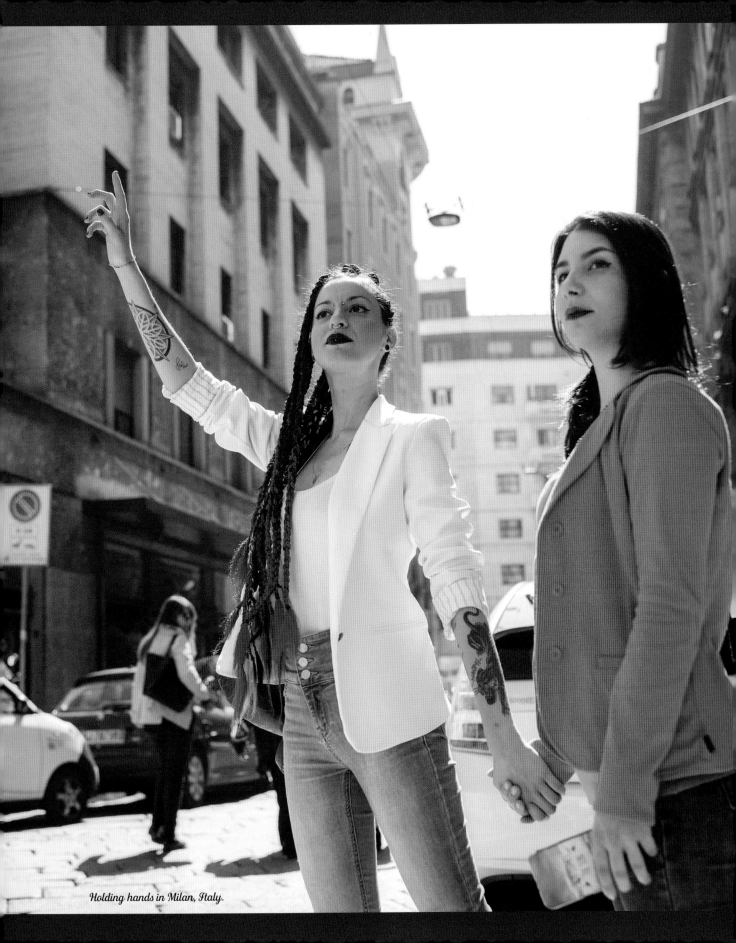

Holding hands in Milan, Italy.

also wearing bright red lipstick. I have no other make-up; my eyebrows are unplucked and my legs are virgin. This is make-up as political pronouncement. Like the other, femmier members of my gang, I am wearing lipstick as a statement: we all paint on the same full Joan Crawford mouth. 'Barely there' make-up is just about to arrive, but we are doing lipstick as performance and revel in making conspicuous the artifice of femininity.

After years of no bra and no make-up, despite having become skilled in the application of both in my early teens, I cautiously return to them in my mid-twenties. I have finally worked out what postmodernism means. Lipstick seemed to be dangerously apolitical during my never-ending angry young feminist phase, but I finally realise that postmodernism means I can wear lipstick ironically. I stomp about in my boots, with my big, retro scary glasses, and delight in applying my lippy in inappropriate places. I flourish my lipstick at dinner tables, in meetings and in the classroom. I draw attention to the manufacture of femininity, using it, I hope, to deadly effect: it especially disconcerts older heterosexual men at work, those who are senior to me. I use it to create alliances. Bring out a lipstick among other women and you are sure to embark on a discussion about brand, colour, style. It's a great icebreaker, my ticket to inclusion among even the most unreconstructed femininities of heterosexuality.

These are some of the ways in which I can resolve the dilemma of wearing frocks without, as I would have put it at the time, 'looking like a normal girl'. To some extent I had more scope for performing oppositional femmeness than my straight women friends. Mainstream fashion was central to this paradigm shift in subcultural style. The late 1980s was when mainstream women's fashion started to get girlier: deconstructionist bagginess would continue, but 'body con' was on its way, with overtly feminine styling. Lots of woman vaguely on the left looked like a lesbian at that moment in the 1980s, and within another decade only masculine-coded women looked like lesbians.

At the same time that mainstream fashion got femmier, lesbian femme became more prominent in the subcultural world and was recognised and appropriated by dominant consumer culture.[6] This culminated in the short-lived vogue for 'lesbian chic' in 1993, renewed a decade later with the TV series, *The L Word*. Masculine-coded women became more and more conspicuous — unless, that is, we think *The L Word*'s Shane is a butch as it gets?

I looked like a dyke when I walked down the street alone during the 1980s . But what happens now? When I walk with a butch or masculine-coded woman, I read as queer: Lisa Walker and others were right when they suggested that the lone femme is all-too-likely to be read as heterosexual. She 'is invisible as a lesbian unless she is playing to a butch'.[7] When I walk alone now, I don't think I look like a dyke, though I rather wish I did.

A feature on lesbian style in Diva magazine, 2007.

Lesbian style in 2007
Left to right: gilded goth beauty;
on the double deck catwalk;
tongue-in-cheek attitude.

all over the shops this autumn, and this July's *US Vogue* featured an article about masculine looks for autumn called 'How to Borrow from the Boys'. But in these days of such heightened gender sophistication, you have to ask one question: borrowing from what kind of boy?

Like biological women who decide they want to adopt a male gender, fashionable women do not necessarily want to model themselves on Stan Ogden from Coronation Street. Similarly, the 'boy' that a lot of fashion designers are pointing women towards is not by the kind of rug-

girls wearing boy's clothes. 'The androgynous look has always been around,' she says with a shrug. 'I mean, come on, Marlene Dietrich and Madonna. But what I have noticed is how boys dress like girls too in their ultra skinny tight jeans, so everyone almost blends into one. You're not sure if they are a boy or girl until you cop a feel!'

THE SKINNY LOOK
Likewise, current high fashion means that you often can't tell the straight girls from the gay girls. Sara Buys describes this new androgynous look as a 'modern Patti Smith kind of vibe.' She adds that it is 'definitely worn by plenty of straight girls so boundaries are blurring.' Key

Young dykes are likely to pledge their allegiance to the politics and dress sense of a new Shoreditch electro band

SARAH LINCOLN, EMMA SULLEY; PATRICK DEMARCHELIER

ger bugger who spends his Saturday nights down the pub farting and telling smutty jokes.

Bronwyn Cosgrave, author of *Made for Each Other: a History of Oscar Dressing*, believes that 'there is more of a cross-dressing angle going on. I'm thinking Giorgio Armani's Prive collection which debuted in Paris at the July couture shows and which was based on David Bowie.'

Rebecca Smith is a gay woman and the art director at *Lula*, a hip new fashion mag for kids with a queer sensibility, as well as a designer for high fashion magazines such as *Vogue* and *Elle*. She is not particularly wowed by the current hullabaloo with

items include things like an Ann Demeulemeester white shirt, Acne black jeans, a tailored Stella McCartney black jacket, a Rick Owens skinny leather jackets, anything from Noir and a pair of Yves Saint Laurent boots.

The word 'skinny' keeps cropping up. Alas, skinny is very fashionable right now and ironically, as all fashion bunnies know, it is more important to have a skinny body than to have a fashionable outfit. The quest to find looser shapes without looking old-fashioned is just as hard for dykes as it is for straight women. But the good news for dykes is that daring eye contact and a confident gait (including Monty just

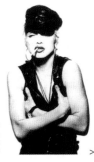

Strike a pose
Cover image from
Madonna's 1990
single *Justify My Love*

>

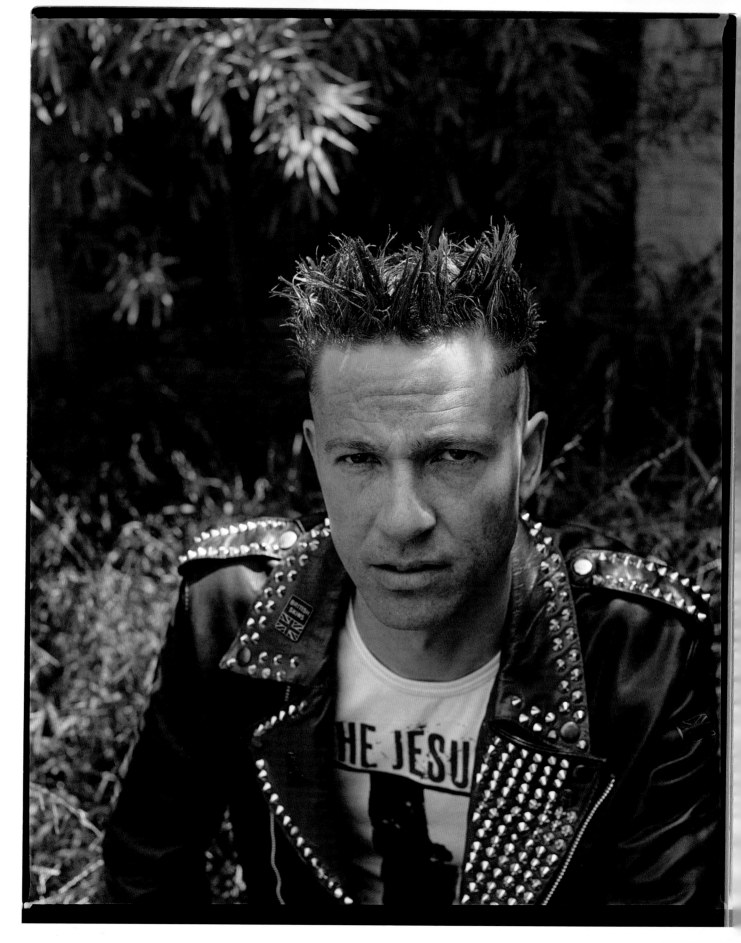

55. Punk Jacket

MARCUS BUNYAN

I arrived in Melbourne in August 1986 after living and partying in London for 11 years. I had fallen in love with an Australian skinhead boy in 1985. After we had been together for a year and a half his visa was going to expire and he had to leave Britain to avoid deportation. So I gave up my job, packed up my belongings and went to Australia. All for love.

We landed in Melbourne after a 23-hour flight and I was driven down Swanston Street, the main drag (which in those days was open to traffic), and I was told this was it; this was the centre of the city. Bought at a milk bar, the Australian version of the corner shop, the first thing I ever ate in this new land was a Violet Crumble, the Oz equivalent of a Crunchie. Everything was so strange: the light, the sounds, the countryside.

I felt alienated. My partner had all his friends and I was in a strange land on my own. I was homesick but stuck it out. As you could in those days, I applied for gay de facto partnership status and got my permanent residency. But it did not last and we parted ways. Strange to say, though, I did not go back to England: there was an opportunity for a better life in Australia. I began a photography course and then went to university. I became an artist, which I have now been for over 30 years.

Melbourne was totally different then from the international city of today: no café culture, no big events, no shopping on Sundays, everything shut down early. At first living there was a real culture shock. I was the only gay man in town who had tattoos and a shaved head, who wore Fred Perrys, braces and Doc Martens. All the other gay men seemed to be stuck in the New Romantics era. In 1988 I walked into the Xchange Hotel on Commercial Road, at that time one of the pubs on the city's main gay drag, and said to the manager, Craig, 'I'm hungry, I'm starving, give me a job', or words to that effect. He thought a straight skinhead had come to rob the place, but he gave me a job, sweet man. He later died of AIDS.

I went to my first Mardi Gras in Sydney the same year, when the party after the parade was in the one pavilion, the Horden at the showgrounds, and there were only 3000 people there. I loved it. Two men, both artists

Marcus Bunyan, 'Self-portrait with punk jacket and The Jesus and Mary Chain t-shirt', 1992. Gelatin silver print.

who lived out in Newtown, picked me up and I spent the rest of the weekend with them, having a fine old time. I still have the gift Ian gave me from his company, Riffin Drill, the name scratched on the back of the brass belt buckle that was his present. I returned the next year and the party was bigger. I ventured out to Newtown during the day when the area was a haven for alternatives, punks and deviants (not like it is now, all gentrified and bland), and found an old second-hand shop quite a way up from the train station. And there was the leather jacket, unadorned save for the red lapels. It fitted like a glove. Somehow it made its way back with me to Melbourne. Surprise, surprise!

Then I started making the jacket my own. Studs were added to the red of the lapel and to the lower tail at the back of the jacket, with my initials MAB (or MAD as I frequently referred to myself) as part of the design. A large, Gothic Alchemy patch with dragon and cross surrounded by hand-painted designs by my best mate and artist, Frederick White, finished the back of the jacket. Slogans such as 'One Way System,' 'Oh Bondage, Up Yours!' and 'Anarchy' were stencilled to both arms and the front of the jacket; cloth patches were pinned or studded to the front and sides: Doc Martens, Union Jack, Southern Cross ... and Greenpeace. I added metal badges from the leather bar, The Gauntlet, and a British Skins badge with a Union Jack had pride of place on the red lapel. And then there was one very special homemade badge. Made out of a bit of strong fabric and coloured using felt-tip pens, it was attached with safety pins to the left arm. It was, and still is, a pink triangle. And in grey capital letters written in my own hand, it says, using the words of the Latin proverb, 'SILENCE IS THE VOICE OF COMPLICITY'.

I have been unable to find this slogan anywhere else in HIV/AIDS material, but that is not to say it has not been used. This was my take on the Silence = Death Collective's protest poster of a pink triangle with those same words, 'Silence = Death' underneath, one of the most iconic and lasting images that would come to symbolise the AIDS activist movement. Avram Finkelstein, a member of the collective who designed the poster, comments eloquently on the weight of the meaning of 'silence': 'Institutionally, silence is about control. Personally, silence is about complicity.'[1] In a strange synchronicity, in 1989 I inverted the pink triangle of the 'Silence = Death' poster so that it resembled the pink triangle used to identify gay (male) prisoners sent to Nazi concentration camps because of their homosexuality; the Pink Triangles were considered the 'lowest' and 'most insignificant' prisoners. It is estimated that the Nazis killed up to 15,000 homosexuals in concentration camps. Only in 2018, when writing this piece, did I learn that Avram Finkelstein was a Jew. He relates both variants of the pink triangle to complicity because 'when

Marcus Bunyan, 'Self-portrait with punk jacket, flanny and 14-hole steel toe-capped Docs', 1991. Gelatin silver print.

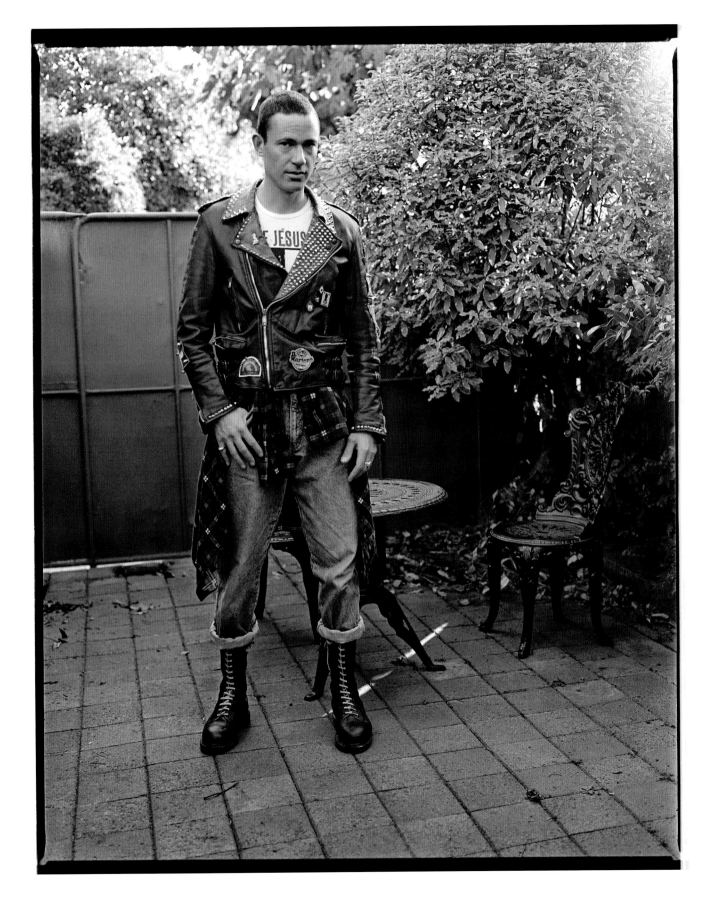

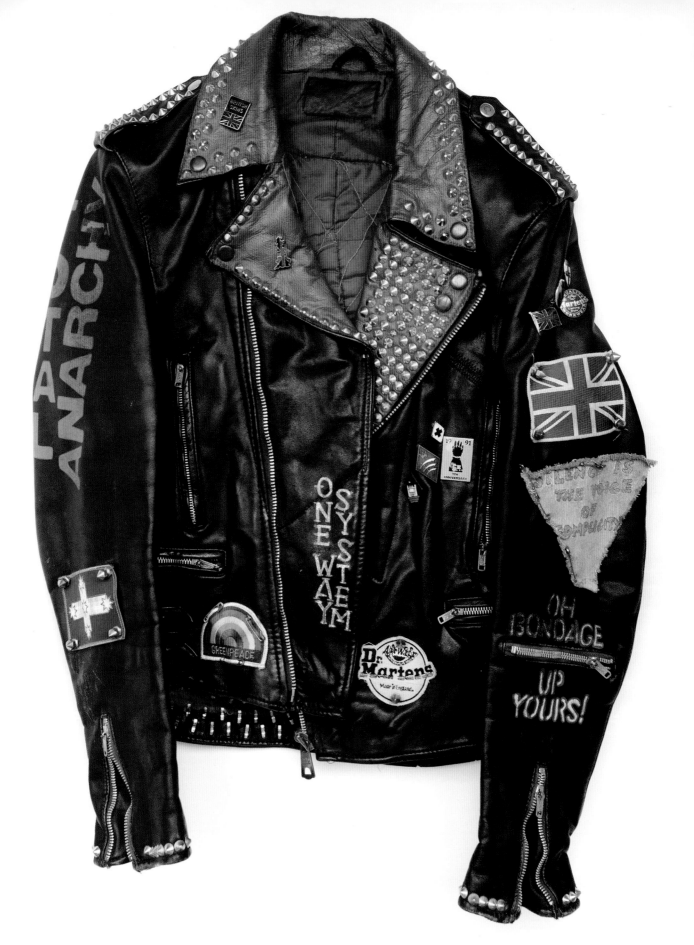

you see something happening and you are silent, you are participating in it, whether you want to or not, whether you know it or not'.[2]

Finishing the jacket was a labour of love and it took several years to reach its final state of being. I usually wore it with my brown, moth-eaten punk jumper, bought off a friend who found it behind a concert stage. Chains and an eagle adorned the front of the jumper, and safety pins held it all together. On the back was a swastika made out of safety pins, to which I promptly added the word 'No', using more safety pins, making my political and social allegiances very clear. Both the jumper and the jacket have been donated to the Australian Lesbian and Gay Archives.

By 1993 I had a new boyfriend and was at the beginning of a 12-year relationship that would be the longest of my life. We were both into skinhead and punk gear, my partner having studied fashion design with Vivienne Westwood in London. We used to walk around Melbourne dressed up in our gear, including the jacket, holding hands on trams and trains, on the bus and in the street. Australia was then such a conservative country, even in the populated cities, and our undoubtedly provocative actions challenged prevailing stereotypes of masculinity. We wore our SHARP (Skinheads Against Racial Prejudice) T-shirts with pride and opposed any form of racism, particularly from neo-fascists.[3]

Why did we like the punk and skinhead look so much? For me, it had links to my working-class roots growing up in Britain. I liked the butch masculinity of the shaved head and the Mohawk, the tattoos, braces, Docs and Perrys — but I hated the racist politics of straight skinheads. 'SHARPs draw inspiration from the biracial origins of the skinhead subculture ... [they] dress to project an image that looks hard and smart, in an evolving continuity with style ideals established in the middle-to-late 1960s. They remain true to the style's original purpose of enjoying life, clothes, attitude and music. This does not include blanket hatred of other people based on their skin colour.'[4]

By the very fact of being a 'gay' punk and skinhead, too, I was effectively subverting the status quo: the heteronormative, white patriarchal society much in evidence in Australia at the time. I was subverting a stereotypical masculinity, that of the straight skinhead, by turning it 'queer'. Murray Healy's excellent book, *Gay Skins: Class, masculinity and queer appropriation*, was critical to my understanding of what I was doing intuitively. Healy looks into the myths and misapprehensions surrounding gay skins by exploring fascism, fetishism, class, sexuality and gender. Queer undercurrents ran through skinhead culture, and shaven heads, shiny DMs and tight Levis fed into fantasies and fetishes based on notions of hyper-masculinity. But Healy puts the boot into those myths of masculinity and challenges assumptions about class, queerness and real men. Tracing the

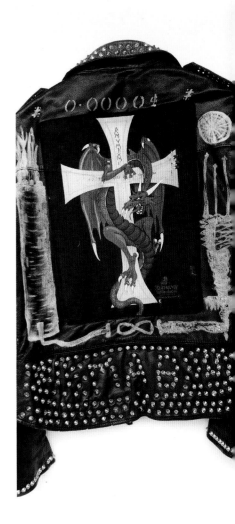

historical development of the gay skin from 1968, he assesses what gay men have done to the hardest cult of them all. He asks how they transformed the gay scene in Britain and then around the world, and observes that the 'previously sublimated queerness of working class youth culture was aggressively foregrounded in punk. Punk harnessed the energies of an underclass dissatisfied with a sanitised consumer youth culture, and it was from the realm of dangerous sexualities that it appropriated its shocking signifiers.'[5] There is now a whole cult of gay men who like nothing better than displaying their transformative sexuality by shaving their heads and putting on their Docs to go down to the pub for a few drinks. Supposedly as hard as nails and as gay as fuck, the look is more than a costume, as much leatherwear has become in recent years: it is a spiritual attitude and a way of life. It can also signify a vulnerable persona open to connection, passion, tenderness and togetherness.

In 1992 I took this spiritual belonging to a tribe to a new level. For years I had suffered from depression and self-harm, cutting my arms with razor blades. Now, in an act of positive energy and self-healing, skinhead friend Glenn performed three and a half hours of cutting on my right arm as a form of tribal scarification. There was no pain: I divorced my mind from my body and went on a journey, a form of astral travel. It was the most spiritual experience of my life. Afterwards we both needed a drink, so we put on our gear and went down to the Exchange Hotel on Oxford Street in Sydney with blood still coming from my arm. I know the queens were shocked – the looks we got reflected, in part, what blood meant to the gay community in that era – but this is who I then was. The black and white photograph in this chapter was taken a day later. Paraphrasing Leonard Peltier, I was letting who I was ring out and resonate in every deed. I was taking responsibility for my own being. From that day to this, I have never cut myself again.

These tribal belongings and deviant sexualities speak of a desire to explore the self and the world. They cross the prohibition of the taboo by subverting gender norms through a paradoxical masculinity that ironically eroticises the desire for traditional masculinity. As Brian Pronger observes,

> Paradoxical masculinity takes the traditional signs of patriarchal masculinity and filters them through an ironic gay lens. Signs such as muscles [and gay skinheads], which in heterosexual culture highlight masculine gender by pointing out the power men have over women and the power they have to resist other men, through gay irony emerge as *enticements* to homoerotic desire – a desire that is anathema to orthodox masculinity. Paradoxical masculinity invites both reverence for the traditional signs of masculinity and the violation of those signs.[6]

Violation is critical here. Through violation gay men are brought closer to a physical and mental eroticism. I remember going to dance parties with my partner and holding each other at arm's length on the pumping dance floor, rubbing our shaved heads together for what seemed like minutes on end among the sweaty crowd, and being transported to another world. I lost myself in another place of ecstatic existence. Wearing my punk jacket, being a gay skinhead and exploring different pleasures always took me out of myself into another realm – a sensitive gay man who belonged to a tribe that was as sexy and deviant as fuck.

Marcus Bunyan, 'Marcus (after scarification)', Sydney, 1992. Gelatin silver print.

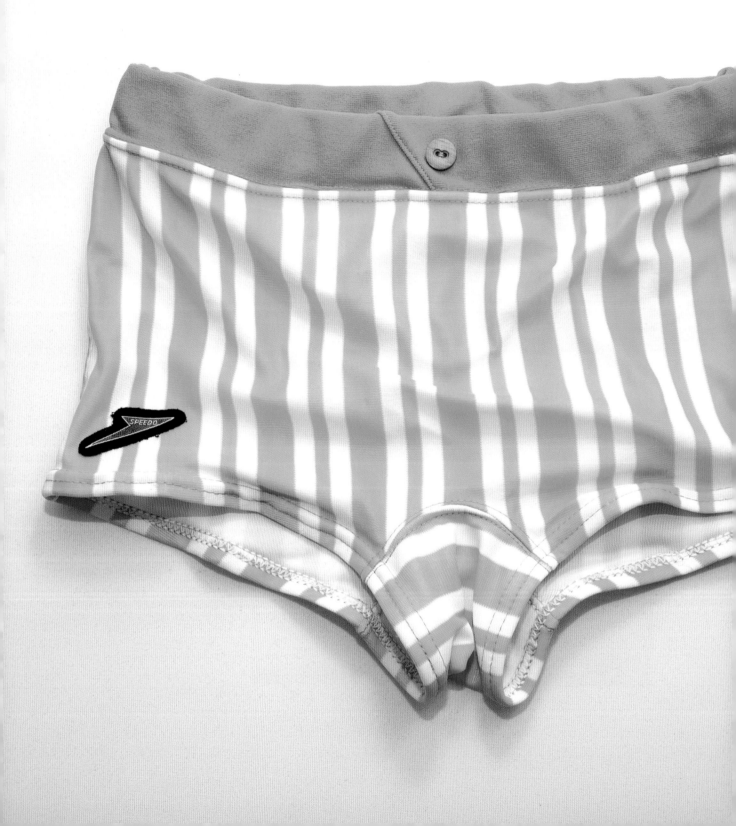

56. The Australian Speedo

YORICK SMAAL

The Speedo is a classic style of Australian swimwear known by many names.[1] The 'dick tog' or 'dick sticker' leaves little ambiguity as to the anatomy it accentuates, while other slang terms like 'marble bags', 'lolly bags' and even 'sluggos' translate easily enough. One popular moniker – the 'budgie smuggler' – makes less sense outside the Australian setting, but its emphasis on the male crotch also becomes apparent once it is known that the budgie (short for budgerigar) is a small, long-tailed native parrot about 18 centimetres long. The Speedo's tightly fitting form and its propensity to flatter the almost naked male body helps explain why it has found cult status among many queer men.

Whatever they have been called, Speedos have a long association with beach culture. Generations of Australians have sought out the surf, sun and sand for leisure, health and fitness. And while swimwear design has come a long way since the conservative styles of the early twentieth century, glistening physiques have blurred the boundaries between outdoor pleasure and intimate desire. Line drawings, photographs and calendars of men in their Speedos have aroused lust and longing. The rugged and ready Australian lifesaver, an iconic symbol of national masculinity, has attracted his fair share of queer attention. In recent decades, men in swimming briefs have attended gay pool parties and marched in floats at the Sydney Gay and Lesbian Mardi Gras. As a fashion article, the Speedo can signal gay identity; as a fetish object, it is incorporated into sexual scenarios and fantasies.

Gaily striped in aqua and white with a contrasting waistband and button, this particular pair of Speedos dates from the late 1960s. Fashioned for beachwear, they are made from Bri-Nylon, a silky thermoplastic polymer. The Speedo logo is clearly visible on the lower bottom right of the swimsuit. Similar stretch togs appeared in other colours such as orange and navy, and retailed for $4.99 in October 1969.[2] Earlier that decade, gay man Peter

The author's retro Speedos from the late 1960s.

Travis, a flamboyant Sydney artist, designed the classic Speedo brief that has inspired countless imitations and remains popular today. He created the costume to sit on the hip rather than the waist and to move with the body. Travis, then a keen surfer, was primarily concerned with comfort and performance and admitted later that 'the sexuality aspect was "just a bonus"'.[3] His design was an instant success, due in no small part to its diminished size. The trunk tapered from 18 centimetres to 13 and finally to 7.5.[4] Male swimwear became racier in the 1970s, with the changing social mores heralded by the sexual revolution. In the summer of 1974, a skimpy male costume showed more beach body than ever before. It gave 'Australian men ... the chance to outdo bikini birds [women] on brevity'. The size and shape of the garment were so risqué that bold colours and patterns were used to distract the eye.[5]

The Speedo's origins half a century earlier were modest and conservative. The company that designed and produced them was established by Scotsman Alexander McRae in the Sydney suburb of Redfern in 1914. McRae Knitting Mills, as the firm was then known, produced its first bathing suit in 1924. Early garments made in knitted cotton jersey had limited stretch and were heavy when wet. A few years later the company introduced the revolutionary 'racerback', which still covered the torso but freed the arms and shoulders for ease of movement. In 1928 the Speedo name was coined in a staff competition and the winning slogan, 'Speed on in your Speedo', earned its creator the tidy sum of £5.[6]

According to John Rickard, the consumerism of the 1920s created a hedonist beach culture where 'the attractive young displayed their bodies with cheerful eroticism'.[7] Bathing bodies of both sexes became sites of both discipline and pleasure as controversy raged around the shrinking coverage of naked flesh.[8] Beach inspectors patrolled the shores for inadequate or indecent swimming costumes. Interwar gender norms ensured the male body was subject to less regulation and control than women's, and the man's 'topper', an appropriately named detachable shirt, allowed male swimmers to bare their torso and maximise their sun exposure.[9] This two-piece design featured in a newspaper advertisement from the mid-1930s. Canny, body-conscious readers may have recognised its queer undertone. Beneath the heading 'Next to your figure Speedo Looks Best!', two handsome young men with coiffed hair hold cigarettes and converse in close proximity. Separated by a single rail, the taller figure, dressed only in his Speedo trunks, exhibits a lithe bronzed body, while his companion, who wears a collared 'topper', props his folded arms on the other side of the bannister. His head is bowed as his eyes drift towards his companion's crotch.

Speedo trumpeted the 'perfect comfort and easy action' of these costumes, despite a modesty flap of extra fabric hiding the physical outline

'Speedo Looks Best!', an advertisement from the mid-1930s.

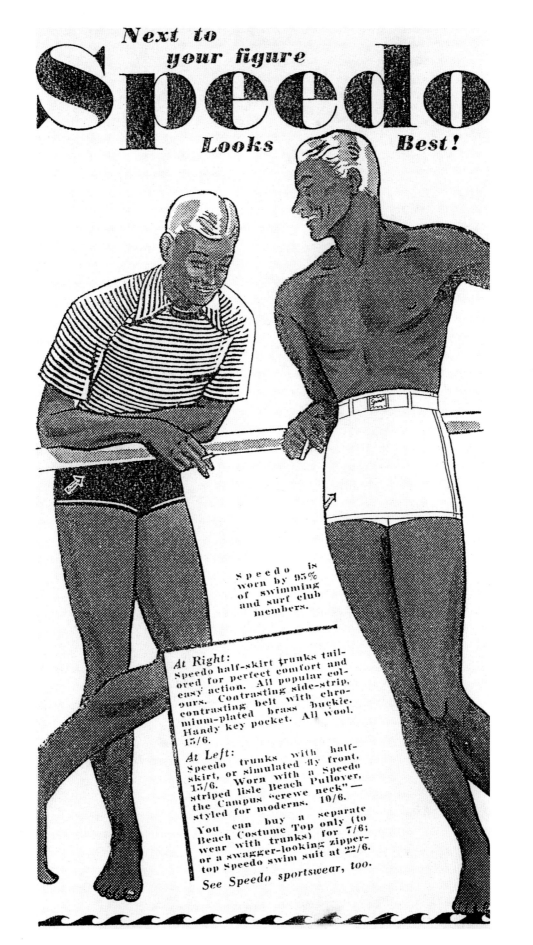

Next to your figure Speedo Looks Best!

Speedo is worn by 95% of swimming and surf club members.

At Right: Speedo half-skirt trunks tailored for perfect comfort and easy action. All popular colours. Contrasting side-strip, contrasting belt with chromium-plated brass buckle. Handy key pocket. All wool. 15/6.

At Left: Speedo trunks with half-skirt, or simulated fly front, 15/6. Worn with a Speedo striped lisle Beach Pullover, the Campus "crewe neck" — styled for moderns. 10/6. You can buy a separate Beach Costume Top only (to wear with trunks) for 7/6; or a swagger-looking zipper-top Speedo swim suit at 22/6.

See Speedo sportswear, too.

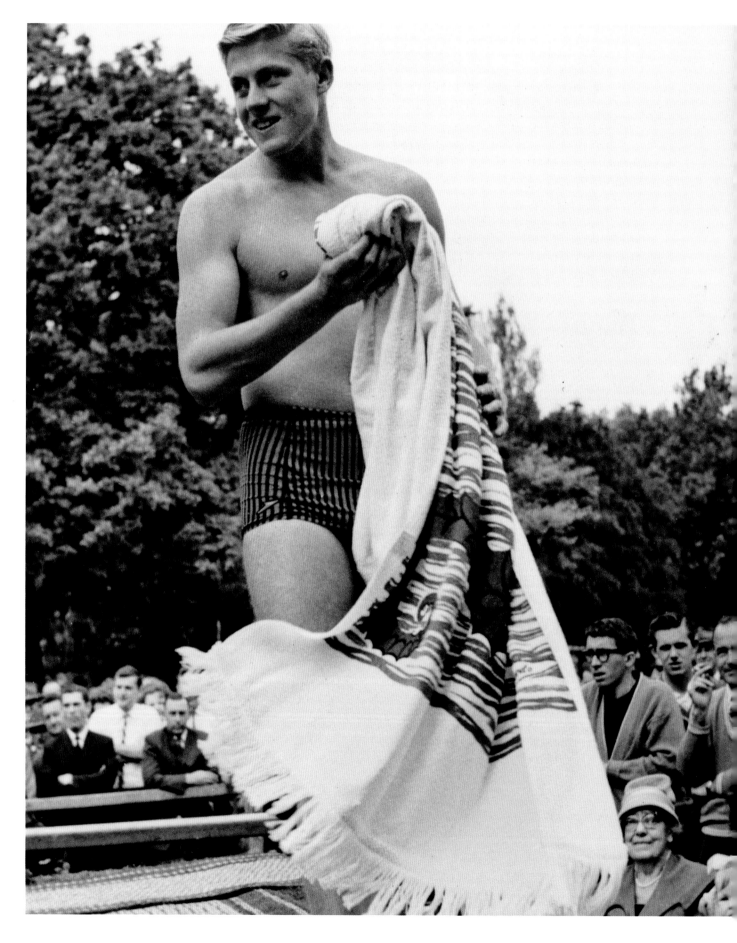

glorified in later designs. The half-skirt, as it was known, persisted until 1957 when it was replaced by a quarter-skirt, before its removal altogether early the following decade. But even with relatively demure swimwear, men frequented beaches and baths to socialise and have sex. As John O'Donnell recalls, the Sydney foreshore formed an important part of the city's cruising culture during the 1930s. A toilet block set in the hill at the south end of Bondi Beach was a good place to meet people, while the path around the headland offered sheltered spots for couples or groups to rendezvous. Others met under the cover of darkness in an unlocked surf shed at nearby Tamarama Beach, where they frolicked among the boats and beach gear.[10] Giles' Hot Sea Baths at the northern end of Sydney's Coogee Beach had a particular reputation among those 'in the know', with numerous places to hide away from prying eyes.[11]

The police attempted to supress these activities when they became aware of them. In 1947 they intensified their efforts to rid Sydney's beaches of so-called 'perverts'. At one unnamed location, two young constables 'were especially assigned for this work. They usually wore swimming togs and mingled with the crowds and received co-operation from beach inspectors.'[12] One unlucky clerk found himself before the local magistrates' court a few years later after mistaking the availability of an undercover officer in the Bondi Beach dressing sheds. Clad only in his bathers – perhaps a pair of Speedos – the constable witnessed the 25-year-old defendant 'walk up and down four or five times in front of the cubicles with only a towel around his waist' before sitting in a changing cubicle opposite the policeman where he made an 'immoral suggestion'. The young man pleaded guilty to soliciting for immoral purposes and was sentenced to three months' imprisonment.[13]

Appreciation of the male form in swimwear extended beyond the beach and changing sheds to the city. Fashion parades allowed the curious and the queer to enjoy Speedos away from the water. In early 1956, for instance, the South Australian Hotel in Adelaide hosted an all-male fashion preview of Speedo's upcoming suits for the following summer. Three well-built models, 'big, brawny and bronzed' Sydney beach inspectors, paraded the latest styles, including bright prints, spots and stripes.[14] Other men modelled swimwear for large public audiences as part of outdoor pageants like those held at the Waratah Festival in Sydney's Hyde Park in the early 1960s. The park was a well-known queer cruising spot in its own right.

Like-minded men also struck up conversation at shopfronts and in department stores where swimwear appeared with other male attire. Speedos featured in elaborate displays in specialised menswear stores like Stafford's at Coolangatta on Queensland's Gold Coast, as well as in large urban emporiums like Myers and David Jones. One 1966 advertisement for Speedos at Myers in Melbourne told consumers to 'Gear up for action!' in its

Modelling Speedos at the Waratah Festival, Sydney, during the early 1960s.

Jetstream swimwear.[15] This particular store had a reputation in queer circles for action of a different sort. In the 1950s and 1960s the men's department was managed by the flamboyant queen Freddie Amussen, whose young floorwalkers were known as 'Freddie's Boys'.[16]

Furtive experiences and fantasies among the merchandise were shared openly in the decades after gay liberation. One man who came of age in the 1980s later explained just how erotic shopping trips could be. He recalled his arousal among racks of Speedos in department stores. 'I would surreptitiously try them on, feeling incredibly daring and guilty, but also sporting a raging hard on.'[17] Stories like his, which appeared in Australia's glossy gay magazines like *Campaign*, *Outrage* and later *DNA*, ensconced the Speedo in modern queer male culture. Muscled cover boys in tightly fitting costumes beckoned potential readers to newsagents' sales racks, and photo shoots and feature articles on the pages inside celebrated Speedo's fit and form.

The modern lifesaver in his Speedos was a regular subject in gay publications and other commercial products like postcards and calendars. The lifesaver's inclination to wedge his bathers between his muscled buttocks attracted the lingering queer gaze of beachgoers, photographers and consumers alike. Prolific shutterbugs like Denis Maloney produced numerous images of this heterosexual hero for the emerging pink market. 'Australia's surf lifesaving carnivals,' he said in the mid-1980s, 'are the only sporting event where white Caucasian athletes resemble the classical Greek ideal of nakedness with dignity.'[18]

Guides to the nation's best gay beaches appeared in the issues of many summer magazines. Along with directions on where to find them and how to get there, they reminded readers what to expect on their arrival. As one 1983 article noted, 'there is no escape from the hard reality of cruising and assessment. Who's got the best tan? Who's got the best fitting pair of bathers?'[19] Appraisal by others was par for the course, but some men enjoyed the attention. One 27-year-old Sydneysider admitted:

> I love it that other guys get turned on seeing me at the beach. I
> know how to put on a show, too. If I know I'm being watched,
> I sometimes slip my hand down the front and adjust myself.
> Sometimes I pull them down at the front and have a bit of a look.
> This gives other people a bit more of a glimpse too ... I'm pretty
> much half-erect most of the time when I'm wearing my speedos.[20]

This young man admitted owning around 30 pairs of Speedos by the 2000s, including trunks like those featured here, as well as G-strings and everything in between. His story is told in Tim Hunter's 2005 short film, *Packed Lunch*, which profiles gay men and their love and lust for the

The cover of Manly Beach: A hot and sensual journey down under, an erotic film released on VHS in 1991.

Speedo. In the same documentary, 28-year-old Clint explains that the Speedo's allure comes not only from its small size but the fabric itself. Lycra, the smooth, shiny stretch fibre that revolutionised swimwear in the 1970s, forms part of this fascination.[21] 'Budgie smugglers' made an early erotic debut in Kristen Bjorn's 1991 pornographic film, *Manly Beach*, named after Sydney's famous northern coastline of the same name. The cover of the now obsolete VHS features three bronzed lifesavers in apposite parrot-green Speedos. The drawstrings are undone and hanging loose ready for quick removal.

Those with more than a passing interest in Speedos can now meet like-minded others online on websites like speedosforum.org, where they can share stories and images. They continue a long tradition of worshipping the Australian male swimmer's body and the garment itself.

A candid shot of Speedo-wearing beachgoers features in the Golden Aussies calendar, November 1991.

Figure 1.2

Figure 1.3

57. The World's First Gay Travel Guide

DANIEL F. BRANDL-BECK

Many have long believed homosexuality originates in dangerous or titillating places that are located elsewhere. The English term 'bugger' attributes sodomy to Bulgaria; their neighbouring Romanians attributed homosexuality to Turkey; the French called it 'the Arab way,' or 'l'amour allemande' (that is, love German style); and the Germans named it 'die französische Krankheit': the French malady.[1] If same-sex desires were lived someplace else, then it made sense for our ancestors to travel elsewhere if they wanted to meet other queers. The Mediterranean was the primary point of geographical and mythological reference before World War I, but between 1919 and 1933 Germany at large, and Berlin in particular, became the El Dorado for mobile queers. The metropolis was the world's first large-scale 'gay' travel destination. But how did travellers navigate homosexual spaces in foreign places 100 years ago?

Der Internationaler Reiseführer, which translates as the International Travel Guide, is an inconspicuous little booklet 13.4 centimetres high, 10.6 centimetres wide and 0.4 centimetres thick.[2] This first-ever homosexual guidebook was published in December 1920, some 44

Homosexual meeting spots in Berlin, 1918–39. The past lives on: the cluster of markers in the centre on the left corresponds to the gay district of the twenty-first century.

The cover and title page of Der Internationale Reiseführer, 1920.

years before Bob Damron issued his first *Address Book* in 1964, and half a decade before the first edition of *Spartacus*. These newer publications were indispensable travel aids for same-sex desiring travellers before the advent of the internet. So, too, was the *Reiseführer*. It was produced by Karl Schultz-Verlag, the publishing house also responsible for the magazine *Die Freundschaft* (Friendship), the most widely-read German homosexual publication between 1919 and the mid-1920s. *Die Freundschaft* was influential: its initial weekly print run was 20,000 copies, and this increased steadily until 1922, when up to 50,000 copies were sold each week.[3] The magazine combined 'political campaigning, education, networking and entertainment' and addressed a broad audience of all genders.[4] Its scope included information on the emancipation movement, advice about medical and legal matters, listings of commercial meeting places in Berlin and beyond, and details of businesses serving the queer community. There were also classified advertisements, current affairs, short stories, serialised novellas and letters to the editor.

The magazine fostered homosexual tourism. Classified advertisements allowed queer travellers to identify those commercial establishments that professed their particular hospitality to 'friends from out-of-town' or 'Ausländer!' (Foreigners!), and to communicate with Berliners before their planned trip.[5] Here are two such advertisements:

> Two gay gunners wish to travel to Berlin in late November [1919]. Due to unfamiliarity with the city, we hope to make local acquaintances for sociable encounters. (No one over 25 yrs., write soon, photo requested.)[6]

> Sophisticated young businessman, 25 y.o., seeks to meet distinguished gentleman to enhance his short Berlin holiday in late September [1921] with theatre visits etc. Age unimportant. Please send offers with photo to publishers under 'holiday pleasure'.[7]

On rare occasions, Berliners sought contact with visitors from abroad:

> Gentleman, college education, well connected, very fond of classic [*sic*] music (piano), fine arts, and science would like to be companion to foreign Gentlemen who stay in Berlin. Letters with mark 'Hellas 153' to this paper.[8]

Prompted by customer demand, in early 1920 the publishers of *Die Freundschaft* announced their plan to produce a homosexual travel guide for the summer holiday season and asked their domestic and international

readers for information about their local home scene that might be included.[9] After some delay the first issue of the 72-page *Internationale Reiseführer* was launched on 15 December 1920 at the price of 6 Marks.[10] This pocket-sized book contained listings of homosexual infrastructure in 89 places throughout the German Reich, in 10 European cities and in New York.[11] The volume's introduction reminded readers that they must 'liberate' themselves in order to become truly happy and cautioned that such fulfilment was achieved only through 'true love', not by following one's 'sensual urges'.[12] This set the tone for what Manfred Herzer calls the guide's 'dogged discretion'.[13]

Associations, cafés, taverns, hotels and businesses are listed for larger cities, but details for smaller towns are sparse. Unsurprisingly, the bulk of the listings, including 53 commercial queer spaces, are contained in the 10-page Berlin section. Most entries for smaller towns referred to the publishers or a poste restante address from which readers could request particulars. Discretion was urged when addresses were mentioned. Codes like 'friendship', 'art', science', and 'humanitarianism', as well as the qualification that only 'reputable' or 'entirely impeccable' inverts may make contact, reflected the contemporary legal situation in most countries. But this guardedness also tells of a process of collective queer identity-making. The community included discreet queers with whom one could be seen in public and marginalised gender non-conformists who were best kept in the dark.

A second edition of the *Reiseführer* was issued in February 1921. There was talk of a third edition for the autumn of that year, but this was never published. Eventually, in February 1926, the editors of *Die Freundschaft* explained that their guidebook project had been abandoned because the travel manuals had become 'entirely worthless' after only a few months: the queer scene was rapidly changing everywhere.[14] Readers continued to request a travel information service, though, so *Die Freundschaft* began including a travel section on the back cover of some issues. This consisted of a list of cities and towns with code numbers of subscribers who lived there: readers could contact them for up-to-date details. Although names and addresses were not provided, the publisher, Karl Schultz-Verlag, acted as the intermediary and charged one Reichsmark to forward readers' letters to those listed. This service was available to all *Freundschaft* readers who had substantiated their identity. By the end of 1926 the list of places where *Freundschaft* subscribers could be contacted to obtain queer travel information included 53 German locations and 23 cities elsewhere.[15] *Die Freundschaft*'s rival paper, *Das Freundschaftsblatt*, announced a similar service for the summer holiday period of 1926. Readers could write to individuals or homosexual emancipation groups all over Germany, as well as in eight other countries.[16] The *Internationale Reiseführer* in this new form remained a popular, if infrequent,

A queer event: the writing on the back of this photo reads 'München 1931 Modellball' ('Munich 1931 Models' Ball').

ᔥ

Opposite: Advertisements in Die Freundschaft, 1921. The first tells readers about the Alexander Palace, which offers a ball and cabaret. The others extol the virtues of various dances, bars and concerts: an Italian costume ball with a raffle, the Verona Palace Tavern, the Nuremburg Tavern and an artists' evening called 'The Night of Dorian Gray'.

feature of *Die Freundschaft* until the early 1930s.

Why did Berlin become the magnet for same-sex-desiring people from Germany and elsewhere during the 1920s and early 1930s? Berlin then had the most advanced queer subculture anywhere in the world, even though male homosexuality was illegal. During the Weimar period from 1919 to 1933 the German capital hosted a rich, diverse and colourful – if non-cohesive – homosexual community, which provided a comparatively welcoming space for same-sex-desiring men and women from near and far. There were between 100 and 150 bars, specialist bookstores and a full range of businesses for both Berliners and visitors to the city. This large homosexual infrastructure attracted thousands of travellers from the provinces and abroad. There were some 30 German homosexual magazines in circulation during the 1920s, when the abolition of press censorship allowed writers to address the subject openly.[17] This relative freedom of the press and of assembly, along with the authorities' comparative laissez-faire approach and most Berliners' indifference to same-sex love, allowed a critical mass of queers to construct networks on which they built and sustained a multi-faceted subculture and politicised their right to embody their desires. All of this, in turn, enabled the development of a strong self-awareness and growing self-confidence.

Postwar Germany was also a very cheap place for foreigners to visit and live in. The inflationary conditions attracted many bargain hunters between 1919 and 1923. In early 1920 someone in possession of American dollars could take a room at a reasonable hotel and enjoy three meals a day, including one bottle of wine, 'for a real cost of 4.30 Marks as against 96 Marks a German would have to pay'.[18] World War I and its aftermath had also severely eroded the old imperial–German morality. Many people turned to prostitution as economic conditions worsened and sex workers were a common sight in Weimar Berlin. In this city of four million inhabitants – the world's third largest in the 1920s – there were an estimted 35,000 male prostitutes.[19]

Things soon changed. After they came to power on 30 January 1933, the Nazis swiftly and unrelentingly destroyed all queer facilities and services in Berlin and throughout Germany. Same-sex-attracted Germans continued to form stealthy bonds under the sombre shade of the swastika, however, and men from elsewhere continued to travel to the German capital and to other places in the German Reich for pleasure, work and education. They sought out well-hidden meeting places for queers, even if they no longer had the help of an up-to-date printed travel guide or a forwarding service for letters of inquiry about the local 'gay' scene.

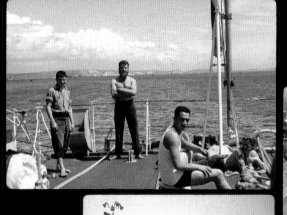

58. Keith's Slides

CHRIS BRICKELL

Keith Hulme, David Wildey's partner (Chapter 35), grew up in Christchurch before serving in the Middle East during World War II. The travel bug bit him and he holidayed overseas in later decades. These colour slides date from 1961, when Keith visited France, Britain and the United States.

Gay tourism scholar Howard Hughes suggests holidays contribute to the making of sexual identity by giving men and women space for 'regeneration, self-realisation [and] freedom'. Holidaymakers 'escape into a world of fantasy and indulge in kinds of behaviour generally frowned on at home'.[1] Keith's letters to friends and his slides tell of various pleasures. He marvelled at the modernity of air travel as he flew high above the oceans 'on a carpet of cloud'. By 1960 well-to-do New Zealanders could fly to Europe via Australia and Asia or Fiji and North America. When it came to the sea, Keith followed in the footsteps of generations of queer men who admired sailors: on board a boat he photographed shirtless seamen, some of them playing Scrabble. Other images from the same trip show seamen loitering on the open decks, their naked arms bare in the sun. On shore, another sailor, wearing the famous square rig uniform, sits carefree on a grassy knoll with his cigarette. In Paris, Keith saw the Champs-Élysées from the top of the Arc de Triomphe and gazed upon the Parisian Statue of Liberty. At Long Beach in California, at an amusement park called The Pike, he found thrills on a rollercoaster called the Cyclone Racer, billed as 'The World's Greatest Ride'. There was more to The Pike than its rides, though: locals and sailors engaged in drunken debauchery there on a daily basis.

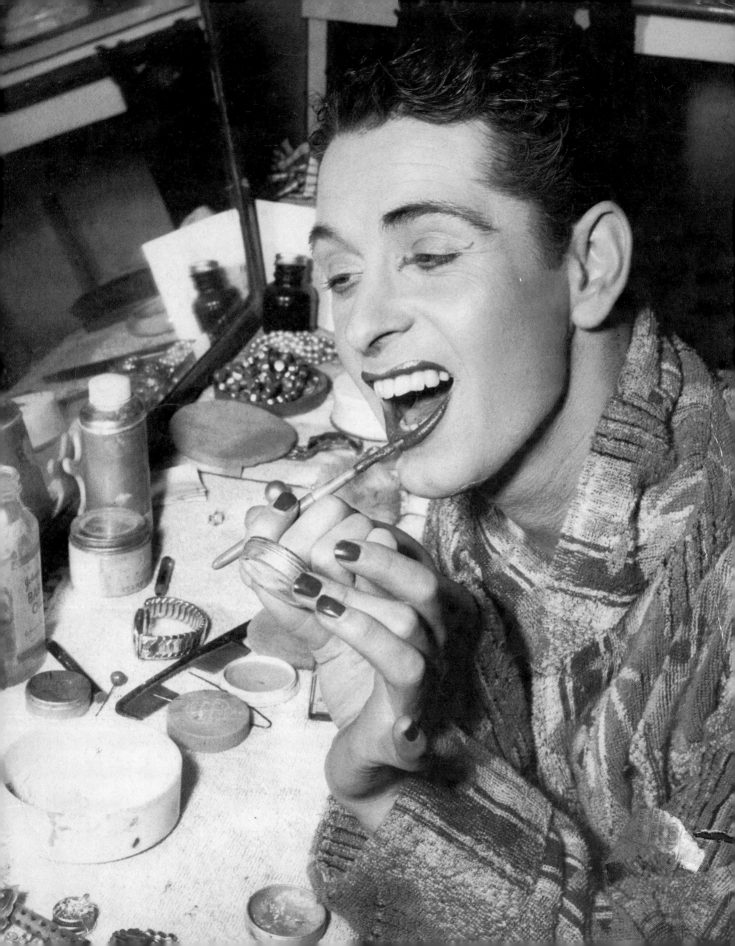

59. John Hunter's Make-up Box

CHRIS BRICKELL

John Hunter was a teenager when he first put on a frock and performed in front of servicemen during World War II. The young New Zealander was too young to enrol in the army, much less go overseas, but he joined civilian groups — the Arcadian Revellers Review and the St John Ambulance Concert Party — and entertained the American and New Zealand troops in the military camps of Auckland.[1]

John's kit contained a small cardboard box. Measuring 9 x 15 centimetres, the black box with red lettering originally held Baisenko joss sticks, a Japanese brand, but John used the container to store stage make-up: tubes of grease paint in gold paper that smelled of oil and pastel rather than incense. Grease paint was an essential ingredient in any actor's arsenal. Opera singer Ludwig Leichner invented the easy-to-apply grease paint stick in 1873, when theatres' gaslight and limelight bleached performers' facial features and created the need for vibrant make-up.[2] Grease paint lived on into the era of electric stage lighting. Each of John's examples is marked with Leichner's trademark harp symbol and a number. Twenty is a pure white, four-and-a-half a flesh colour, and there are eight others in the box. These colours feature on the chart in the Leichner company's 1938 *Handbook on Make-up for Stage and Screen*, with its 61 shades of cream, buff, peach, yellow and brown, as well as white and black.

John Hunter carefully prepared for his role each time he went on stage. After a shave to remove his 5 o'clock shadow — and a cigarette for luck — he sorted out his make-up. 'First comes a brisk powdering of face, chest and arms followed by the application of grease paint base. Eyebrows are next, tinting and arching occupying some minutes. Then lipstick and the tinting of fingernails completes the toilette.'[3] The Leichner *Handbook* gave further detail about how to apply the grease paint: 'Take a stick or tube … and smooth it all over the face including the ears, right up to the hair — as thinly

John Hunter applies his make-up before a performance at Sydney's Empire Theatre.

The make-up box with its oily pastels.

as possible – and pat it well in so that you get a perfectly smooth surface.'[4] John peeled off the surplus wax paper as each stick wore down. His make-up box included several toothpicks to assist in applying small amounts of grease paint and he used carmine on his cheeks. A photograph of John's make-up table shows the jars of carmine alongside a range of other objects: a comb, a powder puff, a bottle of acetone and one of baby oil. Make-up successfully applied, then John donned a foundation garment, an uplift bra, stockings (a 'seductive mesh type'), a frock, rings and bangles and a wig. As one newspaper put it, stage make-up helped John metamorphose 'from man about town to svelte siren in thirty minutes'.[5]

John Hunter had a 10-year career as a female impersonator. In 1944, as the war drew to a close, he joined The Kiwis, a group of entertainers who

returned to New Zealand after entertaining troops near Middle Eastern battlefields. The Kiwis toured New Zealand and treated audiences to variety shows with such alliterative names as 'Alamein Antics', 'Cairo Carnival' and 'Desert Days'. John appeared in a great many skits as a nurse, a maid, a can-can girl and the popular singer Gracie Fields.[6] After the war the men set out for Australia and played extended seasons in Brisbane, Adelaide, Perth, Sydney and Melbourne. The Kiwis Revue, as the group was now called, popped back to New Zealand for the occasional sell-out trip, and in 1950 they returned permanently. The cast of funny men and female impersonators entertained audiences for another four years.

John was The Kiwis' most fêted performer. The promoters and newspapers gushed. As one writer declared, he 'has the face and figure when made up to make the deception entirely convincing. A natural charm of manner on stage gives the finishing touch to anything he is called upon to perform.'[7] After an appearance in the small New Zealand town of Whakatane in 1945, the local newspaper described the young man's transformation as 'something of a miracle. The characterisations were so convincing that one was at times completely at peace with the idea that it could not possibly be an all-male cast. John's remarkable lightness on his feet enables him to do ballet dancing in a manner of which any girl could be genuinely proud.'[8]

John later told an interviewer about his work. 'I played the ingenue roles ... I had quite a reasonable singing voice, a soprano voice.'[9] On tour around New Zealand in 1950 he played a fiancée, a sarong girl and a mysterious 'lady with a past'. In a skit titled 'The Roaring Twenties', John and fellow female impersonator Ralph Dyer, a stalwart of the wartime concert parties, dressed as flappers, while two other company members appeared on stage as their 'boy friends'.[10] 'We had beautiful clothes,' John remembered. 'In the Charleston, in the Roaring Twenties scene, we wore those authentic beaded gowns, some of them really were museum pieces, they were quite lovely.' In Australia John became well known for his role in the balcony scene from Noël Coward's *Private Lives*. But that was not all. 'I remember dancing the can-can girls ... and I used to wear those slingback patent leather shoes, you know, with the cut out heel, and whoops! I was doing the big high kick, and off went the shoe into the stalls, and I heard a man call out 'Howzat!'. He'd caught it.'[11]

Shoes were not the only source of mishap. The potions on John's make-up table did not always behave themselves:

> I was ready to go on at Her Majesty's and the call came over the intercom for 'standby', and I was just ready to go. I turned for one more dab of powder on the chin or the nose and I had a large bottle of acetone sitting on the dressing table and it fell off and

spilt and went all down the front of a synthetic white jersey gown which I wore for the *Private Lives* scene. The whole of the front panel of the jersey gown just disintegrated, there was a great gaping hole, and I could hear my entrance music being played for about the third time, and quickly my marvellous dresser, Marie Ross, grabbed a double silver fox fur that was used in another scene, and she said, 'Quick, hold it against you and don't move.' Of course when I walked on stage [my director] Terry Vaughan looked up from the pit, and frowned like mad, and thought, 'What the hell has he got that bloody animal in front of him for?' And of course I was in dreadful pain, I'd burnt all my legs with acetone, burnt my tights through, it was shocking![12]

John and his flash car.

While John crossed gender on stage, in his everyday life he embraced a sophisticated, cosmopolitan kind of masculinity that was fairly unusual in 1950s New Zealand. He had publicity photos taken while hopping in and out of a flash car dressed in a sharp suit, and a souvenir programme listed his hobbies as skiing, tennis, reading and Chinese food. John and his friends also belonged to a broader tradition of chorus boys, cross-dressers and queer culture. The New Zealanders were the antipodean equivalent of the British 'Soldiers in Skirts', the Americans' long-running show *This is the Army*, and other entertainment groups that had more than their share of queer performers.[13] Historian Allan Bérubé suggests these troupes provided gay servicemen 'with a temporary refuge where they could let their hair down to entertain their fellows'.[14]

When John Hunter opened his make-up box and reached for the tube of Leichner four-and-a-half, he readied himself for a quiet transgression of sorts. The mostly unquestioning heterosexual audiences lapped up the impersonations. He remembered the adulation decades later. 'The queues at the stage door for autographs, and goodies, and chocs, oh dear, they were so nice. I used to get some wonderfully funny letters. Loving ones, and funny ones.'[15] John and the other female impersonators became the object of 'square' (that is, heterosexual) men's gaze and they inverted the taken-for-granted assumptions about the kinds of bodies those men would be attracted to. As Yorick Smaal explains in the Australian context, 'queer men could delight in the male gaze with tacit approval, willingly objectified and desired in ways they were usually not'.[16] All the while, the homosexual men in the audience revelled in the sumptuous displays played out before their eyes and imbued them with camp meaning. Many bought tickets and went along in groups, eager to see their friends in frocks. Some teenagers went with their parents, revelled in the 'camp sensibility' of the shows and speculated about the sexuality of the performers.[17]

Those on the gay party circuit got to know John Hunter, 'the belle of The Kiwis', during the early 1950s. The Kiwis threw house parties and made friends as they toured New Zealand. Some gay locals, including Christchurch man Derrick Hancock, befriended the impersonators and made a point of catching up with The Kiwis whenever they were in town.[18] Derrick's archive of memorabilia, now in the Alexander Turnbull Library, includes a movie star-style photo signed: 'Best wishes Derrick, Sincerely, John'. The make-up kit was also passed along the line. John handed the small box to David Wildey, a one-time lover who, like Derrick, kept a collection of newspaper clippings and programmes documenting John's career. When David went into a rest home he gave the box to his friend Roger, and Roger gave it to me. The make-up box is a queer heirloom passed through the generations.

'Best wishes Derrick, Sincerely, John'.

A living room of the 1960s.

60. The Portable Lesbian Party

ALISON ORAM

Doreen and a group of lesbians regularly met for parties during the late 1960s. 'We used to put a supper on and we danced, talked, and you just let your hair down and you could relax completely and utterly and that was the whole idea of it.'[1] When Doreen moved to Leeds in her mid-thirties she soon made new friends there: 'There was a lass had a farmhouse outside Keighley and once a month we used to have a get-together there and we danced. In those days I had a scooter ... and I used to take the record player plus records on the back of it to this place.'[2]

The portable record player was key to the conviviality of these occasions: it was possible to have a party anywhere it could be plugged in. Newly mass produced in the 1960s, it was an aspirational consumer object for young people that became fashionable and ubiquitous. It was a stylish box, often in two-tone colours, with a lid that snapped shut to protect the turntable. The portable record player was not an intrinsically queer object, but in Doreen's circles – and other groups of friends – it enabled a queer social life to be enjoyed to the full.

These lesbian parties point to the growing importance of lesbian networks during the 1960s,

the continuing secrecy around expressing a lesbian identity, lesbians' increasing geographical mobility, and the pleasures of music and dance in a queer context. So how did lesbians find out about these socials in women's homes? They were often organised through the Minorities Research Group, a British national lesbian network that started in 1964 and aimed to build lesbian community and shift public opinion towards a more positive view of lesbians. The group privately published a newsletter called *Arena Three*.[3] Doreen had been living in London for a few years before she moved to Leeds and became involved in the group.

Parties in private homes offered discretion to lesbians like Doreen and allowed them to avoid the potential dangers of public meeting places. Women feared being known as lesbian among their straight neighbours and were also anxious about losing their job if their sexuality became common knowledge at work. Social taboos made it awkward for middle-class women to drink in pubs without the company of male partners, and many lesbians were reticent about going even to gay pubs. Although Doreen visited the New Penny, a long-standing gay pub in Leeds in the late 1960s, she worried about seeing people from work in there and thought the other patrons were 'coarse'.[4] Parties were more popular among middle-class women, although they did need someone to have a large flat or home of their own that had sufficient privacy. Even then, a degree of care was needed. Doreen described how she dealt with workplace questions. 'Next day the girls'd say to you, "Oh what did you do at the weekend?" and you'd say you'd been to a party, but you just had to gloss over who was there.'[5]

The record player that Doreen faithfully carried over the Pennines to Keighley meant her friends could dance and be merry. One popular brand, now keenly sought after by collectors of vintage memorabilia, was named the Dansette. The 'ette' was both a diminutive and a feminised descriptor. A stack of five or six records — most often 45s or 'singles' — could be queued

The Dansette record player.

above the turntable, and each one dropped with a satisfying 'kerplunk' once the previous record had finished. The hiss and occasional jump in the music where the vinyl had been scratched were familiar to users. The women's music included the pop hits of the day, smoochy ballads as well as good dance music: 'We danced to a lot of Dusty Springfield and lots of old classics as well. All the Tamla Motown stuff was at its height, and the Ronettes and the Supremes were played over and over ... [In the 1970s] the Bee Gees were popular. Rod Stewart, Marc Bolan, it was the glam rock era. David Bowie was very big then.'[6]

In a period when homosexuality was regarded as shameful, a sustaining sense of community grew alongside these lesbian friendship networks. The isolation of many lesbians was very real during the 1960s, but the social life of that record player challenges the stereotype of the lonely lesbian. Doreen and the others in Yorkshire were not friendless, even if they were somewhat hidden away at their parties.

The portability of the record player also spoke to a growing mobility among lesbians: the ownership of cars, scooters and motorbikes slowly grew during the 1960s. When Doreen brought the record player and the records to a party, 'people from Newcastle came down, and Rochdale. There were people from Manchester.'[7] In London Doreen had owned a motorbike and she appeared in a 1967 documentary about lesbians on BBC TV.[8] 'I found out later that in *The Listener* there was a photo of me with my motorbike and another lass, who was just a friend actually, which we didn't even know had been taken. There was no name, so with helmets on you don't know anybody anyway.'[9] Motorbikes have been part of lesbian iconography since squads of women police officers used them during World War I, and many butch lesbians, some of whom trained in the army, worked in garages during the 1940s and 1950s.

Doreen's lesbian network probably overlapped with that of Judith, a social worker who moved to Rochdale, near Manchester, in the mid-1960s. Judith's psychiatrist told her about a lesbian party in south Manchester, and this led to her dramatic experience of coming out:

> I was well tanked up with three sorts of drugs and then a lot of whisky and I drove to south Manchester to the party, and I walked in and it was wonderful, I just felt immediately at home, comfortable for the first time in my life in a large party. Super! I didn't even consider what to dress in, I just put on an ordinary little dress. When I walked into the room I realised that there were about five women in dresses and the whole damn lot of them, about another twenty more, were in trousers, I was absolutely staggered.[10]

"It's all right, they're just good friends".

It's all right, they're just good friends, from Arena Three, August 1968.

Judith's account echoed many descriptions of butch and femme role-playing in the 1960s, though private parties generally offered more leeway in dress codes than the handful of lesbian clubs and pubs. Like Doreen, Judith did a lot of travelling to maintain her new lesbian identity: 'I wasn't in the scene at all. I'd got friends obviously who were Manchester-centred. The amount of petrol I spent travelling to, you know, Cheadle, and overnight and back again and this sort of thing, I really don't know. I knew two women who lived in Rochdale, and I knew the hospital staff where I was working [who were lesbian].'[11]

Parties remained important for lesbians during the 1980s, but they served slightly different functions in a period of greater openness. They were valuable both for women who were just coming out and for professional women who sought discretion. Millie, who had moved to a town near Brighton and worked as a teacher, came out in her mid-fifties in the 1980s in the context of a lesbian 'social' hosted by a couple in the Brighton suburbs: 'I had no idea what being gay was like. Not a clue. I went to an open house in Preston Drove. Once a month they had socials. It was just music and some nice food. Gradually it became less scary. It became somewhere you went for a laugh. For women like me, who are not very out in many respects, it was comfortable.'[12] Jill describes the same lesbian socials that Millie attended: 'About half the women had been married with children; some were still married and came with or without their husband's knowledge. You never revealed your surname or expected anyone to give theirs, because many women knew they could be sacked for being gay, or lose their children.'[13]

Private parties were a safe alternative to Brighton's club scene. 'Many women preferred the discretion of a private house to clubs like Caves or the Longbranch, and they were good women-only parties.' These were freer in some ways than the lesbian-feminist scene: 'You felt comfortable there wearing whatever you wanted at a time when make up, long hair and skirts were often frowned on in lesbian venues.' Like Doreen and Judith, Jill recalled the relaxing pleasures of private parties in a spacious home in suburban Brighton during the 1980s: 'The dance music was put on the CD player by Lin, who was very laid back, always in trousers with a Rod Stewart hairstyle. We would bop away to Tina Turner or Whitney Houston in this beautiful, low lit, front room, behind the cream full-length curtains of the bay windows.'[14]

The stack of records played on a turntable in a stylish 1960s box had been superseded by small, silver compact discs played on a stereo system, but lesbian parties continued to be a highlight of the women's queer social scene.

A detail of the arm, with a record in the queue.

61. The Rangers Motor Club Flag

TIMOTHY ROBERTS

Flag (n):
A usually rectangular piece of fabric of distinctive design that
is used as a symbol (as a nation), as a signalling device, or as a
decoration.
Merriam-Webster Dictionary, 2017

When Captain James Cook 'hoisted English Coulers' on Bedhan Lag to
claim the entire east coast of Australia for Great Britain on 22 August 1770,
the Union Jack was a potent signifier of imperial power and possession.[1]
Almost 200 years later, when Neil Armstrong and Buzz Aldrin hoisted the
first United States flag on the moon, they unfurled an icon of humankind's
existence, persistence and achievement. Commanding yet often surrounded
by contention, flags are political devices vested with symbolic authority.

It is for similar reasons of affirming presence and asserting identity that
the Rangers Motor Club put in an order to Foxcraft Flags in the early 1980s.
The Rangers MC was established in Queensland, Australia, by Ian Mann, John
Muller and a group of like-minded friends in 1980. They set out to serve
a community of homosexual men who were interested in the outdoors.
Queensland's legislative and social environment was harsh on queer
communities at the time. The state's Criminal Code Act prescribed jail terms
of up to seven years for the offence of sodomy. Prosecutions were rare but
anti-homosexual attitudes abounded. Brisbane's only sauna, The 179, was
raided by police and closed down in 1977, and the state's Literature Board of
Review banned the distribution and sale of *The Joy of Gay Sex* and *The Joy
of Lesbian Sex*, even though the heterosexually oriented version, *The Joy*

The Rangers Motor Club flag, c. 1980–84.

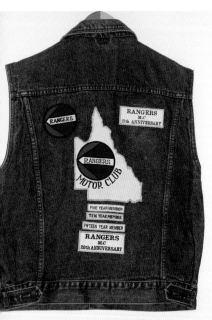

A Murray River brand denim vest belonging to foundation Rangers MC member Allan Killips, 1970s.

of Sex, was freely available.[2] In spite of the oppressive climate, the Rangers MC, along with such organisations as the Queensland chapter of Campaign Against Moral Persecution (CAMP) and, a little later, the Queensland AIDS Council, played an important role in providing spaces for members of queer communities to connect with one another.

Over a dozen motor clubs for homosexual men operated across Australia from the 1970s until the 2000s. The earliest group was Sydney's South Pacific Motor Club, founded in 1970 in the vein of similar American clubs.[3] By the time the Rangers MC was founded in 1980 each Australian state and the Australian Capital Territory had at least one motor club catering for gay men. Some of these subtly promoted their connection to leather and fetish culture. The South Pacific and Southern Region Motor Clubs, for instance, exaggerated the letters S and M in their logos. The badge of the Rangers MC, though, bore no reference to kink and fetish. Noel Lewington, an Australian authority on leather history, suggests that the Rangers MC was 'a social club more than anything else'.[4] For most of its history it had approximately 15 full and 30 associate members.[5]

Because the criminal status of male homosexuality required care, the names and badges of all homosexual men's motor clubs in Australia were discreet. A club member knew he was in congenial company when he recognised a badge. The Rangers MC badge consisted of a stylised arrow pointing left marked out in green, brown and white, colours traditionally associated with national park officials. The flag, which consisted of the badge imposed over a map of Queensland in white against a blue background, was a prominent feature at official club events, especially the Red Rock Run, the annual highlight of the club's calendar. First held in May 1981, this trip to national parkland in New South Wales, a state with less oppressive laws than Queensland, attracted members from other Australian motor clubs. They drove cars and rode motorbikes throughout the south-east corner of Queensland every few months, and hosted barbecues and an annual formal dinner for members and guests from other clubs, usually in Brisbane. There was even an annual Christmas event. Frank Croucher, the last president of the Rangers MC and the secretary of the Australian Club Run Association, recalls: 'Our club flag was either flown where there was a suitable pole or on prominent display at all our club functions, and the majority of members had the club uniform.'[6]

The Rangers MC uniform echoed the colours of the club flag and consisted of an army-style khaki shirt with club patches on each sleeve below the shoulder, blue jeans, boots, and a sleeveless denim overlay vest bearing a back-patch in the shape of a Queensland map with the Rangers MC badge in the centre. Croucher highlights the respect that members had for the club colours: 'the overlay served as a medium for the stitching on of logo patches

from the other motor clubs throughout Australia. There was a stipulation that no other club's logo or badge should be higher on the overlay than Rangers' own. Most clubs had this same stipulation.[7]

Both the club's flag and uniform were subtle identifiers to gay men in an era when homosexuality was illegal across various states in Australia. The Rangers MC flag, like those of other motor clubs, had a special significance. Flags claimed a space for a community, even if only for a night or a weekend. As homosexuality was decriminalised across the country state by state, including in New South Wales in 1984 and Queensland in 1991, social opportunities grew. When new meeting places — gay bars, nightclubs and saunas — emerged, highly organised fraternities, including motor clubs, became less critical to the gay community's fabric. In 2011, after 31 years of continuous operation, the Rangers MC disbanded. The last remaining club, the Dolphin Motor Club in Sydney, closed down in 2014. The Rangers MC flag survives among the ephemera, regalia and photographs of former club members. They are invaluable relics from Queensland's club for queer campers, ensuring the colours keep flying high.

Rangers Motor Club members holding the club's standard, c. 1988.

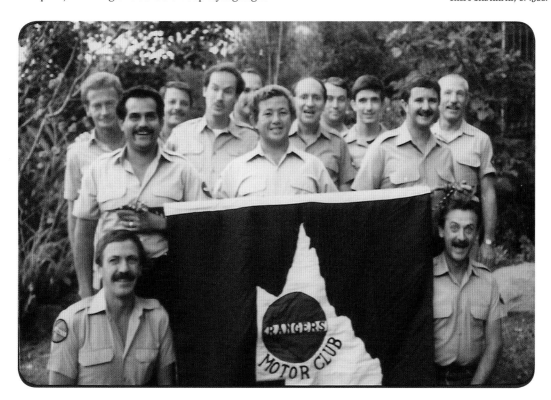

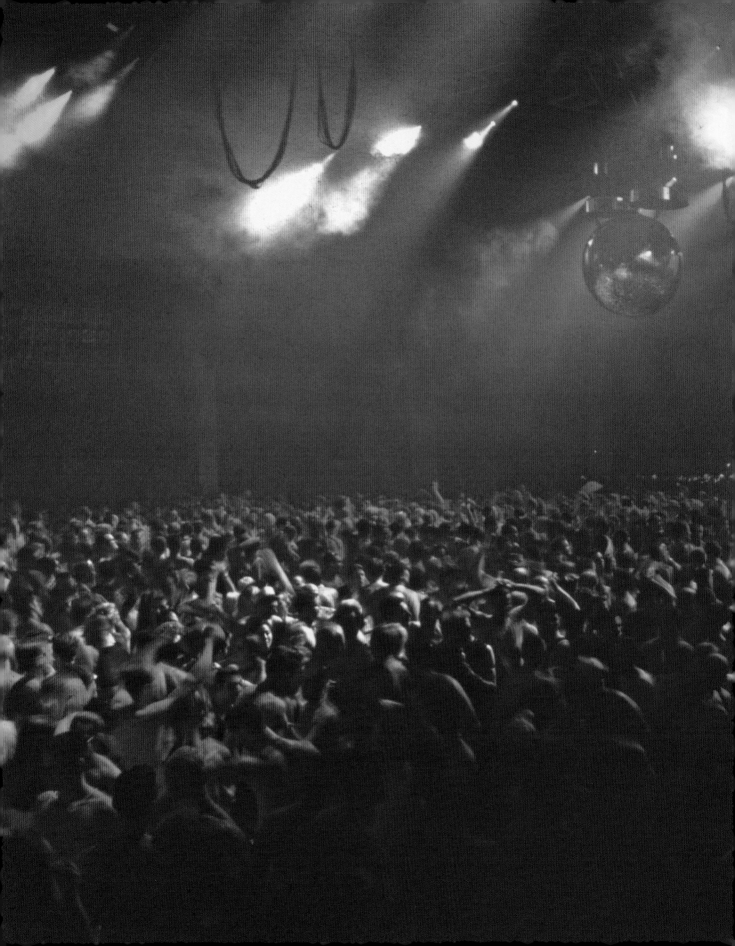

62. The Disco Ball and the DJ

PHILIP HUGHES

For a long time members of New Zealand's gay community have felt the need to get together, be with our own people, talk our own language and flirt. We have spent our weekdays feeling like the members of a minority and need a safe haven on the weekends. Some of us have battled to keep parts of our lives secret. We wanted our own bars, clubs and dancefloors where straight people didn't want to go. Sometimes we took over straight spaces and made them our own. This kind of spatial modification began in the 1970s, but it continued well into the twenty-first century. One night in 2013, on Queen's Birthday of all days, a pop-up gay dance was set to take place in a rough pub in suburban Christchurch. I hated the venue: it smelled of beer and straightness, it didn't seem very gay friendly and the energy wasn't in the place. I knew at least 100 people would turn up. The start time was 8 o'clock; when I arrived about 7.30 the others were still decorating. Within half an hour it became a gay space. Unlike a gay club, it was not inherently queer, but needed a little transformation – and we had to bring our own bits and pieces. We decorated a wall with a rainbow flag, a symbol that says 'This event is queer'. There were condom stickers everywhere and AIDS awareness posters. As the DJ, I thought about the music. I knew we needed to own this space for ourselves. I wanted to make sure that when people walked in they would know they were arriving at a gay venue and would forget we were in a stinky old pub. I ended up playing a bit of dance music, stuff people could relate to. When they walked in they heard a lot of divas, a lot of pop music. With

Mirror ball with rainbow lights and smoke, Sydney Gay and Lesbian Mardi Gras Party, 1999.

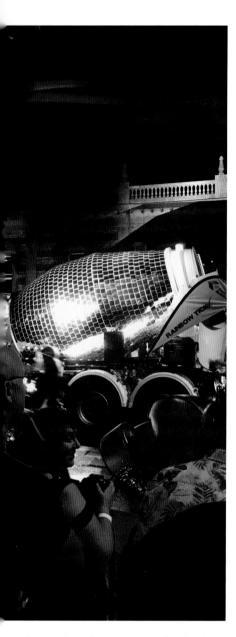

A disco-themed concrete truck, Auckland Pride Parade, 2018.

☙

Opposite: A mirror ball in the Museumsquartier, Vienna, 2018.

gay paraphernalia all over the room, and the music fitting the scene, the pub had become a very different place.

The mirror ball played a pivotal role. It was already there in one corner of the room, along with a kind of a sparkly disco light in the other corner. When I first walked in I thought, 'Oh, what a drab place', but by the time we put the flag behind the mirror ball, it became a gay icon. Suddenly it was no longer bouncing off a boring old brown wall, but reflecting a rainbow flag and spreading colour around the room. The ball became the focus of the whole dancefloor, delineating its edges. It said, 'Come here, dance here. Don't dance on the carpet over there. Go under the mirror ball.' It also centred the whole crowd and brought us together.

When the first mirror balls appeared in nightclubs during the 1920s they were not especially connected to gay life. But they became popular during the 1970s when disco was at its height and, as Tim Lawrence, a cultural studies scholar, wrote, early disco had a real 'queer aesthetic' and gay-owned businesses offered disco to diverse urban audiences.[1] This was a change from earlier decades, when bands played at most dances and men and women danced in pairs. This basic pattern was essentially the same whether the dance was the waltz, the foxtrot or the jive. During the 1970s DJs replaced bands, and those who went to discos did not always take to the dancefloor as male–female couples. Instead many danced by themselves or in groups with their friends. It was unsurprising, then, that gay and lesbian dancers adopted disco for their own. Disco helped them to break out of the rules of straight society. Even now, when a mirror ball reflects a rainbow flag and gay dancers, rather than a grey wall in a suburban pub, it becomes very queer. History lives on: I see myself as a historian as well as a gay man and a DJ.

My style is a combination of house, retro and club music – tracks with big energy. Other people say, 'We know your style, it's music to make people happy.' They are falling in love with music and they are going to have a good time. That's my intention. The gay crowd has been working hard all week. They want to dance their feet off. I will play tracks from the Top 40, but also more intense music with big energy and lots of beats to it. Some DJs play a style of music that is kinky and seductive, designed to make people fall in love or go off with each other, but that's not me. When people get up and dance I want them to have an intense experience. And a mirror ball, an icon of the dance floor, channels this feeling.

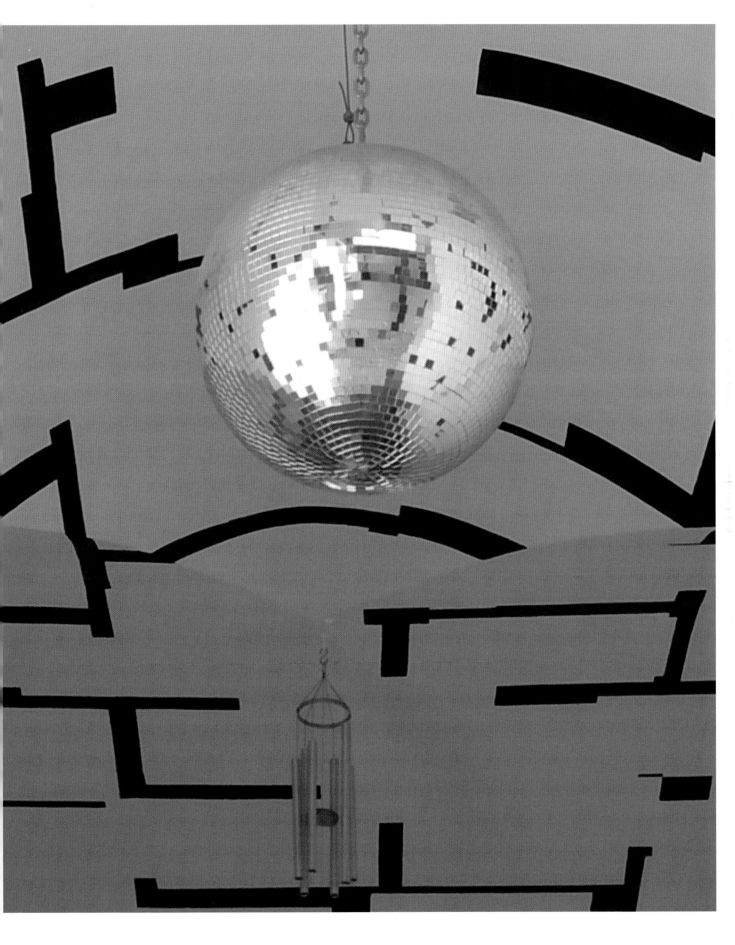

63. Queer Smartphones

SIMON CLAY

The smartphone is a strange thing. It is a portal to a vast realm of knowledge and potentials, but we carry it around with casual indifference to its power. Trying to describe this device to someone 20 years ago would have been a conversation of fantasy, yet now it is a fantasy to conceive of a world without it. The smartphone's ethereal connections have given birth to new forms of networks and relationships. The fitness and health apps used to record exercise time, heart rate and sleep cycles put us in touch with our biomechanical networks. The ability to check if our bus is running on time, or how congested the morning traffic is, connects us with the city transport system. Online banking and stock market apps further integrate us into financial institutions and economic dynamics.

Although there is an inherently queer quality to anything that permanently alters the social world, the smartphone is an exceptional case. Having blurred the already messy divide between online and offline experience, it has re-defined how we understand ourselves and relate to others. Media commentators critique the deity-like quality of smartphones with sharp cynicism and decry the apparent plague of isolation it has provoked among us. But this new digital deity has queered social interaction to such an extent that it has rendered the experience of socialising totally unrecognisable to some. This begs the question: who is actually being isolated here? The smartphone's users, or outsiders baffled by the technology?

Invented in 2009 and continuing to build momentum, the smartphone app Grindr has dramatically reconfigured the landscape of gay culture and the ways gay men relate to each other within it. Grindr's tiled screen shows the closest 100-odd users based on customisable demographic preferences and a set of subcultural identities known as 'Tribes'. The bright interface, chequered with pictures of luscious muscles and headless torsos, lets users 'cruise' the surrounding area for a range of possibilities: sex, drugs, work (and not just sex work), new flatmates, networking contacts and so on. The app employs a 'gamified' framework that facilitates these interactions, cultivates

a particular set of users and influences 'Grindr culture' more broadly.

Writers have suggested that all games share four key traits: a goal, rules, a feedback system and voluntary participation. All of these shape the Grindr experience.[1] An official set of rules governs the Grindr game: soliciting is not allowed, display photos must not be too revealing and users are expected to behave respectfully towards others. These formal injunctions are layered on top of various unofficial rules: the social norms, cultural dynamics and forms of digital etiquette that facilitate (or hinder) interactions between people online. Such interactions – compliments, criticisms, an avalanche of messages or cold rejection – become the feedback system of the game. A user's level of 'success' can be measured through the feedback other users provide. There are rewards too: receiving erotic selfies, being 'starred' or favourited and enjoying the gratification of being pursued by many. It is even possible to 'lose' at the Grindr game by getting blocked, being continuously rejected or being 'ghosted', that is, having one's conversations perpetually left in limbo.

Grindr's unique approach to social networking spawned a spate of apps with a similar design, including Growlr, Recon, Scruff and, of course, Tinder. Most of them – the first three on this list – cater for the gay community. These apps re-orientate the user in terms of their location, experience of sexuality and social dynamics. They use geo-location to reconfigure the surrounding environment into a topography of potential lovers, acquaintances, friends and those who fall somewhere in between. Streets and landmarks ebb away to reveal the coordination points of the people to whom our smartphone guides us. Re-conceptualising our suburbs and cities as cyber-social landscapes smacks of queerness. It presses us to re-orientate our location in the new terms governed by the app's algorithm. We are no longer inside our home or at the train station; instead we are 300 metres from 'hungdaddy' or 735 metres from 'NewInTown'. Using the app is akin to peering through a looking glass, stalking the streets looking for creatures only we can see through our device. The algorithm dictates where they are and when we see them, presenting a new epistemology of connection that we embrace with unwitting creativity.

The gamified dynamics of apps like Grindr push users to commodify men's bodies in a range of ways: showcasing their muscles, for instance, or offering a personal curation of tattoos. Subtle prompts to disassemble your body and personality into discrete parts, so that people will engage with you, render such apps very queer indeed. This is a double-edged sword. Such a reductive approach to desire, to the body and ultimately to self-worth, has a profoundly isolating impact on some. Many older men who use Grindr feel ostracised from the gay community when young men approach them with repeated requests to play the 'Daddy' or to provide 'rewards' (money) for

The smartphone is a portal into a range of worlds.

sex.[2] How do older Grindr users deal with a once-familiar community that now seems unrecognisable and even hostile? What does it mean when they can no longer see themselves among their own? On the other hand, Grindr and other apps can prompt creative ways of exploring identity. Young people who are still assembling their own sense of themselves are often confronted with a hostile outer world. Apps help them to distil the aspects of the body, eroticism and aesthetics that most appeal to them. They can find their niche or search out the most delicious morsel in the banquet.

Whether they intend to or not, those who have a dating app installed on their phone make a statement about who they are, how they relate to friends and lovers and the politics they adopt. When we glimpse Tinder on someone else's phone are we witnessing a post-break-up attempt to 'get back out there' and find the next big love? Or are we seeing the evidence

of a serial dater, someone who burns through lovers like acid, or the first sign of a devastating affair? If we look over an acquaintance's shoulder and glimpse Grindr open, we may assume he is proud of his sexuality. Perhaps, depending on our religious bent, we might interpret the app's presence as a sign of his damnation.

In her seminal essay 'A Cyborg Manifesto', Donna Haraway boldly wrote 'We are all chimeras, theorized and fabricated hybrids of machine and organism; in short, we are cyborgs.'[3] She suggests that contemporary medical and technological interventions on the body have changed us into something that no longer resembles the historical image of 'human'. Pacemakers, IUDs and genetic medicine are three such examples. These medical developments have enabled us to live longer and stronger by engineering the 'natural' body in new ways, which render us closer to cyborgs than to humans. We can extend this theory to smartphones, a technology unheard of in 1985 when Haraway penned her manifesto.

In recent years, a psychological phenomenon known as 'ringxiety', or Phantom Vibration Syndrome, has received increasing attention. This is the perception that our phone is ringing or vibrating when it is not. It is exceptionally prevalent among medical professionals: one survey showed 68 per cent of staff at an academic medical centre experienced these 'sensory hallucinations'.[4] The phones we constantly carry around or keep within arm's reach have become 'a kind of fifth limb or second brain' and we feel slightly unhinged from reality when we do not have them.[5]

We live a significant portion of our lives through our phones. We pluck a news story from Google, refer to our calendar or make some hurried notes at a bus stop while an idea is still fresh. The smartphone is an extension of our consciousness. When we misplace our phone our list of phone numbers is not the only thing we lose. We risk having our identity stolen by others. Our phone's access to Facebook, Twitter, Instagram or Messenger means anyone who steals our phone may hack into our internet banking, gain unfettered access to personal email, our Grindr or Tinder account, and our (potentially risqué) photo gallery.

Smartphones have altered our lives in unforeseeable ways, knitting together new forms of connection and expressions of identity and re-defining the way many aspects of our lives are lived. They have become so deeply embedded in social reality that a world without them is inconceivable. The fact this single artefact of modern technology can become an independent entity of our consciousness, and re-configure how we experience our identity so profoundly, renders the smartphone a truly queer object.

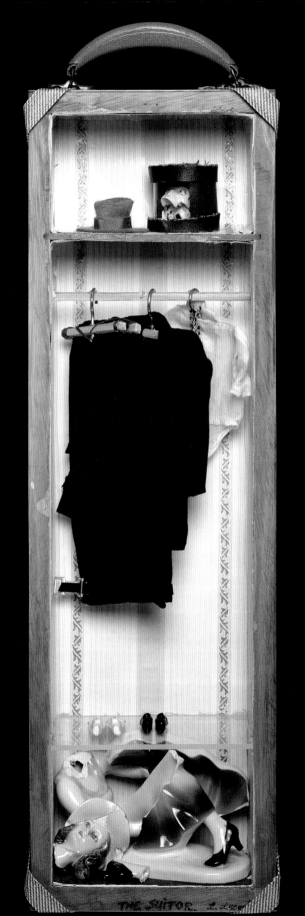

*The Suitor, from the series Hidden Agender
by New Zealand artist Lauren Lysaght, 1993.*

Contributors

Robert Aldrich is Professor of European History at the University of Sydney. He teaches and carries out research in modern European and colonial history.

Ben Anderson-Nathe lives with his big queer family in Portland, Oregon. He is Professor and Director of the Child, Youth, and Family Studies program at Portland State University.

Neil Bartlett is a British theatre director, performer and author whose books include the pioneering Wilde study *Who Was That Man?* and the novels *Ready to Catch Him Should He Fall* and *The Disappearance Boy*. His work is fully documented at www.neil-bartlett.com

Heike Bauer is Professor of Modern Literature and Cultural History at Birkbeck College, University of London. Her recent books include *The Hirschfeld Archives: Violence, death, and modern queer culture* (2017) and (ed.) *Sexology and Translation: Cultural and scientific encounters across the modern world* (2015).

Daniel F. Brandl-Beck is a Swiss-New Zealander. He has studied history and English in Auckland, Hamilton and Brisbane, holds a PhD in history from the University of Queensland, and currently lives in Switzerland.

Chris Brickell is Professor of Gender Studies at the University of Otago. His books include *Mates and Lovers: A history of gay New Zealand* (2008), *Manly Affections: The photographs of Robert Gant, 1885–1915* (2012) and *Teenagers: The rise of youth culture in New Zealand* (2017).

Loren Britton is an artist and curator based between Berlin and New York, whose work explores abstraction of form in language and translation. Britton works on histories of trans*gender bodies, specifically looking for origin points of trans* desire. For more information: http://lorenbritton.com

Marcus Bunyan is an Australian image maker whose work investigates the boundaries between identity, space and environment (marcusbunyan.com). For over 10 years he has written the Art Blart blog (artblart.com), which posts mainly on photography. With over 1400 posts in the archive, the website has become a form of cultural memory.

James Burford is a lecturer in Research Education and Development at La Trobe University, Australia. His research interests include doctoral education, academic mobilities and queer theory.

Joanne Campbell completed her PhD in art history at the University of Otago in 2016 and has contributed to a variety of arts publications. She lives in Wellington, New Zealand, with her wife and sons and enjoys research and writing on a diverse range of topics.

Christopher Castiglia and **Christopher Reed** both teach in the English Department of Pennsylvania State University. Castiglia specialises in nineteenth-century American literature, Reed in modernist visual culture. Together they authored *If Memory Serves: Gay men, AIDS, and the promise of the queer past* (2012).

Elise Chenier is Professor of History at Simon Fraser University in British Columbia, where she teaches the history of sexuality and oral history. She is currently writing a book on same-sex wedding practices in the United States before the marriage equality movement.

Simon Clay is a PhD candidate in gender studies at the University of Otago.

Rachel Hope Cleves is Professor of History at the University of Victoria in British Columbia. She is working on a biography of the writer Norman Douglas.

Judith Collard is a senior lecturer in the Department of History and Art History at the University of Otago. She lectures in gender issues in art history as well as in medieval and Renaissance art, and art from the 1960 to the 1980s.

Matt Cook is Professor of Modern History at Birkbeck University of London. He specialises in the history of sexuality and the history of London in the nineteenth and twentieth centuries.

Kate Davison is completing her PhD thesis, 'Sex, Security and the Cold War: A transnational history of homosexual aversion therapy 1948–1981', at the University of Melbourne.

Nadia Gush is the former director of the Charlotte Museum Trust and is currently researching lesbian, gay, bisexual and queer women's social life in the 1980s.

Katherine A. Hermes is Professor of History at Central Connecticut State University. She is the co-editor with Karen Ritzenhoff of a volume of essays, *Sex and Sexuality in a Feminist World* (2008), and co-author with Cheryl Meyer, Taronish Irani and Betty Yung of *Explaining Suicide: Patterns, motivations and what notes reveal* (2017).

Margo Hobbs teaches modern and contemporary art history at Muhlenberg College in Allentown, Pennsylvania. She earned her PhD at Northwestern University, and is currently working on a book-length study of lesbian feminist photographers on the American West Coast.

Dino Hodge has a PhD in history from the University of Melbourne and is an Honorary Senior Fellow with the University's Indigenous Studies Unit. He works in Australia's remote Northern Territory communities as a fly-in, fly-out clinical audiologist.

John Howard is Emeritus Professor of Arts and Humanities, King's College London. Of several books, he has published two historical monographs with University of Chicago Press and two documentary photobooks with University of Valencia Press.

Philip Hughes is a school teacher and part-time DJ who lives in Christchurch, New Zealand.

Diane Johns holds an MA and a PhD in English from the University of Oregon, and an MSEd in community mental health counselling from Northern Illinois University. A quilter and dancer for over 40 years, she currently works as a freelance editor when she is not travelling with her wife or spending time with her three grandchildren.

Timothy Willem Jones is senior lecturer in history at La Trobe University, Melbourne. He is a historian of religion, gender and sexuality in the modern West.

Kath Khangpiboon is co-founder of the Thai Transgender Alliance and works as a lecturer in the Faculty of Social Administration at Thammasat University, Thailand.

Tirza True Latimer is Professor in Visual Studies at California College of the Arts. Her latest book about queer visual culture, *Eccentric Modernisms: Making differences in the history of American art* (2016), is the source of an exhibition, *Other Points of View*, at Leslie-Lohman Museum of Gay and Lesbian Art, New York, opening in February 2020.

Reina Lewis is Professor of Cultural Studies, London College of Fashion, University of the Arts London. A specialist on feminist postcolonial theory and religion and fashion, and on queer visual cultures, she creates chances to showcase lesbian style whenever possible. Since 2000 she has periodically frocked up to host Tart Salon, a showcase for women's creativity, politics and culture, where intelligent conversation is expected and encouraged.

Amanda Littauer is Associate Professor in the Department of History and the Center for the Study of Women, Gender & Sexuality, Northern Illinois University.

Craig Middleton is Curator of the Centre of Democracy in Adelaide, South Australia. He is interested in political histories in museum settings, community engagement as museological practice, curatorial activism, and LGBTIQ+ and museums. He is co-author (with Nikki Sullivan) of the forthcoming book, *Queering the Museum* (2019).

Robert Mills is Professor of Medieval Studies in the History of Art Department at University College London. His books include *Seeing Sodomy in the Middle Ages* (2015) and *Derek Jarman's Medieval Modern* (2018).

Gregory Minissale is Associate Professor of Art History at the University of Auckland and author of *The Psychology of Contemporary Art* (2013). He is currently conducting research into matter and contemporary art using psychological approaches.

Wayne Murdoch has a particular interest in Australian social history before World War II. His PhD thesis was on Kamp Melbourne in the 1920s and 1930s.

Alison Oram is Professor of Social and Cultural Studies at Leeds Beckett University. Her research focuses on twentieth-century lesbian and queer history, and the ways the themes of sexuality and the family appear in public history.

Richard Bruce Parkinson is Statutory Professor of Egyptology at the University of Oxford and a fellow of The Queen's College, Oxford, specialising in the study of ancient Egyptian poetry of the classic period. Drawing on his research on the 'subaltern' aspects of ancient poems, he has also published on LGBTQ+ history across world cultures. From 1992 to 2012 he was Assistant Keeper in the Department of Ancient Egypt and Sudan at the British Museum.

Carina Pasquesi works in American literature and sexuality studies and teaches at Baruch College, The City University of New York. Her recent publications include 'The Perils and Pleasures of Drinking in Herman Melville and Will Self' in *Queer Difficulties in Verse and Visual Culture*, and 'The Morgesons: Elizabeth Stoddard's "Ars Erotica"' in *Legacy: A Journal of American women writers*. She is currently at work on a book about adult-centred spaces, specifically bars and the cultures of regularhood in the United States.

Helen Pausacker is Deputy Director of the Centre for Indonesian Law, Islam and Society, Melbourne Law School, the University of Melbourne. She is a member of the Australian Lesbian and Gay Archives.

Jutathorn Pravattiyagul is an associate scholar at Harvard University, Asia Center, and her work focuses on Kathoey and discrimination toward transgender people.

Erica Rand is Professor of Art and Visual Culture and of Gender and Sexuality Studies at Bates College. Her writing includes *Barbie's Queer Accessories* (1995), *The Ellis Island Snow Globe* (2005), and *Red Nails, Black Skates: Gender, cash, and pleasure on and off the ice* (2012).

Barry Reay holds the Keith Sinclair Chair in History at the University of Auckland, New Zealand. His most recent book is *Sex in the Archives: Writing American sexual histories* (2018).

Bev Roberts is an Australian writer and historian.

Timothy Roberts is a researcher and consultant in Australian art heritage, decorative arts and material culture to 1945. He is president of the Professional Historians Association (Queensland) and a councillor of the Royal Historical Society of Queensland, and has contributed to *Australiana*, *Design and Art Australia Online*, and *The Queensland History Journal*. Tim's interest in Australia's queer history focuses on gay lives and culture in Queensland, and the history of Australia's leather community.

Shirleene Robinson is Senior Curator of Oral History and Folklore and Indigenous Programs at the National Library of Australia. She is also an Honorary Associate Professor in the Department of Modern History at Macquarie University. Recent publications include the co-authored *Gay and Lesbian, Then and Now: Australian stories from a social revolution* (2016) and *Serving in Silence? Australian LGBT servicemen and women* (2018).

Peter Sherlock is the inaugural vice-chancellor of the University of Divinity, Melbourne. He is author of *Monuments and Memory in Early Modern England* (2008), and his research interests include the material culture of remembering and forgetting and the intersection of gender and religion.

Lukasz Szulc is a Marie Curie Individual Fellow in the Media and Communications Department at the London School of Economics and Political Science.

Yorick Smaal is a senior lecturer in history at Griffith University, Australia. He is author of *Sex, Soldiers and the South Pacific: Queer identities in Australia in the Second World War* (2015).

Katsuhiko Suganuma is lecturer in humanities at the University of Tasmania. His writing focuses on queer desires in Japan and elsewhere. He is an author of *Contact Moments: The politics of intercultural desire in Japanese male-queer cultures* (Hong Kong University Press, 2012), and a co-editor of *Boys Love Manga and Beyond: History, culture, and community in Japan* (University Press of Mississippi, 2015).

Nikki Sullivan is a curator at the Migration Museum in Adelaide, and Honorary Associate Professor, Department of Media, Music, Communication and Cultural Studies at Macquarie University. She is the author of numerous books, including *A Critical Introduction to Queer Theory* (2003).

Jane Trengove lives and works in Melbourne. She has worked across a range of visual art media including painting, installation, collaborative works and the coordination/curation of visual arts projects since the 1980s.

Jeffrey Vaughan, a New Zealander, is an IT consultant and occasional writer who likes tea.

Paerau Warbrick teaches in Te Tumu, the School of Māori, Pacific and Indigenous Studies at the University of Otago, and is also a barrister with particular expertise in Māori land law.

Peter Wells died in 2019. Having studied queer history at the University of Warwick from 1974 to 1977, he began making gay films in 1981 and made the flamboyantly queer feature film *Desperate Remedies* with his then partner Stewart Main. He co-founded the Auckland Writers Festival and in 2016 initiated the Samesame But Different LGBTQI Writers Festival. *Hello Darkness* was his last book.

Melissa M. Wilcox is Professor and Holstein Family and Community Chair in Religious Studies at the University of California, Riverside. Her work in queer and transgender studies in religion focuses on identity, politics, practice and theory.

Graham Willett is a recovering academic from Australia. He has been researching and writing on Australian queer history for over 30 years. He is a long-time committee member of the Australian Lesbian and Gay Archives.

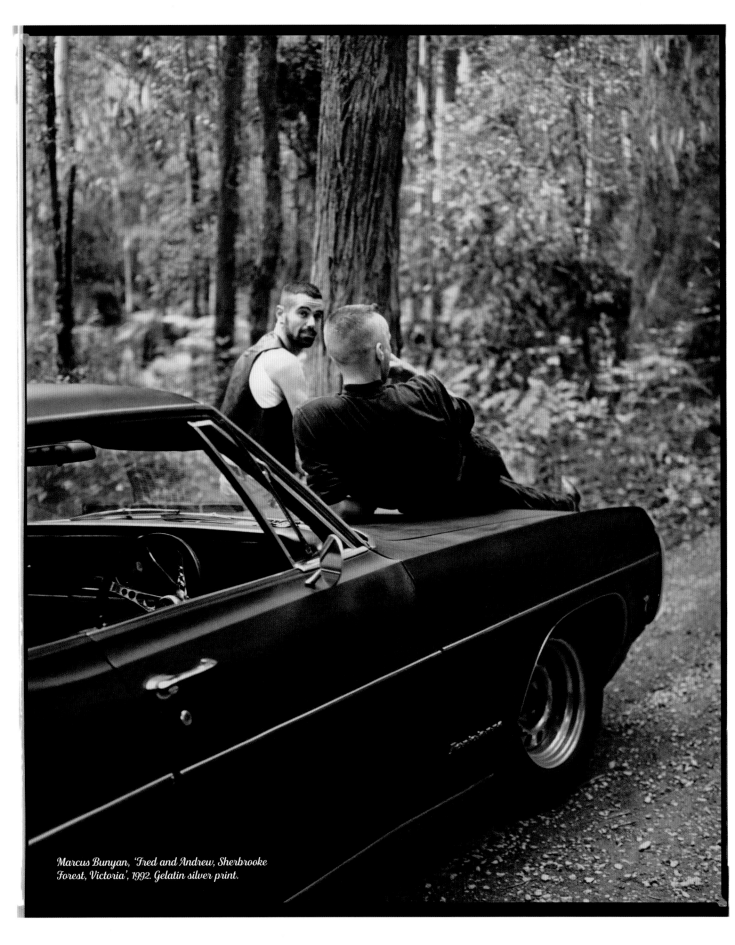

Marcus Bunyan, 'Fred and Andrew, Sherbrooke Forest, Victoria', 1992. Gelatin silver print.

Notes

1. The Queerness of Objects

1. The best-known works include, but are hardly limited to, Robert Aldrich, *The Seduction of the Mediterranean: Writing, art and homosexual fantasy* (London: Routledge, 1993); George Chauncey, *Gay New York* (New York: Basic, 1994); Matt Cook, *London and the Culture of Homosexuality, 1885–1914* (Cambridge: Cambridge University Press, 2008); Lilian Faderman, *Surpassing the Love of Men: Romantic friendship and love between women from the sixteenth century to the present* (New York: Morrow, 1981); Matt Houlbrook, *Queer London* (Chicago: University of Chicago Press, 2005); John Howard, *Men Like That: A southern queer history* (Chicago: University of Chicago Press, 1999); Elizabeth Kennedy and Madeline Davis, *Boots of Leather, Slippers of Gold: The history of a lesbian community* (New York: Routledge, 1993).

2. Neil MacGregor, *A History of the World in 100 Objects* (London: Allen Lane, 2010).

3. R.B. Parkinson, *A Little Gay History: Desire and diversity across the world* (London: British Museum, 2013).

4. Susan Stabile, 'Biography of a Box: Material culture and palimpsest memory', in Joan Tumblety (ed.), *Memory and History: Understanding memory as source and subject* (New York: Routledge, 2013), pp. 194–212 (p. 197).

5. Hans Hahn and Hadas Weiss, 'Introduction: Biographies, travels and itineraries of things', in Hans Hahn and Hadas Weiss (eds), *Mobility, Meaning and Transformations of Things* (Oxford: Oxbow, 2013), pp. 1–14 (p. 4).

6. Adam Geczy and Vicki Karaminas, *Queer Style* (London: Bloomsbury, 2013).

7. Valerie Steele, *A Queer History of Fashion: From the closet to the catwalk* (New Haven: Yale University Press, 2013).

8. Chauncey, *Gay New York*, p. 52.

9. Hahn and Weiss, 'Introduction', p. 7.

10. Anamaria Depner, 'Worthless Things? On the difference between devaluing and sorting out things', in Hahn and Weiss (eds), *Mobility, Meaning and Transformations of Things*, pp. 78–90 (p. 82).

11. Parkinson, *A Little Gay History*, p. 29.

12. On the significance of the silhouettes, see Rachel Hope Cleves, *Charity and Sylvia: A same-sex marriage in early America* (New York: Oxford University Press, 2014).

13. Stabile, 'Biography of a Box', p. 196.

14. Michael Warner, 'Fear of a Queer Planet', *Social Text*, 29 (1991), pp. 3–17.

15. Christopher Reed, 'Design for (Queer) Living: Sexual identity, performance, and decor in British *Vogue*, 1922–1926', *GLQ*, 12, 3 (2006), pp. 377–403 (p. 378).

16. Arlene Stein and Ken Plummer, '"I Can't Even Think Straight": "Queer" theory and the missing sexual revolution in sociology', *Sociological Theory*, 12, 2 (1994), pp. 178–87.

17. Wayne Murdoch, *Kamp Melbourne in the 1920s and '30s: Trade, queans and inverts* (Newcastle upon Tyne: Cambridge Scholars Publishing, 2017), ch. 8.

18. Matt Houlbrook, '"The Man with the Powder Puff" in Interwar London', *The Historical Journal*, 50, 1 (2007), pp. 145–71.

19. On these 'treatments', see Tommy Dickinson, *'Curing Queers': Mental nurses and their patients, 1935–74* (Manchester: Manchester University Press, 2015).

20. See, for instance, Clare Barlow (ed.), *Queer British Art, 1861–1967* (London: Tait Publishing, 2017); Catherine Lord and Richard Meyer, *Art and Queer Culture* (London: Phaidon, 2013).

21. Emily Robinson, 'Touching the Void: Affective history and the impossible', *Rethinking History*, 14, 4 (2010), pp. 503–20.

22. See, for instance, Matt Cook, *Queer Domesticities: Homosexuality and home life in twentieth-century London* (Houndmills: Palgrave: 2014).

23. Andrew Gorman-Murray, 'Reconciling Self: Gay men and lesbians using domestic materiality for identity management', *Social and Cultural Geography*, 9 (3), 2008, pp. 283–301.

24. John Potvin, *Bachelors of a Different Sort: Queer aesthetics, material culture and the modern interior in Britain* (Manchester: Manchester University Press, 2014).

25. On the feelings evoked when looking back at queer history, see Heather Love, *Feeling Backward: Loss and the politics of queer history* (Cambridge: Harvard University Press, 2009).

26. Manuel DeLanda, *A New Philosophy of Society: Assemblage theory and social complexity* (London: Continuum, 2006), p. 5.

27. Jearld Moldenhauer, 'A Literary Breakthrough: Glad Day's origins', in Stephanie Chambers (ed.), *Any Other Way: How Toronto got queer* (Toronto: Coach House Books, 2017), pp. 158–61.

28. Bruno Latour, *Reassembling the Social: An introduction to actor network theory* (Oxford: Oxford University Press, 2005), p. 240.

29. Stabile, 'Biography of a Box,' p. 196.

30. Gorman-Murray, 'Reconciling Self', p. 292.

31. Stabile, 'Biography of a Box,' p. 197; Latour, *Reassembling the Social*, p. 1.

32. Chris Brickell, *Mates and Lovers: A history of gay New Zealand* (Auckland: Random House, 2008); Rebecca Jennings and Liz Millwood, '"A Fully-Formed Blast from Abroad?" Australasian lesbian circuits of mobility and the transnational exchange of ideas in the 1960s and 1970s', *Journal of the History of Sexuality*, 25, 3 (2016), pp. 463–88.

33. On similarities and differences between historical and contemporary modes and understandings of sexuality see Christopher Reed, *Art and Homosexuality* (Oxford: Oxford University Press, 2011), p. 7.

2. The First Gay Kiss?

1. I am grateful to the Oxford Expedition to Egypt for providing images of the tomb, and to the following for comments on a draft: Chris Brickell, Julia Hamilton, Chris Hollings, Helen Neale and my husband Tim Reid.

2. Ahmed M. Moussa and Hartwig Altenmüller, *Das Grab des Nianchchnum und Chnumhotep: Old Kingdom tombs at the causeway of King Unas at Saqqara*, Archäologische Veröffentlichungen, Deutsches Archäologisches Institut, Abteilung Kairo 21 (Mainz: Zabern, 1977); Yvonne Harpur and Paolo Scremin, *The Chapel of Niankhkhnum & Khnumhotep: Scene details*, Egypt in Miniature 3 (Reading; Oxford: Oxford Expedition to Egypt, 2010). The title of this chapter comes from the headline of an article by William Holland, 'Mwah ... Is This the First Recorded Gay Kiss? Egyptian Manicurists Become Homosexual Icons', *Sunday Times*, 1 January 2006 (News, p. 3).

3. Wolfgang Westendorf, 'Homosexualität', *Lexikon der Ägyptologie* II (Wiesbaden: Harrassowitz, 1976), pp. 1272–73; Greg Reeder, 'Same-sex Desire, Conjugal Constructs, and the Tomb of Niankhkhnum and Khnumhotep', *World Archaeology*, 32, 2 (2000), pp. 193–208; Greg Reeder, 'Queer Egyptologies of Niankhkhnum and Khnumhotep', in Carolyn Graves-Brown (ed.), *Sex and Gender in Ancient Egypt: 'Don Your Wig for a Joyful Hour'* (Swansea: Classical Press of Wales, 2008), pp. 143–55.

4. Richard Bruce Parkinson, '"Homosexual" Desire and Middle Kingdom Literature', *Journal of Egyptian Archaeology*, 81 (1995), pp. 57–76; Richard Bruce Parkinson, '"Boasting about Hardness": Constructions of middle kingdom masculinity', in Graves-Brown (ed.), *Sex and Gender in Ancient Egypt*, pp. 115–42.

5. Yvonne Harpur, 'Two Old Kingdom Tombs at Giza', *Journal of Egyptian Archaeology* 67 (1981), pp. 24–35, p. 29, n. 31. See John Baines, 'Egyptian Twins', *Orientalia*, 54 (1985) pp. 461–82 (pp. 463–70); Vera Vasiljevic, 'Embracing His Double: Niankhkhnum and Khnumhotep', *Studien zur Altägyptischen Kultur*, 37 (2008), pp. 363–72; Linda Evans and Alexandra Woods, 'Further Evidence that Niankhkhnum and Khnumhotep were Twins', *Journal of Egyptian Archaeology*, 102 (2016), pp. 55–72. For David O'Connor's unpublished hypothesis that they were conjoined twins see 'A Mystery, Locked in Timeless Embrace': www.nytimes.com/2005/12/20/science/a-mystery-locked-in-timeless-embrace.html.

6. Parkinson, *Voices*, pp. 120–21.

7. Greg Reeder, 'Same-sex Desire, Conjugal Constructs, and the Tomb of Niankhkhnum and Khnumhotep', *World Archaeology*, 32, 2 (2000), pp. 193–208 (p. 207); for an alternate view see Linda Evans and Alexandra Woods, 'Further Evidence that Niankhkhnum and Khnumhotep Were Twins', *Journal of Egyptian Archaeology*, 102, 1 (2016), pp. 55–72.

8. Brian Whitaker, *Unspeakable Love: Gay and lesbian life in the Middle East* (London: Saqi, 2006).

9. See, for example, www.newnownext.com/lgbt-history-month-5-gay-love-stories-for-the-ages/10/2016/ and https://meteodesigns.deviantart.com/art/Khnumhotep-Niankhkhnum-146712376 by 'Meteodesigns' aka Robert Long.

10. Stop-homophobia.com: https://twitter.com/wipehomophobia/status/618787355936354305

11. See, for example, 'Bros', in Kendra Josie Kirkpatrick, *Informative Ancient Egypt Comics*: www.kendrajosiekirkpatrick.com/informative-ancient-egypt-comics?lightbox=dataItem-im4zrmx8; Thomas A. Dowson, 'Why Queer Archaeology? An introduction', in *Queer Archaeologies = World Archaeology*, 32, 2 (2000), pp. 161–65; Thomas A. Dowson, 'Archaeologists, Feminists, and Queers: Sexual politics in the construction of the past', in Pamela L. Geller and Miranda K. Stockett (eds), *Feminist Anthropology: Past, present, and future* (Philadelphia: University of Pennsylvania Press), pp. 89–102 (pp. 96–99); Thomas A. Dowson, 'Queering Sex and Gender in Ancient Egypt', in Graves-Brown (ed.), *Sex and Gender in Ancient Egypt*, pp. 27–46.

12. British Museum EA 826: see John Baines and Liam McNamara, 'The Twin Stelae of Suty and Hor', in Zahi A. Hawass and Janet E. Richards (eds), *The Archaeology and Art of Ancient Egypt: Essays in honor of David B. O'Connor* (Cairo: Conseil Suprême des Antiquités de l'Egypte, 2007) 1, pp. 63–79. Translation: Miriam Lichtheim, *Ancient Egyptian Literature: A book of readings II: The New Kingdom* (Berkeley, CA; London: University of California Press, 2006), pp. 86–89.

13. Steven Blake Shubert, '*Double Entendre* in the Stela of Suty and Hor', in Gary N. Knoppers and Antoine Hirsch (eds), *Egypt, Israel, and the Ancient Mediterranean World: Studies in honor of Donald B. Redford*, (Leiden; Boston: Brill, 2004), pp. 143-65. The idea was first suggested by Aleister Crowley in *The Winged Beetle* (London: privately printed, 1910), pp. 99–101.

14. 'The Tale of the Eloquent Peasant', in Richard Bruce Parkinson, *The Tale of Sinuhe and Other Ancient Egyptian Poems, 1940–1640 BC*, Oxford World's Classics (Oxford: Oxford University Press, 1998), p. 70

3. Tūtānekai's Flute
1. D.M. Stafford, *Te Arawa* (Auckland: Reed, 1994), pp. 84–86.

2. My thanks to Dr Paul Tapsell and Krzysztof Pfeiffer who allowed the use of the photograph of Tūtānekai's flute for this publication.

3. Stafford, *Te Arawa*, p. 84; see also Ngahuia Te Awekotuku, 'Hinemoa: Retelling a famous romance', *Journal of Lesbian Studies*, 5, 1 and 2 (2001), pp. 1–11.

4. George Grey, *Nga Mahi a Nga Tupuna*, 4th edn (Wellington: Reed, 1971), p. 113. For the English translation of the passages in Grey, see Clive Aspin, 'Hōkakatanga – Māori sexualities', Te Ara – The Encyclopedia of New Zealand: www.teara.govt.nz/en/hokakatanga-maori-sexualities/page-1

5. Grey, *Nga Mahi a Nga Tupuna*, p. 113.

6. William Williams, *A Dictionary of the New Zealand Language*, 3rd edn (Auckland: Upton, 1892), p. 172. The second edition (London: Norgate, 1852, p. 159) listed a definition of 'tapui' as 'a companion'.

7. See the fluidity of the term in Jessica Hutchins and Clive Aspin (eds), *Sexualities and the Story of Indigenous People* (Wellington: Huia, 2007); see also D. Murray, 'Who Is Takatāpui?': Māori language, sexuality and identity in Aotearoa/New Zealand', *Anthropologica*, 45, 2 (2003), pp. 233–44.

8. Hutchins and Aspin, *Sexualities*. It is important to understand Māori knowledge systems and the position of whānau relationships within those structures: Waitangi Tribunal, *Ko Aotearoa Tēnei: A Report into Claims Concerning New Zealand Law and Policy Affecting Māori Culture and Identity: Te Taumata Tuatahi and Te Taumata Tuarua*, Vols 1 and 2 (Wellington, 2011); E. Durie, *Māori Custom and Values in New Zealand Law* (Wellington: New Zealand Law Commission, 2001).

9. See Alan Davidson, *A History of Church and Society in New Zealand* (Wellington: Education for Ministry, 2004); on the role of missionaries in the South Island of New Zealand see T.A. Pybus, *Māori and Missionary* (Wellington: Reed, 1954).

10. It is for the Tapsell whānau to tell stories of takatāpui within their own whānau and hapū.

11. *Auckland Star*, 13 April 1928, p. 5.

12. Aspin, 'Hōkatanga'.

13. Arthur Carman, *Māori Rugby 1884–1979* (Wellington: Sporting Publications, 1980); Brendan Hokowhitu, 'Tackling Māori Masculinity: A colonial genealogy of savagery and sport', *The Contemporary Pacific*, 16, 2 (2004), pp. 259–84.

14. S.M. Mead, 'Te Toi Mātauranga Māori mo ngā Ra Kei Mua: Māori Studies Tomorrow', *The Journal of the Polynesian Society*, 92, 3 (1983), pp. 333–51; I.H. Kawharu, 'Maori Sociology: A commentary', *The Journal of the Polynesian Society*, 93, 3, 1984, pp. 231–46; Moana Jackson, 'The Treaty and the Word', in G. Oddie and R.W. Perrett (eds), *Justice, Ethics and New Zealand Society* (Auckland: Oxford University Press, 1992), pp. 1–10; Ranginui Walker, *Ka Whawhai Tonu Matou, Struggle Without End* (Auckland: Penguin, 1990).

15. Te Awekotuku, 'Hinemoa', p. 3.

16. *New Zealand Parliamentary Debates*, 17 April 2013, Volume 689, p. 9496.

4. Faces of Queer-Aboriginality in Australia
1. Robert Reynolds, 'Writing Queer Cultural Histories', *Critical inQueeries*, 1, 1 (1995), pp. 69–83.

5. Pasting Together an Identity
1. https://trove.nla.gov.au/, the Australian National Library databases of digitised newspapers.

2. For further discussion of the scrapbooks, see Ruth Ford, 'Speculating on Scrapbooks', *Australian Historical Studies* 106 (1996), pp. 111–26.

3. Scrapbook 1, p. 49; Scrapbook 1, p. 95. Gabrielle Fleury worked at Alice Anderson's women's garage. See Georgina Clarsen, *Eat My Dust: Early women motorists* (Baltimore: Johns Hopkins University Press, 2008), p. 116.

4. Geraldine died two years later, December 1931, in Cheltenham (death notice, *Argus*, 4 January 1932, p. 1) but this is not recorded in Monte's scrapbooks. For further details of Agnes' and Geraldine's life, see Wayne Murdoch, 'Harriet Elphinstone Dick and the "New Woman"', in Graham Willett, Wayne Murdoch and Daniel Marshall (eds), *Secret Histories of Queer Melbourne* (Melbourne: Australian Lesbian and Gay Archives, 2011), pp. 27–29 (p. 29).

5. Interview with Margaret Taylor, Monte's last partner, by Graham Carbery and Mark Riley, 9 July 1990, held at the Australian and Lesbian Gay Archives.

6. Scrapbook 2, pp. 7, 11–14. For further details of Barker's life, see Rose Collis, *Colonel Barker's Monstrous Regiment: A tale of female husbandry* (London: Virago, 2001).

7. Scrapbook 1, p. 72. For further details of Payne's life see Ruth Ford, 'Sexuality and "Madness": Regulating women's gender "deviance" through the asylum, the Orange Asylum in the 1930s', in Catharine Coleborne and Dolly MacKinnon (eds), *Madness in Australia: Histories, heritage and the asylum* (Brisbane: University of Queensland Press, 2003), pp. 109–20.

8. Monte Punshon, *The Times Between: Life lies hidden* (Kobe: Kobe Japan–Australia Society, 1987), p. 63; Helen Pausacker, 'Monte Punshon', in Willett, Murdoch and Marshall (eds), *Secret Histories*, pp. 167–71.

9. Punshon, *The Times Between*, pp. 101–02.

10. Interview with Margaret Taylor.

11. Ibid.

7. The Queering of Action Man
1. Eva-Maria Simms, 'Uncanny Dolls: Images of death in Rilke and Freud', *New Literary History* 27, 4 (1996), p. 663.

2. Quoted in Simms, 'Uncanny Dolls', p. 673.

3. Félix Guattari, *Schizoanalytic Cartographies*, trans. Andrew Goffey (London: Bloomsbury, 2013).

4. Judith Halberstam, 'F2M: The making of female masculinity', in Laura Doan (ed.), *The Lesbian Postmodern* (New York: Columbia University Press, 1994), p. 211.

5. Gilles Deleuze and Félix Guattari, *A Thousand Plateaus: Capitalism and schizophrenia* (Minneapolis: University of Minnesota Press, 1987), p. 277.

9. Fragments of Sappho
1. Diane Rayor and Andre Lardinois, *Sappho: A new translation of the complete works* (Cambridge: Cambridge University Press, 2014), pp. 3–4; Willis Barnstone, *The Complete Poems of Sappho* (Boston: Shambhala, 2009), p. xvii.

2. Rayor and Lardinois, *Sappho*, pp. 6, 15.

3. Rayor and Lardinois, *Sappho*, p. 7.

4. Barnstone, *Complete Poems*, xxvii.

5. Rayor and Lardinois, *Sappho*, p. 5.

6. Fragment 31, Rayor and Lardinois, *Sappho*, p. 44. The translation used here is Rayor's; Barnstone's translation is different to that of Rayor and Lardinois, but his analysis of the significance of the poem, on p. xx, is similar.

7. Fragment 16, Rayor and Lardinois, *Sappho*, p. 33.

8. Barnstone, *Complete Poems*, p. xxiv.

9. Barnstone, *Complete Poems*, pp. xxix.

10. Florence Tamagne, 'The Homosexual Age, 1870–1940', in Robert Aldrich (ed.), *Gay Life and Culture* (London: Thames and Hudson, 2006), pp. 167–96 (p. 168).

11. Renée Vivien, 'Sappho Lives Again', in Terry Castle (ed.), *The Literature of Lesbianism* (New York: Columbia University Press, 2003), pp. 610–11.

12. James Courage, Diary, 10 September 1927, MS 999-79, Hocken Collections, Dunedin.

13. Fragment 94, Rayor and Lardinois, *Sappho*, p. 64.

14. Sidney Abbott and Barbara Love, *Sappho was a Right-On Woman: A liberated view of lesbianism* (New York: Stein and Day, 1985).

15. Laura Doan, *Fashioning Sapphism: The origins of a modern English lesbian culture* (New York: Columbia University Press, 2001).

10. New World Slavery's Queer Object
1. Hortense Spillers refers to the losing of gender difference under conditions of slavery where 'the female body and the male body become a territory of cultural and political maneuver, not at all gender-related, gender-specific': Spillers, *Black, White, and in Color: Essays on American literature and culture* (Chicago: University of Chicago Press, 2003), p. 206.

2. See Marianne Noble, *The Masochistic Pleasures of Sentimental Literature* (Princeton: Princeton University Press, 2000).

3. See Fred Moten, *In the Break: The aesthetics of the black radical tradition* (Durham: Duke University Press, 2003).

4. Harriet Beecher Stowe, *Uncle Tom's Cabin*, ed. Jean Fagan Yellin (New York: Oxford University Press, 1998), p. 386.

5. Stowe, *Uncle Tom's Cabin*, p. 376.

6. Stowe, *Uncle Tom's Cabin*, p. 378.

7. Stowe, *Uncle Tom's Cabin*, p. 360.

8. Stowe, *Uncle Tom's Cabin*, p. 386.

9. See, for instance, Gayle Rubin, *Deviations: A Gayle Rubin reader* (Durham: Duke University Press, 2011); Tim Dean, *Unlimited Intimacy: Reflections on the subculture of barebacking* (Chicago: University of Chicago Press, 2009); Patrick Califia, *Public Sex: The culture of radical sex* (Jersey City: Cleis, 2001) and Samuel Delany, *Times Square Red, Times Square Blue* (New York: New York University Press, 1999).

10. Eva Cherniavsky, *The Pale Mother Rising: Sentimental discourses and the imitation of motherhood in nineteenth-century motherhood* (Indianapolis: Indiana University Press, 1995), p. 137.

11. Freda's Mountaineering Memoir
1. Bee Dawson, *Lady Travellers: The tourists of early New Zealand* (Auckland: Penguin, 2001); Sally Irwin, *Between Heaven and Earth: The life of a mountaineer, Freda du Faur* (Melbourne: White Crane Press, 2000).

2. Freda du Faur, *The Conquest of Mount Cook* (Christchurch: Capper Press, 1977 [1915]), p. 145.

3. Du Faur, *Conquest*, p. 104.

4. J.A.S., 'Freda du Faur', *New Zealand Alpine Journal*, 6, 23 (1936), p. 389.

5. Alison McLeod, Transcript of Diary, ARC 1994.34, Canterbury Museum, 16 July; 28 August 1919.

6. Du Faur, *Conquest*, pp. 27, 32.

7. Du Faur, *Conquest*, p. 28.

8. Du Faur, *Conquest*, p. 25.

9. Du Faur, *Conquest*, p. 29.

10. Du Faur, *Conquest*, pp. 139–40.

11. Du Faur, *Conquest*, p. 141.

12. Du Faur, *Conquest*, p. 145.

13. Irwin, *Between Heaven and Earth*, p. 251.

14. Irwin, *Between Heaven and Earth*, p. 231.

15. Havelock Ellis, *Studies in the Psychology of Sex, Volume II: Sexual inversion*, 3rd edn (Philadelphia: F.A. Davis, 1918), p. 4.

16. Irwin, *Between Heaven and Earth*, ch. 21. On the rest cure in general see Suzanne Poirier, 'The Weir Mitchell Rest Cure: Doctors and patients', *Women's Studies*, 10 (1983), pp. 15–40.

12. Teddy's Illustrated Letter

1. Edward Wolfe to Norman Douglas, August 1924, Norman Douglas Collection, Beinecke Library, Box 20, Folder 324.

2. Michael Rocke, *Forbidden Friendships: Homosexuality and male culture in Renaissance Florence* (New York: Oxford University Press, 1996).

3. Chiara Beccalossi, 'The "Italian Vice": Male homosexuality and British tourism in Southern Italy,' in John H. Arnold, Joanna Bourke and Sean Brady (eds), *Italian Sexualities Uncovered, 1789–1914*, (London: Palgrave, 2015), pp. 185–203.

4. Giuseppe [Pino] Orioli, *Adventures of a Bookseller* (New York: Robert M. McBridge & Co., 1938), p. 118.

5. Biographical information about Douglas is drawn from my work in progress, 'The World's Best Bad Man: The life of Norman Douglas'. For a published biography of Douglas, see Mark Holloway, *Norman Douglas: A biography* (London: Secker & Warburg, 1976).

6. Ian Littlewood, *Sultry Climates: Travel and sex* (Cambridge, Mass.: Da Capo Press, 2001), p. 132.

7. Norman Douglas to Muriel Draper, 4 June 1924, Muriel Draper Papers, Beinecke Library, Box 1, Folder 67.

8. John Russell Taylor, *Edward Wolfe* (London: Trefoil Books, 1986). Taylor claims that Wolfe rejected Duncan Grant's sexual overtures, but Frances Spalding's biography of Grant claims that David 'Bunny' Garnett found the two in bed together; Frances Spalding, *Duncan Grant: A biography* (London: Pimlico, 1998), p. 225.

9. Eleanor Jones, 'Bloomsbury and Beyond', in Claire Barlow (ed.), *Queer British Art 1861–1967* (London: Tate Publishing, 2017), p. 103.

10. Taylor, *Edward Wolfe*, p. 62. For information about Nelson, see Gemma Romain, *Race, Sexuality and Identity in Britain and Jamaica: The biography of Patrick Nelson, 1916–1963* (London: Bloomsbury Academic, 2017).

11. Linda C. Dowling, *Hellenism and Homosexuality in Victorian Oxford* (Ithaca: Cornell University Press, 1994); Matt Cook, *London and the Culture of Homosexuality, 1885–1914* (Cambridge: Cambridge University Press, 2003).

12. Norman Douglas, *Birds and Beasts of the Greek Anthology* (London: Chapman and Hall, 1928).

13. Norman Douglas Collection, Beinecke Library, Box 20, Folder 324.

14. Joseph J. Fischel, *Sex and Harm in the Age of Consent* (Minneapolis: University of Minnesota Press, 2016).

15. Norman Douglas, *Looking Back: An autobiographical excursion* (New York: Harcourt, Brace and Company, 1933), p. 205. A copy of *Looking Back* annotated by Douglas's one-time literary executor Willie King gives Barton's true last name as Browne.

13. Four Saints in Three Acts

1. A. Everett Austin, quoted by Eugene R. Gaddis, *Magician of the Modern: Chick Austin and the transformation of the arts in America* (New York: Knopf, 2000), p. 81.

2. The phrase appeared in Stein's book *Geography and Plays* (1922).

3. Anthony Penrose, *The Lives of Lee Miller* (London: Thames and Hudson, 1985), p. 50.

4. Virgil Thomson, *Virgil Thomson* (New York: Da Capo Press, 1966), p. 238.

5. Anthony Tommasini, *Virgil Thomson: Composer on the aisle* (New York: Norton, 1997), p. 265.

14. Donald Friend's Life in Letters

1 Donald Friend Correspondence, Australian Library of Art, State Library of Queensland (SLQ) 28025/3, p. 3.

2. SLQ 28025/6, p. 2; 28025/4, p. 1; 28025/3, p. 1.

3. Service Record: Donald Stuart Leslie Friend, National Archives of Australia, series B883, control NX96987.

4. SLQ 28025/26, p. 1.

5. For further reading on homosex in wartime Brisbane, see Yorick Smaal, *Sex, Soldiers and the South Pacific 1939–45: Queer identities in Australia in the Second World War* (United Kingdom: Palgrave Macmillan, 2015). Donald Friend's *A Brisbane Bedroom* (1944) is in the collection at the Queensland Art Gallery, Brisbane, acc. 2007.218.

6. SLQ 28025/14-16; 28025/24, p. 4.

7. Paul Hetherington (ed.), *The Diaries of Donald Friend*, Vol. 2 (Canberra: National Library of Australia, 2003), pp. 263–66.

8. SLQ 28025/29, pp. 1–2.

9. SLQ 28025/40, p. 2; 28025/44–45; 28025/33.

15. Dear Dawn, Can I Hold You?

1. Andrew Matzner, 'Prince, Virginia Charles,' *GLBTQ: An Encyclopedia of Gay, Lesbian, Bisexual, Transgender, and Queer Culture*: www.glbtq.com/social-sciences/prince_vc.html

2. Magnus Hirschfeld, *Transvestites: The erotic drive to cross-dress* (Buffalo: Prometheus Books, 1991; 1st pub. Berlin, 1910; trans. Michael A. Lombardi-Nash); Harry Benjamin, *The Transsexual Phenomenon* (New York: Julian Press, 1966).

3. Susan Stryker, 'My Words to Victor Frankenstein above the Village of Chamounix: Performing transgender rage,' in Susan Stryker and Stephen Whittle (eds), *The Transgender Studies Reader* (Milton: CRC Press, 2006), pp. 244–57.

4. Susan Stryker '(De)Subjugated Knowledges: An introduction to transgender studies,' in Stryker and Whittle (eds), *The Transgender Studies Reader*, pp. 1–18.

5. Julieta Aranda, *E-Flux Journal: What's love (or care, intimacy, warmth, affection) got to do with it?* (Berlin: Sternberg Press, 2017).

16. A Gay Magazine in Communist Poland

1. *Efebos* is available at www.transnationalhomosexuals.pl/magazines

2. Lukasz Szulc, *Transnational Homosexuals in Communist Poland: Cross-border flows in gay and lesbian magazines* (Cham: Palgrave Macmillan, 2018).

3. Lukasz Szulc, 'Operation Hyacinth and Poland's Pink Files', 2016: http://notchesblog.com/2016/02/02/operation-hyacinth-and-polands-pink-files/

4. Waldemar Zboralski, interview with Wojciech Kowalik, 'Moja Karta Homoseksualisty', *Replika*, July 2013, pp. 12–13.

5. Ibid.

6. *Polityka*, 29 October 1988, p. 2.

7. Lukasz Szulc, 'Was Homosexuality Illegal in Communist Europe?', 2017: http://notchesblog.com/2017/10/24/was-homosexuality-illegal-in-communist-europe/

8. Krzysztof Tomasik, *Gejerel: Mniejszości Seksualne w PRL-u*, Warszawa: Wydawnictwo Krytyki Politycznej, 2012. See also a review of the book in English: Lukasz Szulc, 'Krzysztof Tomasik, Gejerel: Mniejszości Seksualne w PRL-u', *Sexualities*, 18, 8 (2015), pp. 1018–19.

9. Paweł Fijałkowski, interview with Adriana Kapała.

10. Paweł Fijałkowski, 'Wspomnienie o *Efebosie*', 2007, Homiki.pl: http://homiki.pl/index.php/2007/06/wspomnienie-o-efebosie/

11. John M. Bates, 'From State Monopoly to a Free Market of Ideas? Censorship in Poland, 1976–1989', in M. Diaz-Sacke (ed.), *Censorship & Cultural Regulation in the Modern Age* (Amsterdam: Rodopi, 2004), pp. 141–67.

12. Szulc, *Transnational Homosexuals*, p. 144.

13. Krzysztof Tomasik, *Homobiografie. Wydanie Drugie, Poprawione i Poszerzone* (Warszawa: Wydawnictwo Krytyki Politycznej, 2014), p. 82.

14. Szulc, *Transnational Homosexuals*, pp. 158–60.

15. Martial, Book IV, Epigram XLII, in T.K. Hubbard (ed.), *Homosexuality in Greece and Rome: A sourcebook of basic documents* (Berkeley: University of California Press, 2003), p. 424.

16. See Dennis Altman, 'AIDS and the Globalization of Sexuality', *Social Identities*, 14, 2 (2008), pp. 154–60.

17. *Efebos*, 1987, p. 1.

18. *Efebos*, 1987, p. 4.

19. Szulc, *Transnational Homosexuals*, p. 200.

20. Fijałkowski, 'Wspomnienie o *Efebosie*'.

21. Agnès Chetaille, 'Poland: Sovereignty and sexuality in post-Socialist times', in Manon Tremblay, David Paternotte and Carole Johnson (eds), *The Lesbian and Gay Movement and the State: Comparative insights into a transformed relationship* (Farnham: Ashgate, 2011), pp. 119–33.

17. The Cunt Coloring Book

1. Tee A. Corinne, 'Imagining Sex into Reality', *Courting Pleasure* (Austin: Banned Books, 1994), p. 119.

2. Tee A. Corinne, 'Imagining Sex', p. 120.

3. Tee A. Corinne, 'On Censorship', unpublished MS, 1992, p. 1.

4. Corinne, 'Imagining Sex', p. 122.

5. Corinne, 'Imagining Sex', p. 122.

6. Corinne, 'On Censorship', p. 1.

7. Corinne, 'On Censorship', p. 1.

8. Corinne, 'On Censorship', p. 2.

9. Corinne, 'On Censorship', p. 2. The original title returned when Last Gasp Press of San Francisco became the publisher of an expanded, multilingual edition and it sold briskly.

10. See Laura U. Marks, 'Video Haptics and Erotics', *Screen 39*, 4 (Winter 1998), pp. 331–48.

18. Henry's Albums

1. See www.facebook.com/FaulknerMorganArchive/. I have benefited greatly from email conversations with one of the archives' founders, Jonathan Coleman.

2. Barry Reay, *New York Hustlers: Masculinity and sex in modern America* (Manchester: Manchester University Press, 2010), Index: Faulkner, Henry.

3. Daphne Phelps, *A House in Sicily* (New York: Carroll & Graf, 1999), pp. 213–48.

4. Kinsey Institute (KI), University of Indiana, Bloomington, The Thomas Painter Collection (Painter), Box 1, Series 2, C. 1, Vol. 7: Painter Letters: 26 March 1950.

5. Box 1, Series 2, C. 1, Vol. 6: Painter Letters: 13 November 1949.

6. Jonathan Coleman to Barry Reay, email, November 2017.

7. Dotson Rader, *Tennessee: Cry of the heart* (New York: Doubleday, 1985), pp. 235–36.

8. Quoted in Charles House, *The Outrageous Life of Henry Faulkner* (Sarasota, FL: Pub This Press, 2005), p. 217.

19. Sammy's Stud File

1. Justin Spring, *Secret Historian: The life and times of Samuel Steward, professor, tattoo artist, and sexual renegade* (New York: Farrar, Straus and Giroux, 2010).

2. Jennifer Burns Bright, 'Queerest of the Queer: Why Samuel Steward's masochism matters', in Debra A. Moddelmog and Martin Joseph Ponce (eds), *Samuel Steward and the Pursuit of the Erotic* (Columbus, OH: Ohio State University Press, 2017), ch. 7 (p. 144).

3. See Justin Spring, *An Obscene Diary: The visual world of Sam Steward* (North Pomfret, VT: Antinous Press and Elysium Press, 2010).

4. Spring, *Secret Historian*, 'Afterword: The Steward Papers', pp. 407–14.

5. Samuel M. Steward, *Chapters from an Autobiography* (San Francisco: Grey Fox Press, 1981), p. 96.

6. Spring, *Secret Historian*, p. 203.

7. Ibid., p. 380.

8. KI, Samuel Steward Collection, Series 2, F, S.S. 1955 Diary, 18 January 1955.

9. Justin Spring has told me that the image, about 23 x 30 centimetres, would have hung in Steward's shop: email, November 2017.

10. There are examples in Spring, *Obscene Diary*.

11. Barry Reay, 'Autoarchivism: Alfred Kinsey's informants', in Barry Reay, *Sex in the Archives: Writing American sexual histories* (Manchester: Manchester University Press, 2018), ch. 3.

12. Yale University Library, Beinecke Rare Book and Manuscript Library, General Collection of Modern Books and Manuscripts, GEN MSS 987: Samuel Steward Papers, Box 25, The Stud File.

13. KI, Samuel Steward Collection, Series 2, F, S.S. 1955 Diary, 16 January 1955.

14. KI, Samuel Steward Collection, Series 2, D, S.S. 1953–4 Diary, 23 October 1953. Also quoted, in part, in Spring, *Secret Historian*, pp. 207–08.

15. Jeremy Mulderig (ed.), *Philip Sparrow Tells All: Lost essays by Samuel Steward, writer, professor, tattoo artist* (Chicago: University of Chicago Press, 2015), p. 186.

16. Tim Dean, 'Sam Steward's Pornography: Archive, index, trace', in Moddelmog and Ponce (eds), *Samuel Steward and the Pursuit of the Erotic*, ch. 2 (pp. 27, 43).

20. The Proverbial Lavender Dildo

1. 'Celebrate Sex!' ad, *On Our Backs* (November/ December 1991). For help with aspects of this essay I thank Jack Lamon, Jill Posener, Hazel Meyer and Quinn Miller, and especially Grace Glasson, for astute and creative research collaboration and support.

2. Fatale Media, 1990. Fatale Media is especially famous now for the 1998 instructional video, *Bend Over Boyfriend*.

3. Lynn Comella, *Vibrator Nation: How feminist sex toy stores changed the business of pleasure* (Durham: Duke University Press, 2017), pp. 36–37, 54–56; Hallie Lieberman, *Buzz: The stimulating history of the sex toy* (New York: Pegasus Books, 2017), p. 234.

4. Hallie Lieberman, 'If You Mold It, They Will Come: How Gosnell Duncan's devices changed the feminist sex-toy game forever,' bitchmedia, 26 May 2015: www. bitchmedia.org/article/if-you-mold-it-they-will-come-dildo-history-feminist-sex-toy-stores

5. Lieberman, Buzz, pp. 233–36.

6. Doc Johnson Mr. Softee Pastels Dong, 8', Lavender product page, (1999–2018): www.dearlady.us/ Doc-Johnson-Mr-Softee-Pastels-Dong-Lavender/ p/0255012N/?vp=3

7. Come As You Are Co-operative (1997-2018): http:// www.comeasyouare.com/

8. Email to the author, 25 April 2017.

9. Nomia (2007): http://www.nomiaboutique.com/ home.html; In-store conversation with employee, 30 March 2018.

10. Heather Findlay, 'Freud's Fetishism and the Lesbian Dildo Debates,' in Corey K. Creekmur and Alexander Doty (eds), *Out in Culture: Gay, lesbian, and queer essays on poplar culture* (Durham: Duke University Press, 1995), p. 328.

11. Susie Bright and Jill Posener (eds), *Nothing But the Girl: The blatant lesbian image, a portfolio and exploration of lesbian erotic photography* (New York: Freedom Editions, 1996).

12. Phone conversation with author, 30 March 2018.

13. Email to the author, 25 April 2017.

14. Susie Bright, 'Great Balls from China and Other Tall Toys', *On Our Backs*, (March/April 89) p. 6.

15. Alycee J. Lane, 'What's Race Got to Do with It?,' *Black Lace*, (Summer 1991), p. 21.

16. Kai M. Green, 'Troubling Waters: Mobilizing a trans* analytic,' in E. Patrick Johnson (ed.), *No Tea, No Shade: New writings in black queer studies* (Durham: Duke University Press, 2016), pp. 72–73.

17. Come as You Are Co-operative, 'About Us' (1997–2018): www.comeasyouare.com/about-us/

18. *Salacious*. One of five rotating images on the home page.

21. Amos's Chair

1. Amos Badertscher, *Baltimore Portraits* (Durham: NC: Duke University Press, 1999). The Badertscher archive is divided between his residence in Baltimore (BB) and the Leslie–Lohman Museum of Gay and Lesbian Art in New York, where the whole collection will eventually reside. Unless indicated otherwise, the figures in this chapter are all high-quality digital images of the original photographs (usually 20 x 25 centimetres) from Badertscher's personal archives, and appear with his permission.

2. For a more detailed analysis of Badertscher's work, see Branka Bogdan and Barry Reay, 'Queer Baltimore: The photography of Amos Badertscher', in Barry Reay, *Sex in the Archives: Writing American sexual histories* (Manchester: Manchester University Press, 2018), ch. 9.

3. The direct quotes from Amos about his chairs come from a series of emails in April and May 2017. Any observations come from conversations between the author and Amos Badertscher in Baltimore in late June and early July 2015 and again in June 2016.

4. Craig Seymour, 'A Conversation with Amos Badertscher', *The Archive: The Journal of the Leslie/ Lohman Gay Art Foundation*, 38 (2011), pp. 4–7 (p. 5).

5. See, especially, José Esteban Muñoz, 'Rough Boy Trade: Queer desire/straight identity in the photography of Larry Clark', in Deborah Bright (ed.), *The Passionate*

Camera: Photography and bodies of desire (New York: Routledge, 1998), pp. 167–77.

6. Amos Badertscher, 'Fred B. Merry, 1997', unpublished writing for a photograph, 2017, BB.

7. Badertscher, 'Fred B. Merry'.

22. Cruising Masculine Spaces

1. Ross Moore, 'Neil Emmerson's *habit@t*: The garden as mode of post-modern intercourse', *Imprint*, 37 (2002), p. 3.

2. Robert Schubert, *Neil Emmerson: 3 works, (surrender, penance, IWYS)*, Catalogue (Sydney: Art Gallery of New South Wales, Contemporary Projects, 2000).

3. *Independent*, 9 April 1998; BBC News, 9 April 1998; *Los Angeles Times*, 9 April 1998.

4. D.A. Miller, 'Secret Subjects, Open Secrets', *The Novel and the Police* (Berkeley: University of California, 1988), p. 207.

5. Neil Emmerson in conversation with the author, 23 February 2013.

6. George Chauncey, *Gay New York* (New York: Basic, 1994), pp. 50–57.

7. Geoffrey Blodgett, 'Frederick Law Olmsted: Landscape architecture as conservative reform', *Journal of American History*, 16 (1976), pp. 881–82.

8. Roy Rosenzweig, 'Middle-Class Parks and Working-Class Play: The struggle over recreational space in Worcester, Massachusetts, 1870–1910', *Radical History Review*, 21 (1979), pp. 33–36.

9. John Howard, 'The Library, the Park, and the Pervert: Public space and homosexual encounter in post-World War II Atlanta', *Radical History Review*, 62 (1995), pp. 173–77.

10. Chauncey, *Gay New York*, pp. 179–204; George Chauncey, 'Privacy Could Only be Had in Public: Gay uses of the streets', in Joel Sanders (ed.), *Stud: Architecture of masculinity* (New York: Princeton Architectural Press, 1996), pp. 224–67.

11. Ken Inglis, *Sacred Places: War memorials in the Australian landscape* (Melbourne: Miegunyah Press, 1999), pp. 435–44; 458–83.

12. Andrew Stephenson, 'Palimpsetic Promenades: Memorial environments and the urban consumption of space in post-1919 London', *Australia and New Zealand Journal of Art* 6 (2005), pp. 48, 52–57.

23. The Stuff of Cruising

1. Portions of this series have been exhibited in Fuerteventura, Spain, in London and Reading, and in San Francisco.

2. See Rosa-Maria Medina-Domenech and Richard Cleminson, 'Consumerism, Gender Diversity and Moralization of Sexuality in the Iberian 1960s', in Kostis Kornetis, Eirini Kotsovili and Nikolaos Papadogiannis (eds), *Consumption and Gender in Southern Europe since the Long 1960s* (London: Bloomsbury, 2016), pp. 59–84 (p. 60).

3. See, for instance, George Chauncey, '"Privacy Can Only be Had in Public": Gay uses of the streets', in Joel Sanders (ed.), *Stud: Architectures of masculinity* (New York: Princeton Architectural Press, 1999) pp. 224–67.

4. Ann Cvetkovich, *An Archive of Feelings: Trauma, sexuality, and lesbian public cultures* (Durham: Duke University Press, 2003).

5. Alvin Baltrop, *The Piers* (Madrid: TF Editores, 2015); Fiona Anderson, 'Cruising the Queer Ruins of New York's Abandoned Waterfront', *Performance Research*, 20, 3 (2015), pp. 135–44.

6. Mark W. Turner, *Backward Glances: Cruising the queer streets of New York and London* (London: Reaktion, 2003), p. 35.

7. Many I've consulted insist this graffito is a campy queer-authored claiming of space. Many others accept my suggestion that ATR is the signature of the Association of Television-watchers and Radio-listeners, a right-wing 'accuracy'-in-media/neighbourhood-watch group. So instead of colloquially referencing eternity, 'until the grave' invokes AIDS and constitutes a homophobic hate crime.

8. John Howard, *White Sepulchres: Palomares disaster semicentennial publication* (Valencia: University of Valencia Press, 2016), pp. 91, 118.

9. Richard Hornsey, 'After the Bathhouse; or, In Praise of Awkwardness', *English Language Notes*, 45, 2 (2007), pp. 49–62 (p. 56).

10. See for example Trinh T. Minh-ha, 'Documentary Is/Not a Name', *October*, 52 (1990), pp. 76–98, and also Douglas Crimp, 'Randy Shilts' Miserable Failure', in Martin Duberman (ed.), *A Queer World: The center for lesbian and gay studies reader* (New York: New York University Press, 1997), pp. 641–48.

24. The Warren Cup
1. Dyfri Williams, *The Warren Cup* (London: British Museum Press, 2006), p. 36.

2. Williams, *Warren Cup*, pp. 7, 13.

3. John Pollini, 'The Warren Cup: Homoerotic love and symposial rhetoric in silver', *The Art Bulletin*, 8, 1 (1999), pp. 21–52 (p. 33).

4. John Clarke, 'The Warren Cup and the Contexts for Representations of Male-to-Male Lovemaking in Augustan and Early Julio-Claudian Art', *The Art Bulletin*, 75, 2 (1993), pp. 275–94 (p. 284).

5. Williams, *Warren Cup*, p. 12.

6. Williams, *Warren Cup*, p. 51.

7. Williams, *Warren Cup*, p. 54; Pollini, 'Warren Cup', p. 27.

8. Williams, *Warren Cup*, p. 17.

9. John Potvin, *Bachelors of a Different Sort: Queer aesthetics, material culture and the modern interior in Britain* (Manchester: Manchester University Press, 2014), p. 140.

10. Rodger Streitmatter, *Outlaw Marriages: The hidden histories of fifteen extraordinary same-sex couples* (Boston: Beacon Press, 2002).

11. Williams, *Warren Cup*, p. 26.

12. Streitmatter, *Outlaw Marriages*, p. 30.

13. Robert Aldrich, *The Seduction of the Mediterranean: Writing, art and homosexual fantasy* (London: Routledge, 1993).

14. Streitmatter, *Outlaw Marriages*, p. 138.

15. Williams, *Warren Cup*, p. 62.

25. Monuments
1. The monument became widely known through the publication of Alan Bray, *The Friend* (Chicago: Chicago University Press, 2006). For other examples of same-sex monuments see https://historicengland.org.uk/research/inclusive-heritage/lgbtq-heritage-project/love-and-intimacy/graves-and-monuments/

2. For an account of their lives and deaths and Finch's will, see Archibald Malloch, *Finch and Baines: A seventeenth-century friendship* (Cambridge: Cambridge University Press, 1917).

3. The English translation is as provided in Jean Wilson, '"Two names of friendship, but one Starre": Memorials to single-sex couples in the early modern period', *Church Monuments* X (1995), pp. 70–83 (pp. 82–83).

4. The epitaphs are still visible on the monument today, and are recorded by Henry Keepe, *Monumenta Westmonasteriensia* (London: printed for C. Wilkinson and T. Dring, 1683), pp. 201–02.

26. Robert Gant's Shoes
1. Charles Knight, Diary, 2 February 1892, 90-362, Alexander Turnbull Library.

2. Valerie Steele, *Fetish: Fashion, sex and power* (New York: Oxford University Press, 1996), p. 5.

3. Richard von Krafft-Ebing, *Psychopathia Sexualis*, 7th edn (Philadelphia: F.A. Davis, 1892), pp. 176–77.

4. Krafft-Ebing, *Psychopathia Sexualis*, p. 179.

5. Steele, *Fetish*, pp. 11, 14.

6. For sustained discussions of Robert Gant's life and photographs see Chris Brickell, *Manly Affections: The photographs of Robert Gant, 1885–1915* (Dunedin: Genre, 2012); Chris Brickell, 'Visualizing Homoeroticism: The photographs of Robert Gant, 1887–1892', *Visual Anthropology*, 23, 2 (2010), pp. 136–57.

7. Robert Gant, 'At the End of a Holiday', *Sharland's Trade Journal*, 7 July 1894, pp. 58–61.

8. H.G. Cocks, *Nameless Offences: Homosexual desire in the nineteenth century* (London: IB Taurus, 2010), p. 187.

9. Cocks, *Nameless Offences*, p. 166.

28. Saint Sebastian
1. Charles Darwent, 'Arrows of Desire: How did St Sebastian become an enduring, homo-erotic icon?', *Independent*, 10 February 2008: www.independent.co.uk/arts-entertainment/art/features/arrows-of-desire-how-did-st-sebastian-become-an-enduring-homo-erotic-icon-779388.html

2. Richard A. Kaye, 'Losing His Religion: Saint Sebastian as contemporary gay martyr', in Peter Horne and Reina Lewis (eds), *Outlooks: Lesbian and gay sexualities and visual cultures* (London: Routledge, 1996), pp. 86–108 (p. 91); Christopher Reed, *Art and Homosexuality: A history of ideas* (Oxford: Oxford University Press, 2011), p. 100.

3. Kaye, 'Losing His Religion', p. 93.

4. Jonathan Weinberg, *Male Desire: The homoerotic in American art* (New York: Abrams, 2004), p. 26.

5. James Saslow, *Pictures and Passions: A history of homosexuality in the visual arts* (New York: Viking, 1999), p. 99.

6. Kaye, 'Losing His Religion', p. 98.

30. The Paintings of Lois White
1. Nicola Green, *By the Waters of Babylon: The art of A. Lois White* (Auckland: Auckland City Art Gallery), 1993, p. 25.

2. Green, *Waters of Babylon*, p. 25; 'Art Exhibition', *New Zealand Herald*, 27 April 1933, p. 12.

3. Roger Blackley, catalogue entry in Robyn Notman and Linda Cullen (eds), *Beloved: Works from the Dunedin Public Art Gallery* (Dunedin: Dunedin Public Art Gallery, 2009), p. 172.

4. Caroline Jordan, 'Designing Women: Modernism and its representation in *Art in Australia*', in Jeanette Hoorn (ed.), *Strange Women: Essays in art and gender* (Carlton: Melbourne University Press, 1994), pp. 28–37.

5. Green, *Waters of Babylon*, p. 53.

6. 'A Conversation with Lois White', *Art in New Zealand*, 18 (1981), p. 41; Jonathan Weinberg, *Speaking for Vice: Homosexuality in the art of Charles Demuth, Marsden Hartley, and the first American avant-garde* (New Haven: Yale University Press, 1993), pp. 32–40.

7. Hilary Lapsley, 'Outing Auntie Cal: War stories, hidden histories, and family conversations', *Women's Studies Journal*, 30 (July 2016), p. 13.

8. Alison Oram, 'Repressed and Thwarted, or the Bearer of the New World: The spinster in inter-war feminist discourses', *Women's History Review*, 1 (1992), pp. 413–33.

9. Cited in Oram, 'Repressed and Thwarted', p. 420; M.

Esther Harding, *The Way of All Women: A psychological interpretation* (London: Longman, 1933), p. 87.

10. Green, *Waters of Babylon*, p. 18.

11. Jo Aitken, 'Wives and Mothers First: The New Zealand teachers' marriage bar and the ideology of domesticity, 1920–1940', *Women's Studies Journal*, 12 (1996), p. 83; Barbara Brookes, *A History of New Zealand Women* (Bridget Williams, Wellington, 2016), p. 247; Green, *Waters of Babylon*, p. 27.

31. The L Word Quilt
1. See, for instance, Matt Cook, *Queer Domesticities: Homosexuality and home life in twentieth-century London* (Houndmills: Palgrave, 2014).

2. Diane Johns, 'An open letter to the DCQG Board and members from Diane Johns (Oct. 2, 2004)'. Diane Johns' personal collection. Unless otherwise specified, all documents cited here are part of this.

3. Shelly Roberts, *Roberts' Rules of Lesbian Living* (Duluth, MN: Spinsters Ink, 1996), p. 63.

4. Johns, 'An open letter'.

5. Johns, 'An open letter'; Nancy Baker to Diane Johns, 2 October 2004.

6. Email from Diane Johns to NIU-LGBT on 1 October 2004. Subject: 'Quilt Censorship in DeKalb County'.

7. Email from Diane Johns to lgbtquilters. 6 October 2004; email from Diane Johns to Susan, 6 October 2004; letter to DCQG Members from Board of Directors, 5 October 2004; email from Frank to Diane Johns, 8 October 2004; 'An Open Letter to DCQG from Diane Johns', 8 October 2004.

8. Nina Gougis, 'Lesbian starts own event after her work was banned from first', *Northern Star*, 8 October 2004; Chris Rickert, 'Quilt with gay theme banned from show', *DeKalb Daily Chronicle*, 8 October 2004; Andrew Davis, *Windy City Times*, 13 October 2004: www.windycitymediagroup.com/lgbt/DeKalb-Quilt-Controversy/6345.html; Andrew Davis, *Windy City Times*, 27 October 2004: www.windycitymediagroup.com/lgbt/Alternate-Quilt-Show-a-Success/6492.html; 'Quilt controversy offers a chance for understanding', *DeKalb Daily Chronicle*, 17 October 2004.

9. Jake Finch, 'Shocking quilts', *Quilter's Home*, March 2009, Michigan State University: http://museum.msu.edu/museum/tes/quiltshumanrights/QHR1.htm

32. The Queen of Polka Holes
1. Jo Applin, *Yayoi Kusama: Infinity mirror room – Phalli's Field* (London: Afterall Books, 2012), p. 8.

2. Applin, *Yayoi Kusama*, p. 30.

3. Luce Irigaray, *This Sex Which Is Not One*, trans. Carolyn Burke (Ithaca: Cornell University Press, 1985).

4. Judith Butler, *The Psychic Life of Power: Theories in subjection* (Stanford: Stanford University Press, 1997).

5. Sara Ahmed, *Queer Phenomenology: Orientations, objects, others* (Durham: Duke University Press, 2006).

6. William Leith, 'Say "NO" and change your life', *Guardian*, March 2018: www.theguardian.com/global/2018/mar/18/the-power-of-saying-no-change-your-life-psychology-william-leith

7. Yayoi Kusama, *Mizutama no Rirekisho* (Tokyo: Shueisha, 2013), p. 25.

33. Queer Dogs
1. Most of the criticism focuses on gender and sexual politics in Radclyffe Hall's novel *The Well of Loneliness* (1928). See, for example, Esther Newton's ground-breaking article, 'The Mythic Mannish Lesbian: Radclyffe Hall and the new woman', *Signs*, 9, 2 (1984), pp. 557–75; Jack Halberstam, *Female Masculinity* (Durham: Duke University Press, 1998); Jay Prosser, *Second Skins:*

The body narratives of transsexuality (New York: Columbia University Press, 1998); and the more recent article by Katherine A. Costello, 'A No-Man's-Land of Sex: Reading Stephen Gordon and "her" critics', *Journal of Lesbian Studies*, 22, 1 (2018), pp. 165–84.

2. See, for instance, Richard Dellamora's discussion of Hall's 'masculine style' in *Radclyffe Hall: A life in the writing* (Philadelphia: University of Pennsylvania Press, 2011), p. 86.

3. Newton, 'The Mythic Mannish Lesbian', pp. 557–75.

4. Laura Doan, *Fashioning Sapphism: The origins of a modern lesbian culture* (New York: Columbia University Press, 2001), pp. 107, 190.

5. Doan argues that, contrary to prevalent critical assumptions, in the 1920s Hall and Troubridge were not part of the famous Parisian lesbian subculture of the time. Doan, *Fashioning Sapphism*, p. 98.

6. Una Troubridge, *The Life and Death of Radclyffe Hall* (London: Hammond and Hammond, 1961), p. 49

7. Carlo F. Clarke, 'Ladies Kennel Association Notes', *The Tatler*, 30 May 1923, p. 54.

8. When the Kennel Club took over Crufts in 1939, the Ladies Kennel Association hosted the event and continues to do so to this day.

9. Troubridge, *The Life and Death of Radclyffe Hall*, p. 50.

10. Carlo F. Clarke, 'Ladies Kennel Association Notes', *The Tatler*, 21 January 1923, p. 68.

11. A picture of the Clarkes at the Sussex County Club Coursing in Ford and Clymping was published in *The Illustrated Sporting and Dramatic News*, 25 December 1909, p. 725.

12. Clarke, 'Ladies Kennel Association Notes', 21 January 1923, p. 68.

13. Troubridge, *The Life and Death of Radclyffe Hall*, p. 64.

14. Troubridge, *The Life and Death of Radclyffe Hall*, p. 50.

34. Our Own Dear House

1. Heritage Council of Victoria, Victorian Heritage Database Report, 14 April 2016: www.Vhd.heritagecouncil.vic.gov.au/places/342/download-report

2. See Bev Roberts, 'Miss Newcomb's Teapot', in *The LaTrobe Journal*, 87 (2011), pp. 74–85; P.L. Brown and Jean I. Martin, 'Newcomb, Caroline Elizabeth (1812–1874)', Australian Dictionary of Biography, National Centre of Biography, Australian National University: http://adb.anu.edu.au/biography/newcomb-caroline-elizabeth-2238/text2441

3. Cited by Philip Brown, *Clyde Company Papers*, Vol. 3 (London: Oxford University Press, 1958), p. 634.

4. Anne Drysdale, Diary, 13 August 1841. All quotations from Anne Drysdale's diary are taken from the edited version, Bev Roberts (ed.), *Miss D & Miss N: An extraordinary relationship* (Melbourne: Australian Scholarly Publishing, 2009).

5. Rev J.D. Dodgson, 'Mrs Dodgson', *The Wesleyan Chronicle*, Melbourne, January, March, April 1875.

6. Quotations from Caroline Newcomb's diary from Dodgson, 'Mrs Dodgson'.

7. *Geelong Advertiser*, 8 October 1874.

8. Dodgson, 'Mrs Dodgson'.

9. Dinah Mulock Craik, *A Woman's Thoughts About Women* (London: Hurst & Blackett, 1858).

10. Claire Hayward, 'Queer Objects of Affection': https://emotionalobjects.wordpress.com/2014/07/16/queer-objects-of-affection/

35. An Attic Apartment

1. Matt Cook and Andrew Gorman-Murray, 'Introduction', in Andrew Gorman-Murray and Matt Cook (eds) *Queering the Interior* (London: Bloomsbury, 2017), p. 4.

2. David Wildey to Tom Robinson, 22 July 1993, MS-3570/010, Hocken Collections (HC). For a more detailed account of these groups and social networks see Chris Brickell, *Southern Men: Gay lives in pictures* (Dunedin: Genre Books, 2013).

3. Annotation from 1993 on transcript of diary entry from 8 January 1944, MS-3549/015, HC.

4. Geoffrey Ward to David Wildey, 5 July 1956, MS-3549/036, HC.

5. Frank Ross to David Wildey, 18 March 1971, MS-3549/037, HC.

6. Notebook in author's collection.

7. Geoffrey Ward to David Wildey, 26 September 1954, MS-3549/036, HC.

8. E.J. McLaughlin to David Wildey, 10 August 1959, MS-3549/019, HC.

9. Tony Simpson, 'Looks Like It's Open Season on Queers', in Alison Laurie and Linda Evans (eds), *Twenty Years On: Histories of homosexual law reform in New Zealand* (Wellington: LAGANZ, 2009).

10. David Wildey, Transcript of diary, MS-2549/010, HC.

36. The Rotary Dial Telephone

1. Rex Batten, *Rid England of this Plague* (London: Paradise, 2006).

2. Matt Houlbrook, *Queer London: Perils and pleasures in the sexual metropolis, 1918–1957* (Chicago: University of Chicago Press, 2005); Matt Cook, 'Warm Homes in a Cold Climate', in Matt Cook and Heike Bauer (eds), *Queer 1950s: Rethinking sexuality in the postwar years* (New York: Palgrave Macmillan, 2012), pp. 115–32.

3. Rex Batten, interview with Matt Cook as part of his Queer Domesticities project, May 2014; see also Michael, interview with Justin Bengry as part of 'Queer Beyond London', November 2017.

4. Ajamu X, interview with Matt Cook as part of 'Queer Beyond London', June 2017.

5. Interviews from the Leeds 'Now and Then' project, West Yorkshire Archive Service (WYAS), February 2008.

6. Julie Bindel, interview for the Leeds 'Now and Then' project, WYAS, February 2008.

7. Contributors to 'Queer Beyond London' Leeds' witness seminar, May 2017.

8. 'Help for the Troubled Thousands', *Manchester Evening News*, 28 June 1988.

9. Prudence, interview for 'Before Stonewall' project, British Library Sound Archive, August 2003.

10. Ted Donovan, interview for the Leeds 'Now Then' project, WYAS, February 2008.

11. Derek Jarman, *Smiling in Slow Motion* (London: Century, 2000).

12. Derek Jarman, *Modern Nature: The journals of Derek Jarman* (London: Century, 1991).

37. C734

1. Michael Warner, 'Normal and Normaller: Beyond gay marriage', *GLQ*, 5, 2 (1999), pp. 119–71 (p. 122).

2. James O'Higgins and Michel Foucault, 'Sexual Choice, Sexual Act: An interview with Michel Foucault', *Salmagundi*, 58/59 (Fall 1982–Winter 1983), pp. 10–24 (p. 19).

3. Heather Love, *Feeling Backward* (Cambridge:

Harvard University Press, 2009), p. 51.

4. Laura Kipnis, *Against Love: A polemic* (New York: Pantheon, 2003), p. 50.

5. Fernanda Santos, 'Eloping to Vegas? Why not Lower Manhattan', *New York Times*, 7 January 2009: www.nytimes.com/2009/01/08/nyregion/08marriage.html

6. Iris Marion Young, 'The Ideal of Community and the Politics of Difference', in Linda J. Nicholson (ed.), *Feminism/Postmodernism* (New York: Routledge, 1990), pp. 300–23.

38. Saint Eugenia's Relics

1. Brief notices include A. Bouillet, 'l'art religieux à l'exposition rétrospective du Petit-Palais en 1900', *Bulletin Monumental*, 65 (1901), pp. 138–66 (pp. 157–58); *Les Trésors des Églises de France*, catalogue of exhibition at Musée des Arts Décoratifs, Paris, 2nd edn (Paris: Caisse nationale des monuments historiques, 1965), p. 427.

2. My summary draws especially on E. Gordon Whatley, 'More than a Female Joseph: The sources of the late-fifth-century *Passio Sanctae Eugeniae*', in Stuart McWilliams (ed.), *Saints and Scholars: New perspectives on Anglo-Saxon literature and culture in honour of Hugh Magennis* (Cambridge: D.S. Brewer, 2012), pp. 87–111 (pp. 109–11); and Émile Boisseau, *Varzy (Nièvre): Son histoire, ses monuments, ses célébrités* (Paris: Société anonyme de l'imprimerie Kugelmann, 1905), pp. 86–127.

3. Quoted in Whatley, 'Female Joseph', p. 107.

4. Campbell Bonner, 'The Trial of Saint Eugenia', *The American Journal of Philology*, 41, 3 (1920), pp. 253–64 (p. 256).

5. For a more detailed analysis of these and other depictions, including manuscript illuminations, see Robert Mills, 'Visibly Trans? Picturing Saint Eugenia in medieval art', *TSQ: Transgender Studies Quarterly*, 5, 4 (2018), pp. 540–64.

6. M. Anfray, *Architecture Religieuse du Nivernais au Moyen Age: Les Églises Romanes* (Paris: Picard, 1951), pp. 112–22; Réné Lussier and Jacques Palet, 'La Collégiale Sainte-Eugénie de Varzy', *Bulletin de la Société Nivernaise des Lettres Sciences et Arts*, 27 (1934), pp. 547–66.

7. Because of the work's similarities to another panel now in New York representing the powerful Dinteville brothers, the triptych's painter has been identified as the Master of the Dinteville Allegory. For an overview of the debates, see Frédéric Elsig, 'Les Limites de la Notion d'«École»: Remarques sur la peinture à Troyes au XVI^e Siècle', in Leila El-Wakil, Stéphanie Pallini and Lada Umstätter-Mannedova (eds), *Études Transversal: Mélanges en l'honneur de Pierre Vaisse* (Lyon: Presses Universitaire de Lyon, 2005), pp. 41–46.

8. The panel is reproduced in its unrestored state, showing the bowdlerisation, as plate 2 in Mary F.S. Hervey and Robert Martin-Holland, 'A Forgotten French Painter: Félix Chrétien', *Burlington Magazine*, 19, 97 (1911), pp. 48–49; 52–55. See also Boisseau, *Varzy*, p. 84.

9. Scholarship on this point is legion, but the classic argument for seeing the wound in Christ's side as feminised or breastlike is Caroline Walker Bynum, 'The Body of Christ in the Later Middle Ages: A reply to Leo Steinberg', in *Fragmentation and Redemption: Essays on gender and the human body in medieval religion* (New York: Zone, 1992), pp. 79–117.

10. Recent analyses include Kirk Ambrose, *The Nave Sculpture of Vézelay: The art of monastic viewing* (Toronto: Pontifical Institute of Mediaeval Studies, 2006), pp. 39–44; and Robert Mills, *Seeing Sodomy in the Middle Ages* (Chicago: University of Chicago Press, 2015), pp. 200–08.

11. Jacobus de Voragine, *The Golden Legend: Readings on the saints*, trans. by William Granger Ryan (Princeton, NJ: Princeton University Press, 2012), pp. 101–04 (Agnes), pp. 154–57 (Agatha), pp. 551–53 (Eugenia) and pp. 704–09 (Cecilia).

12. Jules Dumoutet, *Monographie des Monuments de la Collégiale de Varzy (Nièvre) Consacrée à Sainte-Eugénie: 1ème et 2ème livraisons* (Paris: Lemercier [lithographs]; Firmin-Didot [text], 1859).

13. Cynthia Hahn, *Strange Beauty: Issues in the making and meaning of reliquaries, 400–circa 1204* (University Park, PA: Pennsylvania State University Press, 2012), pp. 38–44.

14. Quoted in Mills, *Seeing Sodomy*, pp. 206–07.

15. For a recent overview of debates and terminology in this fast-developing area, see Paisley Currah and Susan Stryker (eds), *Postposttranssexual: Key concepts for a twenty-first century transgender studies*, inaugural special issue of *TSQ: Transgender Studies Quarterly*, 1, 1–2 (May 2014). I draw especially here on the summary provided in Trystan T. Cotton's essay 'Surgery' at pp. 205–07.

39. A Tram Ticket, an Egyptian and an Englishman

1. Robert Aldrich, *The Seduction of the Mediterranean: Writing, art and homosexual fantasy* (London: Routledge, 1993), *Colonialism and Homosexuality* (London: Routledge, 2003), and *Cultural Encounters and Homoeroticism in Sri Lanka: Sex and serendipity* (London: Routledge, 2014). On homoeroticism in the Arabic and Islamic world, see most recently Joseph Allen Boone, *The Homoerotics of Orientalism* (New York: Columbia University Press, 2014).

2. Forster's letters to Carpenter and to other acquaintances about his time in Egypt, including Goldsworthy Lowes Dickinson and Florence Barger, have been published in Mary Lago and P.N. Furbank (eds), *Selected Letters of E.M. Forster* (London: Collins, 1983). For more on Forster, see Wendy Moffat, *E.M. Forster: A new life* (London: Bloomsbury, 2010).

3. Forster to Carpenter, 27 March 1917.

4. Forster to Carpenter, late October 1917.

5. Forster's Mohammed notebook, Forster Papers, Modern Archive Centre, King's College, Cambridge University, xi/10.1–Vo 3/1. The tram ticket can be found in xi/10.2 Mohammed el Adl [Scraps], in the same set of papers.

6. Forster met and fell in love with the Indian (Sir) Syed Ross Masood (1889–1937) when the latter was a student at Cambridge. Although Masood, who was heterosexual, could not respond to Forster's physical desires, they became close lifelong friends, and Forster wrote to a sympathetic Masood about his relationship with Mohammed el-Adl.

7. Michael Haag, *Alexandria: City of memory* (New Haven: Yale University Press, 2004).

40. To My Friend from His Friend

1. I am grateful to Alan Smith for sharing this story with me. I would like to thank Gary Jaynes and John Waugh, whose enthusiastic researches into the book, the author and the recipient have been invaluable, and Michael Hurley, whose comments have set me thinking hard about this material. All (mis)judgements are, of course, my own.

2. See also Wayne Murdoch, *Kamp Melbourne in the 1920s and '30s: Trade, queans and inverts* (Newcastle Upon Tyne: Cambridge Scholars, 2017), pp. 33–37, 177.

3. Martin Green, *Children of the Sun: A narrative of 'decadence' in England after 1918* (Wideview Books: 1980 [1976]), p. 6.

4. Groves' report on Paraguay was produced as a letter to a friend in Sydney and was reprinted in 'Where Revolutions Rage', *Mercury* [Hobart], 9 October 1912, p. 3. See also

Arthur R Groves, 'The Man and the Horse: An Argentine sketch', *Boys Own Paper*, 6 July 1912, pp. 632–33.

5. 'A Correction', *Nash's Pall Mall Magazine*, February 1918, p. 424. Marie Hedderwick Browne's *A Spray of Lilac, and Other Poems and Songs* (1892) has been digitised but this volume pre-dates the poem 'Love's Guerdon'.

6. Ruth Ford, 'Speculating on Scrapbooks, Sex and Desire', *Australian Historical Studies*, 106 (1996), pp. 111–26; Graham Willett, 'Making an Exhibition of Ourselves: GLQ public history as public history', *La Trobe Journal*, 87 (May 2011), pp. 4–18.

42. Waiting Till We Meet Again

1. Mareo described Freda as Thelma's bosom friend and the term was widely used in press coverage to describe their close relationship. See: 'Mareo Case', *Evening Post*, 24 March 1936; 'Crown Story', *Auckland Star*, 17 February 1936; 'Wife Murder Charge', *New Zealand Herald*, 18 February 1936.

2. Charles Ferrall and Rebecca Ellis, *The Trials of Eric Mareo* (Wellington: Victoria University Press, 2002).

3. 'Note of Apology', *Auckland Star*, 26 February 1936.

4. Dianne Haworth and Diane Miller, *Freda Stark: Her extraordinary life* (Auckland: HarperCollins, 2000), p. 53.

5. C.D. Abby Collier, 'Tradition, Modernity, and Postmodernity in Symbolism of Death', *Sociological Quarterly*, 44 (Fall 2003) pp. 727–49 (p. 744).

6. 'Miss Thelma Trott a Cultured Singer', *The Mercury* (Hobart), Wednesday 23 October 1929, p. 3; Megan McCarthy, '"We Were at the Beginning of Everything": The first women students and graduates of the University of Queensland', *Crossroads*, 5, 2 (2011), pp. 35–44 (p. 35).

7. 'Entertainments', *New Zealand Herald*, 23 November 1926.

8. Alison Laurie, 'Lady-Husbands and Kamp Ladies: Pre-1970 lesbian life in Aotearoa New Zealand', PhD thesis, Victoria University of Wellington, 2003, p. 300.

9. Paul Gittins, *Epitaph*, Series 1, 'Till We Meet Again', 1997, Director: Juliet Monaghan, TV1, New Zealand.

10. Haworth and Miller, *Freda Stark*, pp. 36; 58–59.

11. Keith Rankin, 'Unemployment in New Zealand at the Peak of the Great Depression', University of Auckland, *Working Papers in Economics* 144 (1995), p. 13.

12. 'Brilliant Opening', *Auckland Star*, 22 September 1934.

13. 'Mareo Trial', *Evening Post*, 26 February 1936.

14. 'Famous K.C.'s View', *Auckland Star*, 18 July 1942; 'The Mareo Case "Steps Being Taken"', *Evening Post*, 21 July 1942; Ferrall and Ellis, *Trials*, pp. 121–25.

15. First Trial Notes of Evidence, cited in Ferrall and Ellis, *Trials*, p. 19.

16. 'Second Mareo Trial', *Auckland Star*, 1 June 1936; 'Detectives Produce Mareo's Statement', *Northern Advocate*, 25 February 1936.

17. Chris Brickell, *Mates and Lovers: A history of gay New Zealand*, (Auckland: Random House, 2008), pp. 73–75, 140–47, 161–64.

18. Haworth and Miller, *Freda Stark*, p. 59; Laurie, 'Lady-Husbands', p. 303.

19. Laurie, 'Lady-Husbands', pp. 304, 307.

20. Laurie, 'Lady-Husbands', p. 306. See also Jill Gardiner, *From the Closet to the Screen: Women of the Gateways Club 1945–85* (London: Pandora Press, 2003).

21. Thomas R. Dunn, 'Queerly Remembered: Tactical and strategic rhetorics for representing the GLBTQ past', PhD thesis, University of Pittsburgh, 2011, p. 243.

22. Dunn, 'Queerly Remembered', p. 243.

23. Peter Wells, cited in Haworth and Miller, *Freda Stark*, p. 145.

43. A Set of Wedding Photos

1. Karen Dunak, *As Long as We Both Shall Love: The white wedding in postwar America* (New York: NYU Press, 2013).

2. Mabel Hampton, interview by Joan Nestle, undated (tape 1), Herstories: Audio Visual Collections of the LHA, Lesbian Herstory Archives, Brooklyn, New York: http://herstories.prattinfoschool.nyc/omeka/document/SPW63

3. Bernard S. Robbins, 'Psychological Implications of the Male Homosexual Marriage', *Psychoanalytic Review*, 30, 4 (1943), pp. 428–37.

4. Testimony of Peggy J. Davis, 25 March 1951, Office of the Provost Marshal, Fort Myer, VA, p. 6, decimal 220.8, box 3778, classified decimal file, 1950–51, Records of the Adjutant General's Office, 1917, Record Group 407, National Archives at College Park, MD.

5. Elise Chenier, 'Love-Politics: Lesbian wedding practices in Canada and the United States from the 1920s to the 1970s', *Journal of the History of Sexuality*, 27, 2 (2018), pp. 294–321.

6. See also David Sonenschein, 'The Ethnography of Male Homosexual Relationships', *The Journal of Sex Research*, 4, 2 (1968), pp. 80–81.

7. To see the full set of photographs, go to: http://digitallibrary.usc.edu/cdm/ref/collection/p15799coll4/id/5904

8. For a detailed history of the wedding cake, including the practice of the cutting of the cake, see Simon R. Charsley, *Wedding Cakes and Cultural History* (New York: Routledge, 1992).

44. Carl Wittman and the AIDS Quilt

1. The NAMES Project Foundation, The AIDS Memorial Quilt: www.aidsquilt.org/about/the-aids-memorial-quilt; National Park Service, LGBTQ Memorials: The Names Project and the AIDS Quilt: www.nps.gov/articles/lgbtq-memorials-aids-quilt.htm

2. Emily Hobson, *Lavender and Red: Liberation and solidarity in the gay and lesbian left* (Oakland: University of California Press, 2016), 25. See also Ian Keith Lekus, 'Queer and Present Dangers: Homosexuality and American antiwar activism during the Vietnam era', PhD thesis, Duke University, 2003, UMI Microform, pp. 313–34.

3. Liz Highleyman, 'Who Was Carl Wittman?' *Seattle Gay News* 34, 18 (2006): www.sgn.org/sgnnews34_18/page30.cfm

4. Mab Segrest, *Memoir of a Race Traitor* (Boston: South End Press, 1999), pp. 42–63; Letter from Allan Troxler to Diane Johns, 1 February 1986, Diane Johns' personal collection. 'Sun Assembly' is still an unpublished manuscript.

45. Exhibit A: The Powder Puff

1. Matt Houlbrook, '"The Man with the Powder Puff" in Interwar London,' *The Historical Journal* 50, 1 (2007), pp. 145–71, (p. 162).

2. Houlbrook, 'Man with the Powder Puff', p. 157.

3. 'Feculent Farrington – Strikes a Snag in a Soldier – Filthy Fellow Fined a Fiver', *Truth* (Melbourne), 8 April 1916, p. 3.

4. 'Queer Queans – Powdered and Painted Perverts – The Potting of a "Pretty Joey" – How Nuss Nussed the Naughty Ninny', *Truth*, 5 January 1929, p. 7.

5. 'The Week Around the City Courts', *Truth*, 5 January 1929, 12; PROV, VA 667 Office of the Victorian Government Solicitor, VPRS 30/P0 Criminal Trial Briefs, Unit 2265 1929/79 R vs Sinclair.

6. 'Powders and Rouges – Police Allegations against Young Man', *Truth*, 13 November 1937, p. 4.

7. 'Assault with Tomahawk Appeal Against Sentence Fails', *Argus*, 2 February 1923, p. 12.

46. Neil McConaghy's Penile Plethysmograph

1. Neil McConaghy, 'Aversion Therapy in the Treatment of Male Homosexuals', in G.L. Mangan and L.D. Bainbridge (eds), *Behaviour Therapy: Proceedings of a symposium held by the Queensland branch of the Australian Psychological Society, 14–15 January 1967* (St Lucia: University of Queensland Press, 1969), p. 45.

2. The figure of 200+ patients was given by McConaghy in a speech in 1973. Sue Wills Private Archive, transcript of proceedings at the Geigy Psychiatric Symposium: 'Liberation Movements and Psychiatry', Prince Henry Hospital, 6–7 August 1973.

3. Anne Deveson, *7 Days* – 'Love is Love: Lesbians', ATN7 Public Affairs, 21:30 Tuesday 15 February 1966.

4. Hans Jurgen Eysenck (ed.), *Behaviour Therapy and the Neuroses: Readings in modern methods of treatment derived from learning theory* (London: Pergamon Press, 1960); Hans Jurgen Eysenck, 'Pavlov or Freud', *Lancet*, 277/7175 (4 March 1961), pp. 492–93.

5. Mat Savelli and Sarah Marks, 'Communist Europe and Transnational Psychiatry', in Mat Savelli and Sarah Marks (eds), *Psychiatry in Communist Europe* (Basingstoke: Palgrave Macmillan, 2015).

6. Kurt Freund, *Homosexualita u Muže* (Prague: Státni Zdravotnické Nakladatelstvi/State Medical Publishers, 1962).

7. Kurt Freund, *Die Homosexualität beim Mann* (Leipzig: S. Hirzel Verlag, 1963; trans. & rev. edn), pp. 236–40.

8. Kurt Freund, 'Diagnostika Homosexuality u Mužu'', *Čekoslovenská Psychiatrie* 53/6 (December 1957), pp. 382–94.

9. Kurt Freund, 'Laboratory Differential Diagnosis of Homo- and Heterosexuality: An experiment with faking', *Review of Czechoslovak Medicine 7* (1961), pp. 20–31.

10. McConaghy, 'Aversion Therapy'.

11. Neil McConaghy, *A Neo-Pavlovian View of Behaviour Therapy*, 3 audio-cassette tapes (Leonia, New Jersey: Sigma Information, 1974), tape 2, side 1.

12. McConaghy, *A Neo-Pavlovian View*; McConaghy, 'Aversion Therapy', p. 45.

13. Neil McConaghy, 'Penile Volume Change to Moving Pictures of Male and Female Nudes in Heterosexual and Homosexual Males', *Behaviour Research and Therapy* 5 (1967), pp. 43–48 (p. 43).

14. McConaghy, 'Penile Volume Change', p. 43.

15. Neil McConaghy Archive, 'Av. Therapy', film reels, c. 1965.

16. McConaghy, 'Aversion Therapy'; McConaghy, *A Neo-Pavlovian View*.

17. Fabian LoSchiavo, interview by Kate Davison, 4 April 2017, Australian Lesbian and Gay Archives.

18. Darlinghurst in downtown Sydney, once regarded as a slum, has historically been associated with bohemian and sexually liberal culture, including the sex industry and the gay movement.

19. LoSchiavo interview.

20. Emma Cooper, *Louis Theroux: A place for paedophiles*, BBC, 19 April 2009.

21. Nathan Ha, 'Detecting and Teaching Desire: Phallometry, Freund, and behaviourist sexology', *Osiris* 30 (2015), pp. 205–27.

47. A Military Discharge Certificate

1. Rebecca Jennings, *Unnamed Desires: A Sydney lesbian history* (Clayton, Victoria: Monash University Publishing, 2015).

2. Ruth Ford, 'Disciplined, Punished and Resisting Bodies: Lesbian women and the Australian Armed Services, 1950s–60s', *Lilith: A feminist history journal*, 9 (1996), p. 60.

3. Noah Riseman, Shirleene Robinson and Graham Willett, *Serving in Silence: Australian LGBT servicemen and women* (Sydney: NewSouth, 2018), p. 53.

4. Riseman, Robinson and Willett, *Serving in Silence*, p. 53.

5. Riseman, Robinson and Willett, *Serving in Silence*, p. 3.

6. Julie Hendy, interviewed by Shirleene Robinson, 16 May 2016.

7. Ruth Ford, 'Lesbians and Loose Women: Female sexuality and the women's services during World War II' in Joy Damousi and Marilyn Lake (eds), *Gender and War: Australians at war in the twentieth century* (Cambridge, New York and Melbourne: Cambridge University Press, 1995), pp. 81–104 and Ford, 'Disciplined, Punished and Resisting Bodies'.

48. The Moral Majority is Neither

1. Campaign Against Repression, 'The Moral Majority is Neither: An information kit on the New Christian Right in the USA prepared for the Australian visit of Jerry Falwell' (Sydney: Campaign Against Repression, 1982).

2. Gay Davidson, 'Protest Earns Benign Smile', *Canberra Times*, 22 May 1982, p. 3.

3. 'Gay Nuns Disrupt Falwell Service', *Sydney Morning Herald*, 22 May 1982.

4. Recorded the next year on 'Hormones of Jeans: The Gay Liberation Quire goes down on vinyl' (EP, 1983). Noel Maloney, '500 in Falwell Protest', *Gay Community News*, June 1982, p. 5.

5. Timothy Willem Jones, interview with Ken Davis, 3 November 2013.

6. Sam Heilner, 'Names and Faces', *Boston Globe*, 21 May 1982, p. 1.

7. Melissa Wilcox, *Queer Nuns: Religion, activism and serious parody* (New York: New York University Press, 2018).

8. Sam Heilner, 'Names and Faces', *Boston Globe,* 21 May 1982, p. 1.

49. Devotional Objects

1. I would like to thank Tim Jones for connecting me with the community of LGBTQ historians in Australia and New Zealand.

2. See Melissa M. Wilcox, *Queer Nuns: Religion, activism, and serious parody* (New York: New York University Press, 2018), p. 70.

3. See, for example, E. Frances King, *Material Religion and Popular Culture* (New York: Routledge, 2010).

4. I am deeply grateful to indefatigable archivist Nick Henderson at the Australian Lesbian and Gay Archives for finding images and newspaper articles related to the Green Park beat.

5. 'Sisters Save the Day! And Some Relics', *The Star* 5, 20 (22 April 1984), p. 2.

6. Sisters of Perpetual Indulgence, Sydney, 'Statement to the Denominational Press and Radio', 7 April 1984, *Oxford Weekender News*, 13–26 April 1984, p. 6.

7. Daniel Welzer-Lang, Jean-Yves Le Talec and Sylvie Tomolillo, *Un mouvement gai dans la lutte contre le SIDA* (Paris: L'Harmattan, 2000), pp. 87–89.

8. Anthony M. Petro, *After the Wrath of God: AIDS, sexuality, and American religion* (New York: Oxford University Press, 2015).

50. Political Buttons

1. Steven F. Kruger, *AIDS Narratives: Gender and sexuality, fiction and science* (New York: Routledge, 2013), p. 187.

2. The buttons and the collection can be viewed on the Elihu Burritt Library website: http://content.library.ccsu.edu/cdm/landingpage/collection/GLBTQ

3. Richard Curland, 'Historically Speaking: Campaign buttons date back to Washington's inauguration', *The (Norwich, Connecticut) Bulletin*, 225, 11 June 2016: www.norwichbulletin.com/news/20160611/historically-speaking-campaign-buttons-date-back-to-washingtons-inauguration; Jude Stewart, 'The Simple, Humble, Surprisingly Sexy Button: A visual history', *Slate*: www.slate.com/news-and-politics/2018/03/students-from-thousands-of-schools-stage-a-walkout-to-protest-gun-violence-and-honor-parkland-victims.html

4. Gore Vidal, *Sexually Speaking: Collected sex writings* (San Francisco: Cleis Press, 1999), p. 269; Larry Kramer, *The American People: Volume I: Search for My Heart: A novel* (New York: Farrar, Straus and Giroux, 2015), p. 48, is explicit. He calls George Washington 'our first gay president'. See also Larry Kramer, 'Was George Washington Gay?' *Harper's Magazine*, February 1993: https://harpers.org/archive/1993/02/was-george-washington-gay/

5. Michael Allen, 'Political Buttons and the Material Culture of American Politics, 1828–1976', *The Pacific Northwest Quarterly*, 99, 1 (2007), 30: www.jstor.org/stable/40492044

6. See, for example, the Library of South Australia's extraordinary World War I collection of buttons: https://collections.slsa.sa.gov.au/resource/D+8775/1-73(Misc)

7. Scott Keeter, Cliff Zukin, Molly Andolina and Krista Jenkins, 'The Civic and Political Health of the Nation: A generational portrait', *Center for Information and Research on Civic Learning and Engagement (CIRCLE)* (New Brunswick, NJ: Eagleton Institute of Politics, 2002), 10: https://files.eric.ed.gov/fulltext/ED498892.pdf

8. Donnelly Colt Buttons, GLBTQ Buttons B.10_I.03a: http://content.library.ccsu.edu/cdm/singleitem/collection/GLBTQ/id/1132/rec/1

9. Ferne Sales and Mfg. Inc. GLBTQ Buttons B.01_I.23: http://content.library.ccsu.edu/cdm/singleitem/collection/GLBTQ/id/975/rec/1; Larry Kramer, 'Interview with Sarah Schulman and Jim Hubbard', *ACTUP Oral History Project*, 16 February 2005; MIX: The New York Lesbian & Gay Experimental Film Festival, 11 December 2005: www.Actuporalhistory.com

10. Loughery Buttons 02_I.26, Loughery Collection, GLBTQ Archive, CCSU: http://content.library.ccsu.edu/cdm/singleitem/collection/GLBTQ/id/904/rec/1

11. GLBTQ Buttons B.01_I.01: http://content.library.ccsu.edu/cdm/singleitem/collection/GLBTQ/id/962/rec/16

12. Justin Parkinson, 'The Rise of the Rainbow Flag', *BBC News Magazine*, 16 June 2016: www.bbc.com/news/magazine-36538429

51. Plastic Politics

1. In this chapter we use the English translation 'transgender' with the knowledge that this risks some misunderstanding. Rather than assume a seamless translation, we understand that Thai notions of gender and sexual identity are commonly embedded within a category-based scheme where sex, gender identity and expression, and sexual orientation, are not each unique components of a person, but are instead seen as combining to produce mutually exclusive combinations of characteristics. In this chapter our use of the word transgender speaks to *phu chai kham phet* (transgender men) as well as associated transfeminine identities, including *phu ying kham phet* and *kathoey*.

2. Siam is the former name of the country now known as Thailand. We use 'Siam' to refer to the pre-1939 period, and 'Thailand' for the post-1939 period. Corvée labour was a form of unfree and unpaid labour that 'commoners' had to undertake over fixed periods of time.

3. Pinkaew Laungaramsri, '(Re)crafting Citizenship: Cards, colors, and the politic of identification in Thailand', *Harvard-Yenching Institute Working Paper Series* (2015), pp. 1–32 (p. 5).

4. Laungaramsri, '(Re)crafting Citizenship', p. 5.

5. Laungaramsri, '(Re)crafting Citizenship', p. 6.

6. Laungaramsri, '(Re)crafting Citizenship', p. 5.

7. This chapter draws on the findings of two separate empirical studies that interviewed Thai transgender participants. The first study, entitled 'A qualitative study on the exclusion and discrimination of LGBTI people in Thailand: Effects on access to markets and services', was conducted by Adisorn Juntrasook, James Burford, Timo Ojanen, Titikarn Assatarakul, Athitha Kongsup and Nada Chaiyajit at Thammasat University. It undertook 'life story' interviews with 20 LGBTI people in Thailand, with funding support from the World Bank Group and the Nordic Trust. The full World Bank report on this issue (of which this Thammasat study was a part), entitled 'Economic Inclusion of LGBTI Groups in Thailand', was published in March 2018. The second study is based on Jutathorn Pravattiyagul's unpublished doctoral thesis on discrimination experienced by Thai transgender women in Europe and Thailand. All names used in both studies are pseudonyms.

8. C. Jenkins, P. Pramoj na Ayutthaya and A. Hunter, 'Kathoey in Thailand: HIV/AIDS and life opportunities' (Washington, DC: USAID, 2005).

9. Peter A. Jackson, 'Tolerant but Unaccepting: The myth of a Thai "gay paradise"' in Peter A. Jackson and Nerida M. Cook (eds), Genders and Sexualities in Modern Thailand (Chiang Mai: Silkworm Books, 1999), pp. 226–42.

52. Bloomers and Monocles

1. Marjorie Garber, Vested Interests: Cross-dressing & cultural anxiety (New York and London: Routledge, 1992).

2. Nikki Sullivan, A Critical Introduction to Queer Theory (Edinburgh: Edinburgh University Press, 2003).

3. Amy Kesselman 'The "Freedom Suit": Feminism and dress reform in the United States, 1848–1875', Gender & Society, 5, 4 (1991), p. 496.

4. Scott Herring, 'Material Deviance: Theorizing queer objecthood,' Postmodern Culture, 21, 2 (2011): www.pomoculture.org/2013/09/03/material-deviance-theorizing-queer-objecthood, p. 6.

5. Charles Baudelaire, 1863. 'The Painter of Modern Life': www.writing.upenn.edu/library/Baudelaire_Painter-of-Modern-Life_1863.pdf

6. Laura Doan, 'Passing Fashions: Reading female masculinities in the 1920s,' Feminist Studies, 24, 3 (1998), pp. 663–700; Marius Hentea, 'Monocles on Modernity,' Modernism/Modernity, 20, 2 (2013), pp. 213–37.

7. Shari Benstock, The Women of the Left Bank, Paris 1900–1940 (Austin, TX: University of Austin Press, 1986).

8. From 7 November 1800 French law explicitly prohibited women from wearing trousers in Paris without a police permit except during carnival. The law, which was on the books until 2013, was last applied in the 1930s when the French Olympic committee stripped the French athlete Violette Morris of her medals because she insisted on wearing trousers. See Gretchen Van Slyke, 'Who Wears the Pants Here? The policing of women's dress in nineteenth-century England, Germany and France', Nineteenth Century Contexts: An interdisciplinary journal, 17, 1 (1993), pp. 17–33.

9. Lillian Faderman, Surpassing the Love of Men: Romantic friendship and love between women from the Renaissance to the present (New York: William Morrow, 1981), p. 369.

10. On female masculinity see Judith Halberstam, Female Masculinity (Durham: Duke University Press, 1988).

11. Melanie Taylor, 'Peter (A Young English Girl): Visualising transgender masculinities', Camera Obscura, 19, 2 (2004), p. 29.

12. Taylor, 'Peter', p. 28.

13. Doan, 'Passing Fashions', p. 681.

53. A Lesbian Waistcoat

1. Yann Bradburn, telephone interview with Nadia Gush, 24 March 2018.

2. Katherine Gordon, 'Miro Magic: Meet the new names on international fashion designers' lips', Fashion Quarterly, August 1998, p. 81.

3. Karen Wilson, interview with Nadia Gush, 27 February 2018.

4. Ibid.

54. Lesbian Lipstick

1. An earlier version of some of this material appeared in Diva magazine.

2. Danae Clarke, 'Commodity Lesbianism', Camera Obscura, 9, 1–2 (1991), pp. 181–201; Frank Mort, Cultures of Consumption: Masculinities and social spaces in late twentieth-century Britain (London: Routledge, 1996).

3. Reina Lewis and Katrina Rolley, 'Ad(dressing) the Dyke: Lesbian looks and lesbians looking', in Peter Horne and Reina Lewis (eds), Outlooks: Lesbian and gay sexualities and visual culture (London: Routledge, 1996), pp. 178–90; Reina Lewis, 'Looking Good: The lesbian gaze and fashion imagery in gay lifestyle magazines', Feminist Review, 55 (1997), pp. 92–109.

4. Laura Doan, Fashioning Sapphism: The origins of a modern English lesbian culture (New York: Columbia University Press, 2001).

5. S28 was a piece of British legislation, passed in 1988 and repealed in 2003, that sought to prevent local authorities from 'promoting' homosexuality.

6. Vicki Karaminas, 'Born this Way: Lesbian style since the eighties', in Valerie Steele (ed.), A Queer History of Fashion: From the closet to the catwalk (New Haven: Yale University Press, 2013).

7. Lisa Walker, 'How to Recognize a Lesbian: The cultural politics of looking like what you are', Signs, 18, 4 (1993), pp. 866–90 (p. 881).

55. Punk Jacket

1. Anonymous. 'The Artist Behind the Iconic Silence = Death Image', University of California Press Blog, 1 June 2017: https://blog.ucpress.edu/blog/27892/the-artist-behind-the-iconic-silence-death-image

2. Silence Opens Door, 'Avram Finkelstein: Silence=Death,' YouTube, 4 March 2010: https://youtube/7tCN9YdMRiA

3. Skinheads Against Racial Prejudice was started in 1987 in New York as a response to the bigotry of the growing white power movement in 1982.

4. Anonymous, 'Skinheads Against Racial Prejudice': https://en.wikipedia.org/wiki/Skinheads_Against_Racial_Prejudice

5. Murray Healy, Gay Skins: Class, masculinity and queer appropriation (London: Cassell, 1996), p. 397.

6. Brian Pronger, The Arena of Masculinity: Sports, homosexuality, and the meaning of sex (New York: St Martin's Press, 1990), p. 145.

56. The Australian Speedo

1. 'Australian Slang for "Men's Swimwear"': http://blog.corka.com.au/2012/07/australian-slang-for-mens-swimwear.html

2. Newspaper advertisement, Bundaberg News-Mail, 10 October 1969, p. 12, Speedo Scrapbook, 1969–1971, Museum of Applied Arts and Sciences (MAAS) Sydney, 2001/92/1-3/9.

3. Sydney Morning Herald, 20 December 2016: www.smh.com.au/comment/obituaries/peter-travis-designer-of-speedos--an-arresting-sight-on-bondi-beach-20161218-gtdv00.html

4. DNA (December 2004), p. 62.

5. 'Summer '74: A brief season', Tailor and Men's Wear Australasia, March 1973, pp. 20–24, Speedo Scrapbook, 1970–1973, MAAS Sydney, 2001/92/1-3/12.

6. TS manuscript, 'Speedo: Company History', Subject File, Speedo Historical File, 1988–1990, MAAS Sydney, 2001/92/1-2/7.

7. John Rickard, 'For God's Sake Keep us Entertained', in Bill Gammage and Peter Spearritt (eds), Australians 1938 (Broadway NSW: Fairfax, Syme & Weldon Associates, 1987), p. 348.

8. Douglas Booth, 'Nudes in the Sand and Perverts in the Dunes', Journal of Australian Studies, 53 (1997), p. 170.

9. Clipping, 'The Swimsuit', Speedo Historical File, 1988–1990, MAAS Sydney, 2001/92/1-2/7.

10. John O'Donnell, 'John's Story', in Garry Wotherspoon (ed.), Being Different: Nine gay men remember (Sydney: Hale Iremonger, 1986), p. 46.

11. Garry Wotherspoon, City of the Plain: History of a gay sub-culture (Sydney: Hale Iremonger, 1986), 64.

12. Evening Advocate (Innisfail), 7 January 1947, p. 2.

13. National Advocate (Bathurst), 9 February 1950, p. 4.

14. Newspaper clipping, Adelaide News, 22 March 1956, Speedo Scrapbook, 1954, 1956, 1969–70, 1981–2, 1982, MAAS Sydney, 1/92/1-3/23.

15. Newspaper advertisement, Sun, 28 October 1966, p. 9, Speedo Scrapbook, 1966–69, MAAS Sydney, 2001/92/1-3/5.

16. Graham Willett, 'Freddie Asmussen', in Graham Willett, Wayne Murdoch and Daniel Marshall (eds), Secret Histories of Queer Melbourne (Parkville, Vic.: Australian Lesbian and Gay Archives, 2011), pp. 81–82.

17. DNA (December 2004), p. 62.

18. Outrage (March 1985), p. 14.

19. Outrage (December 1983), p. 9.

20. DNA (December 2004), p. 65.

21. Clipping, 'Lycra', Speedo Historical File, 1988–1990, MAAS Sydney, 2001/92/1-2/7.

57. The World's First Gay Travel Guide

1. Graham Robb, Strangers: Homosexual love in the nineteenth century (New York: Norton, 2005 [2003]), p. 7.

2. Der Internationale Reiseführer (Berlin: Karl Schultz-Verlag, 1920–21). A copy of this first edition is held at Staatsbibliothek zu Berlin, call number Ps 4574.

3. Martin Lücke, Männlichkeit in Unordnung: Homosexualität und männliche Prostitution in Kaiserreich und Weimarer Republik (Frankfurt am Main: Campus, 2008), p. 257.

4. Stefan Micheler, Selbstbilder und Fremdbilder der 'Anderen': Eine Geschichte Männer begehrender Männer in der Weimarer Republik und der NS-Zeit (Konstanz: UVK-Verlags-Gesellschaft, 2005), p. 84.

5. Die Freundschaft, 1, 11 (n.d. 1919), p. 4, 19 November 1921, p. 11.

6. Die Freundschaft, 1, 15 (n.d. 1919), p. 4.

7. Die Freundschaft, 24 September 1921, p. 10.

8. Die Freundschaft, 16 September 1922, p. 5. The original advertisement was published in English.

9. Die Freundschaft, 19 February 1920, p. 8.

10. Die Freundschaft, 13 November 1920, p. 2. In comparison, a substantial daily newspaper could be purchased in 1920 for 20 Pfennig and a light meal of potato fritters with coffee cost 1.50 Mark at a Berlin restaurant.

11. The listed European cities were Amsterdam, Basel, Brünn (Brno), Copenhagen, The Hague, Florence, Linz, Lobendau (Northern Bohemia), London, Madrid,

Marseilles, Nice, Paris, Pilsen, St Gallen, Vienna and Zürich.

12. *Der Internationale Reiseführer*, p. 3.

13. Manfred Herzer, 'Spartacus Gay Guide 1920', *Capri: Zeitschrift für schwule Geschichte*, 4 (1991), 29.

14. *Die Freundschaft*, 30 January 1921, n.p.; 10 February 1926, p. 57.

15. The other cities were in Austria, Brazil, Czechoslovakia, Denmark, England, Estonia, France, Italy, Sweden, Switzerland, Spain, Turkey, the United States and Yugoslavia: *Die Freundschaft*, December 1926, n.p.

16. These included Graz, Ireland, Iceland, New York, London, Prague and other Czechoslovakian cities, Porto Alegre, Sao Paulo, Vienna and Zürich. *Das Freundschaftsblatt*, 23 July 1926, p. 8; 26 August 1926, p. 7; 3 September 1926, p. 5.

17. Lücke, *Männlichkeit*, p. 234.

18. 'Welcome to Germany? The *Fremdenplage* in the Weimar Inflation', in Wilhelm Treue (ed.), *Geschichte als Aufgabe. Festschrift für Otto Büsch zu seinem 60. Geburtstag* (Berlin: Colloquium, 1988), p. 635.

19. Mel Gordon, *Voluptuous Panic: The erotic world of Weimar Berlin* (Los Angeles: Feral House, 2008), pp. 15–16, p. 27.

58. Keith's Slides
1. Howard Hughes, 'Holidays and Homosexual Identity', *Tourism Management*, 18, 1 (1997), pp. 3–7 (p. 5).

59. John Hunter's Make-up Box
1. Chris Bourke, *Blue Smoke: The lost dawn of New Zealand popular music* (Auckland: Auckland University Press, 2013), p. 126; 'From Man About Town to Svelte Siren in 30 Mins', unattributed newspaper cutting, 77-244-6/16, Alexander Turnbull Library.

2. www.cosmeticsandskin.com/bcb/greasepaint.php

3. 'From Man About Town'.

4. Leichner Make-up and Beauty Service, *Leichner*

Handbook on Make-up for Stage and Screen, 1938: www.fulltable.com/vts/m/mk/l.htm, p. 2.

5. 'From Man About Town'.

6. 'The Kiwis', programmes in author's possession.

7. *The Kiwis Souvenir* (New Zealand: Specialty Press, 1946), p. 12.

8. *Bay of Plenty Beacon*, 5 October 1945, p. 8.

9. John Hunter, interview with Nancye Bridges, c. 1990, 221754, AOK 002 384, National Film and Sound Archive of Australia.

10. The Kiwis Review Company programme, author's collection.

11. Hunter, interview.

12. Hunter, interview.

13. Kris Kirk and Ed Heath, *Men in Frocks* (London: GMP, 1984); Allan Bérubé, *Coming Out Under Fire: The history of gay men and women in World War II*, 2nd edn (Chapel Hill: University of North Carolina Press, 2010), ch. 3.

14. Bérubé, *Coming Out Under Fire*, p. 68.

15. Hunter, interview.

16. Yorick Smaal, *Sex, Soldiers and the South Pacific, 1939–45* (Houndmills: Palgrave, 2015), pp. 83–85.

17. Chris Brickell, *Mates and Lovers: A gay history of New Zealand* (Auckland: Godwit, 2008), p. 192.

18. Derrick Hancock, conversation with Chris Brickell, 8 October 2005.

60. The Portable Lesbian Party
1. Lesbian Identity Project (LIP) interviews, 2002–07, Leeds, Beckett University Archive, Doreen, p. 4.

2. LIP Interviews, No. 7, Doreen, p. 3.

3. Alison Oram, 'Little By Little? *Arena Three* and lesbian politics in the 1960s', in Marcus Collins (ed.), *The Permissive Society and its Enemies* (London: Rivers Oram/New York University Press, 2007); Rebecca Jennings, *A Lesbian History of Britain: Love and sex*

between women since 1500 (Oxford: Greenwood World Publishing, 2007), pp. 152–65.

4. LIP Interviews, No. 7, Doreen, p. 8.

5. LIP Interviews, No. 7, Doreen, p. 4.

6. Jill Gardiner, *From the Closet to the Screen: Women at the Gateways Club, 1945–85* (London: Pandora Press, 2003), pp. 79–80, 216.

7. LIP Interviews, No. 7, Doreen, p. 3.

8. 'Man Alive. Consenting Adults. Part 2. The Women.' BBC TV, 14 June 1967.

9. LIP Interviews, No. 7, Doreen, p. 6.

10. LIP Interviews, No. 3, Judith, p. 3.

11. LIP Interviews, No. 3, Judith, p. 5.

12. Maria Jastrzebska and Anthony Luvera (eds), *Queer in Brighton* (Brighton: New Writing South, 2014) p. 45.

13. Jastrzebska and Luvera, *Queer in Brighton*, p. 186.

14. Jastrzebska and Luvera, *Queer in Brighton*, pp. 185–86.

61. The Rangers Motor Club Flag
1. Journal of H.M.S. Endeavour, 1768–1771 [Manuscript] MS1, National Library of Australia, Wednesday 22 August 1770 (unpaginated).

2. Jay Watchorn, 'A Curious Southerner Takes a Look at Gay Brisbane', *Campaign* 28 (January 1978), p. 41; *The 1979–80 Annual Report of the Queensland Literature Board of Review*, Brisbane: Queensland Government Printer, 1980.

3. Noel Lewington and Peter Toogood, 'On the Run: Motor clubs and bars before now', notes originally presented at the Bob Buckley Memorial Lecture, 11 May 1994, Sydney Leather Pride Week, p. 18.

4. Lewington and Toogood, 'On the Run', p. 17.

5. *The Australian Club Run Association presents The 1997 National Run, Melbourne, 31 Oct–4 Nov 1997* [Pamphlet], Australian Lesbian and Gay Archives, Papers of Noel Lewington, sleeve 71.

6. Frank Croucher, email to the author, 22 March 2018.

7. Ibid.

62. The Disco Ball and the DJ
1. Tim Lawrence, 'Disco and the Queering of the Dance Floor', *Cultural Studies*, 25, 2 (2011), pp. 230–43.

63. Queer Smartphones
1. Jane McGonical, *Reality is Broken: Why games make us better and how they can change the world* (New York: Penguin Press, 2011); Evangelos Tziallas, 'Gamified Eroticism: Gay male "social networking" applications and self-pornography', *Sexuality & Culture*, 19 (2015), pp. 759–75.

2. Simon Clay, 'The (Neo)Tribal Nature of Grindr', in Anne Hardy, Andy Bennett and Brady Robards (eds), *Neo-Tribes: Consumption, leisure, and tourism* (Houndmills: Palgrave Macmillan, 2018), pp. 235–51.

3. Donna Haraway, 'A Cyborg Manifesto: Science, technology, and socialist-feminism in the late twentieth century', in *Simians, Cyborgs, & Women: The reinvention of nature* (New York: Routledge, 1991), pp. 149–82.

4. Michael Rothberg and others, 'Phantom Vibration Syndrome Among Medical Staff: A cross-sectional survey', *British Medical Journal*, 34 (2010), pp. 1–4.

5. Danielle Knafo and Rocco Lo Bosco, *The Age of Perversion: Desire and technology in psychoanalysis and culture* (Abington and New York: Routledge, 2016).

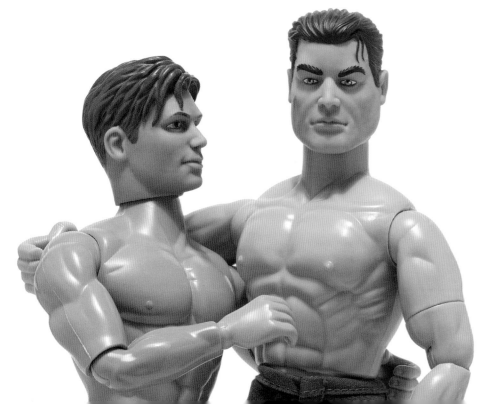

Photo credits

Endpapers: Chris Brickell collection; Half title: Photograph by Michael Stevens; Imprint page: H3488, SLV; Contents page opener: GH007985, Te Papa; GH007984, Te Papa; Contents pages: Chris Brickell collection; p. 10: Photograph by Marcus Bunyan; p. 12: Cartoon by Sam Orchard; p. 13: 1394865, Pixabay.com; Photograph by Alan Dove; p. 14: Oc1964,015a, British Museum; p. 15: 1979.325.001, Henry Sheldon Museum of Vermont History; p. 16: Photograph by Jearld Moldenhauer; p. 19: Photograph by Jeffrey Vaughan; p. 21: Chris Brickell collection; p. 22: Yvonne Harpur and Paolo Scremin, *The Chapel of Niankhkhnum & Khnumhotep: Scene details, Egypt in miniature 3* (Reading; Oxford: Oxford Expedition to Egypt, 2010), p. 477; p. 24: Photograph by R.B. Parkinson; p. 25: Yvonne Harpur, *Decoration in Egyptian Tombs of the Old Kingdom: Studies in orientation and scene content, studies in Egyptology* (London; New York: Routledge & Kegan Paul, 1987), frontispiece; p. 27: MeteoDesigns; p. 28: 1/1-006741-F, ATL; p. 29: Photograph courtesy of Krzysztof Pfeiffer and Paul Tapsell; p. 32: 1/4-055617-G, ATL; p. 34: EP/1975/2576/4A-F, ATL; p. 35: Photograph courtesy of Tamati Coffey; p. 36: Margaret Widdup, NTRS 259, Glass Plate Portrait [no number], Northern Territory Archives Service; p. 38: B6968, State Library of South Australia; p. 40: Dino Hodge, *Did You Meet Any Malagas?* (Nightcliff: Little Gem, 1993); p. 42: Dino Hodge, *Colouring the Rainbow: Blak queer and trans perspectives* (Mile End: Wakefield Press, 2015); p. 43: Photograph courtesy of Panos Couros; p. 45-49: ALGA; p. 50: Photograph by Alan Dove; p. 52: Jeffrey Vaughan collection; p. 53: Photograph by Alan Dove; p. 54-61: Photographs by Malcolm Sired; p. 62: Ben Anderson-Nathe collection; p. 64: Photograph by Lee Watts, Ben Anderson-Nathe collection; p. 67: Ben Anderson-Nathe collection; p. 69: Ben Anderson-Nathe collection; p. 70: WC; p. 71: Sackler Library, Oxford University; p. 72: WC; p. 73: WC; p. 74: WC; p. 75: LC-USZ62-77334, LC; p. 76: AME4B6, Jeff Morgan, Alamy.com; p. 78: FKCE7G, The Advertising Archives, Alamy.com; p. 79: D98BYJ, World History Archive, Alamy.com; p. 81: WC; p. 82: Photograph by Alan Dove; p. 84: 19XX/2/978, Canterbury Museum; p. 85: Photograph by Alan Dove; p. 86: MC/94/1/8, South Canterbury Museum; p. 88-91: Box 20, Folder 324, BRB; p. 92: Guy Bell/Alamy Live News, Alamy.com; p. 93: Box 20, Folder 324, BRB; p. 94-99: Wadsworth Atheneum Archives; p. 100: National Gallery of Australia, with permission of the estate of the late Donald Friend; p. 101: Australian Library of Art, State Library of Queensland, Acc. 28025, letter 15; p. 103: Australian Library of Art, State Library of Queensland, Acc. 28025, letter 33; p. 104: Australian Library of Art, State Library of Queensland, Acc. 28025; p. 105-11: BRB, with permission of Sandy Thomas Books; p. 112: GBDN7R, Maciej Bledowski, Alamy.com; p. 114: Courtesy of Lambda Warszawa; Courtesy of Waldemar Zboralski; p. 115: Courtesy of Pawel Fijałkowski; p. 116-17: Courtesy of Lambda Warszawa; p. 118-23: Tee A. Corinne Papers, Coll 263, Special Collections & University Archives, University of Oregon, Eugene, Oregon; p. 124-27: Faulkner-Morgan Pagan Babies Archive, Lexington, Kentucky; p. 128 BRB, photograph by author, 2016, permission of the estate of Samuel Steward; p. 130: Permission from the estate of Samuel Steward; p. 131: Collection of Miriam and Ira D. Wallach, Division of Art, Prints and Photographs, The New York Public Library, Astor, Lenox and Tilden Foundations, copyright Estate of Robert Giard; p. 132: Photograph by Colin Kelley; p. 134: BJN5B9, Niels Poulson, Alamy.com; p. 136: Erica Rand collection; p. 138: Erica Rand collection; p. 139: *On Our Backs*, November/December 1991, p. 49, John Hay Library, Brown University, HQ75 O5; p. 140: Badertscher Collection, Baltimore; p. 141: Badertscher Collection, Baltimore; p. 142: Photograph by Branka Bogdan; p. 143: Badertscher Collection, Baltimore; p. 145: Badertscher Collection, Baltimore; p. 146-53: Photograph by Neil Emmerson; p. 154-161: Photograph by John Howard; p. 162: Ashley Van Haeften, WC; p. 164-65: 1999,0426.1, British Museum; p. 166: Courtesy Jack Woody, Twelvetrees Press; p. 167: Photograph by Marcus Bunyan; p. 168: OPO4530, Historic England Archive; p. 170: PD.13-1972, Fitzwilliam Museum, Cambridge; p. 171: PD.12-1972, Fitzwilliam Museum, Cambridge; p. 172-75: Westminster Abbey; p. 176: PA1-q-962-30, ATL; p. 177: PA1-q-962-40, ATL; p.178: 90-017/643, Wairarapa Archive; p. 179: PA1-q-962-61, ATL; p. 181: PA1-q-963-04-3, ATL; PA1-q-963-04-5, ATL; PA1-q-963-06-5, ATL; p. 182: Neil Bartlett collection; p. 184: 3g07132u, LC; p. 186: WC; LC-USZC4-3316, LC; p. 187: WC; p. 188-89: Photographs by Jane Trengove; p. 190: 1981-031, Dunedin Public Art Gallery; p. 192: Dunedin Public Art Gallery; p. 193: G-418, ATL; p. 194-197: Photograph by Diane Johns; p. 198: Diane Johns collection; p. 200: Photograph by Daisuke Aochi, Naoshima Miyanoura Port Square, 'Red Pumpkin' © Yayoi Kusama, 2006; p. 202-05: Photograph by Katsuhiko Suganuma, Naoshima Miyanoura Port Square, 'Red Pumpkin' © Yayoi Kusama, 2006; p. 206: MSS_HallR_and_TroubridgeUVL_25/5/004, University of Texas, Austin; p. 208: MSS_HallR_25/5/001, University of Texas, Austin; p. 210: MSS_HallR_and_TroubridgeUVL_25/5/003, University of Texas, Austin; p. 211: KMJAHH, Alamy.com; p. 212: F BOX 4802/5-6, SLV; p. 214: F BOX 4802/5-6, SLV; p. 217: HT 115, Museums Victoria; H3488, SLV; p. 218-21: Chris Brickell collection; p. 222: BKF643, Moviestore Collection Ltd, Alamy.com; p. 223: WC; p. 225: WC; p. 227: Alamy.com; p. 229: ADOP71, V & A Images, Alamy.com; p. 230-35: Photograph by Christopher Castiglia and Christopher Reed; p. 236: Photo © Ministère de la Culture – Médiathèque du Patrimoine, Dist. RMN-Grand Palais/Luc Joubert; p. 238: Treasury of Saint-Pierre, Varzy (Nièvre), photographs by Robert Mills; p. 241: Choir of Saint-Pierre, Varzy (Nièvre), Musée Auguste Grasset collection; p. 242: Choir of Saint-Pierre, Varzy (Nièvre), photograph by Robert Mills; p. 243: Treasury of Saint-Pierre, Varzy (Nièvre), photograph by Robert Mills; p. 244: G3AW3R, Chronicle, Alamy.com; p. 245: Forster Papers, King's College Library, Cambridge; p. 246: Forster Papers, King's College Library, Cambridge; FF9GG8, Granger Historical Picture Archive, Alamy.com; p. 248-49: Forster Papers, King's College Library, Cambridge; p. 250-52: ALGA; p. 253: PA1q-926-051-1 ATL; p. 254: ALGA; p. 255: Chris Brickell collection; p. 256-59: Peter Wells collection; p. 260: Peter Wells collection; p. 261: PA1-f-239-50, ATL; p. 262: 34-409, Auckland Libraries; p. 265: MUS NL MBA 783.2 W257, National Library of Australia; p. 266: 973-22, Auckland Libraries; p. 267: Photograph by Kath Kingswood; p. 268-273: ONE Archives at the USC Libraries; p. 274: Photograph by Carol Highsmith, LC-HS503- 2457, LC; p. 276: Diane Johns collection; p. 277: Photograph by Helga Motley, Diane Johns collection; p. 278: Names Project Foundation collection; p. 279: Diane Johns collection, reproduced with permission of the NAMES Project; p. 280: VA 667 Office of the Victorian Government Solicitor, VPRS 30/PO Criminal Trial Briefs, unit 2084 1925/230 R vs Gaw & Lindsay, Public Records Office Victoria; p. 282: Female and Gaols Branch, Chief Secretary's Department, Central Register of Male Prisoners, VPRS 515/P1 item 70, record page 95, Public Records Office Victoria; p. 284: H2008.105 29, SLV; p. 286-88: Neil McConaghy Archive, photographs by Kate Davison; p. 290: image detail from Kurt Freund, F. Sedlacek and K. Knob, 'A Simple Transducer for Mechanical Plethysmography of the Male Genital', *Journal of the Experimental Analysis of Behavior* 8/5 (1965), 169-70; pp. 292-95: Neil McConaghy Archive, photographs by Kate Davison; p. 296-301: Julie Hendy collection; p. 302: ALGA; p. 303: Photographs by Ken Lovatt; p. 304: ALGA; p. 305: Tim Jones collection; p. 306: ALGA; p. 308: Les Sœurs de la Perpétuelle Indulgence, Couvent de Paris © 1990; p. 310: Photograph by Chris Brickell; p. 313: Photograph by John Entwistle, courtesy of Soami Archive; p. 314-17: Kathy Hermes collection; p. 319: F1DXFG, Simon Leigh, Alamy.com; p. 320: Photograph by Hanny Naibaho, Unsplash.com; p. 322-24: Photographs by Kath Khangpiboon; p. 326: HT2015.1210, Migration Museum, Adelaide; p. 328: 1851.11.15.196.1, Punch Limited; p. 329: HT2003.15, Migration Museum, Adelaide; p. 331: Smithsonian American Art Museum/Art Resource; p. 332: Photograph by Nadia Gush; p. 334: Karen Wilson collection; p. 335: Photograph by Nadia Gush; pp. 336-37: Reina Lewis collection; p. 338: Reina Lewis collection, reproduced courtesy of *Diva Magazine*; p. 339: KD31BA, Image Source, Alamy.com; p. 341: Reina Lewis collection, reproduced courtesy of *Diva Magazine*; p. 342-49: Photograph by Marcus Bunyan; p. 350: Photograph by Paul Renata; p. 353: Advertisement clipping (unattributed copy), 2001/92/1-2/7, 'Speedo Historical File', Speedo Swimwear Archive Collection, Museum of Applied Arts and Sciences, image edited by Paul Renata; p. 354: The Leicagraph Company Pty Ltd, Sydney, New South Wales, Australia, October 1962, Photograph Album, 2001/92/1-7/49, p. 21, Speedo Swimwear Archive Collection, Museum of Applied Arts and Sciences; p. 356: Copyright Kristen Bjorn, reproduced with permission; p. 357: Photography by Denis Maloney, Straight Line Graphics, Sydney, 1991, ALGA; p. 358: Annotations by Daniel Brandl-Beck; p. 360: Photographs by Daniel Brandl-Beck; p. 362: Schwules Museum, Berlin; p. 363: *Die Freundschaft*, No. 30, 30 July to 5 August 1921, Schwules Museum; p. 364: Chris Brickell collection; p. 366: PAColl-7921-09, ATL; p. 368: Chris Brickell collection; p. 370: PAColl-7921, ATL; p. 371: PAColl-9297-95, ATL; p. 372: MOWA09, M&N, Alamy.com; p. 374: British Library, CreativeCommons; p. 375: *Arena Three*; p. 377: AP100R, Alan King, Alamy.com; p. 378-80: Private collection; p. 381: Papers of Noel Lewington, ALGA; p. 382: Photograph by Peter Elfe, ALGA; p. 384: Photograph by Michael Stevens; p. 385: Photograph by Chris Brickell; p. 386: Photograph by Simon Clay; p. 389: Dan Silva, Unsplash.com; p. 391: E8PKBE, Alesky Boldin, Alamy.com; p. 392: 1993-0022-3, Te Papa; p. 395: Photograph by Marcus Bunyan; p. 406: D32MKC, Alamy.com; p. 408: Clem Onojeghuo, 327667, Unsplash.com. p. 412-413: JFKBJC, Carolyn Jenkins, Alamy.com; p. 417: 1993-0022-4, Te Papa.

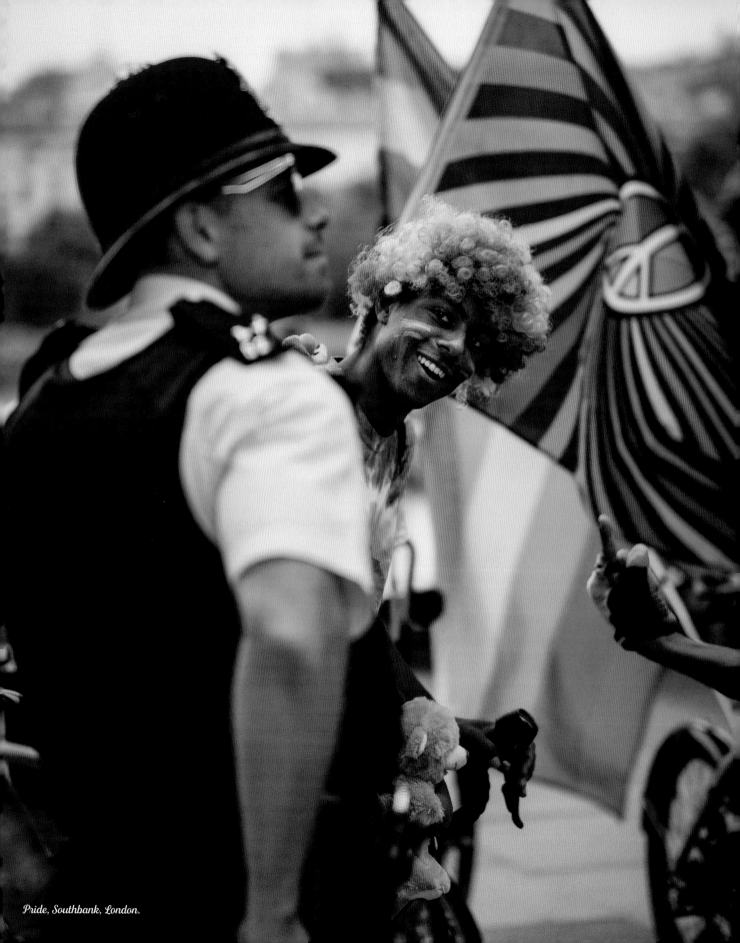

Pride, Southbank, London.

Index

Page numbers in **bold** refer to images.

At the Bourne Free Parade in Bournemouth, 2017.

Correction, from the series Hidden Agender by New Zealand artist Lauren Lysaght, 1993.